T0141835

Springer Series on Cultural Computing

Editor-in-chief

Ernest Edmonds, University of Technology, Sydney, Australia

Series editors

Sam Ferguson, University of Technology, Sydney, Australia
Frieder Nake, University of Bremen, Bremen, Germany
Nick Bryan-Kinns, Queen Mary University of London, London, UK
Linda Candy, University of Technology, Ultimo, Australia
David England, Liverpool John Moores University, Liverpool, UK
Andrew Hugill, De Montfort University, Leicester, UK
Shigeki Amitani, Adobe Systems Inc., Shinagawa-ku, Tokyo, Japan
Doug Riecken, Columbia University, New York, USA
Jonas Lowgren, Linköping University, Malmö, Sweden
Ellen Yi-Luen Do, University of Colorado Boulder, Boulder, USA

Cultural Computing is an exciting, emerging field of Human Computer Interaction, which covers the cultural impact of computing and the technological influences and requirements for the support of cultural innovation. Using support technologies such as location-based systems, augmented reality, cloud computing and ambient interaction researchers can explore the differences across a variety of cultures and provide the knowledge and skills necessary to overcome cultural issues and expand human creativity. This series presents the current research and knowledge of a broad range of topics including creativity support systems, digital communities, the interactive arts, cultural heritage, digital museums and intercultural collaboration.

More information about this series at http://www.springer.com/series/10481

Vladimir Geroimenko
Editor

Augmented Reality Art

From an Emerging Technology to a Novel
Creative Medium

Second Edition

 Springer

Editor
Vladimir Geroimenko
Faculty of Informatics and Computer
 Science
The British University in Egypt (BUE)
Sherouk City, Cairo
Egypt

ISSN 2195-9056 ISSN 2195-9064 (electronic)
Springer Series on Cultural Computing
ISBN 978-3-030-09921-3 ISBN 978-3-319-69932-5 (eBook)
https://doi.org/10.1007/978-3-319-69932-5

1st edition: © Springer International Publishing Switzerland 2014
2nd edition: © Springer International Publishing AG 2018
Softcover re-print of the Hardcover 2nd edition 2018
This work is subject to copyright. All rights are reserved by the Publisher, whether the whole or part
of the material is concerned, specifically the rights of translation, reprinting, reuse of illustrations,
recitation, broadcasting, reproduction on microfilms or in any other physical way, and transmission
or information storage and retrieval, electronic adaptation, computer software, or by similar or dissimilar
methodology now known or hereafter developed.
The use of general descriptive names, registered names, trademarks, service marks, etc. in this
publication does not imply, even in the absence of a specific statement, that such names are exempt from
the relevant protective laws and regulations and therefore free for general use.
The publisher, the authors and the editors are safe to assume that the advice and information in this
book are believed to be true and accurate at the date of publication. Neither the publisher nor the
authors or the editors give a warranty, express or implied, with respect to the material contained herein or
for any errors or omissions that may have been made. The publisher remains neutral with regard to
jurisdictional claims in published maps and institutional affiliations.

Printed on acid-free paper

This Springer imprint is published by Springer Nature
The registered company is Springer International Publishing AG
The registered company address is: Gewerbestrasse 11, 6330 Cham, Switzerland

This pioneering book is dedicated to the future generations of augmented reality artists.

Many thanks to the British University in Egypt (BUE) for the support, without which this new edition would not have been possible.

Preface

The book you are holding in your hands in a paper, or more likely digital format, is a unique one. This is the second edition of the first ever monograph on augmented reality art. It is written by a team of world-leading artists and researchers, pioneers in the use of augmented reality as a novel artistic medium, and is being dedicated to the future generations of augmented reality artists.

The book explores a wide range of major aspects of augmented reality art and its enabling technology. It is intended to be a starting point and essential reading not only for artists, researchers, and technology developers, but also for students and everyone who is interested in emerging augmented reality technology and its current and future applications in art.

It was very difficult to make this book happen, because augmented reality art is still in its infancy at present, and there are therefore relatively few research materials available. We owe a debt to our contributors who have managed to produce this monograph in the face of these difficulties. The team includes 30 researchers and artists from 12 countries (Australia, Canada, Egypt, Germany, Ireland, Italy, Netherlands, Romania, Slovenia, UAE, UK, and USA). Many of the authors are members of the Manifest.AR group (www.manifestar.info).

Manifest.AR was the first artist collective that started using augmented reality (AR) to create art and activist works. The group was formed when AR creation first became possible on smartphones. Manifest.AR explores what makes AR unique as a medium, separating it from other forms of new media, such as virtual reality, Web art, video, and physical computing.

The collective found its roots in the groundbreaking 2010 We AR in MoMA intervention. Mark Skwarek and Sander Veenhof realized they could challenge the Museum of Modern Art's extreme exclusivity by placing artworks inside and around the museum and invited selected artists to participate. Finding talented and accomplished AR artists for the show was very difficult—at the time of the MoMA intervention, very few people even knew what AR was. The group of invited participants included most of those who became core founders of Manifest.AR: Sander Veenhof, Mark Skwarek, Tamiko Thiel, Will Pappenheimer, Christopher Manzione, and John Craig Freeman. After the We AR in MoMA intervention, it

was time to put down in words the thoughts, goals, and future visions of the first artists working with this new technology. Tamiko Thiel proposed choosing a group name to give an identity to future collaborations. Sander Veenhof suggested the name Manifest.AR and that the group should write a manifesto to document this historic moment, the birth of mobile AR as an art form. Mark Skwarek brought together what became the original founder's group (the above artists, plus Geoffrey Alan Rhodes) and was the driving force behind getting the group to write and publish the "AR Art Manifesto," Manifest.AR's debut as a group entity, on January 25, 2011.

Here is the manifesto in full:

"All that is Visible must grow beyond itself and extend into the Realm of the Invisible" (Tron, 1982).

Augmented Reality (AR) creates Coexistent Spacial Realities, in which Anything is possible—Anywhere!

The AR Future is without boundaries between the Real and the Virtual. In the AR Future we become the Media. Freeing the Virtual from a Stagnant Screen we transform Data into physical, Real-Time Space.

The Safety Glass of the Display is shattered and the Physical and Virtual are united in a new In-Between Space. In this Space is where we choose to Create.

We are breaking down the mysterious Doors of the Impossible! Time and Space died yesterday. We already live in the Absolute, because we have created eternal, omnipresent Geolocative Presence.

In the 21st Century, Screens are no longer Borders. Cameras are no longer Memories. With AR the Virtual augments and enhances the Real, setting the Material World in a dialogue with Space and Time.

In the Age of the Instantaneous Virtual Collective, AR Activists aggravate and relieve the Surface Tension and Osmotic Pressure between the so-called Networked Virtual and the so-called Physical Real.

Now hordes of Networked AR Creatives deploy Viral Virtual Media to overlay, then overwhelm closed Social Systems lodged in Physical Hierarchies. They create subliminal, aesthetic and political AR Provocations, triggering Techno-Disturbances in a substratosphere of Online and Offline Experience.

Standing firmly in the Real, we expand the influence of the Virtual, integrating and mapping it onto the World around us. Objects, banal By-Products, Ghost Imagery and Radical Events will co-exist in our Private Homes and in our Public Spaces.

With AR we install, revise, permeate, simulate, expose, decorate, crack, infest and unmask Public Institutions, Identities and Objects previously held by Elite Purveyors of Public and Artistic Policy in the so-called Physical Real.

The mobile phone and future Visualization Devices are material witness to these Ephemeral Dimensional Objects, Post-Sculptural Events and Inventive Architectures. We invade Reality with our Viral Virtual Spirit.

AR is not an Avant-Garde Martial Plan of Displacement, it is an Additive Access Movement that Layers and Relates and Merges. It embraces all Modalities. Against the Spectacle, the Realized Augmented Culture introduces Total Participation.

Augmented Reality is a new Form of Art, but it is Anti-Art. It is Primitive, which amplifies its Viral Potency. It is Bad Painting challenging the definition of Good Painting. It shows up in the Wrong Places. It Takes the Stage without permission. It is Relational Conceptual Art that Self-Actualizes.

AR Art is Anti-Gravity, it is Hidden and must be Found. It is Unstable and Inconstant. It is Being and Becoming, Real and Immaterial. It is There and can be Found —if you Seek It.

The first edition of this book captured a special moment in time, the birth of augmented reality as a new medium. It showed the first efforts of the artist's pioneering in this once virgin medium. New mediums require a period of discovery. *Augmented Reality Art: From an Emerging Technology to a Novel Creative Medium* was a snapshot of that incredible moment of discovery. The progression that took place in the first few years was truly impressive. During this time, the leading artists took every opportunity to create work that they could. At times, some of the artists were doing 3–4 shows in one week. This allowed them to experiment at a rapid pace. In this period, they explored what makes the medium unique and different from its predecessors. One area that had great promise was the ability to tie an idea to a physical location or object.

It is worth to remember that the first works in cinema were basically mirror copies of the theater stage. Actors would perform a narrative on a theatrical stage while the film crew recorded it. It took 50 years to get from the invention of film to Orson Welles's *Citizen Kane*, which is considered to be the first masterpiece in the black-and-white film's golden age displaying mastery over the technology as well as cinematic narrative technique. The team behind its creation had absolute mastery of the medium on all levels for that time.

Augmented reality art has yet to have its *Citizen Kane*, a masterpiece truly worthy of the technology. It is not to say that groundbreaking work has not been done, but it will look primitive compared to what is coming in the near future. This is largely due to the limitations of the current hardware and software. The early years of augmented reality art development were trying times. Complex artworks that worked perfectly during testing would be dead at the gallery opening. Certain wireless providers would work at one event and not at others. Many times, you would see the people crowded around the one guy who showed up with an AT&T wireless plan because all the other carriers were dead. SDKs and other software for AR art development would be in business one day and bought by Apple the next (who would subsequently remove the software from the public market). Work would exist one day and be gone the next. During this ongoing period, documentation was critical. Most of the early work exists only as documentation. Sadly, this is still somewhat the case. But there is hope that comes in the form of AR Kit by Apple and AR Core by Google. This development software is quite good, is easy to work with, and makes AR a hundred times more accessible to the development community than it ever has been. There is a real chance this software might bring AR to the general public. If more people start using the technology, more exciting tools for artists will be developed.

For the ideal experience, the user's view needs to move from the LCD of the phone to something like a pair of lightweight AR glasses. The experience needs to be directly in front of the user's field of view. Rock solid tracking is needed to orient the AR artwork in the physical space. And on top of this, the software needs to be able to integrate the digital content into the physical space, including color correction, depth of field, shadows, and moving objects. We still have a few years before this, so artists will have to make due with the current smartphones.

In this updated and revised edition of the book, we see the second generation of AR artworks and new talents joining the AR artist community. The projects have progressed conceptually and technically. The smartphones have improved dramatically, especially their sensors, speed, and resolution. Next-generation AR headsets like the HoloLens have also become available. These advances have opened up an entirely new and improved set of tools artists to create with. It is never been as exciting to create AR as today and the future looks bright!

The content of the book is arranged as follows. You can read chapters in sequence or randomly.

Chapter 1 "Augmented Reality Activism" narrates the exciting story of the first generation of activists that began working with augmented reality to further their causes. These activists pioneered the development of mobile AR in search of what made it unique from other mediums and what traits could be used to further activists agendas. Many of these works are the first explorations of their type with this new technology and act as a road map for future activists working with AR. What dangers do those working with this technology face? Does AR have the ability to empower the masses? Can it create real social change and can it unite society by turning virtual experiences into physical ones? The activists in this chapter set out to find these answers.

Chapter 2 "Critical Interventions into Canonical Spaces" describes augmented reality interventions led by the author in 2011 with the artist group Manifest.AR at the Venice Biennale, and in collaboration with the design office PATTU at the Istanbul Biennal. The interventions used the emerging technology of mobile augmented reality to geolocate virtual artworks inside the normally, curatorially closed spaces of the exhibitions via GPS coordinates. Unlike physical art interventions, the artworks cannot be removed or blocked by the curators or other authorities and will remain at those locations as long as the artist desires. The artworks exploit the site-specificity as an integral part of the artwork while simultaneously questioning the value of location to canonize works of art, and the power of the curator as gatekeeper to control access to the spaces that consecrate works of art as part of the high art canon.

Chapter 3 "ART for Art: Augmented Reality Taxonomy for Art and Cultural Heritage" proposes an activity-based taxonomy method that is designed to produce technology adoption insights. The proposed method is evaluated on adoption of augmented reality technology in the context of art and cultural heritage. In this process, an AR Taxonomy for Art and Cultural Heritage has been built, which was used to classify 86 AR applications in this domain. The results of classification provided a meaningful insight into technology adoption, to name a few: general

lack of support for communication and personalization activities; the quality of adoption did not reach satisfying quality level; despite limited immersion capacity, handheld AR systems are the most commonly used systems; irrespective of difficult and costly setups, many spatial AR systems were utilized (presumable due to high immersion capability).

Chapter 4 "Beyond the Virtual Public Square: Ubiquitous Computing and the New Politics of Well-Being" first explores augmented reality and ubiquitous computing in general and then describes examples of place-based augmented reality artworks within the framework of electracy (the digital apparatus). Apparatus theory correlates technological innovations with the corresponding inventions in institutional practices, including individual and collective identity behaviors. The authors, working with an electrate consultancy (the EmerAgency), test an augmented deliberative design rhetoric intended to overcome individual alienation from collective agency. It is an electrate equivalent of the ancient Theoria. Theoria, augmented by literacy, became journalism—the fourth estate of a democratic society. The konsult practice described in this chapter updates Theoria for a fifth estate with a new function supporting collective well-being, in the global experience of a potentially ubiquitous public square.

Chapter 5 "Augmented Interventions: Redefining Urban Interventions with AR and Open Data" proposes that augmented reality art and open data offer the potential for a redefinition of urban interventionist art practices. It examines the possibilities for redefining the activist art practice of urban intervention with data and augmented reality to introduce new hybrid techniques for critical spatial practice. The combination of augmented reality and open data is seen to provide a powerful tool-set for the artist/activist to augment specific sites with a critical, context-specific data layer. Such situated interventions offer powerful new methods for the political activation of sites which enhance and strengthen traditional non-virtual approaches and should be thought of as complementary to physical intervention. The chapter offers a case study of the author's *NAMAland* project, a mobile artwork which used open data and augmented reality to visualize and critique aspects of the Irish financial collapse.

Chapter 6 "The Aesthetics of Liminality: Augmentation as an Art Form" reveals that while one can make arguments that much AR-based art is a convergence between handheld device art and virtual reality, there are gestures that are specific to augmented reality that allow for its specificity as a genre. The chapter explores some historical examples of AR and critical issues of the AR-based gesture, such as compounding of the gaze, problematizing of the "retinal," and the representational issues of informatic overlays. This also generates four gestural vectors analogous to those defined in his chapter in the *Oxford Handbook of Virtuality* (2014), which is being examined through case studies. Through these studies, it is hoped that a deeper understanding of an augmented semiotics can be achieved.

Chapter 7 "Augmented Reality in Art: Aesthetics and Material for Expression" starts with an analysis of Cinematic Apparatus theory of the 1970s that set the stage for an investigation of cinematic expression in avant-garde film art through a deconstruction of its materials. The material and production elements repressed in

the normal ideological apparatus became the arena for new expression. Cinema accelerated the mechanization and sequence of its era to create the essential medium of that era; augmented reality is a similar acceleration of the electric image that first emerged with electric video installation. Using Jean-Louis Baudry's diagram of the cinematographic apparatus as reference, this chapter excavates and diagrams the electric image apparatus to search out the repressed in viewers' perception. For augmented reality, the first medium which fully realizes the electric image, a new way forward is proposed, toward an avant-garde AR(t).

Chapter 8 "Digital Borders and the Virtual Gallery" shows that augmented reality art, as a new media subset, distinguishes itself through its peculiar mechanics of exhibition and performative recontextualization. It allows the artist to translocate the borders and constraints of the experience from physical to virtual, expressing the piece onto spaces independent of physical or locative constraint, yet still tethered to the real world. This practice of anchoring virtual assets to the physical world allows artists to make use of virtual properties such as mutability and replication, while engaging with issues of embodiment, performance, and presence. The ability to customize work's boundaries, to draw one's own curatorial borders and parameters, is in itself a freedom drawing from augmented reality's strengths, inviting a model of the world as not one in which art happens, but one which is conditionally defined and experienced as an integrative work of art.

Chapter 9 "Immersive Art in Augmented Reality" studies how current AR technology has taken a turn away from the attempt at a sensorial suspension of disbelief in favor of a new social form of immersion. In this new model, space is collapsed not between the real and the virtual, but instead between people in distance and time. In the context of the new mobile form of augmented reality that is based on social interactivity, artists are now beginning to examine the cultural potential this new medium can offer. This chapter will explore several components of this new artistic medium and some markers from art history and gaming culture that help to explain the history of how we have arrived at this new social AR medium. Specifically, it will look at socially immersive artworks and collaborative locative media as outcomes of this new medium based on social immersion rather than sensorial immersion.

Chapter 10 "Skin to Skin: Performing Augmented Reality" undertakes an examination of the use of augmented reality in recent examples of digital performance and installation investigation at the Deakin Motion.Lab. In particular, the authors discuss the concept of "digital dualism" as a means of mapping some of the conceptual shifts augmented reality makes possible for dance and performance technology. Digital dualism sees the disjuncture between "real" and "virtual" in digital performance, as in life, as an artifact of an earlier technological/cultural moment in which the digital had not yet become embedded within and a conduit for everyday life. The authors argue that digital performance within an augmented reality framework provides a demonstration of the inability of digital dualism to stand up even in relation to what might be considered the most unlikely candidate for digital distribution—the embodied experience of the human body.

Chapter 11 "Augmented Reality Painting and Sculpture: From Experimental Artworks to Art for Sale" focuses on a use of augmented reality that is more closely related to traditional painting and sculpture than to interactive game-like AR installations. Based on an analysis of the author's experimental paintings and sculptures, presented in his solo exhibition *Hidden Realities* and the outdoor installation *The Enterprise Jigsaw*, it deals with a particular type of augmented reality paintings that integrate gallery-quality art prints of digital paintings with augmentation by 2D and 3D objects. This type of painting can provide one easy and reliable solution to the acute problem of the salability of augmented reality art. Alongside theoretical considerations, the first ever augmented reality painting for sale on Amazon is presented—the author's artwork *The Half Kiss*. Similar possibilities for AR sculptures are also analyzed.

Chapter 12 "Augmented Reality Graffiti and Street Art" looks at how the concept of augmented reality graffiti enables us to experience an expanded view of the urban environment. It examines how the intersection between graffiti, street art, and AR provides us with a complex socially and technologically encoded interface, which has the potential to combine the first-hand experience of public space with digital media, and creative practices, in a hybrid composition. The chapter begins by looking at the tradition of graffiti and street art; this is followed by a discussion around the philosophical implications for digitally augmented graffiti. A number of key techniques and technologies are then explored through the use of two practice-based case studies.

Chapter 13 "Why We Might Augment Reality: Art's Role in the Development of Cognition" shows that an important aspect of Behavioral Art is "borrowing intelligence" from a humanly organized source, such as a painting, and applies it to a computer process. This process might easily be mistaken for an object de (computer) art, but we must look further into the larger dynamic system, one that includes the audience as well. Since the machine itself is incapable of any type of organization, a human must supply the organizational paradigm to the input, and a human must recognize one in the output. However, by sampling from the environment via machine, a process we can now call augmented reality, we might imbue whatever quality triggered an interpretation of "potentially meaningful" in audience members regarding that painting, to our computed output. This chapter addresses how and why humans tend to employ this particular form of nonverbal expression.

Chapter 14 "Augmenting Wilderness: Points of Interest in Pre-connected Worlds" looks at the way the aesthetics of object-oriented ontology performs in association with augmented reality art made on the borders of Internet connection. The focus of the research is on the notion of "wilderness onticology" by Levi Bryant, and the ideas of "hyperobjectivity" by Timothy Morton, while examining artworks by George Ahgupuk, Alvin Lucier, Mark Skwarek, Nathan Shafer, v1b3, and John Craig Freeman. Most of the conclusions of the research point to the praxis of the art historical anti-tradition as a tool for negotiating ontologies of the wilderness, or the unknown, as well as the virtual objects which exist there, for

creating socially useful forms of art. Other topics include the usage of the Earth art binary of site/non-site, media ecology, and the flanuer.

Chapter 15 "An Emotional Compass: Emotions on Social Networks and a new Experience of Cities" analyzes the methodology and technique used to design and develop an Emotional Compass, a device for orientation in urban environments which uses geolocated content harvested from major social networks to create novel forms of urban navigation. This user-generated content is processed in real time to capture emotional information as well as geolocation data and different types of additional meta-data. This information is then rendered on mobile screens under the form of a Compass interface, which can be used to understand the direction and locations in which specific emotions have been expressed on social networks. This gives rise to achieve novel ways for experiencing the city, including peculiar forms of way-finding techniques which rely on emotions rather than street names and buildings.

Chapter 16 "A Fractal Augmentation of the Archaeological Record: The Time Maps Project" proposes a new method for evoking the complexity of the past from the archaeological record, based on a transdisciplinary approach linking archaeological science, art, and IT technology. Inspired from the fractal theory, this method employs different levels of augmentations from general context to detail and uses a combination of augmented reality techniques and visual media, with a high artistic quality, to create a mixed-reality user experience. The chapter presents an experimental augmented reality application on mobile devices and discusses the efficacy of the method for an educational strategy to help communities recover and transmit their immaterial heritage to future generations. The research was based in Vădastra Village, southern Romania, in an archaeological complex of a prehistoric settlement.

Chapter 17 "Wearable Apocalypses: Enabling Technologies for Aspiring Destroyers of Worlds" examines "Apocalypse" by William S. Burroughs (novelist, essayist, painter 1914–1997), an essay on the possibilities of street art that he wrote as a collaboration with Keith Haring (pop and graffiti artist, social activist 1958–1990). While written in 1988, this essay can serve as a guide for current and future artists who work in augmented reality interventions into public spaces by situating their work within a 2000+ year old cycle of revolution and counterrevolution in art, culture, and spirituality. The author's contention is that looking backward to pre-modern mythology in this way provides larger frame of reference that is even more useful to contemporary augmented reality artists than it was to the graffiti artists of the 1980s that this essay was originally discussing, as the technological and artistic affordances of mobile devices have expanded the possibilities of street art to begin to match Burroughs' vision.

Chapter 18 "User Engagement Continuum: Art Engagement and Exploration with Augmented Reality" analyzes augmented reality as one of the most promising technology, which offers the possibility of mixing physical artworks with digitally augmented users' creations and/or curation of personalized exhibitions. In a similar way that Web enabled users to become active participants in, for example, commenting, sharing views, rating, and deciding on the course of television shows in

real time, augmented reality could act as a medium to leave digital augmentation of artworks in real physical spaces. In this chapter, several AR ideas and solutions are presented with a common theme: Each allows users to engage with art or cultural heritage in different ways. The chapter finishes with a presentation of user engagement continuum based on how AR solutions support engagement with artwork consumption and creation and concludes with implications such AR solution would present.

Chapter 19 "Living and Acting in Augmented Words: How to Be Your Own Robot?" presumes that the AR user experience is currently shifting from passive viewing to active engagement and that augmented reality wearables are going to be as common as smartphones are today. In a 24/7 augmented reality world, we risk to become empowered and controlled by efficiency-focused algorithms only. How to be your own robot is going to be the main challenge. In the near future, there is not just an opportunity for art to manifest itself in new ways, there is also an urgency for that to happen. The chapter describes this shift with references to some of author's own projects to illustrate the various ways in which AR art can manifest itself.

Chapter 20 "Post-human Narrativity and Expressive Sites: Mobile ARt as Software Assemblage" examines an influential selection of experimental mobile augmented reality Art [ARt] in order to explore the progressive conceptual and ethical threads that are emerging from this relatively new but powerful cultural form. Using the concept of the "software assemblage," the author traces the movement of AR beyond its native root system in the industrial, entertainment, and the engineering worlds, and toward the rhizome of radical practice that has come to define mobile ARt. She posits the software assemblage concept as an alternative and relational modality through which to converse with ARt.

Chapter 21 "Really Fake or Faking Reality? The Riot Grrrls Project" traces the evolution of the Riot Grrrls App, a proposition applying the inherent possibilities of image-based augmented technology to an historical exhibition of paintings by the Riot Grrrls, a 1990's feminist punk movement, at the Museum of Contemporary Art, Chicago. The intention was to exploit the structural necessities of augmented reality, by conceptually and visually layering related references in real time, to both poetic and pedagogical ends. To do this, a School of the Art Institute professor and an art historian with expertise in user experience worked as a team to lead a School of the Art Institute class of young students to create augmented artworks using the historic paintings as both augmented triggers but also artistic material. They created inventive formal solutions that engaged museumgoers intellectually and esthetically and were intentionally open-ended.

Finally, we hope that the reader will not judge us too harshly. We have accepted the challenge of being the first, and we have done our best to bring out this pioneering work. Just go ahead and read the book. We hope sincerely that you will enjoy it.

Cairo, Egypt Vladimir Geroimenko
New York, USA Mark Skwarek

Contents

Contributors

Damon Loren Baker Augmented Reality Laboratory, York University, Toronto, Canada

Alison Bennett School of Art, College of Design and Social Context, RMIT University, Melbourne, Australia

Paul Coulton Imagination, Lancaster Institute for the Contemporary Arts, Lancaster University, Lancaster, UK

Klen Čopič Pucihar Faculty of Mathematics, Natural Sciences and Information Technologies, University of Primorska, Koper, Slovenia; Faculty of Information Studies (FIŠ), Novo Mesto, Slovenia

John Craig Freeman Department of Visual and Media Arts, Emerson College, Boston, MA, USA

Jacob Garbe Center for Games and Playable Media, University of California Santa Cruz, Santa Cruz, CA, USA

Vladimir Geroimenko Faculty of Informatics and Computer Science, The British University in Egypt, Cairo, Egypt

Dragoș Gheorghiu Doctoral School, National University of Arts, Bucharest, Romania

Ian Gwilt School of Art, Architecture and Design, University of South Australia, Adelaide, Australia

Claudia Hart Department of Film Video, New Media and Animation, School of the Art Institute of Chicago, Chicago, USA

Stephanie Hutchison Creative Lab, School of Creative Practice, Queensland University of Technology, Brisbane, Australia

Salvatore Iaconesi Department of Digital Design, ISIA School of Design, Florence, Italy

Matjaž Kljun Faculty of Mathematics, Natural Sciences and Information Technologies, University of Primorska, Koper, Slovenia; Faculty of Information Studies (FIŠ), Novo Mesto, Slovenia

Patrick Lichty Animation/Multimedia, Zayed University, Abu Dhabi, UAE

Todd Margolis Qlik, Berkeley, CA, USA

Rose Marie May Museum of Contemporary Art Chicago, Chicago, USA

John McCormick Department of Film and Animation, Swinburne University of Technology, Melbourne, Australia

Conor McGarrigle Dublin School of Creative Arts, Dublin Institute of Technology, Grangegorman, Ireland

Oriana Persico Department of Digital Design, ISIA School of Design, Florence, Italy

Geoffrey Alan Rhodes Department of Visual Communication Design, School of the Art Institute of Chicago, Chicago, IL, USA

Nathan Shafer Institute for Speculative Media and Shared Universe, Anchorage, AK, USA

Mark Skwarek NYU Polytechnic School of Engineering, New York, NY, USA

Livia Ştefan Vauban IT Services, Bucharest, Romania

Tamiko Thiel Manifest.AR, Dover, DE, USA

Gregory L. Ulmer Department of English and Media Studies, University of Florida, Gainesville, FL, USA

Sander Veenhof Independent AR Researcher, Amsterdam, The Netherlands

Jordan Beth Vincent Deakin Motion.Lab—Centre for Creative Arts Research, Deakin University, Melbourne, Australia

Kim Vincs Department of Film and Animation, Swinburne University of Technology, Melbourne, Australia

Judson Wright Pump Orgin, New York, NY, USA

Rewa Wright UNSW Art and Design, The University of New South Wales, Sydney, Australia

Part I
Emerging Augmented Reality Technology and the Birth of Augmented Reality Art

Chapter 1
Augmented Reality Activism

Mark Skwarek

1.1 Introduction

Arguably two of the most important activist events in recent US history were that of the Occupy Wall Street Movement and the whistle-blowing by Edward Snowden (see Fig. 1.1). The two events highlight differences between physical and virtual approaches to activism and their end results.

Many, including some of the mainstream media, argue that the physical presence of protesters in the streets of the Occupy Movement accomplished very little if nothing at all. Yet Occupy created a movement which organized and inspired a new generation of activists, sweeping across the globe. In contrast, Snowden's leaked information shook American society to the core. Although both actions utilized technology, Occupy was largely an effort that took place by taking over the real world with people on the ground. Snowden's action was accomplished largely through the use of technology and courage. The implications of his actions have changed the way we think about communication and the political elite. Does the impact of technology give activists the upper hand in the effort to create change in society or does it remove people in the street from the equation? An emerging technology called augmented reality has the ability to combine both the physical experience of the streets and digital experience of the Internet. AR has the power to take net-based activism such as blogging or even hacktivism (hacktivism is activism with hacked electronic equipment. See http://en.wikipedia.org/wiki/Hacktivism) and turn it into a real-world experience. AR allows activists to place their messages at specific locations anyplace on the face of the earth and share those messages with others either physically at the site or online.

M. Skwarek (✉)
NYU Polytechnic School of Engineering, New York, NY, USA
e-mail: mark.skwarek@gmail.com
URL: http://www.markskwarek.com

© Springer International Publishing AG 2018
V. Geroimenko (ed.), *Augmented Reality Art*, Springer Series on Cultural Computing, https://doi.org/10.1007/978-3-319-69932-5_1

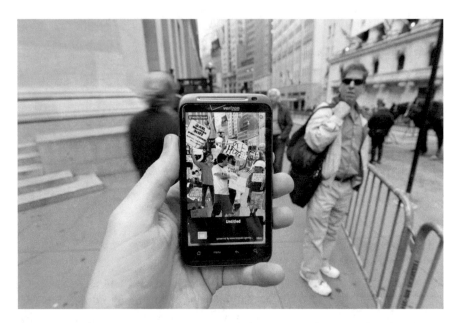

Fig. 1.1 Mark Skwarek, *ProtestAR*, AR Zuccotti Park occupiers in front of NYSE (2011) (Images reproduced courtesy of the artist)

The effects of both Occupy and Snowden were felt across the globe. While both actions had tied to technology, Occupy was largely about the people taking over public space and voicing their problems with the failure of the system during an economic meltdown. Snowden's information leak was done with the aid of technology, by infiltrating the NSA's system and removing computer files that exposed their misdeeds.

In the wake of the initial Occupy Wall Street Movement, the question of the activist's role in modern-day society comes into question. What Occupy accomplished raises many heated debates. What is not in question is that the movement swept across the nation and then the world with the help of the Internet and social media.

Technology in the hands of the masses has had a profound impact on the history and reach of activism. The public now has access to technology which to most people was unimaginable only a few years ago. Now relatively inexpensive, incredibly powerful, networked mobile technology is beginning to find its way into the hands of people around the world. The new technologies grant the public abilities which would once be considered superhuman, but also create a tool that can be exploited, manipulated, and used to spy upon the public.

Some activists have begun working with AR to see its potential as a tool for social change. The works covered in this chapter explore what makes AR unique as a medium and which of its qualities can be best utilized to further activist causes.

This text will document the first activist explorations with AR, what has been done, and compare it to activist approaches from the past and future.

1.2 Past Activists and Their Technology

Activism has a long and accomplished history of creating change on a global scale long before the incorporation of electronic technology. Societies have always organized against repression by any means available. They have been organizing and participating in mass protests against the political and corporate elite since the beginning of recorded history. One of the first recorded mass protests took place in ancient Egypt when workers constructing a royal necropolis did not receive payment. They performed a sit in inside the mortuary temples and refused to leave until they received it (Andrews 2012).

Recently, Egyptians again rose up in protest and occupied the Tahrir Square. This time they were aided by technologies like cell phones and social media. With or without technology, humans will adapt to the situation and use whatever is available to create social change when faced with injustice. Long ago fires and bells were used to signal approaching danger. Paul Revere used lanterns to warn of the approaching British forces. Technology will never be a fix-all solution to fight injustice, but it can aid activists to help level the playing field against the corrupt elite.

Another example: In 1888, Jacob Riis began documenting the horrific living conditions of the lower classes in the New York City slums (see Fig. 1.2). Riis made their largely unseen and unknown living conditions visible to the world by using the newly invented flash photography technology. Riis pioneered the use the flash to capture images in the dark alleyways and interiors of the tenements and slums of New York City. Riis's images had previously been impossible to create before the use of the flash (Yochelson et al. 2007).

More recently art activist Krzysztof Wodiczko began pioneering guerilla projection; he utilized very powerful machines capable of projecting images onto entire building facades (see Fig. 1.3). In 1985, he famously projected a swastika onto the South African Embassy in London for a period of about 2 h before it was shut down by the police. Although the work was short lived, photographs of the intervention were circulated around the global press reaching the eyes of millions (Barnett 2009).

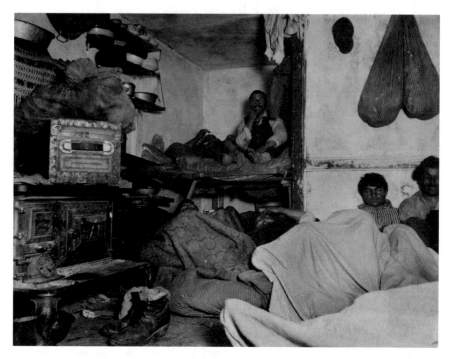

Fig. 1.2 Jacob Riis, *Five Cents a Spot* (1974) (Images reproduced courtesy of the Museum of Modern Art)

1.3 Augmented Reality Activism

Activist approaches of the past may have become less effective or may not have worked as effectively against the new tactics of the political and financial elite. The techniques used by the ancient Egyptian royal necropolis workers to organize may not have been as effective if duplicated for a twentieth century occupation.

The Critical Art Ensemble (CAE) argues: "At one point in time the control of the street was a valued item. In nineteenth century Paris the streets were the conduits for the mobility of power, whether it was the economic or military in nature. If the streets were blocked, and key political fortresses were occupied, the state became inert, and in some cases collapsed under its own weight. This method of resistance was still useful up through the 1960s, but since the end of the nineteenth century it has yielded diminishing returns, and has drifted from being a radical practice to a liberal one" (Critical Art Ensemble 1997).

Some see the Occupy Movement as fitting CAE's classification having achieved very little in the form of political change. Yet the movement spread over 951 cities across 82 countries inspiring a global community of activists (Bell 2011). The power of the digital network and the effect it can have is unquestionable such as the cyber attacks which shut down the Estonian Internet in 2007. Yet human beings are

Fig. 1.3 Krzysztof
Wodiczko, *Projection on
South Africa House*, Trafalgar
Square, London (1985)
(Images reproduced under
creative commons)

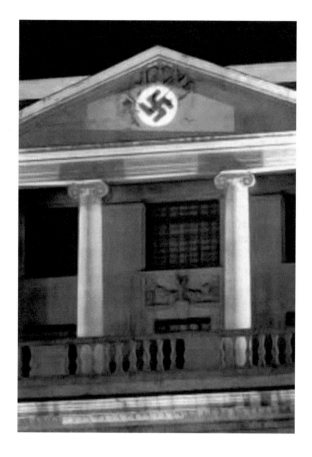

social creatures who will naturally form communal groups when oppressed by those in wielding power. AR is the medium that has the power to bring CAE's electronic civil disobedience and the actions in the street together.

AR allows ideas and messages to be overlaid onto the real world digitally with the purpose of achieving activist goals. Activists can create work with AR software such as Layar and Junaio to make their own inexpensive AR protests using their personal smartphones. Having access to low-cost tools allows more freedom to create and distribute activist messages rooted to the physical world. The goal is generally for the message to reach and mobilize the largest audience possible. AR can turn the global community into an audience while at the same time giving them a voice.

1.4 The Case for Augmented Reality

AR is a technology which has recently become much more accessible to the general public in parallel with the invention of the smartphone. Mobile technology is sweeping the globe. A trickle-down effect has mobile technology beginning to reach developing countries (Carter 2013). More and more people worldwide will have access to networked mobile devices such as smartphones and tablets.

Mobile AR gives activists the ability to make anything anywhere with no cost besides access to a computer and an Internet connection. The borders that separate public and private space no longer restrict the activist's vision. An activist can trigger a protest in a city even when he or she is sitting half way across the globe.

AR can never replace the physical presence of people just like it can never replace reality as a whole; it is merely a tool just like the other tools used by the activists such as placards, signboards, graffiti, fliers, and blogs.

AR is ideal as a social tool to generate conversations in and around the community. It is often experienced in public space at the site of a problem which creates an opportunity to engage people in conversation. AR can create experiences which make people laugh, cry, or think deeply. These experiences can be shared in real time, allowing millions to relive atrocities in hyperrealistic detail as they are happening. This conversation and experience can be easily extended to the Internet and social networks with ease.

1.5 Augmented Reality Activism in the Present

AR activism finds roots in the Situationist's idea of "detournement." In detournement, the artist or activist appropriates an existing media artifact and then alters it with the purpose of giving it new meaning (Boyd and Mitchell 2012). Activists do this with subversive goals, often targeting corporations and advertising. Culture jamming is a modern take on the Situationist's detournement. "Many culture jams are intended to expose apparently questionable political assumptions behind commercial culture. Common tactics include re-figuring logos, fashion statements, and product images as a means to challenge the idea of 'what's cool' along with assumptions about the personal freedoms of consumption" (Boden and Williams 2002).

Some of the first AR activism was inspired by the work of culture jammers and graffiti artists who boldly created works in public spaces without permission from the establishment. Often times these messages were interventions, challenging the notion of public and private space. These activists often modified commercial messages to pointing at social injustice and political issues. Culture jamming interventions by the art activist's groups like the Billboard Liberation Front remix corporate billboards to create subversive political messages (see Fig. 1.4). The process of remixing existing content is ideal for AR activism because it requires minimal effort on the part of the activist.

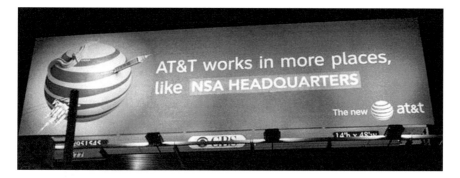

Fig. 1.4 Billboard Liberation Front, Milton Rand Kalman, *NSA_2* (Images reproduced courtesy of the artist)

Logo hacking allows activists to easily target corrupt corporations and expose their misdeeds by generating subversive messages on the corporation's own logo or advertisements. This turns the corporation's own logo against them; countless logos now act as billboards for the activist cause. The activist simply alters the target's logo and/or commercial image creating a subversive version of the original. The majority of the work has already been done by the activist's target. AR logo hacking is the equivalent of the Situationist's detournement with modern technology. What makes AR special from past forms of subversive media remixing is that once the logo hack has been created it affects all the logos of the target entity around the world.

"The leak in your home town" was a smartphone app which overlaid the British Petroleum (BP) sun logo with an AR broken 3D pipe with oil gushing from it. The work was in reaction to the BP oil pipe disaster in the Gulf of Mexico in the summer of 2009. During the BP gulf crisis live video feeds of the broken BP pipe at the bottom of the Gulf of Mexico dominated the media. "the leak in your home town" turned the 2D TV image into a 3D experience (see Fig. 1.5). To active the piece, viewers had to download the app and then aim their cameras at any BP logo. Once the app recognized the BP logo, the same broken 3D pipe would emerge out of the BP flower. Then, the black, boiling smokey oil would plum violently upward. People could walk around the pipe in 360° with their smartphones while watching the animated smoke. The broken pipe and smoke would appear every time they viewed a BP logo with the app. The app tied the spectacle directly to BP's corporate image. The app was the first activist work with mobile AR and is cited by World Trademark Review as the first "AR logo hack" (Smith 2010).

AR logo hacking is using someone's copywritten or trademarked image to generate AR content which is subversive and or done without the owner's permission. Oftentimes the AR enhances the owner's logo or symbol in a cynical way. Logo hacking works because of a process called image recognition. The smartphone's camera sees the copyrighted or trademarked image, an advertisement or object, and then uses its position to orient digital content on top of it (see Fig. 1.6).

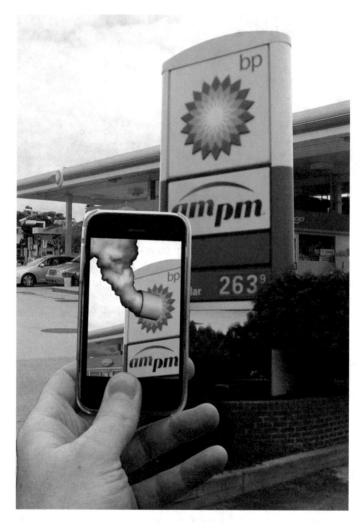

Fig. 1.5 Mark Skwarek and Joseph Hocking, *the leak in your hometown*, Augmented BP logo
(2010) (Images reproduced courtesy of the artist)

At the time this project was created, there were no laws passed addressing image
recognition and logo hacking. Today, laws have begun being passed that regulate
some of the uses of AR. More laws are sure to come with the continued adoption of
augmented reality.

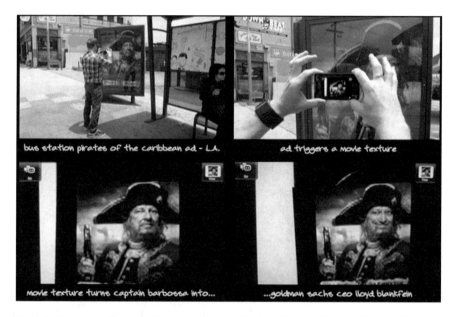

Fig. 1.6 The Heavy Projects, *Pirate Banker*, turns Pirates of the Caribbean's "Captain Barbossa" into Goldman Sachs CEO Lloyd Blankfein with AR (2011) (Images reproduced courtesy of the artist)

1.6 Exposing the Unseen

One of AR's most powerful qualities is that it allows things which cannot be seen by the naked eye to be visible with a smartphone. Walls, doors, private property, and even national borders are easily overcome with AR. Any sort of visual or physical obstruction can be circumvented with AR and an Internet signal (see Fig. 1.7).

Google Goggles allows the public to look at an object or text with their smartphones and call up fairly extensive amount of information about it from the Internet. Using this same technology, AR has the power to expose information related to corruption, pollution, and injustice that were once safely hidden behind walls, boardrooms and the like. AR cannot only tell you where to buy the consumer item in front of you, but it can also let you meet the person who made it. With the "Meet the MakAR" project (shown at Eyebeam's Activist Tech Demo Day), you can see and hear the worker as they build your consumer product. The app workers when the smartphone's camera is aimed at a consumer product. When the app recognizes the product, it generates a real-life worker who possibly made it with audio telling their story.

In the project Erase the Separation Barrier, AR was used to create a large hole through the Israeli–Palestinian Separation Barrier (see Fig. 1.8). The separation barrier is a wall that segregates Palestinians from the Israeli population. People may

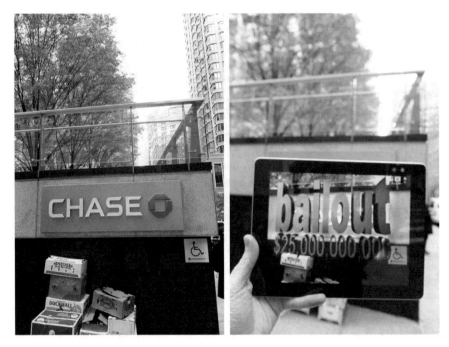

Fig. 1.7 Mark Skwarek, *arOCCUPY app*, shows Wall Street bank bailout amounts (2011) (Images reproduced courtesy of the artist)

not move freely from one side to the other. Military checkpoints are the only gateways. To pass, one must have official papers and wait in lines that can take well over two hours. For many people, life inside the barrier is all they have ever known. The Erase the Separation Barrier project allows people on either side of the barrier to look through the wall and see what was actually on the other side. For some this might have been the first time they had ever seen what was on the other side of the wall. The most recent satellites images, a topographical map, and documentation from ground level at the site of the hole were used to create an accurate model of what was on the other side of the wall. Erase the Separation Barrier is an example of diminished reality. Diminished reality removes parts of reality with AR instead of adding to reality. Future iterations of the project will update with real-time satellite feeds increasing the resolution of the experience.

AR allows protesters to go virtually where they never could in reality, such as the Augmented Reality Korean Unification Project placed the first AR in North Korea by overlaying a North Korean military outpost along the North–South Korean border (see Fig. 1.9). The Augmented Reality Korean Unification Project used AR to erase symbols of war and tension that exist in North Korea and South Korea. The work attempted to create a common ground by making a vision of a

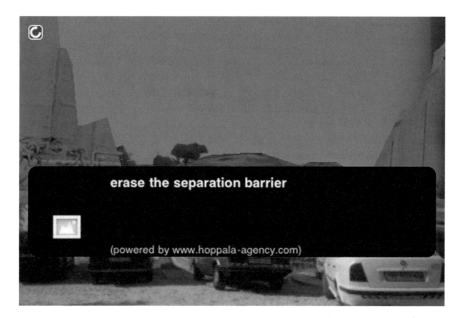

Fig. 1.8 Mark Skwarek, Daz Chandler, and Ghassan H. Bannoura *Erase the Separation Barrier*, see through the Israeli–Palestinian Separation Barrier with AR (2011) screenshot (Images reproduced courtesy of the artist)

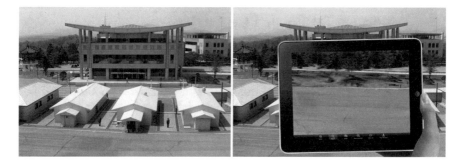

Fig. 1.9 Mark Skwarek, *Korean Unification Project*; military structures and symbols of the ongoing Korean War are erases with AR (2011) (Images reproduced courtesy of the artist)

unified Korea at peace. The work makes it look as though it is not there. The Augmented Reality Korean Unification Project is another example of diminished reality. The creation of the project required traveling to all accessible points along the North–South Korean border and erasing the military structures with AR. This included traveling into North Korea while the two countries were shooting at each other.

1.7 Cultural Loss

In the age of globalization, the history and culture of the past is often forgotten in the wake of change. The intrusion of modern pressures polarizes ethnic and religious communities as the forces from the outside world threaten the homogeneity of their structure. These communities often react by isolating themselves from outsiders (White 2012). AR can serve as a historic documentation of these periods of change, a reminder of people and culture of the past. AR differs from past forms of historic documentation because it can locate the culture, events, and people of a given time in the location where they lived in the physical world, rather than in a book or archive. In the Mechanics of Place mobile art project, developed by Hana Iverson and Sarah Drury, participant Kerem Özcan addressed this issue of cultural loss on Bogazkesen Street in Istanbul, where the tensions of historical change are clearly visible. Istanbul was once known as a crossroads of the world, where people of different races and religions lived together in peace. The intermix of different religions and ethnic populations contributed to the Ottoman Empire's status as one of the world's richest cultures. A recent surge in Muslim nationalism has led to the shunning of outsiders and their cultures. Groups outside the Muslim community are being pushed out, and their presence erased. Özcan re-populated the Istanbul Street with fictionalized residents—people of varying cultural backgrounds, who once made Istanbul the "melting pot" of the world.

1.8 Augmented Reality and Censorship

In 2011, Turkey banned 138 words from Turkish Internet domains. Words including "homemade," "hot," "nubile," "free," and "teen" were part of the censorship campaign against anything insulting to Turkishness and political extremism (Senerdem 2011). Some saw this as part of a crackdown and tightening of religious intolerance by the Turkish government. Petek Kizilelma and Hana Iverson took on Turkey's "forbidden words list" with an AR work that used the words as graffiti in the streets of Istanbul.

Tamiko Thiel's work "Shades of Absence: Governing Bodies" addresses censorship by government officials in the art world. Thiel puts golden silhouettes of censored artists inside the walls of the Corcoran Gallery of Art—including Robert Mapplethorpe, whose planned 1989 show The Perfect Moment was canceled by the museum's director in a preemptive act of self-censorship. Conservative members of Congress had called Mapplethorpe's work "obscene" (Katz 2009).

1.9 Augmented Reality for Protest

Possibly one of the most widely known and discussed AR activist protests was the #arOCCUPYWALLSTREET (#arOWS) intervention at Wall Street (see Fig. 1.10). #arOWS was the occupation of the New York Stock Exchange (NYSE) and Wall Street area with AR by activists from around the world. #arOWS was a AR component of the #OCCUPYWALLSTREET (OWS) movement. #arOWS was started at the beginning of the OWS movement and has continued to participate in OWS events ever since. #arOWS was inspired by OWS's inability to protest at or near the NYSE and Wall Street area. Instead protesters were forced to camp blocks away at Zuccotti Park where they ended up creating the Occupy Camp. Wall Street was all but closed off to local foot traffic and occupied by the New York Police Department around the clock during the OWS movement at Zuccotti Park. Police were on heightened alert, and protesters were strictly prohibited from entering the NYSE area. Those who did faced being detained and possibly arrested if they attempted to do so. As it later turned out, the FBI had treated the OWS movement as terrorists (Estes 2012).

#arOWS was the first organized mass protest using AR as a tool to project the global community's voice to a highly contested location. Over 25 artists from around the world participated in the event covering the Wall Street area with over

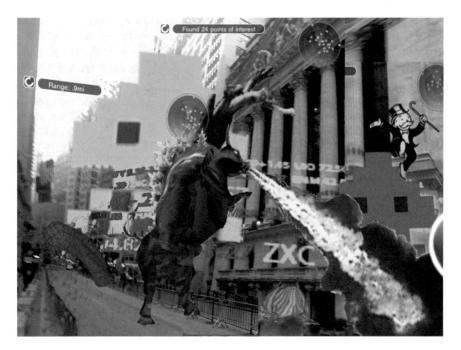

Fig. 1.10 *#arOCCUPYWALLSTREET*, Global AR protest in front of the NYSE (2011) screenshot (Images reproduced courtesy of the artist)

400 protest related augments. At Wall Street AR excited a new group of the global community about the OWS movement. Many of whom would not be able to reach Wall Street due to real-world obstacles such as distance and travel costs. These people created messages and protest works that were seen heard from Wall Street to the other side of the earth. #arOWS was organized by Mark Skwarek whose stated goal was to use AR technology to get more people to come out and participate in the OWS movement. #arOWS showed power or AR technology to deliver the activist's message to Wall Street's front doorstep even though the FBI and police had spent millions and millions of dollars trying to stop them. AR was able to overcome their surveillance, barricades, horses, and excessive police numbers.

One of the iconic works of #arOWS was the ProtestAR app. The app took the protesters from Zuccotti Park and placed them directly in front of the NYSE. The app was created from pictures and audio taken of the occupiers and their messages. The occupiers were cut out of the pictures using image editing software. The cutouts were turned into virtual AR images and placed in front of the NYSE along with recorded sound bites made by the protesters. Organizers of #arOWS went to the forbidden protest zone in front of the NYSE on almost a daily basis and would show the public the augments on a tablet. ProtestAR allowed the occupiers to protest in front of their specified target, the NYSE and be heard.

An interesting comparison between activists working in the physical and those working with AR can be made with AR "Money Grab" by Todd Margolis, and "Reign of Gold" by Tamiko Thiel on the one hand, with the physical intervention "The Day the NYSE went Yippee" by Abbie Hoffman and Jerry Rubin on the other. All of the works were activist interventions that had money falling over the NYSE. In 1967, Hoffman and Rubin staged an intervention inside the NYSE and threw handfuls of real money from a balcony onto the traders on the stock market floor. In 2011, Margolis and Thiel made AR money rain continuously over the NYSE. Both events were well documented and were written about in the press allowing for the AR experience of falling money to be compared to the physical one. To have seen both the physical and AR works, the viewer had to be present at the NYSE. The physical intervention of Hoffman and Rubin was short lived because they were detained almost immediately after starting. The work certainly provoked a reaction from the day traders who witnessed the event. "Some of the brokers, clerks and stock runners below laughed and waved; others jeered angrily and shook their fists" (Ledbetter 2007).

Very few, if any of the general public witnessed the intervention because it happened behind the closed doors of the NYSE. Their work was successful because news press was there to capture and write about the event. In contrast, Margolis and Thiel's works were seen by many of the public (including day traders) who were walking around the NYSE at random times. We do not know if the traders inside the NYSE witnessed the falling money but many were aware of the work. The AR money never stopped falling, so the event is still ongoing and documented to this day. When comparing the physical to AR, it is very hard to beat the emotion of being under real falling money with AR. This difference is a major divider of the physical and AR interpretations of the intervention. Could the effect have been

duplicated with AR? Yes… Margolis and Thiel could have linked their AR money to actual currency like Bitcoin that viewers could have collected. This could have generated the similar excitement and personal investment of Hoffman and Rubin's work. Both approaches received news press largely because of their novelty. In the end, it was the press which brought the events to the global public's attention.

1.10 Augmented Reality Flash Mobs

At the height of the #arOWS protest, a call went out on the Internet for the general public to converge on the New York Stock Exchange in the form of an AR Flash Mob (see Fig. 1.11). Critics of the #arOWS movement said that the people who needed to see the AR protest in front of the NYSE [those working in the NYSE and the general public passing by] were basically unaware that it was even taking place. The protest was invisible to the naked eye. To view it, one needed to have a mobile device with the correct app installed. The goal of the flash mob was to overcome the AR technology barrier and get it seen and in the hands of the public. On November 12, 2011, a group of seemingly ordinary citizens converged on the NYSE armed with smartphones and tablets. Participants were asked to dress in plainclothes which would not identify them as members of the OWS movement because of the heightened police security. Participants were told to find a spot along the metal NYPD barricade that surrounded the NYSE. The goal was to surround the barricade and NYSE with AR flash mobbers. Participants were told to face their smartphone or tablet displays so that the public walking by could see and hear the AR protest. At exactly 4:00 [the beginning of quitting time for NYSE workers], around 30 people had surrounded the NYSE. With their displays facing the public, they loaded the arOCCUPYWALLSTREET app and turned up their volume. Hundreds of people able to see and hear the #arOWS protest on that day (many of whom were NYSE workers) because of the high volume of foot traffic and timing.

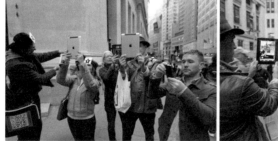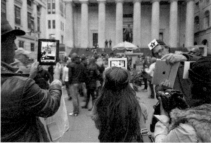

Fig. 1.11 *#arOCCUPYWALLSTREET, Augmented Reality Flash Mob at Wall Street,* AR flash mob in front of the NYSE (2011) (Images reproduced courtesy of the artist)

1.11 Augmented Reality Distributed Action

#arOCCUPY May Day was the occupation of the planet earth by AR activists from around the globe on May 1 (see Fig. 1.12). The event was part OWS's May Day general strike which called for people around the world not to show up for work and to participate in a global strike. AR activists performed a "distributed action" in which they collaborated from across the globe to occupy the earth with AR. The project was organized by an open call that was posted on public Web sites and forums across the Internet. Activists from around the world participated in creating work(s) related to OWS. The works were shared with all those participating and combined into a mass AR protest. The mass AR protest was distributed across the globe at the location of each participating activist as well as people from the general public who were willing to participate. On May 1, 2012, the AR activists and public were instructed to view and show the protest to others. As they did so, they were told to take pictures and video which they were to post to their social networks. The first images posted came from Australia and then Japan. As the day went on, excitement grew to see what country would be next and who could get the best image. Over 20 countries and 42 artists from around the world contributed to the effort. The event engaged the public on the ground as well as the social network.

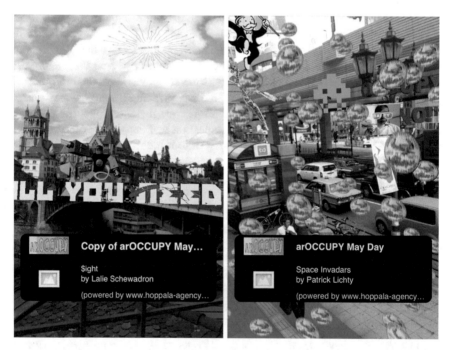

Fig. 1.12 *#arOCCUPY May Day*, Switzerland [L] screenshot (Image reproduced courtesy of Lalie Schewadron), Tokyo, Japan [R] (Image reproduced courtesy of Yuichi Irimoto) screenshot (2012)

The #arOCCUPY May Day was organized in sync with the OWS's May Day Arts Council and Devotion Gallery located in Brooklyn, New York.

1.12 Augmented Reality Environmental Activism

Nathan Shafer was one of the first activists to work on environmental issues with AR. Shafer replaced parts of the environment that had disappeared during the last century with mobile AR. One of Shafer's first works addressing environmental loss was his work that brought back the aurora borealis to his hometown of Anchorage, Alaska (see Fig. 1.13). As part of the sun's cycle every 11 years it goes from a state of high activity to low activity. As it goes into the low activity cycle, it emits less highly energized particles into space. When the energized atoms collide with earth's atmosphere, they create the aurora borealis effect. In the low cycle, the aurora borealis moves north and is seen much less frequently (Bodzash 2010). Even when the sun was in a period of high activity and the aurora borealis is not visible in Anchorage because of manmade light pollution. This light pollution removes the aurora borealis from cities across the world.

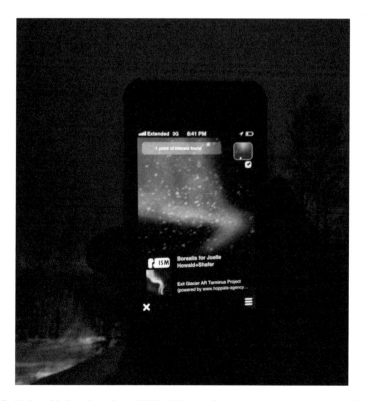

Fig. 1.13 Nathan Shafer, *Borealises* (2010) full view (Images reproduced courtesy of the artist)

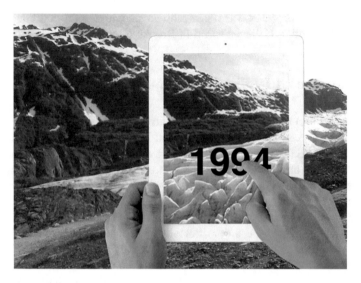

Fig. 1.14 Nathan Shafer, *Exit Glacier Terminus Project* (2012) screenshot (Images reproduced courtesy of the artist)

Another of Shafer's works addresses global warming and environmental degradation (see Fig. 1.14). This was seen in Alaska's rapidly receding glaciers. Shafer used AR to show on site, how the glacier had receded over recent years. Viewers have to travel to the site of the glaciers armed with a smartphone or tablet. Viewers can then see glaciers as they were years ago. The app allowed viewers to roll back time year by year to see global warming's devastating effect on what is left of the glaciers. Shafer's work shocks the viewer when confronted with the extent of the devastation. The amount of the damage brings on a sense of urgency bordering on hopelessness when the viewer is faced with Shafer's documentation.

Art activist John Craig Freeman's work "DéchARge de Rebut Toxique" 12 creates a sprawling radioactive toxic waste dump across the city of Paris, France. The work calls into question the world's reliance on nuclear energy and the consequences tied to long-term use (Freeman 2017a, b).

1.13 Augmented Reality Monuments

Author activist Gregory Ulmer writes of the need for modern monuments to reconcile the tragedies and horrors of today. Because we as a society experience these as a networked collective, there is a need for a modern-day monument which reflects this. In his book Electronic Monuments, Ulmer argues that this monument is needed for the 911 World Trade Center Disaster. Artist activist Brian August created this very monument for World Trade Center called 110 Stories.

August made an AR app that recreated the World Trade Center at the real-world site of ground zero in scale. The app allowed viewers to see the trade center from across the city of New York replacing its iconic silhouette in the Manhattan skyline. Then, August created an interface which allowed viewers to retell their memories of the Trade Center and leave them at the location where they had the memory. The work linked memories in time to physical locations throughout New York City with AR. The memories were stored in a collective database that the community could review from the app and Internet.

1.14 Extreme Augmented Reality Activism

Extreme AR activism is work that pushes the edge, where real danger is involved. The activist's message usually deals with controversial subject matter. These works are often executed in politically dangerous locations. Being caught making or viewing the work could result in fines, blacklisting, deportation, jail or worse. Some activists are willing to take these chances because this type of work usually has the best chance of creating actual change.

Work by the group "The 4 Gentleman" pushes these boundaries by creating works that could get the viewer jail time simply by being caught viewing the mobile app (Fig. 1.15). One work by the group, "Tiananmen Squared" recreates the Goddess of Democracy statue from the Tiananmen Square uprising in Tiananmen Square in Beijing, China. Anyone who is brave enough can travel to Tiananmen Square and view the work. Chinese college art students originally erected the Goddess of Democracy statue with chicken wire and plaster of Paris during the uprising. By simply searching for the term "Tiananmen Square" while in China, the searcher is red flagged and put under observation by Chinese cyber-police. Currently, AR is very low on most government's radars. The data being transmitted it is often overlooked by big brother. This will surely change along with escalating dangers associated with this type of work in the upcoming years.

The Apple Store Intervention with Foxconn Worker (shown at Eyebeam's Activist Tech Demo Day) can be classified as AR spectacle activism (Fig. 1.16). The Foxconn employee's lifeless body is seen contrasted against the polished glass atrium of the 14th street Apple Store with augmented reality. Foxconn, Apple's largest manufacturer, had a string of suicides—employees jumping from the roofs of the factory buildings. Eventually Foxconn, to protect its employees, was forced to install safety nets surrounding these buildings to dissuade would be jumpers. The work appropriated a shocking leaked image of one of the real-world Foxconn employees who had just committed suicide. The work creates a telepresence by mixing the realities Apple Store with the tragedy that took place at the Foxconn Plant. The lifeless Foxconn worker is surrounded by first responders and onlookers from the Foxconn plant. This is contrasted by the Apple store consumers who walk by the tragedy, unknowing and without care as they prepare to make their next Apple purchase. In a future iteration of the project, the app will be subversively

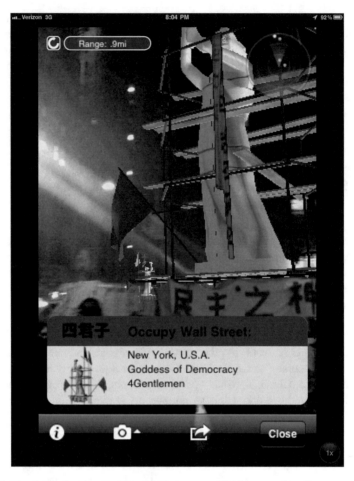

Fig. 1.15 The 4 Gentleman, *Goddess of Democracy* (2011) screenshot (Images reproduced courtesy of Mark Skwarek)

installed on the Apple Store's floor model iPhones so that the unknowing consumers may accidentally experience the intervention while considering their next smartphone purchase.

1.15 Augmented Reality Communication and Creation

Another form of AR activism empowers the public itself with creative tools. These tools allow the public to make their own AR messages at specific geographic locations. These locations are often highly political or private corporate locations which are inaccessible to the general public. The app infiltrAR allowed people to

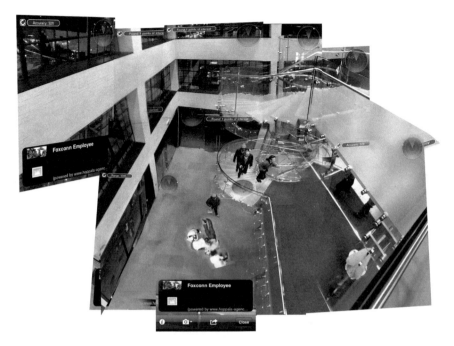

Fig. 1.16 Mark Skwarek, *Apple Store Intervention with Foxconn Worker* (2012) screenshot (Images reproduced courtesy of the artist)

tweet messages directly into the US Presidential Oval Office via an AR hot air balloon (Fig. 1.17). If the President turns on the app, he will see the balloon floating around the office, delivering the last tweeted message. It is important to note that this message can only be seen at the White House. People using this type of app will see messages or creations made by other people. The activist's goal is to make the creation process simple enough that anyone with a smartphone can create and broadcast their messages with minimal effort. Creation software is made to democratize AR technology and empower the masses.

These AR mobile apps rely on the public to create the message or idea. This type of work is called crowdsourcing. They rely on the users to create the message. These projects are often popular because of the creative freedom it provides the public. The activists who make the software can never know or control what the public will create often leading to unexpected results.

The more successful creation apps generate strong metaphors, often giving the public power to remix known experiences from the real world. Skywrite by Will Pappenheimer allows the public to draw AR clouds in the sky with a smartphone or tablet (Fig. 1.18). A person using the app looks at the sky with their mobile device and draws on its display with their finger. As they do so, a cloud appears and the sound of an airplane can be heard. Skywrite could be used in a countless number of ways form art creation to love letters. Pappenheimer creates context to the work by

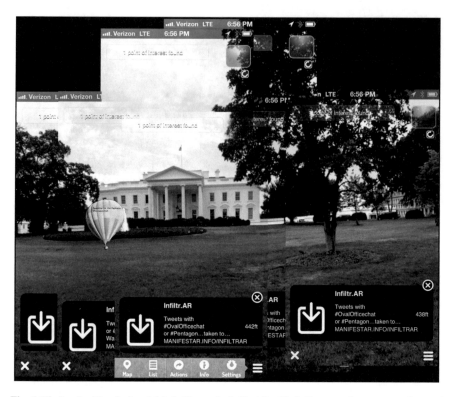

Fig. 1.17 Sander Veenhof and Mark Skwarek, InfiltrAR, AR balloon sends tweets to the oval office (2012) screenshot (Images reproduced courtesy of the artist)

choosing specific locations that people can create messages above. On a number of occasions, Skywrite has been placed over political and corporate locations such as the US White House, the US Capitol Building, and Apple and Facebook's headquarters. The placement of the experience turns most average citizens into activists when asked to draw something above a strategic government building such as the White House.

1.16 Negative Aspects of Augmented Reality

As with every new technology, there has been a backlash against the use of AR for activist purposes. A recurring point of contention is that the technology masks the evils of the world and that it detaches society from reality. "Against those who claim that augmented reality is the future of activism, we need only say: Everyone may wear blinders but the world will still stink of decay" (White 2010). The activist response to White is that we never set out to mask the stink and decay of the world;

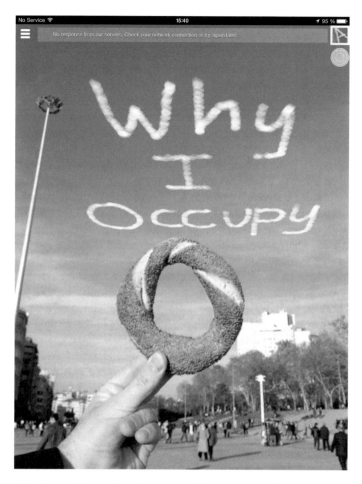

Fig. 1.18 Will Pappenheimer, *Skywrite*, create AR messages with clouds (2012) (Images reproduced courtesy of the artist)

instead, we set out to expose it and bring people out of their homes, to it. AR has the power to reveal the unseen. White misunderstands the technology. Ironically, White's blog text alienates the public from themselves and the real world their monitors. The act of creating a dialogue which solely exists in a net-based format only fuels societies' detachment from reality. The time spent reading is time taken from the real world. Instead, we (AR activists) set out to expose the real world and all its faults to new audiences who are trapped behind White's computer monitor and reveal to them the unseen horrors of the physical. AR can make digital activism engage the physical world. AR can heighten the public's understanding of their physical surroundings making them more in touch with the world around them. We live in a day and age where startling numbers of people communicate more and more through social media such as Facebook and Twitter. AR activists should turn

these technologies into face-to-face experiences that take place in the real world. The goal of future activists working with AR should be to liberate the masses from their computers and get them excited and engaged in the real world by talking to each other! Not all having the same app or fancy smartphone, but using app to generate discussion and community.

Other critics of the technology dislike AR as a tool for activism because they say it is a "safe" medium that is created from behind a monitor and keyboard. They see this technology creating a generation of armchair activists, protesting from the comfort of their homes completely detached from the physical yet complacently satisfied they have fulfilled their obligation in the fight for social justice. Creating a generation of activists who show up at the protest as virtual avatars with digital protest signs made up of one's and zero's. "[AR] absolves 'participants' of some of the basic requirements of a traditional protest [like] showing up, getting hassled [and] offering oneself for arrest,"—Carl Skelton (2012).

Skelton's fears are grounded in the writing of the Situationists and Guy Debord. "All that once was directly lived has become mere representation." The spectacle is the inverted image of society in which relations between commodities have sup-planted relations between people, in which "passive identification with the spectacle supplants genuine activity." "The spectacle is not a collection of images," Debord writes, "rather, it is a social relationship between people that is mediated by ima-ges." Guy Debord (Debord and Nicholson-Smith 1967/1994)

These critics bring up important issues but misunderstand AR as a medium. People have to travel to specific locations to experience almost all current AR activism whether the work is rooted in gravitas or humor. The site-specific quality of AR allows it to leverage a new untapped demographic of potential protesters. These could be tech savvy people who disagree with the state of national policies but are not quite motivated enough to go to the protests. The lure of AR could be the carrot that could motivate these people into making the effort to travel to a protest. Once there they would meet the like-minded people and hopefully become more involved. In this sense, AR has the ability to help build the movement's numbers. Both White and Skelton make very important arguments that future activists working with AR should consider carefully. Some future works will undoubtedly fit the mold that White and Skelton's have predicted. Activists should work to see that these predictions do not come true.

Another argument against the use of AR for activism is that it is a technology of the elite. They say it requires an expensive device and normally a yearlong contract. When smartphones first became available to the public, this was the case but the industry has their eyes on the untapped global market. This market is not in developed countries but instead in third world nation-states. "The big opportunity is in how we put smartphones into the hands of the next billion," says Dan Appelquist, Open Web Advocate at Telefónica Digital. "And we do not believe that the situation we currently see with smartphones in developed markets will neces-sarily be replicated as this happens" (Carter 2013).

The first cell phones appear ridiculous to us now. They were unwieldy and completely unrealistic for the general public. The upfront costs to develop for an AR mobile device have previously kept many activists out of development.

Finally, the vast majority of the general public simply has no idea what AR is.

Lack of knowledge and understanding of the software separates not only the activist creator but also the public from the experience. The transition from smartphones to glasses will usher in exponential growth in the public's understanding of the technology. The general public who is bombarded with content everyday filters AR out.

1.17 The Next Generation of Activist Work

1.17.1 Multi-user Networked Experiences and Telepresence for AR Activism

Augmented reality as a medium has come a long way since the first text for this chapter was written. The original projects written about in this chapter showed how AR allows activists to create works that engage the public in ways never done before. Today, a new set of tools has emerged, allowing activists to create the next-generation activist works. At the same time, the geopolitical landscape has worsened and with it the problems facing the activist.

Mikhail Gorbachev, the former leader of the Soviet Union, was recently interviewed in Time Magazine in December 2016. In the interview, he made a startling statement,

It All Looks as if the World Is Preparing for War. (Gorbachev 2017)

More and more countries with radically opposing views are obtaining weapons of mass destruction (WMDs). Soon, countries and groups of people who want WMDs badly enough will have them. With so many groups of people living so closely and now having WMDs. A nuclear world war would end life as we know it and potentially send our global society back into the dark ages. The world is becoming a smaller place by the day and ideas, and cultures are being forced closer and closer together. The weapons capable of causing mass destruction have become smaller, more powerful, and accessible. Diplomacy with the iron fist no longer seems like an option.

Many of the early AR activist works received considerable press and public attention, but the important question remains… Did these actions actually create change for the greater good? Can AR do more than draw attention to a problem?

Activism

Noun

the policy or action of using vigorous campaigning to bring about political or social change (Oxford Living Dictionaries 2017).

The next-generation mobile hardware and software bring a new and unique set of tools for the activist that allow them to engage the public's senses on a deeper level than ever before. Through multi-user, networked experiences people from opposite sides of the world can meet and interact with one another as though they are standing in the same room, thanks to augmented and virtual reality. This shared and embodied experience allows the activist to create possible to.

1.17.2 The Empathy Machine

One of the most exciting possibilities of AR and VR is as "empathy machines." Empathy machines are technologies that can allow us to understand and relate to people whose conditions are often worse than our own. We can relive world events and experience other's social conditions in Realtime 3D. Viewers can experience the suffering of others from half a world away, in Realtime. 360 VR has turned out to be a fairly immersive experience that is a cost-effective way to easily reach the general public. It works on almost any smartphone, so accessibility is a very large audience. By wearing a Google Cardboard, the viewer can see a 360-degree video recording or real-time stream of the world.

In January 2015, the movie company Vrse created the film Clouds Over Sidra (see Fig. 1.19). The film was the first 360 VR film shot for the United Nations. The film was the heartbreaking story of a 12-year-old Syrian girl growing up at the Za'atari camp in Jordan. The 12-year-old narrates everyday existence, trying to survive in the field. The work is credited with helping raise 3.8 billion dollars in an UN fund raising effort (United Nations Virtual Reality 2016). Clouds Over Sidra was the first VR movie shot for the UN and is seen as one of the first major activist works for 360 VR.

Fig. 1.19 Gabo Arora, Chris Milk, Clouds Over Sidra (2016) 360 VR (Images reproduced courtesy of the artist)

Fig. 1.20 Virtual Human Interaction Lab, Empathy at Scale (2015) VR full view (Images reproduced courtesy of the artist)

Very little, if no work, has been done with multi-user, AR experiences to build empathy for others. Past works that use virtual reality to create empathy have been done, but the approach has been mainly through a singular user experience.

Empathy at Scale, by Stanford University's Virtual Human Interaction Lab, is a VR experience that allows the public to live in someone else's skin (Fig. 1.20). In the VR experience, the participant sees that their skin color along with the race has been changed. The participant experiences what it is like to "walking a mile" in someone else's shoes from a first-person perspective. They see and hear the conditions that the other person lives in. They can feel how other people treat them. The user can experience bullying, prejudice, and injustice.

Augmented and virtual reality gives activists the ability to create a bridge between cultures and ideas. Multi-user networked experiences are now possible at a consumer grade. We can bring all types of people from across the globe into the same room. At the same time, artists must take great care when pointing out others groups and culture's shortcomings. Creating provocative work can gain much media attention, but can also escalate tension between cultures and widen the cultural divide. Watching the news in recent years, we have seen relationships between world powers getting worse and worse. An activist project that takes a lot of public attention by one society can easily be misinterpreted by another society.

Past VR projects, such as Snow World by the Human Interface Technology Laboratory at the University of Washington, have shown that VR can significantly reduce pain in severe burn victims (Fig. 1.21). A study by the Department of Communication at Stanford University showed that children remembered VR experiences as though they were real-world events that they had participated in. Developers are only beginning to unlock the true power of VR and AR. Augmented and virtual reality will very soon give activists, artists, and developers the ability to create anything. They will be able to recreate reality and bend the laws of physics.

Fig. 1.21 Human Interface Technology Laboratory, Snow World (2003) hardware view (Images reproduced courtesy of the artist)

Fig. 1.22 Mobile AR Lab @ NYU, AR VR for Peace Project (2016) HoloLens view (Images reproduced courtesy of the artist)

With the power to create "anything," activists can do anything! The most important thing to build is respect for one another and with it world peace.

The AR VR for Peace Project takes two people who hate each other and brings them together with AR and VR (Fig. 1.22). The project is an ongoing psychology study in advanced multi-user human interaction. There is no one right answer to the problem of hate and misunderstanding, so the project will come up with multiple solutions specific to the different roots of hate. The end goal of the project was to reduce tension and stress, to leave the participants with a greater level of respect and understanding for one another. The goal of the project is to create a bridge between cultures and ideologies with AR and VR.

Fig. 1.23 Mobile AR Lab @ NYU, AR VR for Peace Project (2016) HoloLens user experience (Images reproduced courtesy of the artist)

The participants, who could be on opposite sides of the planet, can see and interact with each other as though they are in the same room (see Fig. 1.23). Being remotely present at a different location other than where the user currently is located is known as telepresence. Telepresence will have a radical impact on the way the global public communicates and understands one another. Activists are now able to bring people together who are separated by distance, rivers, walls, deserts, oceans, and political and economic forces. The HoloLens [AR], VIVE [VR], and Oculus Rift [VR] can all create these networked, multi-user telepresence experiences.

Such a powerful technology is a double-edged sword. A danger of this telepresence is that it can create a culture of "armchair activists" (Chen 2012). A public, who views disasters as immersive entertainment, is numb to reality. A culture of AR and VR "disaster tourism" could evolve where the public experiences the world through from their home, seen through a LCD. Sadly, this culture somewhat already exists in America, with people spending over 10 h a day looking at digital screens (Howard 2016). It is imperative that activists harness AR and VR with the goal to create social change for the greater good. The experiences activists create need not only to entertain, but must compel the viewer to action.

1.17.3 User Experience

The first experience for the AR VR for Peace Project was an experience where two people find themselves trapped on a deserted island. They were forced to work

Fig. 1.24 Mobile AR Lab @ NYU, AR VR for Peace Project (2016) VIVE in-game user experience (Images reproduced courtesy of the artist)

together to survive. When the experience starts, the real-world floor disappears, covered by digital sand and a virtual island materializes under their feet. They wake up in a life raft which has washed ashore on a deserted island with a sinking ship in the distance. Strangely, they find that they only inhabit half of an avatar's body. The participant who becomes the upper half of the body finds themselves lying on the ground. The participant's experience at two different real-world locations. For the AR experience, they both wear the HoloLens augmented reality headset. One participant wears markers on their hands, and the other participant wears them on their feet. The markers allow the participant's feet and hands to be tracked. The tracking allows the participant to interact with the virtual environment (see Fig. 1.24).

They can only drag themselves along the ground with their hands, thanks to the tracking markers. The second participant only inhabits the lower torso, legs, and feet. They can walk, but have no body, arms, or head. Even though they do not have a head, they see the world in a first-person perspective, from where the avatar's head would be. The participant's view seems as though they are floating above a set of legs.

Soon after awakening, the participant's problems get worse. The ocean's tide begins rising, and the islands beach starts to disappear. The only chance to survive is to climb the mountain at the center of the island. There is one more problem they face. As they try to climb, they make some progress but soon come to an impasse that they just cannot overcome on their own. Alone, the participants are destined to fail and drown in the rising tides. The only way to make it up the mountain and to safety is if they combine into a complete avatar. The upper torso can lift themselves on top of the lower body, and they will unite creating a complete avatar. Only now can the two participants scale the mountain wall to safety. The task is not easy and requires the two participants to work in sync to make it past the obstacles and survive the rising water. Some obstacles require the operator of the lower half of the torso to physically jump while the upper half must grab the ledge at precisely the right moment. The user's experience is intentionally very physical. The interactions, such as climbing and jumping, are meant to be as close to the real-world

Fig. 1.25 Mobile AR Lab @ NYU, AR VR for Peace Project (2016) VIVE user experience (Images reproduced courtesy of the artist)

action as possible. The interaction is intentionally designed to be challenging and can only be accomplished when both people work in sync. This is unlike like the traditional video game experience, where players can make it to safety by passively pushing buttons.

Both AR and VR versions of the project were built. Each had pros and cons. The VR version was more immersive, higher resolution, and user interaction was more fluid. This was because the VR version was tethered to a dedicated gaming PC which allowed it to render much higher resolution graphics than the HoloLens. Wearing the VR headset blocked out the user's view of the real world, completely immersing the user in the VR simulated world (Fig. 1.25). Also, the VR controllers gave the users a slightly better experience when interacting with objects in the virtual world, heightening the sense of immersion. The major downside to the VR version was the tethering of the headset to the gaming PC. The cable was dangerous because of the danger of tripping. This required a project worker to constantly watch the participant while they were in the experience. The hardware for the VR experience was heavier and more obtrusive. The VR also took a longer time to set up and prepare.

The AR version of the project was simpler to set up. No external PC was needed. All computations were done locally on the HoloLens. The biggest advantage of the HoloLens was that it was not tethered and the participants were able to freely move around larger spaces than the VR iteration unencumbered. Not being tied to a PC allowed for more freedom when designing the environment. The biggest drawback was the HoloLens's small field of view. The HoloLens was only able to generate a medium-sized display window for AR in front of the viewer's eyes. If the participant looked to the right or left of the window, they would no longer see augmentation. This would somewhat ruin the user's immersion. Also, the participant had to look at the part of the environment they wanted to interact with for the hand and feet trackers to work.

1.17.4 Considerations and Problems

The challenges facing the development of the project faced were numerous. Creating a change in the user's subconscious was no easy task, and many different approaches were considered. To do this, an interaction strategy had to be devised. Would the experience be active or passive? Would they be able to communicate? If so, how would they communicate? How would the people see each other? Should the users be able to interact or should their experience be passive as an observer?

The reasoning for turning the interaction into physical play was to overload the participants with goals so to remove them from their daily and past lives. This was to temporarily break the metal link to the root of their anger and hatred. Combined mental and physical focus, synced with the other participant, was required to make it through the experience. The user's experience and interactions were carefully designed to promote cooperation and goodwill between the players. The user's experience was supposed to be neutral and not linked to any cultural metaphors so not to trigger the user's preconceptions. The design of the avatar, the environment, and user's interactions were given much consideration so that it would not taint the experience.

1.17.5 Test Subjects

Choosing test subjects for the project was a complex task. Taking people who hate each other and putting them in direct contact with one another can be dangerous even if they are in different physical locations. The possibility that experience might heighten animosity was a serious concern. Knowing that small miscalculations could lead to dangerous results when placing different radical groups together, careful thought and testing took place. The strategy needed to take into account the conflict that the project was trying to resolve.

For the first user testing, ten applicants were chosen as potential test subjects. They were told it was multi-user VR playtesting. The reasoning behind the experience in the initial interview. The development team knew in advance that some of the participants had ongoing conflicts with other members in the pool. They were asked seemingly random questions about video games, how much did they play, what types of games they played, had they experienced AR of VR gameplay, what kinds of environments where they're favorite. What conditions created a state of tranquility and which created rage. What types of people did they like to play with? Why they liked to play with these people. They were then asked about the pool of applicants. Their general impression of the other members. If they had any previous interactions.

Interviews were conducted with the two participants, and their conflicts were given a grade determined by the level of animosity. The idea was to start with small problems and scale up to significant problems. We would first work with people

who disliked each other, then move up to people who were angry at one another, and then finally work with people who hated each other.

Test subjects who disliked each other rather than people who hated each other were chosen for the first iteration of the project. For player interaction, an active experience was chosen to allow the players to see and interact with each other. It was decided not to allow the players to communicate aside from visual signals they could send each other with their avatars. Oral and other forms of communication with sound were seen as additional variables, so they were cut from the first iteration of the project.

1.17.6 Outcome

The first iteration of AR VR for Peace Project was largely successful. The test subjects (80%) felt "closer" to the person they had interacted with after completing the experience. The results were overwhelmingly positive across all age groups. The greatest attitude shift happened largely around the gameplay and with people who were competitive. The user's engagement grew dramatically as the players came up against more challenging obstacles that required the users to work together. Most users [90%] would fail on the first obstacle, but by timing their actions, all groups were able to overcome the first set of obstacles.

The problems the users faced mainly involved learning the interface, so they could interact with the virtual environment. Interacting with the environment with the AR markers had a longer learning curve than the VR hand controls. The small field of view on the HoloLens was an issue for most of the participants.

Because there was no audio, some of the users began communicating with gestures. Tapping or waving movements with the hand or foot controllers was the most common form of communication. The majority of participants said that the lack of communication made the experience more challenging.

The test results from the AR VR for Peace Project support the idea that AR and VR can create empathy in users. The ability to overcome a challenging obstacle, which was seemingly impossible, created a bond between users and a shared sense of mental satisfaction. Even with the problems the project faced, the possibility that this technology can create change for the greater good cannot be ignored in the current political climate.

The AR VR for Peace Project was created by NYU's Tandon School of Engineering's Mobile AR Lab in December 2016. The project team was made up of Mark Skwarek, Siyuan Qui, Mayukh Goswami, James P. Lewis, Yao Chen, and John Pasquarello. The next iteration of the project is an international effort including NYU Tandon School of Engineering in Brooklyn, NY, High Institute of Multimedia arts at Mannouba University in Tunisia, NYU Shanghai, and Northwestern Polytechnical University in China. The project will have created networked, multi-user experiences with the goal of creating world peace.

We live in a day and age where geopolitical tensions have come to the point that the USA and North Korea are on the brink of nuclear war which would most likely turn into a world war. On the day this was written, North Korea seems to have tested a hydrogen bomb that they say can be loaded onto an intercontinental ballistic missile capable of hitting the USA (Berlinger and Taehoon Lee 2017). A conflict of this sort will leave countless dead and most likely draw other countries in, becoming a world war. This is not acceptable, and the global community, including activists, needs to do everything it can to stop it. Activism is about creating change for the greater good, not getting famous. Activists working with AR and VR need to step back and think about the end result of their work. If the work they are making will only equal news stories, what good is the work really doing? AR multi-user interactions have great potential to do this, but are certainly not the only technology that can. New tools are becoming available for AR and VR creation on a daily basis. Many of these tools hold unknown potential, possibly the potential to create world peace. It is the activist's job to rise up to save the world, and AR and VR might hold the key that let them do it!

1.18 Dangers Facing the Digital Activist

The dangers facing AR activists have changed along with the technologies they use. In the past, activists had to worry about being caught in the real world. This included being recorded by a surveillance camera, being infiltrated by undercover agents, entrapment, charges of destruction of property, and vandalism to name a few. Today police cars can automatically scan each car's license plate, and security cameras make use of facial recognition algorithms to determine who you are and then search your online profile automatically for any wrongdoing. The tools of science fiction are becoming real, and they are in the hands of the political and financial elite. For those working with AR, the simple act of viewing an augment can leave a digital fingerprint that points straight back to you. In January 2014, the Ukrainian government used protester's cell phones to determine which people were near a protest and sent them a text message saying, "Dear subscriber, you are registered as a participant in a mass disturbance." A new Ukrainian law makes participating in a protest the same offense as a violent crime, punishable by imprisonment (Kramer 2014).

The technological infrastructure that our society now relies on is a system that can be easily monitored and recorded by the US intelligence organizations (NSA, CSS, NRO, etc.) and many other nation-states around the world. Edward Snowden made the dark side our technology painfully clear. The utopia we came to believe in was actually under the close eye of big brother in most likely the largest case of surveillance in the history of mankind. The US government was able to force corporate giants like Google, Facebook, Apple, AT&T, and Verizon to give access to their systems and their customer's private information (Savage et al. 2013).

This surveillance directly affects activists working with mobile AR because the infrastructure it is built on top of, in most cases, relies on corporations such as AT&T and Verizon. Activists working with any of these major providers should assume their data is being monitored by the NSA and possibly other entities. Because AR is a new technology, it largely falls off the elite's radar. But that will change in the near future as AR becomes more commonplace. When activist actions affect the political and corporation's wealth and power, they will crack down. That time is coming soon. Juniper Research says that between 2012 and 2017 AR sales will grow from $82 million to 5.2 billion (Johnson 2012).

With all of these variables facing the AR activist what options are left to create work that will have a real impact on society? This type of work will undoubtedly involve risk. Ways to minimize this risk would start with the foundation upon which the activist builds. This foundation is made up of the networks which the activist message is broadcast across. Activist sites like WikiLeaks use The Onion Router (TOR) to anonymize their communications with their users. There is other similar software such as Free Net that allows users to browse the net, chat, publish, and share files anonymously. There is always a trade-off to anonymity this software provides. Currently small numbers of people use this encryption software, and when they do so, it is usually for a reason. Because of the small numbers of people, it is easy for government agencies and other interested parties to spot them out of the billions of daily communications.

1.19 The Future

What can AR of the future do to aid activists and create real social change? Streaming real-time information visualizations to activists and the public has great potential to aid activists, inform the public, and create change. Modern-day activist heroes Edward Snowden and Julian Assange's whistle-blowing is seen by many as leading the way for modern-day activists. A powerful use for future AR activists would be mixing Snowden's information with Anonymous's hacktivism to create a real-time AR visualization of corruption and injustice. Not just the idea of being spied upon but being able to see it as it's happening. This would take Snowden's revelations to another level. Groups like Anonymous could hack live data streams of the political and corporate elite's wrongdoing and turned them into real-time AR visualizations that could be seen around the world. An example is the prototype The Protester's Survival App which was developed during the OWS movement. The work was made in reaction to the H.R. 347 bill and the Trespass Bill of 2011. They stated that if certain locations were entered by protesters, they could receive a 10-year jail sentence. The problem was these locations were invisible and could move without warning. Being at the wrong place at the wrong time could equal a long jail sentence. The Protester's Survival App and AR made these locations visible. This type of application not only keeps activists out of jail but it saves taxpayers a costly legal process.

Another area that shows great promise for AR as a tool for activism is the further development of AR creation apps (discussed in 1.15). AR creation apps democratize AR by giving the public a tool which they can use to create their own message or idea. Allowing the public to create "anything" with very little effort is the ideal for crowdsourcing. Harnessing the combined creative power of the public is a very powerful thing allowing an activist to create incredible amounts of work that one person could not possibly do on their own. The collective consciousness of the public makes it possible to generate a wide range of ideas allowing the group's overall message to stay fresh, unique, and unexpected. An example app is CreatAR15 that allows people to make anything with AR anywhere simply by downloading the app and asking for it. People can create and edit whatever they want wherever they want as well as upload their own creations.

In the future, activists will be able to record and leave historical events where they happened in HD 3D along with sound. They will have the ability to fast forward and rewind time on site and share it instantly around the world. This will be just one of many consumer grade tools available to the future activist. The science fiction of today is quickly becoming the freeware of tomorrow. Activists need to be ready to utilize this technology as it becomes available.

1.20 Closing

Where does the activist's responsibility lie? At what point is he or she to be held accountable when something goes wrong? Difficult questions face activists working with AR. Being able to view the work anywhere by a rapidly growing population can be a danger. Creating works in locations which could jeopardize the safety of the person(s) viewing the work has become very very easy. This can be done with a great degree of anonymity and literally a few clicks. To achieve the same result in the real-world, activists normally do extensive planning and could be risking their own lives. The creators of activist work must be held accountable for their actions. The AR of tomorrow will be considerably more powerful, easily accessible to a much larger population, and if abused more dangerous.

AR is a very young technology that has a real chance to change the world. The ability to overlay reality with the virtual is a Pandora's box that will certainly be used by both sides. It has an uncertain future and development will be largely driven by commercial interests.

Until AR is able to create actual social change it will continue be attacked by naysayers like Micah White. People are just beginning to figure out what makes AR a unique technology. It offers the activist one of the most powerful tools of expression available. As AR rapidly evolves, it will quickly become more useful. Activists should carefully consider the work they will make and its desired impact on society. How will their work reach the public and who are they trying to affect? What are the long-term implications and possible outcomes, right or wrong? The future AR activist's goal should be to create work that mobilizes people, liberating

them from their digital screen-based realities making a stronger community and creating real social change.

Alice has stepped through the looking glass, and we are not turning back. Emerging mobile technologies such as the smartphone and Google Glass are here to stay. Many will use these technologies in ways that can isolate and fracture society. It is the job all future artists and activists to use this technology for the better, to bring people together, and uproot social injustice.

Acknowledgements Mark Skwarek (with Alan Sondheim and Brenda Grell).

Thanks to: Naomi Skwarek, Andrea Skwarek, Mark Skwarek Sr., James P. Lewis, and Jacques Servin.

References

Andrews E. 11 things you may not know about ancient Egypt. History.com. http://www.history. com/news/history-lists/11-things-you-may-not-know-about-ancient-egypt (2012). Accessed 29 Sept 2017.

Barnett E. Public projection. Fans in a flash bulb. http://fansinaflashbulb.wordpress.com/2009/03/ 10/public-projection/ (2009). Accessed 26 Sept 2017.

Bell M. Occupy the Tundra, Antarctica: protests spread to 951 cities, thanks in part to viral photos online. Washington Post. http://www.washingtonpost.com/blogs/blogpost/post/occupy-the-tundra-antarctica-protests-spread-to-951-cities-thanks-in-part-to-viral-photos-online/2011/10/ 17/gIQAIU9LuL_blog.html (2011). Accessed 9 Oct 2017.

Berlinger J, Taehoon Lee T. Nuclear test conducted by North Korea, country claims; South Korea responds with drills. CNN. http://www.cnn.com/2017/09/03/asia/north-korea-nuclear-test/ index.html (2017). Accessed 9 Oct 2017.

Boden S, Williams J. Consumption and emotion: the romantic ethic revisited. Sociology. http:// www.sagepub.com/mcdonaldizationstudy5/articles/Consumption_Articles%20PDFs/Boden. pdf (2002). Accessed 9 Oct 2017.

Bodzash D. The northern lights are disappearing. Examiner.com, http://www.examiner.com/ article/the-northern-lights-are-disappearing (2010). Accessed 9 Oct 2017.

Boyd A, Mitchell D. Beautiful trouble: a toolbox for revolution. New York: OR Books; 2012.

Carter J. Why basic smartphones will win in the race for 'the next billion' users IN DEPTH Is Nokia onto something? Tech Radar. http://www.techradar.com/us/news/phone-and-commu nications/mobile-phones/why-basic-smartphones-will-win-in-the-race-for-the-next-billion-users-1145720 (2013). Accessed 9 Oct 2017.

Chen H. Text, reply, now occupy. Washington Square News. http://issuu.com/nyu.news/docs/ wsn012312/4 (2012). Accessed 17 Dec 2013.

Critical Art Ensemble. Electronic civil disobedience: and other unpopular ideas. New York: Autonomedia; 1997.

Debord G, Nicholson-Smith D. The society of the spectacle. New York: Zone Books; 1967/1994.

Estes A. The FBI treated occupy like a terrorist group. Yahoo News. http://news.yahoo.com/fbi-treated-occupy-terrorist-group-021450389.html (2012). Accessed 26 Sept 2017.

Freeman J. DéchARge de Rebut Toxique. https://johncraigfreeman.wordpress.com/decharge-de-rebut-toxique/ (2017). Accessed 9 Oct 2017.

Google Dictionary. Activism. https://www.google.com/search?q=Dictionary (2017). Accessed 9 Oct 2017.

Gorbachev M. Mikhail Gorbachev: 'It All Looks as if the World Is Preparing for War'. http://time. com/4645442/gorbachev-putin-trump/ (2017). Accessed 9 Oct 2017.

Howard J. Americans devote more than 10 hours a day to screen time, and growing CNN. http://www.cnn.com/2016/06/30/health/americans-screen-time-nielsen/index.html (2016). Accessed 10 Oct 2017.

Johnson L. Augmented reality apps predicted to generate $300 M in 2013: study. Mobile Marketer. http://www.mobilemarketer.com/cms/news/research/14159.html (2012). Accessed 20 Dec 2013.

Katz J. Imperfect moments: mapplethorpe and censorship, twenty years later. http://www.icaphila.org/news/pdf/mapplethorpe_pr.pdf (2009). Accessed 7 Jan 2014.

Kramer A. Ukraine tracks protesters through cellphones. New York Times, http://mobile.nytimes.com/2014/01/22/world/europe/ukraine-protests.html?_r=0&referrer= (2014). Accessed 21 Jan 2014.

Ledbetter J. The day the NYSE went Yippie, Forty years ago, Abbie Hoffman and friends invaded the heart of American capitalism and sprinkled dollar bills on the exchange floor. Did it make a difference? CNN.com. http://money.cnn.com/2007/07/17/news/funny/abbie_hoffman/CNNMoney (2007). Accessed 20 Dec 2013.

Oxford Living Dictionaries—Activism. https://en.oxforddictionaries.com/definition/activism. Accessed 9 Oct 2017.

Savage C, Wyatt E, Baker P. U.S. confirms that it gathers online data overseas. New York Times, http://www.nytimes.com/2013/06/07/us/nsa-verizon-calls.html?pagewanted=all&_r=0 (2013). Accessed 10 Oct 2017.

Şenerdem E. TİB's 'forbidden words list' inconsistent with law, say Turkish web providers. Hürriyet Daily News, http://www.hurriyetdailynews.com/default.aspx?pageid=438&n=tibs-forbidden-words-list-inconsistent-with-law-2011-04-29 (2011). Accessed 9 Oct 2017.

Smith A. International—trademark owners beware: augmented reality can pollute your brand. World Trademark Review. http://www.worldtrademarkreview.com/account/registerv2/RegisterFree.aspx?ReturnURL=http%3a%2f%2fwww.worldtrademarkreview.com%2fdaily%2fdetail.aspx%3f%3d6F7E9886-3A5F-4783-A028-320B8518FD5A (2010). Accessed 29 Nov 2013.

Streep A. Crisis and opportunities: how one VR startup is capturing the 360-degree reality of the world's most vulnerable people. https://www.wired.com/2016/07/ryot-darg-mooser-disaster-vr/ (2016). Accessed 10 Oct 2017.

United Nations Virtual Reality. United Nations Virtual Reality Series, SYRIAN REFUGEE CRISIS. http://unvr.sdgactioncampaign.org/cloudsoversidra/#.WdsbsGhSxEa (2016). Accessed 10 Oct 2017.

White M. Augmented reality, replacing imagination with computer animation. adbusters, https://www.adbusters.org/blogs/blackspot-blog/augmented-reality.html (2010). Accessed 14 Dec 2013.

White J. Muslim nationalism and the new Turks. Princeton: Princeton University Press; 2012.

Yochelson B, Riis J, Czitrom D. Rediscovering Jacob Riis: exposure journalism and photography in turn-of-the-century New York. New York: New Press; 2007.

Chapter 2
Critical Interventions into Canonical Spaces: Augmented Reality at the 2011 Venice and Istanbul Biennials

Tamiko Thiel

2.1 Introduction

> In the twenty-first Century, Screens are no longer Borders. Cameras are no longer Memories. With AR the Virtual augments and enhances the Real, setting the Material World in a dialogue with Space and Time (Manifest.AR. AR Art Manifesto 2011).

In 2011, using the recently developed mobile technology of geolocated augmented reality (AR), the author was the primary organizer of two interventions into art biennials: in Venice together with Sander Veenhof and Mark Skwarek for our cyberartist group Manifest.AR (Manifest.AR Venice Biennale Intervention 2011) and in Istanbul in collaboration with the Istanbul design team (PATTU, Thiel T. Invisible Istanbul 2011). With geolocated AR artists can place virtual computer graphic artworks at specific locations via the site's GPS coordinates. The artwork can then be viewed by anyone on site in the display of a smartphone or mobile-enabled tablet as an overlay on the live camera view, merged with the surroundings as if the artwork was there in real life.

Both Venice and Istanbul—bound together through centuries of often contentious history—are spectacular cityscapes and sites of the former empire. They continue to fascinate not only for their spectacular settings and artifacts of their past glory, but also for their cultural presence in the globalized contemporary art world. The Venice Biennale, founded in 1895, is the world's oldest art biennial and arguably the city's main claim to relevance as a contemporary international destination. Istanbul, long in decline after the fall of the Ottoman Empire, has been reinvigorated in the past decades by Turkey's rising political and economic power.

T. Thiel (✉)
Manifest.AR, Dover, DE, USA
e-mail: tamiko@alum.mit.edu
URL: http://www.tamikothiel.com

© Springer International Publishing AG 2018

V. Geroimenko (ed.), *Augmented Reality Art*, Springer Series on Cultural Computing, https://doi.org/10.1007/978-3-319-69932-5_2

41

Its art biennial, founded in 1987, is a showcase for Istanbul's new position as a dynamic center of contemporary international culture.

In both interventions, the curatorial questions were the same: How can we go beyond each city's glorious past to address its contemporary concerns and the reality of life in the city today? What role does the art biennial play in the political and cultural life of each city? Can we use the interventions to question the biennial system itself, and the art world's use of that system to define and establish artistic value?

2.2 Challenging and Exploiting the Primacy of Site

The Manifest.AR artist group originally formed around an intervention into the United States' most iconic contemporary art space: the Museum of Modern Art in New York. Sander Veenhof and Mark Skwarek realized that the institutional walls of the white cube were no longer solid, and organized a guerilla exhibit of augmented reality artworks inside the walls of MoMA.[1]

Since time immemorial location has been used to consecrate objects and people. The religious and power centers of the world maintain sacred spaces where only the chosen elect are allowed to enter. In the art world too, access to a location— a gallery, a museum, or other curatorially closed space—is tightly controlled to confer value and thus, via this exclusivity, to canonize the works shown there as "high art." What does it mean however to control physical space when in geolocated virtual space anyone can place whatever they want? (Aceti 2008). Augmented reality artists require no permission from government or artistic authorities to place their works at a specific site. They merely need know the GPS coordinates of the location—and unlike Street Art or other physical art interventions, the infiltrated institutions cannot remove the works, which remain on site as long as the artist wishes.

Technically, it is a trivial difference in GPS coordinates that moves a virtual object from a public space such as Central Park to the curatorially closed space inside the sacred walls of MoMA. As long as curators are gatekeepers for locations of high art, location still confers value—and placing AR works in such a location, even or especially if put there by the artists themselves in subversion of this control, endows the works with the aura of objects canonized by that location.

The epiphany of augmented reality, however, is that although the artworks are virtual, their presence at the site is "real": "actually existing as a thing or occurring

[1]In October 2010, Sander Veenhof and Mark Skwarek organized the AR intervention "We AR in MoMA" (Veenhof 2010) for the Conflux Festival of Psychogeography (Conflux Festival 2010). Cyberpunk author Bruce Sterling blogged the intervention on WIRED (Sterling 2010), MoMA tweeted "Nice, looks like we're having an 'uninvited' AR exhibition tomorrow!" (Museum of Modern Art 2010), and later in an interview with the New York Times the director of digital media welcomed our engagement with her museum (Fidel 2010).

in fact; not imagined or supposed" (Oxford English Dictionary 2013)—and is reproducible by anyone who views the artwork at that site. In this "consensual hallucination" that was the dream of the early cyberpunk authors and virtual reality evangelists (Gibson 1984), augmented reality is redefining the barriers between what we consider "the real" and "the virtual."

Human culture has always been fascinated with the invisible, whether these were gods and supernatural spirits that could only be seen via divine grace, or remote galaxies and tiny organisms that could only be seen with scientific instruments. Both individuals and entire societies invest sites with invisible layers of meaning as a part of personal and collective memory. Augmented reality art can now merge these invisible layers of memory and culture with the actual physical location. As with all site-specific artworks, viewers can also record their own personal encounters in screenshots, creating a dialogue between the work, the site, and their own particular gaze.

In 2011 when we did these interventions there were still voices that spoke of smartphones as elitist devices for the wealthy. Even then however our social lives had already moved into virtual space: we shared experiences by posting our photographs on the Internet, and the small incidents and passing thoughts of our daily lives on Facebook and Twitter. At the time of writing of this chapter, less than 2 years later it is clear that soon more people worldwide will be using mobile devices than PCs, and smartphones will become our main access platform to the digital commons (Standage 2012). What is the likelihood that kids in East Harlem[2] or people of all ages in Kenya (Talbot 2012) will view AR art on smartphones versus viewing art in galleries and museums?

2.3 Site as Canvas and Context

As interventionist art, augmented reality questions the possession and control of a physical space. As site-specific art, it also exploits and appropriates the physical space as its canvas and its context, as the virtual artworks are always seen merged with the live camera view of the surroundings. It enters into a dialogue with the location visually to integrate it into the visual composition of the viewed augment, conceptually to trigger associations of memory and culture, but also physically as the viewer interacts bodily with the site. Usually the viewer must search the surroundings to find the augment, like bird-watchers scanning with binoculars, or must walk the site dodging real-world obstacles in order to experience the artwork in its totality. Thus, though the artwork is virtual, the viewer must engage physically with

[2]In 2012, the author helped the Caribbean Cultural Center and African Diaspora Institute (CCCADI) to bring in a Rockefeller Cultural Innovation Grant to create "Mi Querido Barrio," an augmented reality tour of the history and art of East Harlem. As AR Artistic Director for the project, the author is conducting AR workshops for artists in East Harlem (Rockefeller Foundation 2012; CCCADI 2012).

the site to experience it—an act which engages the kinesthetic sense of the viewer's body and thus situates the viewer and the act of viewing in the physical experience of that site.

Our interventions into art spaces and events are thus instigated by the visual, cultural, and physical facets of experience that the site provides for the artwork as canvas and as context, with an express interest in the dialogues—in the art world and beyond—that engage the site. Many of our works dialogue directly with the other "official" artworks at a venue, and inevitably also with the theme and concept of the exhibition as defined by the curator. Many artists act on and react to contemporary events and discourses, of course, but the ability of augmented reality to geolocate artworks at the site of those discourses increases the potency of their visual argument.[3] In a time when many question the relevance of galleries, museums, and biennials as venues for art, we save the gated communities of the art world from irrelevance by bringing a new form of dialogue into their institutions.

2.4 Manifest.AR Venice Biennale Intervention Themes and Concerns

At the 2011 Venice Biennale we wished to reflect not on Venice's past glory, but on its current situation: wrestling with climate change, overrun by tourists and street vendors, fighting to keep its art biennial relevant in an era in which its national pavilions stand in direct contrast to the globalized, itinerant world of contemporary art, whose artists live and work in multiple systems of cultural reference. The national pavilions that dominate the Venice Biennale are a reflection of its origins at the end of the nineteenth century and the rise of the nation-state with a presumed monolithic ethnic or cultural identity. At the very latest since the end of the Cold War this concept has seemed antiquated, as Russia and Serbia disinherited their former comrades out of the USSR and Yugoslavian pavilions, and non-Western centers of international art such as China and the Middle East rise in prominence (Madra 2006).

Curator Bice Curiger's opening statement questioned this structure as well: "By adopting the title ILLUMInations the 54th International Art Exhibition of the Venice Biennale also aspires literally to shed light on the institution itself, drawing attention to dormant and unrecognized opportunities, as well as to conventions that need to be challenged … Far removed from culturally conservative constructs of 'nation,' art offers the potential to explore new forms of 'community' and negotiate differences and affinities that might serve as models for the future" (Curiger 2011). Curiger also posed five questions on identity to each of the artists officially included

[3]The author's contribution to "We AR in MoMA" was a matrix of screaming faces titled "ARt Critic Face Matrix," a self-referential artwork that critiqued its own validity as an artwork, reflecting on the role of MoMA NY to define what did or did not constituted art (Thiel 2010).

in the Biennale: "Where do you feel at home? Does the future speak English or another language? Is the artistic community a nation? How many nations do you feel inside yourself? If art was a nation what would be written in its constitution?"[4]

As an international artist collective that coalesced around challenging conventions of inclusion and participation, we saw this as a personal invitation to participate. Sander hijacked Curiger's curatorial statement and the Venice Biennale Web site to create our Venice Manifesto, in which we proclaimed (see Fig. 2.1): As "one of the world's most important forums for the dissemination and 'illumination' about the current developments in international art," the 54th Biennial of Venice could not justify its reputation without an uninvited Manifest.AR Augmented Reality infiltration. In order to "challenge the conventions through which contemporary art is viewed," we have constructed virtual AR pavilions directly among the 30-odd buildings of the lucky few within the Giardini. In accordance with the "ILLUMInations" theme and Bice Curiger's 5 questions, our uninvited participation will not be bound by nation-state borders, by physical boundaries, or by conventional art world structures. The AR pavilions at the 54th Biennial reflect on a rapidly expanding and developing new realm of Augmented Reality Art that radically crosses dimensional, physical, and hierarchical boundaries (Manifest.AR Venice Biennale Intervention 2011).

We wanted our intervention however to go beyond merely addressing Curiger's statement, and also reflect on events in the wider world as they related specifically to the realities of Venice as a contemporary city. Questions about control of space went beyond the confines of the Giardini. So-called "public" art has always depended on permissions from the authorities to allow art to be placed in public view, and many a "public" space is actually closely controlled. We therefore placed artworks not only in the controlled curatorial space of the Venice Giardini, but also in the public space of Piazza San Marco, which has itself seen censorship of officially planned artworks (Magill 2007).

Four of us from Manifest.AR were able to actually go to Venice, and another five provided round-the-clock support from their various locations. Although AR artworks can be created and placed on site from anywhere in the world via the Internet, people are needed on site to document the artworks in screenshots and video recordings, and—important for invisible artworks—to spread information on the intervention to the audience and engage them in viewing the artworks. We collaborated closely with another group intervention, The Invisible Pavilion. Organized by Share Festival Director Simona Lodi and the artist group Les Liens Invisible, represented on site in Venice by Gionatan Quintini, we produced a common flyer and held joint AR tours in the Giardini and Piazza San Marco (see Figs. 2.2 and 2.3, and also Manifest.AR Venice Biennale Intervention flyer 2011).

[4]Although Curiger refers frequently to the "five questions," they are not to be found on the official Venice Biennale website. See for instance Flash Art (2011).

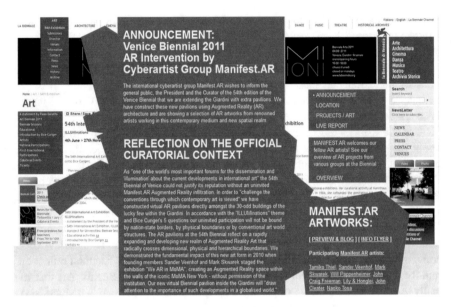

Fig. 2.1 The Manifest.AR Venice Biennial Intervention Web site

Fig. 2.2 In the Venice Giardini: John Craig Freeman, Sander Veenhof, Simona Lodi (Share Festival), and Will Pappenheimer and John Cleater in screens

Fig. 2.3 In Piazza San Marco: John Craig Freeman, Tamiko Thiel, Mark Skwarek, Simona Lodi (Share Festival), Gionatan Quintini (Les Liens Invisible). In screens: Lily and HongLei, Naoko Tosa

2.5 Manifest.AR Artworks in the Venice Biennale Intervention

The author Tamiko Thiel's work, *Shades of Absence*, is a series of three "virtual pavilions" formed of terms of censorship and containing anonymized golden sil- houettes of artists whose works have been censored. It posited a transnational community of censored artists in reply to Bice Curiger's questions: "Is the artistic community a nation? If art was a nation what would be written in its constitution?"

Shades of Absence: Outside Inside addressed the precarious status of artists threatened with arrest or physical violence (see Fig. 2.4). *Shades of Absence: Schlingensief Gilded* is a memorial to the controversial artist Christoph Schlingensief and was placed directly in his posthumous exhibit in the German Pavilion (Fig. 2.5). *Shades of Absence: Public Voids* puts silhouettes of artists whose works in public places have been censored—including several by the Venice Biennale itself—in the Piazza San Marco (Fig. 2.6). In all works, touching the screen while viewing one of the artworks brings a link to a Web site with cases of these particular types of censorship (Thiel T. Shades of Absence 2011).

Sander Veenhof's work *Battling Pavilions* directly challenged the role of the curator, the exclusive nature of the Giardini and the limited number of national pavilions allowed within its Sacred Grove. Users of this augmented reality app were given different curatorial powers depending on their physical location. If they were

Fig. 2.4 *Shades of Absence: Outside Inside* by Thiel T. Shades of Absence (2011). Augmented reality, Venice Giardini. A memorial to artists threatened with arrest or physical violence

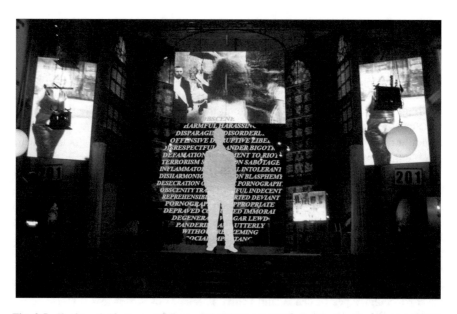

Fig. 2.5 *Shades of Absence: Schlingensief Gilded* by Thiel T. Shades of Absence (2011). Augmented Reality, German Pavilion, Venice Giardini. A memorial to the artist Christoph Schlingensief, placed in his posthumous exhibit in the German Pavilion

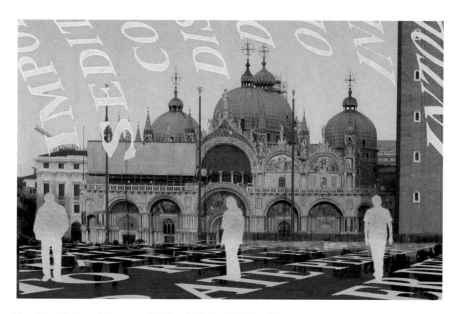

Fig. 2.6 *Shades of Absence: Public Voids* by Thiel T. Shades of Absence (2011). Augmented Reality, Piazza San Marco, Venice. A memorial for artists whose works in public spaces have been censored

outside the Giardini, they could create a new virtual pavilion for any nation of their choice and place it in the Giardini (Fig. 2.7). If they were inside the Giardini, they took on the role of Biennale curator Bice Curiger defending her curatorial powers and could delete any of the upstart intruding pavilions (Figs. 2.8 and 2.9).

In a classic twist, Sander's intervention also became an official part of the Biennale: hearing of his intervention, dropstuff.nl invited him to show his Battling Pavilions on their large screens in three locations around Venice (Veenhof 2011, see Fig. 2.7).

Mark Skwarek's *Island of Hope* addressed the physical situation of the islands of Venice, which since the founding of the city have been under perpetual threat of sinking into the lagoon. Skwarek posited new forces of continental uplift bringing hope of survival to Venice, the tectonic forces erupting out of the ground as fully formed baroque gardens in the Giardini (Fig. 2.10) and in Piazza San Marco (Fig. 2.11). Besides bringing additional landmass, all-powerful goddesses on the islands incorporate objects of hope, and tweets with the hash tag #hope, into the gardens in order to bring peoples' hopes and dreams to life (Skwarek 2011).

John Craig Freeman's *Water wARs: Squatters Pavilion* also focuses on the rising water levels in Venice, but with a dramatic difference. Water wARs is a virtual squatter's camp for refugees of water wars, one camp directly inside the protecting walls of the Giardini (Fig. 2.12), and another "public" camp in Piazza San Marco (Fig. 2.13).

In Venice, a city itself founded by refugees and threatened by constant flooding, Water wARs calls attention to the escalating global struggle for this basic human

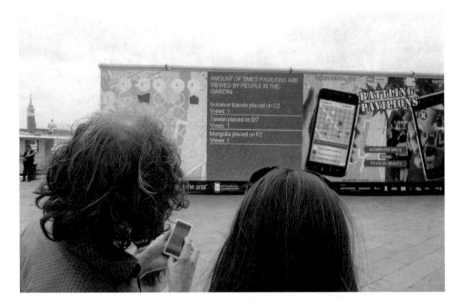

Fig. 2.7 *Battling Pavilions* by Veenhof (2011). Augmented Reality Game. Scoreboard on dropstuff.nl screen during the Venice Biennale, displaying scoreboard of unauthorized virtual pavilions in the Giardini

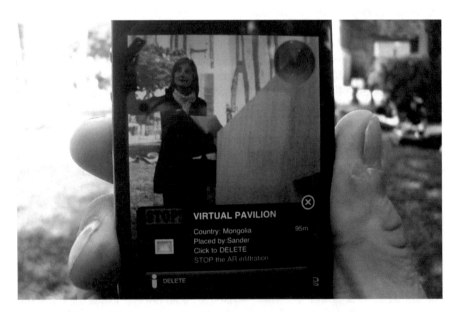

Fig. 2.8 *Battling Pavilions* by Veenhof (2011). Augmented Reality Game. A visitor in the Giardini helping curator Bice Curiger to delete an unauthorized virtual pavilion

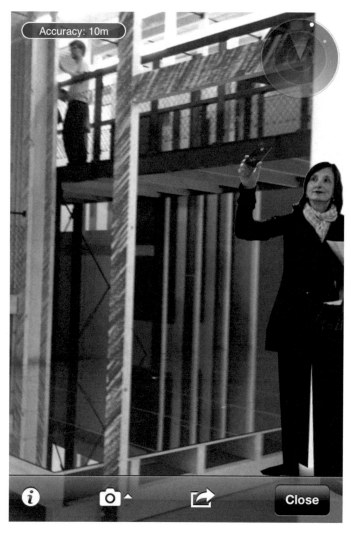

Fig. 2.9 *Battling Pavilions* by Veenhof (2011). Augmented Reality Game. The virtual version of curator Bice Curiger checks the Dutch Pavilion to make sure there are no unauthorized pavilions here

need, made increasingly scarce not only by environmental damage but also through privatization of water supplies by multinational corporations. It questions the ability of sovereign nations to isolate themselves from the rest of the world, as worldwide ecological disasters drive people in desperation to violate the boundaries of the nation-states in pursuit of sheer survival (Freeman 2011).

John Cleater's work *Sky Pavilions* provides help for Venice from an unexpected direction altogether—from above. Alien Sky Pavilions descend from outer space

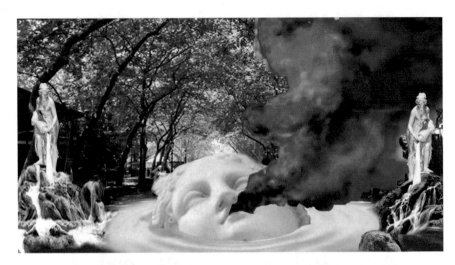

Fig. 2.10 *The Island of Hope* by Skwarek (2011). Augmented Reality. Seen in the Venice Giardini

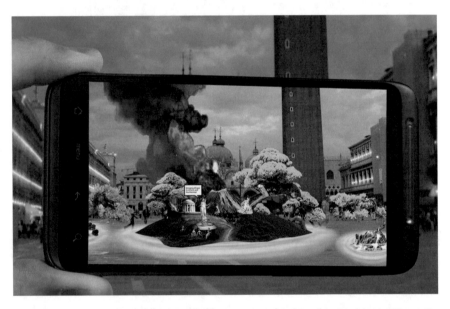

Fig. 2.11 *The Island of Hope* by Skwarek (2011). Augmented Reality. Seen in the Piazza San Marco

and take over Venice: The mothership hovers over Piazza San Marco emitting a mixture of nonsense and guidance to confuse and help tourists, natives, and art seekers (Fig. 2.14). In the Giardini alien "Floaties" lie in wait, begging to be

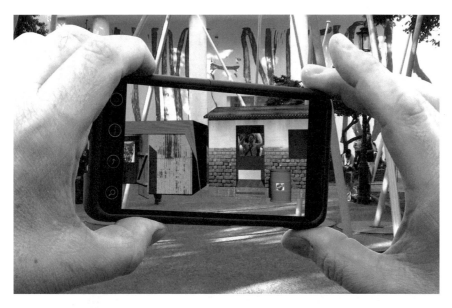

Fig. 2.12 *Water wARs, Giardini* by Freeman (2011). Location-based Augmented Reality. Pavilion for undocumented artists/squatters and water war refugees in front of the Giardini Central Pavilion

Fig. 2.13 *Water wARs, Piazza San Marco* by Freeman (2011). Augmented Reality. Pavilion for undocumented artists/squatters and water war refugees in Piazza San Marco, Venice

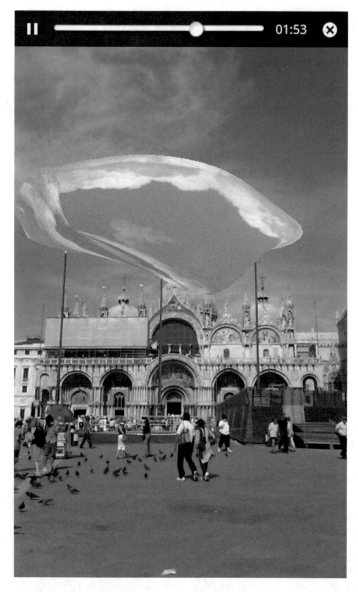

Fig. 2.14 *Sky Pavilions* by Cleater (2011). Augmented Reality and audio. Alien Mothership Sky Pavilion floats over Piazza San Marco

touched, and when activated by obliging visitors spin upwards, carrying secret messages to the mother ship (Fig. 2.15).

Sky Pavilions goes beyond the concept of the nation-state, beyond the concerns of mere earthbound humanoids, and reminds us that the last word in the control of space may not be ours to decide (Cleater 2011).

Fig. 2.15 *Sky Pavilions* by Cleater (2011). Augmented Reality and audio. Alien Sky Pavilion "floats" in the Giardini

Lily and Honglei's work *The Crystal Coffin: Virtual China Pavilion* brings us squarely back to earth and confronts us with the realities of our shifting national structures. It is inspired by China's (current) Holy of Holies: Mao Zedong's crystal coffin, a petrified symbol of eternal Party rule. Placing the crystal coffin into the Giardini, the Sacred Grove of the Venice Biennale, both questions the traditional hierarchy of privilege among national pavilions in the Biennale and thematizes the rise of China as a vital—and financially important—center of contemporary art (see Fig. 2.16).

A second pavilion placed in the Piazza San Marco occupies the heart of this emblematic European city, whose native son Marco Polo "discovered" China for the West, and dominates it with this ultimate symbolic source of Chinese Party power (Fig. 2.17). At the same time, however, the reference to Mao's embalmed presence and the Party's current mandate of "traditional styles" for the pavilion building speaks of the ruling system's authoritarian tendencies that still inhibit the development of Chinese artists and intellectuals (Lily and HongLei 2011).

Will Pappenheimer/Virta-Flaneurazine's *Colony Illuminati* appropriated both the Biennale title "ILLUMInations" and the actual visual imagery of many artworks in the Biennale. This was a secret colony of virtual bufo toads that draws sustenance from high art: as a form of camouflage, their skin appropriates imagery from artworks around them as they multiply among the national pavilions in the Giardini (Fig. 2.18) and spread out into the city, seeking the outlying venues of the Venice Biennale (Fig. 2.19).

Fig. 2.16 *The Crystal Coffin, Giardini* by Lily and Honglei (2011). Augmented Reality. Artwork inspired by the crystal coffin in the Mausoleum of Mao Zedong in Tiananmen Square, seen here in front of the Giardini Central Pavilion

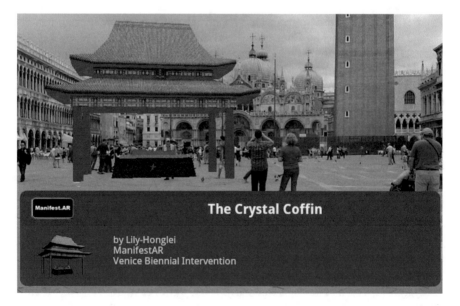

Fig. 2.17 *The Crystal Coffin, Piazza San Marco* by Lily and Honglei (2011). Augmented Reality. Artwork inspired by the crystal coffin in the Mausoleum of Mao Zedong in Tiananmen Square, seen here in Piazza San Marco

Fig. 2.18 *Colony Illuminati* by Will Pappenheimer/Virta-Flaneurazine (2011). Augmented Reality. Colony group on Giardini main concourse

Fig. 2.19 *Colony Illuminati* by Will Pappenheimer/Virta-Flaneurazine (2011). Augmented Reality. Songdongphilic toads in the Arsenale at the Song Dong parapavilion. Video still: Sander Veenhof

When touched on the smartphone screen, the toads release psychotropic drugs that trigger hallucinations in the viewer: a swirl of Internet information surrounding the Biennale and waves of Tintorettoesque ecstasy that Bice Curiger proclaimed to be the true essence of ILLUMInations (see Fig. 2.20 and Pappenheimer and Virta-Flaneurazine 2011).

Naoko Tosa's app *Historia* addressed Bice Curiger's question "Does the future speak English or another language?" and her view that "art offers the potential to explore new forms of 'community' and negotiate differences and affinities that might serve as models for the future" (Tosa 2011). Historia appropriates iconic images from all nations and world cultures, from times both modern and ancient, and uses them to create a mental pavilion of reconstructed meaning. The interactive artwork allows visitors to choose icons, arrange them in a sequence—and then assign each icon a new meaning (Fig. 2.21).

Historia playfully examines the process by which artists appropriate and redefine existing cultural symbols to create their own individual language, and distills it into a smartphone app. These messages, with their newly created, completely individual English "translations," appear as overlays in the Giardini and in Piazza San Marco, an international multicultural messaging mash-up for the transnational nation of art and art tourism (Tosa 2011, see Fig. 2.22).

The issues addressed by our works will remain relevant long after the 54th Biennale is over. Their virtual presence will remain too: as long as our servers run, the artworks of the Manifest.AR 2011 Venice Biennale Intervention will grace the city and the Giardini and can be seen by whomever looks for them (Manifest.AR Venice Biennale Intervention launch page 2011).

2.6 Venice–Lewisburg–Istanbul

Even in the planning stages our Venice Biennale intervention received the enthusiastic support of two curators deeply involved in interventionist art. Lanfranco Aceti, a practiced interventionist himself (Aceti 2008), helped us gain access to the Biennale and proposed a special issue of the Leonardo Electronic Almanac to address the questions raised by the intervention (Aceti et al. 2013). Richard Rinehart invited us to intervene in his Samek Gallery in Lewisburg, Pennsylvania on the same day that we opened at the Venice Biennale—and titled the exhibit "Not Here" to celebrate the fact that the artworks were present even though the gallery was closed for the summer (Rinehart 2011). Later that fall Lanfranco, as director in Istanbul of both ISEA2011 and the Sabanci University Kasa Gallery, invited us to position our Venice artworks in the Kasa Gallery to create the show "Not There" (Aceti 2011; Manifest.AR blog. "Not there" 2011) as part of the ISEA2011 exhibition UNCONTAINABLE, an official parallel program to the Istanbul Biennale.

For the city-state of Venice, the city of Constantinople/Istanbul was a constant, looming presence both culturally and politically. In the early centuries, Venice was part of the Byzantine Empire and owed allegiance—and taxes—to Constantinople,

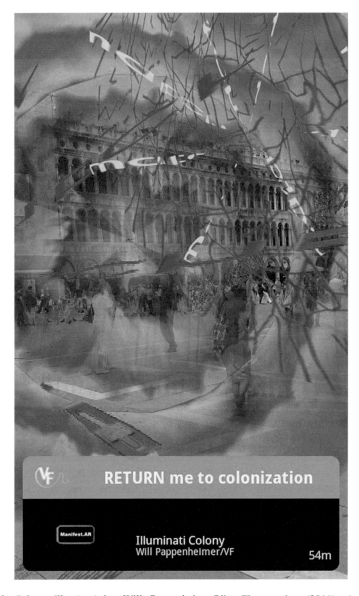

Fig. 2.20 *Colony Illuminati* by Will Pappenheimer/Virta-Flaneurazine (2011). Augmented Reality. Visionary effects of touching Colony Illuminati toads at Piazza San Marco

the great capital of eastern Christendom and seat of the Empire. In 1204, Venice's Doge Enrico Dandolo diverted the Fourth Crusade, bound ostensibly for the Holy Land, to Constantinople to sack the city and break its control over Venice. Weakened, Constantinople never fully recovered and finally fell to the Ottoman invaders in 1453. The lavish booty from Constantinople that adorns the Basilica

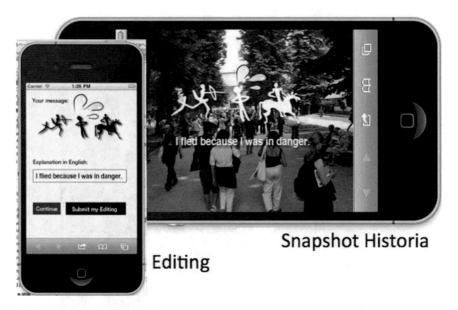

Fig. 2.21 *Historia* by Tosa (2011). Augmented Reality. Users compose messages by appropriating historic icons floating in the space and assigning a new meaning to their message. Seen in front of the Giardini Central Pavilion

San Marco in Venice turned however to poisoned fruit, as the renamed city rose to rival Venice in the Mediterranean as Istanbul, the great Muslim capital of the Ottoman Empire.

After World War I, the Ottoman Empire fell apart, surviving only as the much-reduced country of Turkey, and Istanbul fell into the melancholic slumber poetically described in Orhan Pamuk's novels. In the twenty-first century, however, with Turkey's rising political and economic power Istanbul has once again become a thriving center of contemporary culture, and its former melancholy is not even a childhood memory for the current generation of young artists. Lanfranco's invitation to ISEA2011 and the Istanbul Biennale was an irresistible opportunity to experience a fascinating city through the concentrating prism of a contemporary art biennial.

2.7 "Invisible Istanbul": Istanbul Biennale 2011 AR Intervention

Through an artist residency at the Caravansarai artists' space in Istanbul (Caravansarai 2013), I had met Cem Kozar and Işıl Ünal, Istanbul architects and designers who run the design office PATTU (2017). They were interested in learning to use augmented reality technology and were deeply knowledgeable about

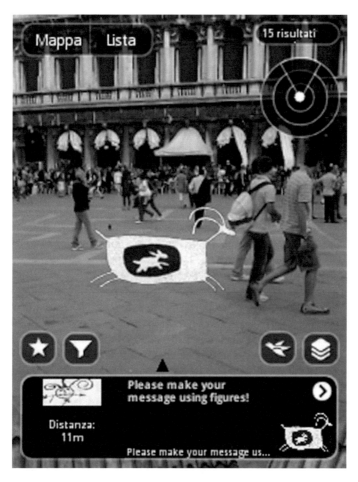

Fig. 2.22 *Historia* by Tosa (2011). Augmented Reality. Users compose messages by appropriating historic icons floating in the space and assigning a new meaning to their message. Seen in front of Cafe Florian, Piazza San Marco

the past and future urban development of the city, making for a fruitful collaboration on both sides. Together we created "Invisible Istanbul," a series of augmented reality works that make visible the unseen tensions within the city and its urban fabric (PATTU and Thiel 2011). As part of the ISEA2011 exhibition UNCONTAINABLE, it was also an official parallel program to the Istanbul Biennale.

The Istanbul Biennale is part and parcel of the urban development plan for the Beyoğlu district of Istanbul, and our artworks reflected on the Biennale both as a site and on its role—and the role of art exhibitions in general—in the official development plans of the city government. Some commented on the Biennale itself, others reflected on the urban space that the Biennale occupies, and yet others drew a

larger circle to place the Biennale area within the overall context of the Beyoğlu district.

The theme of the 2011 Istanbul Biennale also attracted my attention, as the curators Pedrosa and Hoffmann based their concept around the works of Félix González-Torres and his method of creating politically charged artworks by investing small, banal objects from daily life with very personal conceptual significance. This method, and the curators' emphasis "on works that are both formally innovative and politically outspoken" (Istanbul Biennale 2011), spoke directly to how I want to work with augmented reality and presented an excellent point of departure for my own investigations.

Our intervention "Invisible Istanbul" consists of two parts, both of which used AR to place virtual artworks within the real physical space of Istanbul and the Biennale, creating surrealistic and poetic juxtapositions between real and virtual within the context of the hidden urban dynamics of Istanbul. Both begin with Tophane, the former military barracks and munitions factory where the main Biennale buildings are now located.

My works for "Invisible Istanbul," *Captured Images*, took as a point of departure the displays of military power during the Ottoman Empire on the site where now the Istanbul Biennale celebrates its power in the contemporary art world. This work series was inspired by photographs of Tophane taken at the end of the 19th for the last Sultan, Abdul Hamid II, showing displays of military might: soldiers lined up for drills; rows of cannon captured from enemy armies; shells of different caliber ordered by size; cannonballs stacked into pyramids (US Library of Congress 2013). In the 1950s, the barracks and factories were replaced with faceless warehouses and the rows of ordnance replaced with rows of goods. Today, these warehouses have been turned into exhibition spaces for art and the rows of goods have made way for rows of artworks. My artworks continue this transformation, using objects from daily lives as their munitions and appropriating the main Biennale exhibition spaces as their venues, especially the group exhibitions "Untitled (Death by Gun)" and "Untitled (Passport)" (Thiel T. Invisible Istanbul: captured images 2011).

My works also reflect on tensions in Turkish civil society between tradition and modern, between military, political parties, opposition groups inside and outside of the political system, propaganda from all sides, the power of the journalist's pen(cil) to reveal and protest and uncover, but also of the political bureaucracy to define laws and jail sentences that are powerful weapons of intimidation. The Gezi Park protests of 2013 have only made the works more relevant.

In *Captured (cannon balls)*, the ever-present Turkish nazar boncuğu glass amulets were stacked in piles inside the Biennale exhibit "Untitled (Death by Gun)." These amulets shatter when they avert the evil eye—what would it mean to use them as cannonballs (Fig. 2.23)?

Several works deal with the pencil as a symbolic weapon of rhetoric and propaganda for sides, whether journalist, blogger or bureaucrat. They can be fat as cannon as in *Captured (cannon)*, as stubby as projectiles as in *Captured (shells)*, which I placed in the exhibit "Untitled (Death by Gun)," or surround the viewer

Fig. 2.23 *Captured (cannon balls)* by Thiel T. Invisible Istanbul: captured images (2011). Augmented Reality. Virtual nazar boncuğu glass amulets with animated eyeballs. Seen in the Istanbul Biennale exhibition "Untitled (Death by Gun)," with Kris Martin's *Obussen II*

Fig. 2.24 *Captured (stockade)* by Thiel T. Invisible Istanbul: captured images (2011). Augmented Reality. Virtual pencils surround the viewer. Seen here in the Istanbul Biennale exhibition "Untitled (Passport)"

completely as in *Captured (stockade)*, placed in the exhibition "Untitled (Passport)" (see Fig. 2.24).

Of course the pencil has long been replaced by the digital, so I created *Captured (for RSF_RWB)* and placed it also in the exhibit "Untitled (Passport)." The name derives from the Twitter hash tag of Reporters Sans Frontières (Reporters Without Borders), and the artwork consists of RSF_RWB tweets in which I censored the substantive words and animated them to surround the viewer in a constant flashing stream (Fig. 2.25).

Finally, as a memorial to the assassinated Armenian-Turkish journalist Hrant Dink I created *Captured (for Hrant)*. I took the last artifact we saw of him, his worn shoe soles sticking out from under the sheet covering his dead body in the middle of a main street in Istanbul. The shoe soles, in gold, wander around the viewer. This work I put against the stark geometric purity of Biennale architect Ryue Nishizawa's container walls (Fig. 2.26).

PATTU (Cem Kozar and Işıl Ünal) created *Invisible Istanbul: Urban Dynamics* as an augmented reality walking tour that departs from the Istanbul Biennale site in the Tophane neighborhood and winds through the nearby neighborhoods of Karaköy and Galata. Using their deep knowledge of both the city's past and the official development plans for the future, PATTU has used AR as a medium to map and visualize the dynamics of change that shape both the contemporary urban space and the lives of its inhabitants. The smartphone or iPad becomes a viewing instrument to bring into focus forces invisible to the naked or unknowing eye, and make them visible in the public sphere.

For each site or "node" along the route PATTU looked at the past, present, and future uses of the area. The AR artworks at each site envelope the viewer in a cloud of artifacts that reference the activities for which each area was, is, and will be used. This layer of symbolic information is visible as an overlay on the live camera view of the buildings and busy streets at each site, but is also complemented by links to a Web site with an historic photograph of each location and a textual description of the urban dynamic in play at each site (PATTU 2011). A small selection of nodes is described below as examples of the rich layers that can be experienced at each site.

Node 1: The Docks is in Tophane by the Antrepots used for the Istanbul Museum of Modern Art and the Biennale. Looking down at the ground one sees cannon and other munitions, symbolizing the area's previous use as a military barracks and munitions factory. Looking straight ahead, one sees heavy gold painting frames and fragments of well-known modern paintings, symbolizing the area's current use for exhibitions of modern art. Looking up, one sees logos of multinational companies—McDonalds, Converse etc.—symbolizing the development plans that call for turning the whole area into a large terminal and shopping mall for cruise ships, where visitors can shop for the usual international brands without having to deal with the city or culture of Istanbul (Fig. 2.27).

In *Node 4: The Minorities of Istanbul,* the past shows a rich diversity of shop signs in what was Istanbul's most multicultural neighborhood—destroyed by the Pogrom of September 6th/7th 1955, symbolized by the cloths of the textile

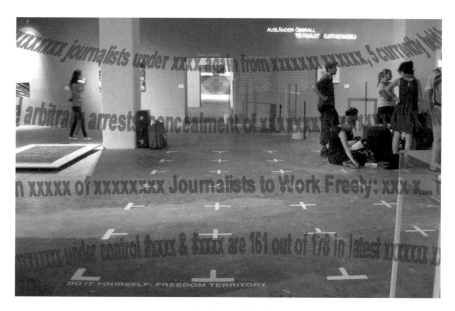

Fig. 2.25 *Captured (for RSF_RWB)* by Thiel T. Invisible Istanbul: captured images (2011). Augmented Reality. The viewer is surrounded by censored tweets from Reporters Sans Frontières —Reporters Without Borders. Seen here in the Istanbul Biennale exhibition "Untitled (Passport)"

Fig. 2.26 *Captured (for Hrant)* by Thiel T. Invisible Istanbul: captured images (2011). Augmented Reality. The viewer is surrounded by the animated footsteps of murdered Armenian-Turkish journalist Hrant Dink. Seen here against the exhibition architecture done by Ryue Nishizawa for the Istanbul Biennale

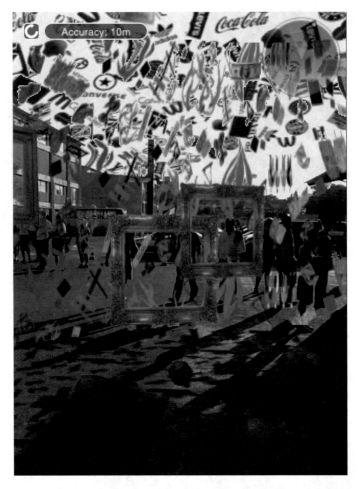

Fig. 2.27 *Invisible Istanbul: Urban Dynamics—Node1* by PATTU (Cem Kozar/Işıl Ünal) 2011. Augmented Reality. The Docks: From munitions factory to art exhibitions to shopping mall

merchants that littered the streets for days afterward. Currently slumbering in urban decline, the future is to be dominated by hotels and shopping malls (Fig. 2.28).

In *Node 5: Brothels,* both the past and the present are dominated by symbols of brothels, the single surviving one being tucked away on the picturesque side street visible in the screenshot. A look skywards shows that this area is slated for development of a park and high-end hotels (Fig. 2.29).

Standing on Voyvoda or Bank Street to view *Node 8: Museum Inflation,* one still sees trucks loading and unloading sacks of money at the same banks that dominated this area in the past. The smaller buildings are now dominated by electronic shops selling everything from lamps to satellite dishes, and the banks themselves are

Fig. 2.28 *Invisible Istanbul: Urban Dynamics—Node 4* by PATTU (Cem Kozar/Işıl Ünal) 2011. Augmented Reality. The Minorities of Istanbul. From cosmopolitan Galata through the Pogrom of September 6/7 to hotels and shopping malls

being turned into art museums. Looking up one sees symbols for art and for the hotels that are also planned for this area in the future (Fig. 2.30).

This is just a small sample of the sites covered by Invisible Istanbul: Urban Dynamics. As diverse as was the past and present in these neighborhoods, the future repeats itself in alarming monotony: multinational brands, upscale hotels—according to the official development plans for the city of Istanbul. The tour should be a requirement for everybody interested in the fate of this fascinating and dynamic city.

Fig. 2.29 *Invisible Istanbul: Urban Dynamics—Node 5* by PATTU (Cem Kozar/Işıl Ünal) 2011. Augmented Reality. Brothels: From many brothels to one brothel to a park and hotels

2.8 Conclusions

The Venice and Istanbul Biennales of 2011, and the questions raised by their curators, framed questions that we took far beyond the curators' original intent in order to also address issues of curatorial control of selection and space, inclusivity and exclusivity, and the autonomy of the artist in light of the possibilities of the new medium of geolocative augmented reality.

Our works at the Venice and Istanbul Biennales went however beyond a reflexive focus on art world dilemmas to address contemporary issues in the cities in which the biennials took place. Venice and Istanbul are two of the world's most compelling cities, overlaid with complex and often conflicting webs of history and

Fig. 2.30 *Invisible Istanbul: Urban Dynamics—Node 8* by PATTU (Cem Kozar/Işıl Ünal) 2011. Augmented Reality. Node 8: Museum Inflation. From banks to electronic shops to art museums and hotels

memory, fantasy and desire. The new technology of mobile augmented reality allowed us to dialogue with these sites in a new manner, transforming specific sites into both the context and the canvas for our works of art.

I end with a quotation from Bice Curiger's curatorial text for the Venice Biennale:

ILLUMInations presents contemporary art characterized by gestures that explore notions of the collective, yet also speak of fragmentary identity, of temporary alliances, and objects inscribed with transience. If the communicative aspect is crucial to the ideas underlying ILLUMInations, it is demonstrated in art that often declares and seeks closeness to the vibrancy of life. This is more important now than ever before, in an age when our sense of

reality is profoundly challenged by virtual and simulated worlds. This Biennale is also about believing in art and its potential (Curiger 2011).

I could not agree more. Perhaps in ways that Bice Curiger did not anticipate.

Acknowledgements Parts of the text and images on the Venice Biennial intervention were previously published as "Site Venice Site Biennale: The Manifest.AR Augmented Reality, Intervention into the 2011 Venice Biennial" in AR[t] magazine, 05 May 2014, ISSN 2213-2481, published by The Augmented Reality Lab (AR Lab), Royal Academy of Art, The Hague, NL.

I am deeply grateful to the following people, without whose help much of what is described in this chapter would not have happened:

Lanfranco Aceti, Editor in Chief of LEA, Director of ISEA2011 and the Kasa Gallery of Sabanci University.

Özden Sahin, Co-Editor of LEA, Conference and Program Director of ISEA2011, Vice-Director and In-house Curator of the Kasa Gallery of Sabanci University.

Rick Reinhart, Director of the Samek Gallery, Bucknell University, and external Co-Editor of the special AR issue of Leonardo Electronic Almanac "Not Here Not There."

Simona Lodi, Share Festival Director, and Gionatan Quintini, Les Liens Invisible, who curated and organized the "Invisible Pavilion" intervention at the Venice Biennale. Many thanks for the wonderful collaboration with Manifest.AR!

Julie Upmeyer and Annika Weshinskey of Caravansarai artist residency in Istanbul for their support and networking. Without them, Invisible Istanbul would not exist.

My fellow artists at Manifest.AR: Sander Veenhof, Mark Skwarek, John Craig Freeman, Will Pappenheimer, Naoko Tosa, John Cleater, and Lily and Honglei, for the ongoing journey together.

My fellow artists at PATTU: Cem Kozar and Işıl Ünal, who taught me so much.

Cornelia Reinauer, the Berlin-Istanbul Express, for support and deep insights.

Elif Dazkir, who wonders when I will remember the Turkish she taught me years ago.

Viviana Torre, Fausto Sartori, and Lorenzo Urbani, who opened the doors to Venice for me.

Marco Ceresa and Bruce Leimsidor, who helped me to reach another level.

References

Aceti L. The virtual places we own: when communities and artists occupy your place without your consent. In: Internet research 9.0: rethinking community, rethinking place; 2008. pp. 15–8.

Aceti L. Not there. Kasa Gallery. 2011. http://www.lanfrancoaceti.com/wp-content/uploads/2011/12/not-there-exhibition-brochure.pdf, http://isea2011.sabanciuniv.edu/other-event/not-there. Both links accessed 17 Aug 2017.

Aceti L, Rinehart R, Şahin Ö, et al editors. Not here not there. Leonardo Electron Almanac. 2013;19(2). http://www.leoalmanac.org/vol19-no2-not-here-not-there-part-2/. Accessed 17 Aug 2017.

Caravansarai. 2013. http://www.caravansarai.info. Accessed 17 Aug 2017.

Caribbean Cultural Center African Diaspora (CCCADI). Mi Querido Barrio Augmented Reality Project. 2012–2016. http://www.cccadi.org/miqueridobarrio. Accessed 17 Aug 2017.

Cleater J. Sky pavilions. Manifest.AR Venice Biennale 2011 Intervention website. 2011. http://manifestarblog.wordpress.com/cleater-venice-2011/. Accessed 17 Aug 2017.

Conflux Festival. We AR in MoMA. 2010. http://confluxfestival.org/projects/conflux-festival-2010/we-ar-in-moma/. Accessed 17 Aug 2017 via Internet Archive Wayback Machine capture 29 June 2012. https://web.archive.org/web/20120629220542/http://www.confluxfestival.org/projects/conflux-festival-2010/we-ar-in-moma.

Curiger B. Introduction by Bice Curiger. ILLUMInazioni – ILLUMInations. Venice Biennale website. 2011. http://www.labiennale.org/en/art/archive/54th-exhibition/curiger/. Accessed 17 Aug 2017 via Internet Archive Wayback Machine capture: https://web.archive.org/web/20160808064951/http://www.labiennale.org:80/en/art/archive/54th-exhibition/curiger.

Fidel A. Art gets unmasked in the palm of your hand. New York Times. 2010. http://www.nytimes.com/2010/12/02/arts/02iht-rartsmart.html. Accessed 17 Aug 2017.

Flash Art. Bice Curiger speaks about the Venice Biennale. http://tamikothiel.com/AR/sa/BiceCurigerSpeaksAboutTheVeniceBiennale_FlashArt2011-01.pdf Accessed 17 Aug 2017.

Freeman JC. Water wARs: Squatters Pavilion. Manifest.AR Venice Biennale 2011 Intervention website. 2011. http://manifestarblog.wordpress.com/freeman-venice-2011/. Accessed 17 Aug 2017.

Gibson W. Neuromancer. New York: Ace Books; 1984.

Istanbul Biennale 2011. Untitled (12th Istanbul Biennial). 2011. http://12b.iksv.org/en/son_haberler.asp?id=35&c=3. Accessed 17 Aug 2017.

Lily and Honglei. The crystal coffin: virtual China Pavilion. Manifest.AR Venice Biennale 2011 Intervention website. 2011. http://manifestarblog.wordpress.com/lily-honglei-venice-2011/. Accessed 17 Aug 2017.

Madra Y. From imperialism to transnational capitalism: the Venice Biennial as a 'Transitional Conjuncture.' Rethinking Marxism. 2006;18(4). http://www.academia.edu/2072820/From_Imperialism_to_Transnational_Capitalism_The_Venice_Biennial_as_a_Transitional_Conjuncture_. Accessed 17 Aug 2017.

Magill RJ Jr. For Gregor Schneider's cube, a long pilgrimage. New York Times. 2007. http://www.nytimes.com/2007/04/16/arts/16iht-cube.1.5303319.html. Accessed 17 Aug 2017.

Manifest.AR. AR Art Manifesto. Manifest.AR artist group official website. 2011. Originally http://www.manifestar.info/. Accessed 12 Mar 2013. Currently http://manifest-ar.art/. Accessed 17 Aug 2017.

Manifest.AR blog. "Not there," Kasa Gallery, Istanbul. 2011. http://manifestarblog.wordpress.com/not-there-kasa-gallery-istanbul/. Accessed 17 Aug 2017.

Manifest.AR Venice Biennale Intervention launch page (launch links work only on Android and iOS devices on site in Venice). 2011. http://manifestar.info/vb11/, original link Accessed 14 Mar 2013, now defunct. http://manifest-ar.art/vb11/, updated link Accessed 27 Aug 2017.

Manifest.AR Venice Biennale Intervention. Venice Biennial 2011 AR Intervention by Cyberartist Group Manifest.AR, Reflection on the official curatorial context. 2011. Original link: http://www.manifestar.info/venicebiennial2011/. Accessed 12 Mar 2013. Current link: http://www.manifest-ar.art/venicebiennial2011/. Accessed 27 Aug 2017.

Manifest.AR Venice Biennale Intervention flyer. Joint Venice Biennale Intervention flyer for Manifest.AR & Invisible Pavilion. 2011. Original link: http://manifestar.info/venicebiennial2011/biennale2011_jointPostcard.pdf. Accessed 29 Nov 2013. Current link: http://manifest-ar.art/venicebiennial2011/biennale2011_jointPostcard.pdf. Accessed 27 Aug 2017.

Museum of Modern Art NY Twitter site. 2010. https://twitter.com/#!/MuseumModernArt/statuses/26786135774. Accessed 17 Aug 2017.

Oxford English Dictionary. Definition of "real." 2013. http://oxforddictionaries.com/us/definition/american_english/real. Accessed 17 Aug 2017.

Pappenheimer W, Virta-Flaneurazine. Colony Illuminati. Manifest.AR Venice Biennale 2011 Intervention. 2011. http://manifestarblog.wordpress.com/pappenheimer-venice-2011/. Accessed 17 Aug 2017.

PATTU. Invisible Istanbul: Urban dynamics. 2011. Original version: http://www.invisibleistanbul.org/ud/. Accessed 12 Mar 2013. Partial version via internet archive wayback machine capture from 15 May 2015. https://web.archive.org/web/20160515221451/http://www.invisibleistanbul.org/ud/. Accessed 27 Aug 2017. Current version: http://www.invisibleistanbul.com/ud/. Accessed 17 Aug 2017.

PATTU. Architecture, research, design. 2017. http://pattu.net/. Accessed 17 Aug 2017.

PATTU, Thiel T. Invisible Istanbul. 2011. http://www.invisibleistanbul.org/. Accessed 17 Aug 2017 via internet archive wayback machine capture from 11 Mar 2016: https://web.archive.org/web/20111125101557/http://www.invisibleistanbul.org/. Accessed 29 Aug 2017.

Rinehart R. Not here: an augmented reality project by MANIFEST.AR. Samek Gallery. 2011. http://galleries.blogs.bucknell.edu/2011/07/08/current-exhibitionnot-here/. Accessed 17 Aug 2017.

Rockefeller Foundation. Caribbean Cultural Center–African Diaspora Institute. 2012. http://www.tamikothiel.com/articles/MiQueridoBarrioPressRelease2013-04-09.pdf. Accessed 17 Aug 2017.

Skwarek M. Parade to hope. Manifest.AR Venice Biennale 2011 Intervention. 2011. http://manifestarblog.wordpress.com/skwarek-venice-2011/. Accessed 17 Aug 2017.

Standage T. Live and unplugged. The Economist. 2012. http://www.economist.com/news/21566417-2013-internet-will-become-mostly-mobile-medium-who-will-be-winners-and-losers-live-and. Accessed 17 Aug 2017.

Sterling B. Augmented reality: AR uninvited at MOMA NYC. Beyond the Beyond. WIRED. 2010. https://www.wired.com/2010/10/augmented-reality-ar-uninvited-at-moma-nyc/. Accessed 17 Aug 2017.

Talbot D. Kenya's startup boom. Technology Review. MIT: Cambridge, MA; 2012. http://www.technologyreview.com/communications/39673/). Accessed 17 Aug 2017.

Thiel T. We AR in MoMA exhibit. Tamiko Thiel website. 2010. http://www.tamikothiel.com/We-AR-in-MoMA/. Accessed 17 Aug 2017.

Thiel T. Invisible Istanbul: captured images. Tamiko Thiel website. 2011. http://www.tamikothiel.com/AR/ii/images.html. Accessed 17 Aug 2017.

Thiel T. Shades of Absence. Manifest.AR Venice Biennale 2011 Intervention. 2011. http://manifestarblog.wordpress.com/thiel_venice-2011/. Accessed 17 Aug 2017.

Tosa N. Historia. Manifest.AR Venice Biennale 2011 Intervention. 2011. http://manifestarblog.wordpress.com/naoko-tosa-venice-biennial-2011/. Accessed 17 Aug. 2017.

U.S. Library of Congress. Abdul-Hamid II Collection of photographs of the Ottoman Empire: Search term 'Tophane.' 2013. http://www.loc.gov/pictures/search/?q=tophane&sg=true; Cannon captured from foreign states http://www.loc.gov/pictures/resource/cph.3b28721/; Cannon shells in various sizes http://www.loc.gov/pictures/resource/cph.3b28724/; Drill of the students of Tophane http://www.loc.gov/pictures/resource/cph.3b47778/. Accessed 17 Aug 2017.

Veenhof S. DIY day MoMA Oct 9th 2010 Augmented Reality art invasion! Sander Veenhof website. 2010. http://www.sndrv.nl/moma/. Accessed 17 Aug 2017.

Veenhof S. Battling Pavilions. Manifest.AR Venice Biennale 2011 Intervention. 2011. http://manifestarblog.wordpress.com/sander-veenhof-venice-biennial-2011/. See also: http://www.sndrv.nl/battle/. Accessed 17 Aug 2017.

Chapter 3
ART for Art: Augmented Reality Taxonomy for Art and Cultural Heritage

Klen Čopič Pucihar and Matjaž Kljun

3.1 Introduction

The world we live in is going through a constant change that is driven by technological advances where some have the power to revolutionize the way we live. Foreseeing this change is difficult, though it is becoming more and more evident that augmented reality (AR) has such potential and may have a similar social and economic impact to the shift from desktop to mobile computing.

However, the development of AR has been mainly pushed by technology which is not optimal for wide-scale adoption because "The technology tools are not an end in themselves, but a means to an end" (Furness 2017). Hence in the context of technology adoption and development, "We should ask not only what, but so what!" (Furness 2017). In order to pursue this goal, AR practitioners and researchers should focus on solving real-world problems combining the "push" of technology and the "pull" of solving problems. Only this coupling can propel the development and uptake of this technology (Furness 2017).

Even so, pursuing this goal is not easy because the lure of AR is strong and unique as it enables deep coupling with human senses which allows for generating

K. Čopič Pucihar (✉) · M. Kljun
Faculty of Mathematics, Natural Sciences and Information Technologies,
University of Primorska, Koper, Slovenia
e-mail: klen.copic@famnit.upr.si
URL: http://klen.si

M. Kljun
e-mail: matjaz.kljun@upr.si
URL: https://pim.famnit.upr.si

K. Čopič Pucihar · M. Kljun
Faculty of Information Studies (FIŠ), Novo Mesto, Slovenia

© Springer International Publishing AG 2018
V. Geroimenko (ed.), *Augmented Reality Art*, Springer Series on Cultural
Computing, https://doi.org/10.1007/978-3-319-69932-5_3

personalized perspectives in which digital information is being blended with what is coming from the real world. At the same time, this deep coupling presents in itself a danger as it can harm human sensing ability of the real world which got highly sophisticated through evolutionary perfection over millions of years. As Furness highlights, "the mantra of AR should be do no harm" (Furness 2017).

In the context of the above, this chapter focuses on augmented reality taxonomy (ART) in the context of art galleries, museums and cultural heritage sites. The authors see these institutions as of high importance in that they serve the humanity by preserving, presenting and communicating the arts and cultural heritage. Yet, nowadays we live in the time of plenty where these institutions have to compete for attention and visitor numbers with many other activities, may they be entertainment, edutainment or sport oriented. Irrespective of the type, they commonly share the link to new technology development that made them possible and/or popular.

The key to attracting attention and visitors to art institutions is finding the right way of integrating new technologies in ways that will enrich offered experiences. This is particularly important when trying to attract the younger audiences. Hence, the ultimate goal of art galleries, museums and cultural heritage sites is to present and interpret their collections in appealing and exciting ways, creating experiences that will remain relevant to the modern-day tech-savvy visitors and attract new audiences (Gutierrez et al. 2008; Mohammed-Amin 2015; Wojciechowski et al. 2004).

Due to the fact that the review of AR in art and cultural heritage resulted in 87 AR applications and that an extensive survey in 2003 already showed that one-third of European museums have already started to experiment with some sort of 3D graphical content (Mohammed-Amin 2015; Wojciechowski et al. 2004), it is clear that these institutions are already pursuing this goal. However, the question that remains is how good is this adoption and how well do these institutions utilize opportunities created by advances in AR technology.

In this chapter, we plan to provide an insight into the adoption of AR technology in art and cultural heritage in order to be able to reflect on future opportunities or highlight the opportunities which have been missed this far. In pursuit of this goal, we first looked at different AR categorizations/taxonomies, but failed to find adequate taxonomy; hence, this chapter proposes activity-based taxonomy method that is able to create taxonomies which provide an insight into technology adoption within a specific domain or context of use. We use the proposed activity-based taxonomy method in order to produce AR taxonomy for art and cultural heritage (ART for art and cultural heritage). We evaluate the proposed taxonomy and adoption of technology by classifying 87 AR applications for art and cultural heritage and discuss the results in the light of good practices, missed opportunities and future developments.

3.2 Review of AR Taxonomies

The main motivation for reviewing AR taxonomies is to select a taxonomy that will enable us to gain insight into how AR technology has been adopted by art galleries, museums and cultural heritage sites.

Before we endeavour on reviewing different AR taxonomies, let us start by looking at the most commonly accepted definition of AR systems which comes in a form of three system requirements, namely: has to combine the real and virtual content, is interactive in real time and is correctly registered in 3D space (Azuma 1997).

In one of the first taxonomies of AR, Milgram and Kishino (1994) formulated the concept of mixed reality continuum which was based on various ways in which the virtual elements and the real world can be combined together (Fig. 3.1). This continuum was later on expanded by Mann who introduced the concept of mediated reality which is complimenting Milgram's concept by introducing another dimension to the continuum representing the amount of mediation or filtering that is being applied on the view of the real world (Fig. 3.2) (Braz and Pereira 2008).

Besides introducing mixed reality continuum which helped to formulate the definition of AR and can be used for high-level categorization of AR, Milgram and Kishino (1994) also present a technical taxonomy for categorizing AR systems. This taxonomy is based on different types of displays being used for building a mixed reality (MR) system. The system proposed three main categories: (i) extent of world knowledge—representing the amount of information the system knows about the environment, (ii) reproduction fidelity—representing the rendering

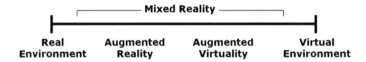

Fig. 3.1 Mixed reality continuum by Milgram and Kishino (1994)

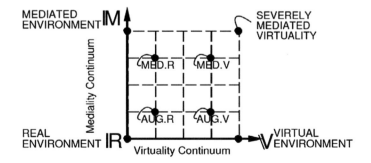

Fig. 3.2 Mediality/virtuality continuum by Mann (2002)

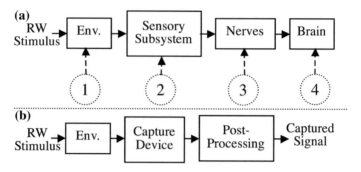

Fig. 3.3 Pathways of real-world stimuli from users' perspective: **a** direct stimuli pathway, **b** indirect stimuli pathway which hooks up to (**a**) in any of the four mixing points (Lindeman and Noma 2007)

quality and (iii) extent of presence metaphor—relating to the extent of immersion of the user in the mixed reality scene.

In his work, Mackay (1998) presents another way of classifying system based on the target of augmentation. Mackay identifies three main possibility targets: (i) augment the user—referring to the situation in which the user wears or carries the device, (ii) augment the physical object by embedding computational devices to physical objects and (iii) augment the environment in which neither the user nor the objects are directly affected, hence the independent devices are collecting the data from the environment and presenting it to the user enabling interaction.

Contrary to technology-oriented approach of the above taxonomies, Lindeman and Noma (2007) look at categorization from users' perspective. Their taxonomy is based on where the mixing of the real and the virtual takes place in the pipeline of capturing, sensing and perceiving environmental signals. Their system proposes two pathways: direct and mediated pathways (Fig. 3.3). In direct pathway, the real-world stimulus (i.e. sound or light signal) first interacts with the surrounding (i.e. bouncing/reflecting from the room surfaces), afterwards it is picked up by the appropriate sensory subsystem (i.e. eyes or ears) that transforms it to nerve signals which are perceived by our brain (Fig. 3.3a).

In the mediated case, the real-world stimulus interacts with the environment, but instead of being sensed by the user, it is captured by an appropriate sensing device (i.e. camera or microphone). The signal is then processed and mixed with computer-generated content and presented to the user at any of the four mixing points (Fig. 3.3b). Theoretically all four mixing points are possible; however, currently only systems capable of mixing point 1 and 2 are available (Fig. 3.4).

The Metaverse road map[1] is a taxonomy that classifies AR based on two spectrums: (i) the spectrum ranging from augmentation (technologies that add new capabilities) to simulation (technologies that model reality) and (ii) the spectrum

[1]http://www.metaverseroadmap.org/overview/

Fig. 3.4 Metaverse (Smart et al. 2007)

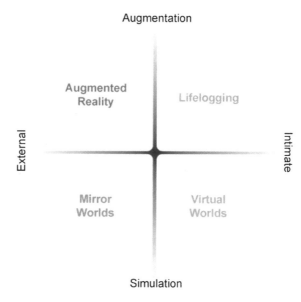

ranging from intimate (identity-focused providing the means for the user to have agency in the environment through avatar, digital profile or direct appearance) to external (world-focused in the sense of providing information and control of the world).

Another technology-oriented taxonomy is called TRACAST and was proposed by Braz and Pereira (2008). This taxonomy is based on six technical parameters, such as the real-world manipulator subsystem, the real-world acquisition subsystem, the tracking subsystem, the virtual model generator subsystem, the mixing realities subsystem and finally the display subsystem. Each criterion is then composed of a number of features, which are used to precisely describe the system in technical terms.

There are also more recent taxonomies that emerged. One of them is a classification scheme proposed by Hugues et al. (2011). This is a functional classification which is based around users' perceptions. Hugues et al. argue that what we augment is not reality but perception of reality because "if reality is by definition everything that exists, then strictly speaking reality cannot be augmented since it is already everything…what is augmented is not reality, but the perception of reality…" (Hugues et al. 2011). Based on this, Hugues et al. proposed a functional taxonomy with two main groups: augmented perception and artificial environment which are at next level divided into subfunctionalities and enable further classification of AR systems (Hugues et al. 2011).

The most recent AR taxonomy was presented by (Normand et al. 2012) and is based on four criteria: (i) the numbers of degrees of freedom required by the application, (ii) the visualization mode/augmentation type which has two categories: the mediated augmentation (i.e. optical or video see-through) and direct

augmentation (i.e. spatial augmentation), (iii) the temporal base of augmentation which can be: $t_0 < 0$ situations to the past, $t_0 = 0$ current situation, $t_0 > 0$ future situation, ∞ imaginary situation that will never materialize, and (iv) the rendering modalities used in the application (i.e. 3D sound, haptic feedback, gustatory modalities ...).

In summary, there are many existing taxonomies for AR; however, all try to act as generic classifiers of AR systems. This makes them most suitable for classifying AR technology and best serve the community of technology developers. Therefore, existing taxonomies can only tell what technologies are being used whilst failing to highlight what they are used for (the "for what" part of technology adoption is missing). Ideally the taxonomy should not only do that, but also enable one to see which opportunities of AR technology remain to be fully exploited in a specific domain or which opportunities are likely to arise with future technology developments. If we take this even further, the taxonomy should also provide an insight into the most prominent areas of adoption of technology (highlighting the "so what" part of technology adoption). This type of taxonomy is required by this chapter as it tries to gain an insight into how effective is technology adoption and how well are opportunities created by advances in technology really utilized in a specific context. As existing taxonomies are not capable of satisfying this goal, we propose a new activity-based taxonomy method presented in the following section.

3.3 Activity-Based Taxonomy Method

Activity-based taxonomy method (Table 3.1) is a tool for gaining an insight into technology adoption within a specific domain. This classification is based on building a model which describes the domain with a set of domain-specific activities. Based on the model, systems are graded on how well they support each activity of the model. Any system can provide support for many activities; however, scores are only provided for supported activities and have a range from 1 to 3 (e.g. minimal, moderate, high support).

Table 3.1 Activity-based taxonomy schema

	Model			
	Activity 1 support score (1–3)	Activity 2 support score (1–3)	Activity 3 support score (1–3)	...
System 1	Support score (1–3)	Support score (1–3)	Support score (1–3)	...
...

Note that scores are only provided for supported activities

2 activities 3 activities 4 activities

Fig. 3.5 Venn diagrams for 2, 3 and 4 activities

The groups that emerge from the classification can be visualized using Venn diagrams which changes based on the number of activities in the model. Visualizations of a model with 2, 3 and 4 activities can be seen in Fig. 3.5.

3.4 AR Taxonomy for Art and Cultural Heritage

In this section, we utilize activity-based taxonomy method in order to build AR taxonomy for art and cultural heritage. In the first subsection, we propose activity model of visiting a museum, art gallery or cultural heritage site which is then used to generate ART for art and cultural heritage.

3.4.1 Activity Model

The proposed model of activity for visiting a museum, art gallery or cultural heritage site (MAVM) is based on the MAVM proposed by (Tillon et al. 2011). Tillon et al. based their model on two activities: analytical and sensitive activities. The analytical activity consists of the visitor exploring, dissecting and objectifying the work of art. In other terms, it consists of contextualizing the artwork in which the artwork is situated into its original context. More specifically, this activity consists of precise description—diving into the details of the work of art, objectification—focusing on putting the work of art into its context of creation within art cultural heritage or historical space, and emergence of questions where questions for the future emerge (Tillon et al. 2011).

The sensitive activity allows visitors to be more sensitive to impressions when viewing a piece of art and is comprised of three types of stimulus: immersion—relates to emergence of the visitor's feelings in the here and now; impregnation—relates to how feelings of the visitor in front of the work of art connect to feelings

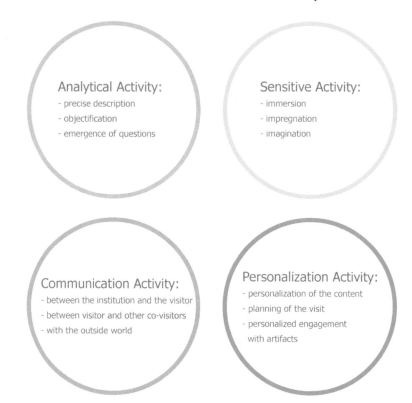

Fig. 3.6 Expanded model of activity of visiting a museum (MAVM). The proposed model complements MAVM proposed by (Tillon et al. 2011)

they experience in their daily life; and imagination—relates to the way the visitor can conceive artwork.

We propose to expand the MAVM model of Tillon et al. (2011) by adding two additional activities: the communication and personalization activities (see Fig. 3.6). Communication activity is a fundamental human activity which is commonly present when one visits a museum or an art gallery. The communication activity can involve various communications, e.g. communication between the institution (e.g. gallery or museum) and the visitor, communication between visitor and other co-visitors, and communication with the outside world (e.g. sharing the visit experience on social networking). All these communications can happen before, during and after the visit and are seen as a vital part of a visit to the museum, art gallery or cultural heritage site.

The personalization activity can be user induced or automatic. There are many criteria upon which personalization can occur, such as personalization of the content, planning of the visit and personalized engagement with artefacts [e.g. curation of personalized art forms (Čopič Pucihar et al. 2016)]. As highlighted by Sevigne and Matisse (2007), such personalization can address personal interests, learning

Table 3.2 AR taxonomy for art and cultural heritage

	Type of technology (hand-held, spatial, mirror or HMD)	MODEL			
		Analytical activity support score (1–3)	Sensitive activity support score (1–3)	Communication activity support score (1–3)	Personalization activity support score (1–3)
System 1	…	…	…	…	…
…	…	…	…	…	…

styles, disabilities, age groups, level of initiation, available time for the visit, offline visit planning or bookmarking.

3.4.2 Taxonomy

AR taxonomy for art and cultural heritage (Table 3.2) is activity-based taxonomy grounded on four activities of MAVM model (Fig. 3.6). To get an insight into technology that is being used, we also add the type of technology to the classifier. Throughout the classification process of classifying 87 AR applications for art and cultural heritage, we identified four different types of AR systems, all of which relate to augmentation of visual senses, namely hand-held AR—a system where display is held in hand or fixed on the stand, but can be manipulated using hands; spatial AR—a system where the environment is augmented by projecting light onto environmental structures; mirror AR—a system where the mirrored reflection of the real world is augmented; head-mounted display AR—a system where the display through which augmentation can be observed is worn on the head of the user (this includes AR glasses).

3.5 Results of Classification

Using the proposed ART for art and cultural heritage, we classify 87 examples of AR applications for art and cultural heritage. This is done in order to evaluate the proposed activity-based taxonomy and gain a meaningful insight into the adoption of AR technology in the context of art galleries, museums and cultural heritage sites. The scoring was done individually by both authors of this chapter. The scores were than compared and discussed in order to obtain unanimous decision on the final score presented in Table 3.3.

The authors did not mark how novel or technically advanced reviewed systems are, but focused on how well the systems support MAVM activities from user's

Table 3.3 Classification results (the complete table with the images of individual prototypes and references is available at https://pim.famnit.upr.si/Art_for_Art_Table.pdf)

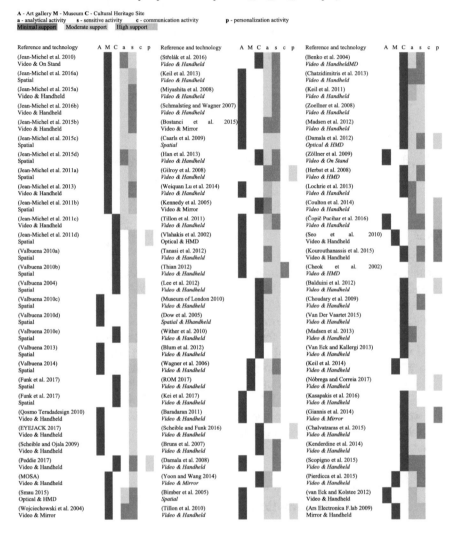

A - Art gallery M - Museum C - Cultural Heritage Site
a - analytical activity s - sensitive activity c - communication activity p - personalization activity
Minimal support Moderate support High support

perspective. It is also important to note that in case of sensual activity, immersion is a very important factor, hence high-quality rendering and the setting/environment in which the system was deployed could not be separated from the obtained score. To sum up, irrespective of additional effort to objectify the obtained scores, it is important to note that the results obtained in Table 3.3 are subjective in nature.

Fig. 3.7 Visualization of classification based on ART for art and cultural heritage

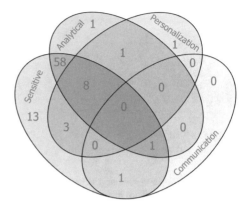

The data in Table 3.3 is summarized by Venn diagram that visualizes the groups that emerged based on classification results (see Fig. 3.7). In the following two subsections, we further analyse the results of classification using descriptive statistics (Figs. 3.8 and 3.9). Due to subjective nature of results, we decided not to run statistical analysis on the gathered data, but instead focus on highlighting good practices from reviewed applications.

3.5.1 Context of Use and AR Technology

Results in Fig. 3.8 show that the majority (47%) of applications were deployed to cultural heritage sites and that hand-held AR is currently the most popular system type (61%). This result is not surprising because hand-held AR applications are mobile solutions and are ideal when deploying technology to an outdoor setting (as is commonly the case in cultural heritage sites). Additionally, systems that are capable of running hand-held AR applications are widely available which further contributes to the popularity of hand-held AR systems. However, hand-held AR systems are faced with limitations when taking into account their ability to immerse the user into augmented world.

From the perspective of MAVM, immersion is a very important element when considering sensitive activity. This is probably one of the key reasons for high percentage of spatial AR applications (24%) which can provide highly immersive experiences, but are plagued by the difficulty and cost of setting up and the limitation in regard to illumination levels (e.g. cannot work in brightly lit environments), hence we see these augmentations mainly as installations in art galleries (Valbuena 2010c, d, e, 2013, 2014) and museums (Jean-Michel et al. 2011a, b, 2015c, d, 2016a). Nonetheless, spatial augmentations of buildings and cultural heritage sites are also becoming more and more common (Funk et al. 2017; Jean-Michel et al. 2011d; Valbuena 2004, 2010a, b).

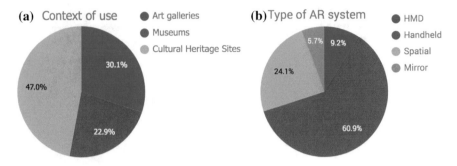

Fig. 3.8 Descriptive statistics: **a** shows in what context most applications were used; **b** shows what type of AR system has seen highest number of applications

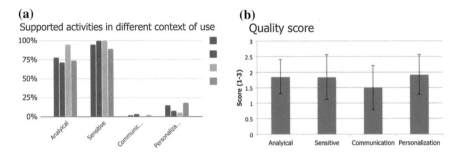

Fig. 3.9 a Percentage of applications supporting individual activities of MAVM for different context of use (blue—all contexts, red—art galleries, orange—museums, green—cultural heritage sites); **b** average support quality score

As expected, the smallest two groups are HMD and mirror AR systems. Despite recent progress in HMDs for AR (e.g. HoloLens[2], Vuzix AR 3000[3], etc.), these systems are still costly and difficult to deploy and obtain especially outside of the research context; hence, low adoption of this technology is not surprising. However, the immersive potential of HMD AR systems greatly surpasses that of hand-held AR systems. As the technology progresses, miniaturizes and becomes more readily available, these systems are likely to become increasingly more important. In the context of mirror AR, except in the context of interaction with our own bodies, we naturally do not look and interact with the world whilst looking through the mirror, hence there is a smaller set of use cases where such set-up is reasonable.

[2]https://www.microsoft.com/en-us/hololens

[3]https://www.vuzix.com/Products/Series-3000-Smart-Glasses

3.5.2 Activity Support

The graph in Fig. 3.9a shows percentage of applications that support an activity. Theoretically, an ideal application would support all activities; however, this may not always be the case and might depend on the context or purpose of the application. Nonetheless, the results clearly show general lack of support for communication and personalization activities across all three contexts (blue colour in Fig. 3.9a). The same trend is confirmed when we look at individual use contexts, namely art gallery, museum and cultural heritage site (red, orange and green in Fig. 3.9a). We believe there are many ways in which currently adopted technology could be utilized to support communication and personalization activities. These will be presented in the following section where we talk about each supported activity individually.

The graph in Fig. 3.9b shows average quality score of activity support with standard deviation (note that only supported activities received a score from 1 to 3). All average scores are smaller than mid-score (2) whilst communication activity scored lower than others (see Fig. 3.9b). This suggesting that overall on average the quality of support for MAVM activities is low, hence the quality of technology adoption is not taking the advantage of technological development. Nevertheless, there is high standard deviation which suggests there ought to be applications which do a good job in supporting MAVM activities, hence the following sections highlight good examples from reviewed applications.

3.5.3 Analytical Activity

Magnetic maps (Yoon and Wang 2014) is a good example of supporting analytical activity, because it enables the user to experiment with invisible forces (e.g. magnetic field) using a tangible interface with a tactile feedback. This is achieved by augmenting real bar magnets which provide the interface for visualization of the magnetic field. Even though the principle used in magnetic maps is not easy to generalized to other situations, it demonstrates how learning by doing with AR can make for excellent support of analytical activity. It also highlights the importance of multimodality of the interface that actually enhances the quality of the experience.

House of Olbrich (Keil et al. 2011) is another example of good analytical support. The application enables the user to create a snapshot of the cultural heritage site (e.g. building facade) from arbitrary point of view and precisely overlays the captured image with additional information even in difficult outdoor lighting conditions. High precision of augmentation should enable easy mapping of provided information to the real world. In addition to this, the application intentionally decided to keep the augmentation stylized like sketches from architect as this makes it easier for the user to grasp different facade features. This highlights that realistic rendering is not something that should be pursued in all AR scenarios.

Augmenting painting by AR Lab (Wojciechowski et al. 2004) and markerless augmented reality tour guide (Tillon et al. 2011) are other examples of good support for analytical activity. These are hand-held AR applications where we particularly like the type of content that is augmented over the paintings. Both focus on what cannot be seen by the naked eye (e.g. revealing content that can only be seen using X-ray, infrared and ultraviolet; showing the back side of the painting, and height map of the painting visualizing the 3D texture of the painting). From the above, we could conclude that a good AR experience is the one that shows interesting information that is there but cannot be seen by the naked eye.

3.5.4 Sensitive Activity

Holoman by Ars Electronica Futurelab (Ars Electronica Futurelab 2009) is an example of good analytical, but also a very important example of supporting sensitive activity. Holoman enables the user to hold a mirror in hand and explore the internal working of his/her body. As you do not see the reflection of yourself as such, but only a heavily mediated representation of the body, any errors in the alignment of the augmentation are unlikely to break the illusion of looking inside your own body. This in turn creates better immersion contributing to analytical and sensitive experience. From the above, we could conclude that with increasing mediation the quality of augmentation and alignment can decrease respectively.

In (Weiquan et al. 2014), the artists create animations instead of text descriptions of their paintings in order to help visitors in analytical and sensitive deduction of the work. Using hand-held AR systems, these animations are then overlaid over painting in the gallery when pointed at using a hand-held device. The results show that this type of learning is more effective and highlight the importance of high quality of augmentation which were done by the artists in the style of the painting itself. This is particularly important in supporting sensitive activity.

In ARART (Kei et al. 2017), the application brings famous paintings to life through animation. By controlling the lighting in the exhibition space and by creating high-quality animations that are tuned to the lighting condition of the exhibition, the authors manage to achieve excellent mixing of animated content with what is there offering good support for sensitive activity of MAVM. This example highlights how important quality of augmentation, particularly in the context of supporting sensitive activity really is.

Besides the above mentioned, good support of sensitive activity is mainly offered by spatial AR systems which in combination with the captivating environment of the place where the installation is set up creates highly immersive experiences. These can be seen in art galleries, museums and cultural heritage sites.

3.5.5 Communication

None of the reviewed applications demonstrated good support for communication activity of MAVM. Hence, we see this as a great opportunity that is missed by these institutions. This is the case because communication activity is becoming ever more important for the tech-savvy society we are becoming as more and more people readily record and share their everyday experiences. Therefore, art and cultural heritage institutions should focus on finding the right way to integrating social networking technology into AR applications whilst exploiting AR communication potential (e.g. context aware bookmarking, sharing the visit experience of "I was here", support artistic expression by enabling curation of augmentation for exhibited artefacts).

3.5.6 Personalization

From reviewed applications, we find two examples of our previous work that offer good personalization potential. Taking artwork home is hand-held AR application that focuses on supporting personalization activity (Coulton et al. 2014) by enabling users to curate personal art exhibitions in their home by replacing existing paintings in their home with the ones provided by the Peter Scott Gallery. The exhibitions are shared with other users of the platform, hence this application provides a sort of communication channel through curated exhibition.

Playing with the artworks (Čopič Pucihar et al. 2016) is another prototype supporting personalization activity by enabling gallery visitors to curate personalized version of the exhibited artwork by colouring printed puzzle which is used to generate a texture map of a 3D sculpture or 2D painting. This enables personalized interaction with the artefact of the gallery and creates a sort of communication channel by sharing the curated content with the museum and other visitors.

Even though our review uncovered some examples of personalization, we see general lack in support of personalization which is a great opportunity for art and cultural heritage institutions and should be further explored and exploited in the future.

3.6 Conclusion

The review of different existing taxonomies highlighted that existing taxonomies act as generic classifiers of AR systems which makes them most suitable for classifying AR technology and best serve the community of technology developers. The goal of this chapter is to gain an insight into the adoption of AR in art and cultural heritage in order to be able to reflect on future opportunities or highlight the

opportunities which have been missed this far. In pursuit of this goal, we propose an activity-based taxonomy model which can be used to gain an insight in adoption of arbitrary technology and is based on formulating activity model for the context in which technology is used.

We utilize activity-based taxonomy in order to generate ART for art and cultural heritage. In this process, we propose expanded model of activity of visiting a museum, art gallery or cultural heritage site (MAVM). Using the proposed ART for art and cultural heritage, we classify 87 relevant AR applications and gained the following insight into technology adoption: (i) despite low immersion (identified as an important aspect of sensitive activity of MAVM), hand-held AR systems are the most commonly used AR systems, (ii) despite difficulty of setting up and high cost, spatial AR is the second most commonly utilized system (presumable due to high immersion capability), (iii) there is a general lack for supporting communication and personalization activities which offer vast potential for enriching experiences of visiting art gallery, museum or cultural heritage sites, and (iv) the quality score is below average score suggesting the quality of adoption of the technology did not reach satisfying level.

To sum up, the proposed activity-based taxonomy model generated a meaningful AR taxonomy for art and cultural heritage. The results of calcifications provided meaningful insights into technology adoption highlighting prominent areas for future developments.

Acknowledgements The research was supported by Slovenian research agency ARRS (program no. P1–0383).

References

Ars Electronica Futurelab. Holoman. aec.at. 2009. https://www.aec.at/futurelab/en/project/holoman/. Accessed 24 Sept 2017.

Azuma RT. A survey of augmented reality. Presence Teleoperators Virtual Environ. 1997; 6 (4):355–85. Available: http://www.mitpressjournals.org/doi/10.1162/pres.1997.6.4.355. Accessed 24 Sept 2017.

Balduini M, Celino I, Dell'Aglio D, Della Valle E, Huang Y, Lee T, et al. BOTTARI: an augmented reality mobile application to deliver personalized and location-based recommendations by continuous analysis of social media streams. J Web Semant. 2012; 16:33–41. http://dx.doi.org/10.1016/j.websem.2012.06.004. Accessed 24 Sept 2017.

Baradaran A. Frenchising Mona Lisa. http://amirbaradaran.com/ (2011). http://amirbaradaran.com/ab_futarism_monalisa.php. Accessed 24 Sept 2017.

Benko H, Ishak EW, Feiner S. Collaborative Mixed reality visualization of an archaeological excavation. In: Third IEEE and ACM international symposium on mixed and augmented reality. IEEE; 2004. p. 132–40. http://ieeexplore.ieee.org/document/1383050/. Accessed 24 Sept 2017.

Bimber O, Coriand F, Kleppe A, Bruns E, Zollmann S, Langlotz T, et al. Superimposing pictorial artwork with projected imagery. IEEE Multimed. 2005 Jan;12(1):16–26. http://ieeexplore.ieee.org/document/1377099/. Accessed 24 Sept 2017.

Blum L, Wetzel R, McCall R, Oppermann L, Broll W, Coudenhove-kalergi RR, et al. The final timewarp : using form and content to support player experience and presence when designing location-aware mobile augmented reality games. In: Proceedings of the 3rd conference on designing interactive systems: DIS'12. New York, New York, USA: ACM Press; 2012. p. 711. http://dl.acm.org/citation.cfm?doid=2317956.2318064. Accessed 24 Sept 2017.

Bostanci E, Kanwal N, Clark AF. Augmented reality applications for cultural heritage using Kinect. Human Centric Comput Inf Sci. 2015;5(1):20. http://www.hcis-journal.com/content/5/1/20. Accessed 24 Sept 2017.

Braz JM, Pereira JM. TARCAST: Taxonomy for Augmented Reality CASTing with web support. Int J Virtual Real. 2008;7(4):47–56.

Bruns E, Brombach B, Zeidler T, Bimber O, Weimar B. Enabling mobile phones to support large-scale museum guidance. IEEE Multimed. 2007;14(2):16–25. http://ieeexplore.ieee.org/document/4160276/. Accessed 24 Sept 2017.

Caarls J, Jonker P, Kolstee Y, Rotteveel J, van Eck W. Augmented reality for art, design and cultural heritage—system design and evaluation. EURASIP J Image Video Process. 2009;2009:1–16. http://jivp.eurasipjournals.com/content/2009/1/716160. Accessed 24 Sept 2017.

Chalvatzaras D, Yiannoutsou N, Sintoris C, Avouris N. Do you remember that building? Exploring old Zakynthos through an augmented reality mobile game. In: 2014 International conference on interactive mobile communication technologies and learning (IMCL2014). IEEE; 2015, p. 222–5. http://ieeexplore.ieee.org/document/7011136/. Accessed 24 Sept 2017.

Chatzidimitris T, Kavakli E, Economou M, Gavalas D. Mobile augmented reality edutainment applications for cultural institutions. In: IISA 2013—4th International Conference on Information, Intelligence, Systems and Applications (IISA). IEEE; 2013. p. 1–4. http://ieeexplore.ieee.org/document/6623726/. Accessed 24 Sept 2017.

Cheok AD, Wang W, Yang X, Prince S, Wan FS, Billinghurst M, et al. Interactive theatre experience in embodied + wearable mixed reality space. In: IEEE and ACM international symposium on mixed and augmented reality, ISMAR 2002. IEEE Computer Socity; 2002, p. 59–68. http://ieeexplore.ieee.org/document/1115073/. Accessed 24 Sept 2017.

Choudary O, Charvillat V, Grigoras R, Gurdjos P. MARCH: mobile augmented reality for cultural heritage. In: Proceedings of the 17th international conference on multimedia 2009. New York, New York, USA: ACM Press; 2009. p. 1023. http://dl.acm.org/citation.cfm?id=1631500. Accessed 24 Sept 2017.

Čopič Pucihar K, Kljun MMMM, Coulton P, Pucihar KČ, Kljun MMMM, Coulton P, et al. Playing with the artworks: engaging with art through an augmented reality game. In: Conference: the 2016 CHI conference extended abstracts. New York, New York, USA: ACM Press; 2016. p. 1842–8. http://www.research.lancs.ac.uk/portal/en/publications/playing-with-the-artworks-engaging-with-art-through-an-augmented-reality-game(3f549016-a1c3-4214-b52e-6bb612aea974).html. Accessed 24 Sept 2017.

Coulton P, Murphy E, Čopič Pucihar K, Smith R, Lochrie M, Pucihar KČ, et al. User curated augmented reality art exhibitions. In: Proceedings of the 8th Nordic conference on human-computer interaction: fun, fast, foundational. New York, New York, USA: ACM Press; 2014. p. 907–10. http://dl.acm.org/citation.cfm?doid=2639189.2670190. Accessed 24 Sept 2017.

Damala A, Cubaud P, Bationo A, Houlier P, Marchal I. Bridging the gap between the digital and the physical: design and evaluation of a mobile augmented reality guide for the museum visit. In: 3rd International conference on digital interactive media in entertainment and arts. New York, New York, USA: ACM Press; 2008. p. 120. http://dl.acm.org/citation.cfm?doid=1413634.1413660. Accessed 24 Sept 2017.

Damala A, Stojanovic N, Schuchert T, Moragues J, Cabrera A, Gilleade K. Adaptive augmented reality for cultural heritage: ARtSENSE project. Euro-Mediterranean conference. EuroMed 2012 Prog. Cult. Herit. Preserv. 2012; p. 746–55. http://link.springer.com/10.1007/978-3-642-34234-9_79. Accessed 24 Sept 2017.

Dow S, Lee J, Oezbek C, Maclntyre B, Bolter JD, Gandy M, et al. Exploring spatial narratives and mixed reality experiences in Oakland Cemetery. In: Proceedings of the 2005 ACM SIGCHI international conference on advances in computer entertainment technology. New York, New York, USA: ACM Press; 2005. p. 51–60. http://portal.acm.org/citation.cfm?doid=1178477. 1178484. Accessed 24 Sept 2017.

van Eck W, Kolstee Y. The augmented painting: playful interaction with multi-spectral images. In: 2012 IEEE international symposium on mixed and augmented reality—arts, media, and humanities (ISMAR-AMH) . IEEE; 2012. p. 65–9. http://ieeexplore.ieee.org/document/6483990/. Accessed 24 Sept 2017.

Van Eck W, Kallergi A. Trees as time capsules: extending airborne museum Hartenstein to the forest. In: Cleland K, Fisher L, Harley R, editors. Proceedings of the 19th International Symposium on Electronic Art, ISEA2013. Sydney: ISEA International Australian Network for Art & Technology University of Sydney; 2013. p. 1–4. http://hdl.handle.net/2123/9693. Accessed 24 Sept 2017.

EYEJACK. Prosthetic reality book. https://eyejackapp.com/products/prosthetic-reality-book (2017). https://eyejackapp.com/products/prosthetic-reality-book. Accessed 24 Sept 2017.

Funk M, Scheible J, Funk M, Pucihar KC, Kljun M, Lochrie M, et al. Using drones for art and exergaming. IEEE Pervasive Comput. 2017;16:48–56. http://ieeexplore.ieee.org/document/7807165/. Accessed 24 Sept 2017.

Furness TA. Forward in augmented reality: Where we will all live by J. Peddie. Switzerland: Springer International Publishing; 2017.

Giannis D, Antonios Ntelidakis, Dimitris Grammenos XZ. Immersing users in landscapes using large scale displays in public spaces. In: Immersing users in landscapes using large scale displays in public spaces on distributed, ambient, and pervasive interactions. 2014. p. 152–62. http://www.scopus.com/inward/record.url?eid=2-s2.0-84901599558%7B%5C&%7DpartnerID=tZOtx3y1. Accessed 24 Sept 2017.

Gilroy SW, Seichter H, Benayoun M, Cavazza M, Chaignon R, Mäkelä S, et al. E-Tree : emotionally driven augmented reality art. In: MM'08 Proceedings of the 16th ACM international conference on multimedia. New York, New York, USA: ACM Press; 2008. p. 945. http://portal.acm.org/citation.cfm?doid=1459359.1459529. Accessed 24 Sept 2017.

Gutierrez M, Vexo F, Thalmann D. Stepping into virtual reality. 1st ed. Santa Clara, CA, USA: Springer-Verlag TELOS; 2008.

Han J, Park K, Ban K, Kim E. Cultural heritage sites visualization system based on outdoor augmented reality. AASRI Proce. 2013;4:64–71. http://dx.doi.org/10.1016/j.aasri.2013.10.011. Accessed 24 Sept 2017.

Herbst I, Braun A, Augustin S, McCall R, Broll W. TimeWarp : interactive time travel with a mobile mixed reality game. In: Proceedings of the 10th international conference on Human computer interaction with mobile devices and services—MobileHCI '08. New York, New York, USA: ACM Press; 2008. p. 235. http://portal.acm.org/citation.cfm?doid=1409240. 1409266. Accessed 24 Sept 2017.

Hugues O, Fuchs P, Nannipieri O. New augmented reality taxonomy : technologies and features of augmented environment. In: Furht B, editor. Handbook of augmented reality. New York, NY: Springer; 2011;2011. p. 47–63.

Jean-Michel S, Julien R, Bernard B, Motot T, Charmoillaux A, Lamy E, et al. on-situ: ray-on. on-situ.com; 2010. www.on-situ.com. Accessed 24 Sept 2017.

Jean-Michel S, Julien R, Bernard B, Motot T, Charmoillaux A, Lamy E, et al. on-situ: Site archeologique de Bibracte. on-situ.com; 2011a. www.on-situ.com. Accessed 24 Sept 2017.

Jean-Michel S, Julien R, Bernard B, Motot T, Charmoillaux A, Lamy E, et al. on-situ: La Rade. on-situ.com; 2011b. www.on-situ.com. Accessed 24 Sept 2017.

Jean-Michel S, Julien R, Bernard B, Motot T, Charmoillaux A, Lamy E, et al. on-situ: une guerre photoraphique. on-situ.com; 2011c. www.on-situ.com. Accessed 24 Sept 2017.

Jean-Michel S, Julien R, Bernard B, Motot T, Charmoillaux A, Lamy E, et al. on-situ: Facade. on-situ.com; 2011d. www.on-situ.com. Accessed 24 Sept 2017.

Jean-Michel S, Julien R, Bernard B, Motot T, Charmoillaux A, Lamy E, et al. on-situ: Site archeologique de Bibracte. on-situ.com; 2013. Accessed 24 Sept 2017.

Jean-Michel S, Julien R, Bernard B, Motot T, Charmoillaux A, Lamy E, et al. on-situ: Masion des projets. on-situ.com; 2015a. www.on-situ.com. Accessed 24 Sept 2017.

Jean-Michel S, Julien R, Bernard B, Motot T, Charmoillaux A, Lamy E, et al. on-situ: GE 200. on-situ.com; 2015b. www.on-situ.com. Accessed 24 Sept 2017.

Jean-Michel S, Julien R, Bernard B, Motot T, Charmoillaux A, Lamy E, et al. on-situ: Le Narbonnaise, entre terre et eau. on-situ.com; 2015c. www.on-situ.com. Accessed 24 Sept 2017.

Jean-Michel S, Julien R, Bernard B, Motot T, Charmoillaux A, Lamy E, et al. on-situ: Panoramas. on-situ.com; 2015d. www.on-situ.com. Accessed 24 Sept 2017.

Jean-Michel S, Julien R, Bernard B, Motot T, Charmoillaux A, Lamy E, et al. on-situ: Memorial de Verdun. on-situ.com; 2016a. www.on-situ.com. Accessed 24 Sept 2017.

Jean-Michel S, Julien R, Bernard B, Motot T, Charmoillaux A, Lamy E, et al. on-situ: Memorial de Dun les Places. on-situ.com; 2016b. www.on-situ.com. Accessed 24 Sept 2017.

Kasapakis V, Gavalas D, Galatis P. Augmented reality in cultural heritage: field of view awareness in an archaeological site mobile guide. de Ruyter B, Kameas A, Mavrommati I, editors. J. Ambient Intell. Smart Environ. 2016;8(5):501–14. http://www.medra.org/servlet/aliasResolver?alias=iospress%7B%5C&%7Ddoi=10.3233/AIS-160394. Accessed 24 Sept 2017.

Kei S, Takeshi M, Junpei W, Masayuki A, Younghyo B, Kitamura Y, et al. ARART. arart.info. http://arart.info/en/. Accessed 15 Aug 2017.

Keil J, Zollner M, Becker M, Wientapper F, Engelke T, Wuest H, et al. The House of Olbrich—an augmented reality tour through architectural history. In: 2011 IEEE International symposium on mixed and augmented reality—arts, media, and humanities. IEEE; 2011. p. 15–8. http://ieeexplore.ieee.org/document/6093651/. Accessed 24 Sept 2017.

Keil J, Pujol L, Roussou M, Engelke T, Schmitt M, Bockholt U, et al. A digital look at physical museum exhibits: designing personalized stories with handheld augmented reality in museums. In: 2013 Digital heritage international congress (DigitalHeritage). IEEE; 2013. p. 685–8. http://ieeexplore.ieee.org/document/6744836/. Accessed 24 Sept 2017.

Keil J, Engelke T, Schmitt M, Bockholt U, Pujol L. Lean in or lean back ? Aspects on interactivity and mediation in handheld augmented reality in the museum. In: Klein R, Santos P, editors. In: 12th Eurographics workshop on graphics and cultural heritage (GCH 2014). EUROGRAPHICS; 2014. p. 1–4.

Kenderdine S, Chan LKY, Shaw J. Pure land: futures for embodied museography. J Comput Cult Herit. 2014;7(2):1–15. http://dl.acm.org/citation.cfm?doid=2635823.2614567. Accessed 24 Sept 2017.

Kennedy BO, Arevalo-Poizat M, Magnenat-Thalmann N, Stoddart A, Thalmann D, Papagiannakis G, et al. Mixing virtual and real scenes in the site of ancient Pompeii. Comput Animat Virtual Worlds. 2005;16(1):11–24. http://doi.wiley.com/10.1002/cav.53. Accessed 24 Sept 2017.

Kourouthanassis P, Boletsis C, Bardaki C, Chasanidou D. Tourists responses to mobile augmented reality travel guides: the role of emotions on adoption behavior. Pervasive Mob Comput. 2015;18:71–87. http://dx.doi.org/10.1016/j.pmcj.2014.08.009. Accessed 24 Sept 2017.

Lee GA, Dunser A, Kim S, Billinghurst M. CityViewAR: A mobile outdoor AR application for city visualization. In: 2012 IEEE International symposium on mixed and augmented reality—arts, media, and humanities (ISMAR-AMH). 2012. p. 57–64.

Lindeman RW, Noma H. A classification scheme for multi-sensory augmented reality. In: Proceedings of the ACM Symposium on Virtual Reality Software and Technology, VRST 2007. New York, New York, USA: ACM Press; 2007. p. 175. http://portal.acm.org/citation.cfm?doid=1315184.1315216. Accessed 24 Sept 2017.

Lochrie M, Čopič Pucihar K, Gradinar A, Coulton P, Lochrie M, Čopič Pucihar K, Gradinar A, Coulton P, Lochrie M, et al. Designing seamless mobile augmented reality location based game interfaces. In: Proceedings of international conference on advances in mobile computing and

multimedia—MoMM '13. New York, New York, USA: ACM Press; 2013. p. 412–5. http://dl.acm.org/citation.cfm?id=2536914. Accessed 24 Sept 2017.

Mackay WE. Augmented reality: linking real and virtual worlds a new paradigm for interacting with computers. In: Proceedings of the working conference on Advanced visual interfaces—AVI. 1998. p. 13–21. http://www.scopus.com/inward/record.url?eid=2-s2.0-84877259574%7B%5C&%7DpartnerID=40%7B%5C&%7Dmd5=37d9eebeaf3d47792def5214515d50d0. Accessed 24 Sept 2017.

Madsen JB, Madsen CB. An interactive visualization of the past using a situated simulation approach. In: 2013 Digital heritage international congress (DigitalHeritage). IEEE; 2013. p. 307–14. http://ieeexplore.ieee.org/document/6743754/. Accessed 24 Sept 2017.

Madsen CB, Madsen JB, Morrison A, Claus B, Boesen J, Judith A, et al. Aspects of what makes or breaks a museum AR experience. In: 2012 IEEE International symposium on mixed and augmented reality—arts, media, and humanities (ISMAR-AMH). IEEE; 2012. p. 91–2. http://ieeexplore.ieee.org/document/6483996/. Accessed 24 Sept 2017.

Mann S. Mediated reality with implementations for everyday life. Presence Connect. 2002;1.

Milgram P, Kishino F. A taxonomy of mixed reality visual displays. IEICE Trans. Inf. Syst. 1994;77(12):1321–9. http://search.ieice.org/bin/summary.php?id=e77-d%7B%5C_%7D12%7B%5C_%7D1321. Accessed 24 Sept 2017.

Miyashita T, Meier P, Tachikawa T, Orlic S, Eble T, Scholz V, et al. An augmented reality museum guide. In: 2008 7th IEEE/ACM international symposium on mixed and augmented reality. IEEE; 2008. p. 103–6. http://ieeexplore.ieee.org/document/4637334/. Accessed 24 Sept 2017.

Mohammed-Amin RK. Augmented experiences: what can mobile augmented reality offer museums and historic sites? University of Calgary; 2015.

MOSA. The museum of stolen art. Hertogenbosch, Netherlands; http://mosa.ziv.bz/. Accessed 24 Sept 2017.

Museum of London. Streetmuseum for iPhone, iPod touch, and iPad on the iTunes app store. 2010 [Cited 15 Aug 2017]. http://itunes.apple.com/us/app/museum. Accessed 24 Sept 2017.

Nóbrega R, Correia N. Interactive 3D content insertion in images for multimedia applications. Multimed Tools Appl. 2017;76(1):163–97. http://link.springer.com/10.1007/s11042-015-3031-5. Accessed 24 Sept 2017.

Normand J, Servières M, Moreau G. A new typology of augmented reality applications. In: Proceedings of the 3rd augmented human international conference. New York, New York, USA: ACM Press; 2012;(July 2017). p. 1–8. http://dl.acm.org/citation.cfm?doid=2160125.2160143. Accessed 24 Sept 2017.

Peddie J. Augmented reality: where we will all live. Cham: Springer International Publishing; 2017. http://link.springer.com/10.1007/978-3-319-54502-8. Accessed 24 Sept 2017.

Pierdicca R, Frontoni E, Zingaretti P, Sturari M, Clini P, Quattrini R, et al. Advanced interaction with paintings by augmented reality and high resolution visualization: a real case exhibition. Lect Notes Comput Sci (including Subser. Lect. Notes Artif. Intell. Lect. Notes Bioinformatics). 2015. p. 38–50.

Qosmo Terada design. N building.app—iPhone meets architecture. 2010 [Cited 15 Aug 2017]. http://www.sonasphere.com/blog/?p=1288. Accessed 24 Sept 2017.

ROM. Augmented reality Royal Ontario Museum (ROM). www.rom.on.ca. 2017. https://www.rom.on.ca/en/exhibitions-galleries/exhibitions/past-exhibitions/ultimate-dinos/augmented-reality. Accessed 24 Sept 2017.

Scheible J, Funk M. DroneLandArt: landscape as organic pervasive display. In: Proceedings of the 5th ACM International Symposium on Pervasive Displays—PerDis '16. New York, New York, USA: ACM Press; 2016. p. 255–6. http://dl.acm.org/citation.cfm?doid=2914920.2939883. Accessed 24 Sept 2017.

Scheible J, Ojala T. MobiSpray: mobile phone as virtual spray can for painting BIG anytime anywhere on anything. Leonardo. 2009;42(4):332–41. http://www.mitpressjournals.org/doi/10.1162/leon.2009.42.4.332. Accessed 24 Sept 2017.

Schmalstieg D, Wagner D. Experiences with handheld augmented reality. 2007 In: 2007 6th IEEE and ACM international symposium on mixed and augmented reality. IEEE; 2007. p. 1–13. http://ieeexplore.ieee.org/document/4538819/. Accessed 24 Sept 2017.

Scopigno R, Gabellone F, Malomo L, Banterle F, Pingi P, Amato G, et al. LecceAR: an augmented reality app. In: Digital presentation and preservation of cultural and scientific heritage—DiPP2015. 2015. p. 99–108.

Seo B-K, Kim K, Park J-I, Seo B-K, Kim K, Park J-I. Augmented reality-based on-site tour guide : a study in Gyeongbokgung. In: Koch R, Huang F, editors. In: Asian conference on computer vision. ACCV 2010: COMPUTER VISION—ACCV 2010 WORKSHOPS. Berlin, Heidelberg: Springer. 2010.

Sevigne C, Matisse ED. Merging augmented reality based features in mobile multimedia museum guides. In: Proceedings of the XXI international symposium CIPA 2007: AntiCIPAting the future of the cultural past. Athens, Greece; 2007. p. 259–64.

Smau. Smau, international exhibition of information communications technology in Milan. smau. it. 2015. https://www.smau.it/company/pages/home/. Accessed 24 Sept 2017.

Smart J, Cascio J, Paffendorf J, Bridges C, Bridges C, Hummel J, et al. Metaverse roadmapoverview. 2007. http://www.metaverseroadmap.org/overview/. Accessed 24 Sept 2017.

Střelák D, Škola F, Liarokapis F, St D, Filip Š, Střelák D, et al. Examining User experiences in a mobile augmented reality tourist guide. In: Proceedings of the 9th ACM international conference on pervasive technologies related to assistive environments—PETRA '16. New York, New York, USA: ACM Press; 2016. p. 1–8. http://dl.acm.org/citation.cfm?doid= 2910674.2935835. Accessed 24 Sept 2017.

Tanasi D, Stanco F, Tanasi D, Buffa M, Basile B. Augmented perception of the past : the case of the telamon from the greek theater of syracuse. In: Multimedia for cultural heritage. First international workshop MM4CH 2011. 2012.

Thian C. Augmented reality—what reality can we learn from it? [Internet]. Museums Web. 2012. [Cited 15 Aug 2017]. https://www.museumsandtheweb.com/mw2012/papers/augmented%7B %5C_%7Dreality%7B%5C_%7Dwhat%7B%5C_%7Dreality%7B%5C_%7Dcan%7B%5C_%7Dwe%7B%5C_%7Dlearn%7B%5C_%7Dfr. Accessed 24 Sept 2017.

Tillon AB, Marchand E, Laneurit J, Servant F, Marchal I, Houlier P, et al. A day at the museum : an augmented fine-art exhibit. In: 2010 IEEE International symposium on mixed and augmented reality—arts, media, and humanities. IEEE; 2010. p. 69–70. http://ieeexplore.ieee. org/document/5643290/. Accessed 24 Sept 2017.

Tillon AB, Marchal I, Houlier P. Mobile augmented reality in the museum: can a lace-like technology take you closer to works of art? In: 2011 IEEE international symposium on mixed and augmented reality—arts, media, and humanities. IEEE; 2011. p. 41–7. http://ieeexplore. ieee.org/document/6093655/. Accessed 24 Sept 2017.

Van Der Vaart M, Damala A. Through the Loupe: Visitor engagement with a primarily text-based handheld AR application. In: 2015 Digital heritage conference. 2015. p. 565–72.

Valbuena P. Energy passages—media art installation. 2004. http://energie-passagen.de/presse%7B %5C_%7Dengl.html. Accessed 24 Sept 2017.

Valbuena P. Augmented spaces. 2010a. [Cited 15 Aug 2017]. http://www.flickr.com/photos/ todaysart/3284513762/in/photostream/. Accessed 24 Sept 2017.

Valbuena P. Dreaming architecture. 2010b. http://www.idsgn.org/posts/dreaming-architecture/. Accessed 24 Sept 2017.

Valbuena P. Augmented sculpture v1. 2010c. http://www.pablovalbuena.com/selectedwork/ augmented-sculpture-v1/. Accessed 24 Sept 2017.

Valbuena P. Quadratura. 2010d. http://www.pablovalbuena.com/selectedwork/quadratura/. Accessed 24 Sept 2017.

Valbuena P. Time tiling. 2010e. http://www.pablovalbuena.com/selectedwork/time-tiling-stuk/. Accessed 24 Sept 2017.

Valbuena P. Chronography. 2013. http://www.pablovalbuena.com/selectedwork/chrono-graphy/. Accessed 24 Sept 2017.

Valbuena P. 6-columns. 2014. http://www.pablovalbuena.com/selectedwork/para-site-6-columns/. Accessed 24 Sept 2017.

Vlahakis V, Ioannidis M, Karigiannis J, Tsotros M, Gounaris M, Stricker D, et al. Archeoguide: an augmented reality guide for archaeological sites. IEEE Comput Graph Appl 2002;22(5):52–60. http://ieeexplore.ieee.org/document/1028726/. Accessed 24 Sept 2017.

Wagner D, Schmalstieg D, Billinghurst M. Handheld AR for collaborative edutainment. In: Advances in Artificial Reality and Tele-Existence. 2006. p. 85–96. http://link.springer.com/10.1007/11941354%7B%5C_%7D10. Accessed 24 Sept 2017.

Weiquan L, Linh-Chi N, Teong Leong C, Ellen Yi-Luen D, Lu W, Nguyen LC, et al. Effects of mobile AR-enabled interactions on retention and transfer for learning in art museum contexts. In: 2014 IEEE international symposium on mixed and augmented reality—media, art, social science, humanities and design (ISMAR-MASH'D). IEEE; 2014. p. 3–11. http://ieeexplore.ieee.org/document/6935432/. Accessed 24 Sept 2017.

Wither J, Allen R, Samanta V, Hemanus J, Tsai Y, Azuma R, et al. The westwood experience: connecting story to locations via mixed reality. In: 2010 IEEE international symposium on mixed and augmented reality—arts, media, and humanities. IEEE; 2010. p. 39–46. http://ieeexplore.ieee.org/document/5643295/. Accessed 24 Sept 2017.

Wojciechowski R, Walczak K, White M, Cellary W. Building virtual and augmented reality museum exhibitions. In: Proceedings of the ninth international conference on 3D Web technology. New York, New York, USA: ACM Press; 2004. p. 135. http://portal.acm.org/citation.cfm?doid=985040.985060. Accessed 24 Sept 2017.

Yoon SA, Wang J. Making the invisible visible in science museums through augmented reality devices. TechTrends. 2014;58(1):49–55. http://link.springer.com/10.1007/s11528-013-0720-7. Accessed 24 Sept 2017.

Zoellner M, Pagani A, Pastarmov Y, Wuest H, Stricker D. Reality filtering: a visual time machine in augmented reality. In: In: Proceedings of the Ninth International Symposium on virtual reality archaeology, and cultural heritage. 2008. http://av.dfki.de/%7B~%7Dpagani/doc/papers/ZoellnerVAST2008.pdf. Accessed 24 Sept 2017.

Zöllner M, Keil J, Wüst H, Pletinckx D. An augmented reality presentation system for remote cultural heritage sites. In: Debattista K, Perlingieri C, Pitzalis D, Spina S, editors. In: The 10th international symposium on virtual reality, archaeology and cultural heritage: VAST. The Eurographics Association; 2009.

Chapter 4
Beyond the Virtual Public Square: Ubiquitous Computing and the New Politics of Well-Being

Gregory L. Ulmer and John Craig Freeman

4.1 Introduction

Whereas the public square was once the quintessential place to air grievances, display solidarity, express difference, celebrate similarity, remember, mourn, and reinforce shared values of right and wrong, it is no longer the only anchor for interactions in the public realm. Public discourse has been relocated to a novel space: a virtual space that encourages exploration of mobile location-based art in public. Moreover, public space is now truly open, as artworks can be placed anywhere in the world, without prior permission from government or private authorities—with profound implications for art in the public sphere and the discourse that surrounds it. The early 1990s witnessed the migration of the public sphere from the physical realm, the town square and its print augmentation, to the virtual realm, the Internet. In effect, the location of public discourse and the site of national identity formation have been extended into the virtual world and the global network. Electracy is to digital media what literacy is to print. It encompasses the broader cultural, institutional, pedagogical, and ideological implications inherent in the transition our society is undergoing. Electracy describes the functional metaphysics necessary to exploit the full discursive potential of electronic media such as mobile media, the Internet, and augmented (mixed) reality. With the emergence of these technologies on mobile devices, the distributed placefulness of Internet public discourse entertains the possibility of a new global democracy.

G. L. Ulmer (✉)
Department of English and Media Studies, University of Florida, Gainesville, FL, USA
e-mail: glue@ufl.edu
URL: http://www.clas.ufl.edu/users/glue/; http://emeragency.electracy.org

J. C. Freeman
Department of Visual and Media Arts, Emerson College, Boston, MA, USA
e-mail: john_craig_freeman@emerson.edu
URL: http://JohnCraigFreeman.net

© Springer International Publishing AG 2018
V. Geroimenko (ed.), *Augmented Reality Art*, Springer Series on Cultural
Computing, https://doi.org/10.1007/978-3-319-69932-5_4

Orators, Rostrums, and Propaganda Stands, shown in Fig. 4.1, are based on the work of Gustav Gustavovich Klucis, including his designs for screen-radio orators, rostrums, and propaganda stands from 1922. Klucis was a pioneering member of the Russian Constructivist avant-garde in the early twentieth century. As Russian politics degenerated under the Stalin dictatorship in the 1920s and 1930s, Klucis came under increasing pressure to devote his artwork to state propaganda. Despite his loyal service to the Communist Party, Klucis was arrested in Moscow on January 17, 1938. His whereabouts remained a mystery until 1989, when it was discovered that he had been executed by Stalin just after his arrest (Šatskih 2001). Each of the four virtual objects display a black-and-white animation from a contemporary mass uprising: Tank Man near Tiananmen Square in Beijing in 1989; the assassination of Neda Agha-Soltan, who was gunned down in the streets of Tehran during the 2009 Iranian election protests; scenes from Tahrir Square in Cairo during the 2011 Arab Spring; and the 2011 Occupy Wall Street uprising. Each of these images is juxtaposed, in montage, with frames from the Odessa Steps scene of Sergei Eisenstein's historic *Battleship Potemkin* film. When touched, the virtual objects play sound from the uprising. The stands call up both the resurgence and nostalgia of current worldwide political idealism as they reimagine the public square, now augmented with the worldwide digital network.

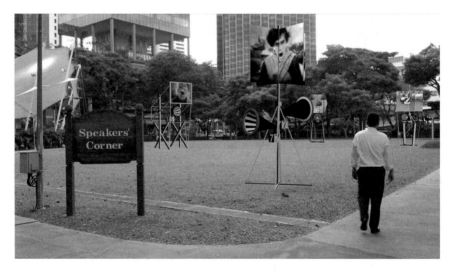

Fig. 4.1 Orators, rostrums, and propaganda stands by John Craig Freeman, Speaker's Square, Singapore, 2013, Augmented reality public art

4.2 Ubimage

The works included here are a sample of experiments testing a consulting practice (konsult) native to electracy (the digital apparatus). The consultations reference the EmerAgency, a virtual "egency," promoting a fifth estate for a global public sphere. The genre of konsult applies Arts and Letters knowledge and methods to policy-formation controversies, with the purpose of giving social media an independent means for a collective voice with which to address governments, corporations, and entertainment entities. One premise of the experiments is that an apparatus is a social machine. Its invention includes not only technologies, but also authoring practices within new institutional support, and identity experience and behavior of individuals and groups (Ulmer 2003).

The technology of augmented (mixed) reality, ubiquitous pervasive computing (mobile locative media), when considered within the full apparatus of electracy, constitutes *ubimage*. It assumes a vision of technics on a trajectory of innovation of which the current emblem is Google Glass: the prospect of a physical and cultural environment in which there is a convergence and syncretism of total real-time information (Internet) with the present lifeworld (Lebenswelt). This convergence exists first as a juxtaposition or superimposition, with a host of emerging practices attempting a suture. Apparatus history shows that the invention of authoring practices has its own sources apart from the evolution of technics.

4.3 Apparatus

The electrate apparatus is invented in three registers: technology, compositional practices, and identity formation. The saturation of everyday environments with mobile devices encountering sensor settings is the contribution of technics. Interactive equipment establishes at the level of technics a feature of the world central to the history of the arts, which materialize and augment a human capacity to be affected by place and event. Marcel Proust's involuntary memory, triggered by the taste of a tea biscuit (Proust 2006) or the Wolf Man (Freud 1963), whose obsessions were triggered by the sight of a maid scrubbing the floor, are two famous examples of embodied triggers, emblematic of this capacity. Ubimage is a logic of *catalysis*, just as literate dialectic is a logic of analysis.

A primary focalizer for the responsibilities of konsult is Paul Virilio and his warnings about the General Accident (Virilio 1997) and more conventionally the historical fact that every invention comes with a Gift Cause (extending Aristotle's four causes beyond intentionality: material, formal, efficient, final) (Falcon 2012). Gift cause is the unintended inevitable accident associated with every invention. What is the accident potential of ubicomp? It is worth remembering that Heidegger anticipated Virilio's warnings in saying that catastrophe is inherent in being. Those YouTube videos showing "funniest home video" moments of smartphoner

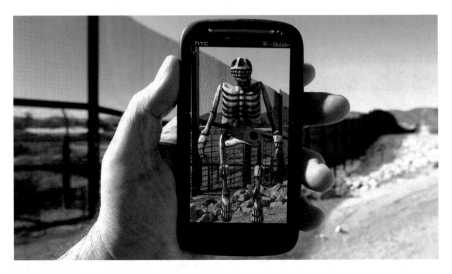

Fig. 4.2 *Border Memorial: Frontera de los Muertos* by John Craig Freeman, On the road to Ajo along Highway 86, Arizona, 2013, Augmented reality public art

accidents reenact one of the founding events of philosophy (Thales fell into a ditch while gazing at the stars). "The actively violent one, the creator, who moves out into the unsaid, breaks into the unthought, who compels the unhappened and makes the unseen appear, this actively violent one stands at all times in peril. In risking a prevailing over being, he must take a risk with regard to the onrush of non-being, with regard to disintegration, "un-constancy", lack of structural order and disorder" (Heidegger 2000).

Heidegger's account foregrounds the "violence" of creative invention that produces both human prevailing against the overwhelming (nature) and also catastrophe (the lesson of tragedy in general). His insight is that aporia is an irreducible dimension of poros. These experiments register this complexity: a/poria, im/mobility, no/way. Ubimage for well-being is a practice of a/poria (im/mobile media).

Border Memorial: Frontera de los Muertos, shown in Fig. 4.2, is an augmented reality public art project and memorial, dedicated to the thousands of migrant workers who have died along the US/Mexico border in recent years trying to cross the desert southwest in search of work and a better life. This project allows people to visualize the scope of the loss of life by marking each location where human remains have been recovered. Based on a traditional form of wood carving from Oaxaca, the virtual object consists of life-sized, three-dimensional geometric models of a skeleton effigy or calaca. Calacas are used in commemoration of lost loved ones during the Mexican Día de los Muertos, or Day of the Dead festivals. According to indigenous belief, despite the tragedy, death should always be celebrated (Holmer 2005). In the tradition of Día de los Muertos, the Border Memorial project is designed to honor, celebrate, and remember those who have died and to

vault this issue into public consciousness and American political debate. The project is intended to provide a kind of lasting iconic presence in an otherwise ephemeral physical environment and cultural discourse.

4.4 Theoria

This sample of works retrieves the institution of theoria, as practiced in the ancient world—a combination of tourism and theory. The most famous example of theoria is the visit of the three Wise Men to the manger in Bethlehem, to determine the truth of the rumors that a new king was born. A theoros (member of a theoria) is sage, someone like Solon for the Classical Greeks, a person trusted by the community, dispatched to sort out fact from fiction in the information flow of a community (Plato 2006a). Theoria toured a situation, consulted with locals who served as guides to all the shrines, sites, and important personages of the area. The theoria announced its findings *in the public square of its home city*, and these findings constituted what was the case. Aristotle's invention of metaphysics began with the *Categories*, as if codifying in grammar the declarative form that may be determined as either true or false, for making trustworthy statements in the service of the Polis. A version of his categories survives today in traditional journalism (the five W's, beginning with "What?").

Ubimage makes possible a new dimension of consulting, triangulating between the present institution of tourism (a vital contemporary vernacular behavior, largest single industry in the world), and the historical practice of divination (tarot, e.g., mapping the universal journey through life for pre-modern people). Divination was an essential part of traditional deliberative reason, concerned with decision making to influence future conditions. It was a faculty for processing the future, just as memory is a faculty for processing the past. Both tourism and divination model a certain functionality to be appropriated by ubimage. Tourism orients GPS (physical mobility), and divination orients EPS—Existential Positioning System (metaphysical mobility). The retrieval of these registers of theoria for konsult calls attention to the contradiction of contemporary media: Enthusiasm for mobile computing masks the metaphysical immobility of modernity, the fundamental aporias that arrest policy decisions on behalf of well-being at every turn (trope). The global city remains as paralyzed as it was when its labyrinth was first surveyed by modernist arts and philosophy. The era of electracy begins in the industrial city.

Tarot and the I Ching are especially misunderstood, due to caricature survivals in New Age and self-help contexts. These popular, vernacular practices, nonetheless, are a resource for invention in that they provide a background tradition of popular decision making. The fifth estate via social media is crowd-sourced self-help democracy. Greek philosophy (literate metaphysics) was not invented from scratch, but was generated in the new educational institution—the Academy—as a syncretism and refinement of cultural features of the contemporary society, including the oral culture of spoken Greek. Tarot was created in Renaissance Italy and is a

popular expression of the same forces shaping the work of the Neoplatonic Academy in Florence. It acquired most of its hermetic aspects in the same environment nurturing the birth of the avant-garde arts in Paris in the nineteenth century, and the commentaries bringing it most fully into contact with contemporary thought are found in psychoanalysis. Psychoanalysis, in its cultural productivity, is divination, repurposed as a new logic mapping the vicissitudes of enjoyment.

Gregory Bateson identified the keywords of the oral and literate apparatuses in his book *Mind and Nature* (Bateson 2002). Reality in the oral apparatus (extended via Religion into the present) is organized by the principles of *salvation* (spiritual transcendence). Reality in the literate apparatus (extended via Science into the present) is organized by the principles of *entropy* (material immanence). Bateson does not address electracy, but the twin realities of salvation and entropy suggest why a third option is desirable. Reality in the electrate apparatus (with the effect of reordering the other institutions) is organized around *well-being*—the problematic of happiness, recently entering public policy in the form of hedonics. At present, this organization is emergent within entertainment, commercial and commodity forms, the institutionalization of aesthetics. As Kant argued in promoting aesthetic taste to equal status with Pure and Practical Reason in his third critique, the function of judgments of beauty and the sublime was to bridge the abyss separating nature's necessity and human freedom (Kant 1951).

Flotsam is floating wreckage of a ship or its cargo. Jetsam is part of a ship, its equipment, or its cargo that is purposefully cast overboard or jettisoned to lighten the load in time of distress and that sinks or is washed ashore by the Coriolis effect: planetary vorticity along with horizontal and vertical friction. Marking the contour of the expected sea level 50 years from now, *Flotsam & Jetsam*, shown in Fig. 4.3,

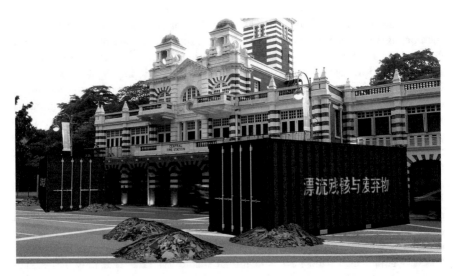

Fig. 4.3 *Flotsam & Jetsam* by John Craig Freeman, Singapore, 2013, Augmented reality public art

is a clarion call for the denizens of the world to take seriously the science of climate change and other abuses to the global environment by envisioning the debris left by storm surge and other manifestations of the incoming tide.

4.5 The Malala Test

What is at stake in this syncretizing ambition for the arts in electracy may be seen in the irreducible hostility between religion and science currently plaguing civilization. We must appreciate that this confrontation is between not just institutions, but entire apparati. Any number of incidents might represent the impasse for our time, as the confrontation between Galileo and the Church did for Bertolt Brecht. A radical Islamist group in Nigeria calling itself "Boko Haram" (meaning "Western Education is Sacrilege") burned down a school in Nigeria, killing 29 students and an English teacher. The Khmer Rouge included in its genocide anyone wearing glasses, a shibboleth signaling "intellectual." Konsult takes the side of Malala Yousafzai against her Taliban would-be assassins: "One child, one teacher, one book, one pen can change the world," she declared, in demanding the right to education for everyone. Ubimage takes up again the old struggle between pens and swords, to demand that religion and science correlate with well-being.

A caveat to avoid melodramatic oversimplifications of the test is found in another version of the opposition: Jihad versus McWorld. Is Las Vegas the best electracy can do in promoting the good life? Each apparatus has its own version of fair and foul. What if obesity fell into the wrong hands? The challenge of ubimage is to extrapolate from the inventions of corporate entertainment (the leading edge of electrate institution formation) the means of metaphysical innovation that transforms the conflict of civilizations into a correlation of apparati. What in fact constitutes well-being? Aristotle said it was happiness, accomplished through the good, but these transcendental terms could only be defined within a Polis, a political community, since they were not given as actual, but only as potential. The fifth estate (ubiquitous democracy) is this Polis. An immediate goal of konsult is to develop a practice to support community institutionalization of well-being outside merely commercial values (Bataille's restricted economy) (Bataille 1991), but also apart from the restrictions of religion and science. The short-term goal of the present experiments is to understand and undergo for ourselves the basic insight into well-being expressed in Arts & Letters tradition, as a first step toward designing a practice for general electracy.

The convergence of Internet and lifeworld producing an ecology of information creates a need and opportunity to develop a contemporary version of the microcosm-macrocosm correspondences enjoyed by pre-modern civilizations. The systems of correspondences organizing divination that oriented individuals to the ethos and habitus of society were destroyed by modernity (scientific industrialized utilitarian society). The program for a new "correspondence" [Baudelaire's "forest of symbols" (Baudelaire 1994), Walter Benjamin's Arcades allegory (Benjamin

1999)] concerns the functionality modeled in oracles such as Tarot or the I Ching, if not the cultural content of those systems. Oracle "games" allow individuals to author epiphanies, and the epiphany form survived in modernist poetry and art in the absence of the system that supplied data from the wisdom traditions in support of practical reason (decision procedures). The experiments undertaken in ubimage design and test a contemporary practice of correspondences, constructing a system of macro-micro-cosmos for an electrate wisdom. Ubimage is a practice of "macroimaging" (arts equivalent of macroeconomics, each dealing with the dynamics of information circulation).

4.6 Obscenario

The obscenario is a transitional alternative to the *scenarios* of conventional consulting, as a means to imagine the future in order to decide policy in a flash. Concepts are literate, and the purpose of Philosophy, according to Deleuze and Guattari, is to create concepts (Deleuze and Guattari 1994). Transition from literacy to electracy requires learning how to extend conceptual thinking within electrate media, in order to imagine our way into the new apparatus. Deleuze and Guattari analyzed "concept" into three components: an idea (term), a problem field addressed by the idea, and a conceptual persona who dramatizes the import of the idea in a situation. Obscenario shifts the emphasis from literate foregrounding of the eidos (abstract configuration of properties) to persona in a situation, which lends itself to imaging. The prototype of a conceptual persona is Socrates, dramatizing "dialectic" as idea in the dialogues of Plato. We rely on this analogy to move into the invention of a post-literate practice: an avatar of concept. The phrase is ambiguous: the concept of "avatar," and an avatar of "concept" (which itself may not appear). The first step, in other words, is to develop within literate skills a concept adequate to the invention of konsult: a practice that does for electracy what the dialogue did for literacy.

 The relay from Socrates is useful to identify the features of obscenario. There are several levels for emulation: (1) Plato creates the dialogue as a device to communicate in writing the new logic of dialectic. Students are introduced to dialectic (analysis and synthesis) through an interface metaphor, the behavior of the gadfly Socrates. Dialogue as pedagogy requires a certain attitude: a commitment among friends to suspend competition in order to discover what is objectively (logically) true; (2) the scenario proper is Socrates encountering an interlocutor on the streets of Athens, in everyday life, as in *Euthyphro*, for example (Plato 2006b). Euthyphro is in a situation: He has decided to prosecute his father for impiety. Socrates asks Euthyphro to define his terms: what does he mean by "impiety." Of course to define a term produces a concept—a literate skill, but Euthyphro is illiterate; (3) the context for the apparatus is the invention of practices of logic to augment pure reason, as a capacity of selfhood (individual identity) in a democratic state (collective identity). The instruction is to extrapolate to our own case.

Concept Avatar is not dialogue or dialectic, but uses those to generate an electrate equivalent, to do for EmerAgency konsult what dialogue did for Plato's Academy. The capacity to be addressed, supported, augmented in konsult via ubimage is not reason (logic), but affect, sensory perception (aesthetics). The medium (equipment) is not alphabetic writing, but ubiquitous computing (pervasive computing: mobile devices in smart environments). Euthyphro in the midst of a situation encountered in the streets of Athens the gadfly Socrates. Egent (intern of EmerAgency) consulting (testifying) on public policy encounters, via smart device in an intelligent environment, avatar. The experiments collected here are traces of avatar. Who is addressee of konsult? First, it is the egent and her network (self-addressed, middle voice). Ubimage is not a spectacle, but a distributed gadfly.

EEG AR: Things We Have Lost, shown in Fig. 4.4, allows participants to conjure up virtual objects by simply imagining them into existence using brainwave sensor technology. As part of the research, development and community engagement of this project, in 2012 we selected people at random in the streets of Liverpool and simply asked "What have you lost?" The location was recorded, a virtual lost object was created based on the response, and the objects were then placed back in the exact GPS coordinates using augmented reality technology, creating a citywide network of lost things. Through this process, a database of lost things was generated, including pensions, empires, dodo birds. During the experimental phase of the project, test subjects were outfitted with EEG-reading brainwave sensors and ask to think deeply about what he or she has lost. Once our software detects a measurable and consistent pattern, it issues a database call to instantiate a virtual lost object at random from the database. The virtual object then appears in front of the participant, viewable on any iPhone or Android device.

Fig. 4.4 *EEG AR: Things We Have Lost* by John Craig Freeman, Liverpool, 2013, Augmented reality public art

4.7 Ordinary Aura

The Socratic Dialogue as a relay for concept avatar clarifies in the hypotyposis (proportional analogy) that konsult foregrounds not critical reason but perceptual affect (see also the three registers of Deleuze and Guattari: Science, Philosophy, Arts—fact, concept, affect-percept). The challenge of ubimage is to design a practice capable of work-play with all three orders at once in the context of a situation. Such is the skill-set of electracy. The exercise testing concept avatar (the thought of feeling) takes up the imperative of the avant-garde, championed in many forms subsequently—to merge art with everyday life. The terminology calls attention to the specific target of ubimage relative to apparatus theory. The STEM engineers, as they say, have saturated the Everyday world (*Lebenswelt*) with equipment (mobile devices networking with sensors in smart environments). That takes care of technics, but the commentary tends to assume that everyday life is unproblematic, which is far from the case. In fact, the Everyday is a major topic of discipline interest, as for example in the philosophy of Henri Lefebvre (Lefebvre 1992), taken up in Situationism, Guy Debord (Debord 1994), not to mention Walter Benjamin's Arcades Project (Benjamin 1999), and the Frankfurt School focus on the problem of alienation as the impoverishment of everyday life experience.

Specifically, the parallel with digital convergence and saturation is the integration of the aesthetic attitude into lifeworld behavior and skills. Here is a key to the electrate apparatus in general: It emerges into metaphysics through the aesthetic attitude, just as literacy as science required the frame of curiosity in order to thrive. The invention of an "attitude" is part of apparatus formation. "Aesthetics" introduces a certain "distance" into experience, termed "aura" by Benjamin. It is important to clarify that the devotion to "pure art" (art for art's sake) during the initial period of electracy in nineteenth-century Paris (Parisian Bohemia in Montmartre cabarets is the electrate equivalent of the Athenian academies creating a space for pure reason) was inventive, a necessary concentration for articulation of art as "logic," prior to dissemination as general cultural interface (GCI) for an electrate civilization. The point is that netizens (ubizens) via the apparatus are able to include aura not as separation from but syncretic with their other institutional behaviors—work, family, leisure. Aura (aesthetic attitude) *creates value*, which recommends it as the means to overcome alienation and recover experience of individual and collective agency, which is the avatar function. The insight is that well-being refers to specific values, whose aesthetic character can and should be realized through public policy. "Being a dynamic principle, the aesthetic function is potentially unlimited; "it can accompany every human act, and every object can manifest it." Its limit lies in the fact that it derives from the dialectical negation of a practical or communicative function. And because the phenomena it produces in the constant renewal of the aesthetic experience are subject to societal judgment, i.e., must find public recognition before they can enter the tradition-creating process as aesthetic norms, there is a second, intersubjective limitation. In contrast to Roman Jacobson's earlier definition of the poetic influence of language, the aesthetic

Fig. 4.5 *Water wARs* by John Craig Freeman, Beneath the Brooklyn Bridge, New York, 2011, Augmented reality public art

function is not self-referential for Mukarovsky, it is more than a statement oriented toward expression for its own sake. Because the aesthetic function changes everything that it touches into a sign, it becomes transparent for the thing or activity that it "sets aside some practical association." Precisely because the aesthetic function differs from all others (the noetic, the political, the pedagogic) in having no "concrete aim" and because it lacks "unequivocal content," it can take hold of the contents of other functions and give their expression the most effective form" (Jauss 1982).

Such is the attitude native to electracy. What the spiritual is to orality and the materialist to literacy, the aesthetic is to electracy.

Water wARs, shown in Fig. 4.5, anticipates the flood of environmental refugees into the developed world caused by environmental degradation, global warming, and the privatization of the world's drinking water supply by multinational corporations like Bechtel. The project consists of a sprawling virtual shanty pavilion for undocumented artists/squatters and water war refugees.

4.8 Choragraphy

Konsult is a practice to correlate existential experience with everyday life materiality. For an environment to be intelligent, the apparatus needs to manage not only physical location (GPS), but EPS, which requires tracking not only presence but absence (*différance*) (Derrida 1998). If conventional wayfinding gives coordinates that say "You Are Here," existential coordinates engage a more complex

orientation: *You are where you are not, and are not where you are.* A konsult is an event of encounter between egents and places, both of which involve dimensions that are not phenomenal, not present, without presence and not presentable. Such are the coordinates mapped through ubimage. Thoreau's *Walden* concludes with a figure that provides an emblem for EPS: "What was the meaning of that South-Sea Exploring Expedition, with all its parade and expense, but an indirect recognition of the fact that there are continents and seas in the moral world to which every man is an isthmus or an inlet, yet unexplored by him, but that it is easier to sail many 1000 miles through cold and storm and cannibals, in a government ship, with 500 men and boys to assist one, than it is to explore the private sea, the Atlantic and Pacific Ocean of one's being alone" (Thoreau 1992).

Choragraphy as ontological mapping takes up this question of coordinating material and spiritual wayfinding, exploring the shifting borders and thresholds between inner and outer well-being.

Thoreau's passage is emblematic because it uses global exploration and mapping as a metaphor for self-knowledge. The challenge of EPS choragraphy is that the space-time for which it is responsible is a second-order construction, figurative rather than literal, emerging through aesthetic formal manipulation of media. But the promise of ubimage is to create an interface convergence of literal and figurative dimensions of human experience.

Clive James gives an idea of the nature of figuration that renders intelligible the non-phenomenal dimension absent from all maps. "Any poem that does not just slide past us like all those thousands of others usually has an ignition point for our attention. To take the most startling possible example, think of 'Spring', by Gerard Manley Hopkins. Everyone knows the first line because everyone knows the poem. 'Nothing is so beautiful as Spring' is a line that hundreds of poets could have written and was probably designed to sound that way. Only two lines further on, however, we get 'Thrush's eggs look little low heavens' and we are electrified. Eventually we see that the complete poem is fitting in its every part, for its task of living up to the standards of thought and perception set by that single flash of illumination. But we wouldn't even be checking up if we had not been put on the alert by a lightning strike of an idea that goes beyond thought and perception and into the area of metaphorical transformation that a poem demands. A poem … is dependent on this ability to project you into a reality so drastically rearranged that it makes your hair fizz even when it looks exactly like itself" (James 2008).

Poetry is a guide for how to introduce an ignition point into public space. Two aspects of James's description are worth noting in our context: the figure of electrification and the lightning strike of an image, resonant with electracy and flash reason; that the version of reality made receivable through aesthetic indirection is—like Plato's metaphysical dimension of chora, the interface between Being and Becoming—beyond both thought and perception.

Tiananmen SquARed, shown in Fig. 4.6, is a two part augmented reality public art project and memorial, dedicated human rights and democracy worldwide. The project includes virtual replicas of the Goddess of Democracy and Tank Man from the 1989 student uprising in Tiananmen Square. Both augmentations have been

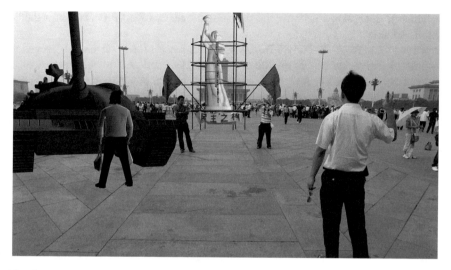

Fig. 4.6 *Tiananmen SquARed* by 4 Gentlemen, Tiananmen Square, Beijing, 2010, Augmented reality public art

placed in Beijing at the precise GPS coordinates where the original incidents took place. The Goddess of Democracy was a 33-foot tall statue, constructed in only 4 days out of foam and papier-mâché over a metal armature. Students from an art institute created the statue, placing it to face toward a huge picture of the late Communist Party chairman Mao Zedong. Tanks later flattened the statue when China's military crushed the protest. Tank Man was an anonymous man who stood in front of a column of Chinese Type 59 tanks the morning after the Chinese military forcibly removed protestors from in and around Beijing's Tiananmen Square on June 5, 1989. The man achieved widespread international recognition due to the videotape and photographs taken of the incident.

4.9 Aesthetic Attitude

Konsult includes aesthetic attitude in the public sphere, to exercise and enhance capacity to be affected. The attitude is modeled in several areas of common experience: tourism, movies, arts and crafts. Konsult applies the vanguard project of merging art with everyday life, not to make art, but to put the stamp of being on becoming. Moment against dromosphere in any case attempts praxis as poiesis. It is possible through ubimage to syncretize in one performance the three intellectual virtues—an *act recorded as image of political import that produces understanding for an egent*: Achilles, Pericles, and Homer in one. Despite his existentialist credentials, Sartre was wrong (Sartre 2013): It is possible to live and tell (at least in

electracy). Such acts constitute the distributed egency of a fifth estate in a global public sphere.

Orhan Pamuk, in his novel *Snow*, tells the story of Ka, an exiled poet who returns to Turkey to report on a wave of suicides, and also to reconnect with a woman he had loved in his youth. He has not written any poetry in a number of years. But during the events of his visit, the old creative capacity returns, at least briefly, and he is able to write a poem. The example is relevant to us not for the poem, but for how the feelings of significance arise in the midst of a situation, pursuing both professional and personal projects, while reflecting on the meaning and purpose of his life. The immediate instructions may be derived from the gradual dawning of inspiration as the circumstances of recent incidents begin to form into a system of correspondences producing epiphany.

"He made his way along the train track, past the snow-covered silo that loomed overhead like a great white cloud, and was soon back inside the station. As he passed through the empty, dirty building, he saw a dog approaching, wagging its curly tail in a friendly way. It was a black dog with a round white patch on its forehead. As he looked across the filthy waiting hall, Ka saw three teenage boys, who were beckoning the dog with sesame rolls.

"There was a long silence. A feeling of peace rose up inside Ka. They were so far from the center of the world, one couldn't even imagine going there, and as he fell under the spell of the snowflakes that seemed to hang in the sky outside, he began to wonder if he had entered a world without gravity. When everyone had ceased to pay any attention to him, another poem came to Ka.

"The poem was made up of many of the thoughts that had come to him all at once a short while earlier: the falling snow, cemeteries, the black dog running happily around the station building, an assortment of childhood memories, and the image that had lured him back to the hotel: Ipek. How happy it made him just to imagine her face—and also how terrified! He called the poem 'Snow.'

Much later when he thought about how he'd written this poem, he had a vision of a snowflake; this snowflake, he decided, was his life writ small; the poem that had unlocked the meaning of his life, he now saw sitting at its center. But—just as the poem itself defies easy explanation—it is difficult to say how much he decided at that moment and how much of his life was determined by the hidden symmetries this book is seeking to unveil. Before finishing the poem, Ka went silently to the window and watched the scene outside: the large snowflakes floating so elegantly through the air. He had the feeling that simply by watching the snowfall he would be able to bring the poem to its predetermined end" (Pamuk 2005).

The relay for ubimage is that becoming-poem occurs in the midst of life experience, and that it makes itself known through augmented perception, memory, imagination, feeling—an emotional intensification associated with revelation. This dimension of ordinary moments in everyday life is the one opened to ontological construction of well-being in electracy. Ubimage is a practice for accomplishing these events, distributed through konsult, to gather an army for well-being through an intensity of shared feeling.

Fig. 4.7 *Peace Doors* by John Craig Freeman, Along the Peace Line, West Belfast, 2010, Augmented reality public art

With nine locations along the Peace Line in West Belfast, *Peace Doors*, shown in Fig. 4.7, addresses the ongoing conflict between the Catholic and Protestant communities there. The Peace Line is constructed of walls, fences, industrial complexes, and even a shopping mall, designed to separate the Protestant Shankill neighborhood to the north from the Catholic Falls Road neighborhood to the south. The first Peace Line barriers were built in 1969, following the outbreak of the Northern Ireland riots and "The Troubles." They were built as temporary structures because they were indeed meant to be temporary, lasting only 6 months, but due to their effective nature they have become more permanent, wider and longer across the city.

4.10 Rationale

Here is an outline of the logic motivating this collection of experiments.

I. Dromosphere

- Frame: Konsult proposes a practice of citizen participation adequate to the conditions of the dromosphere (dimension collapse) theorized by Paul Virilio. Virilio argues convincingly that the light-speed of the digital apparatus has made possible (inevitable) a General Accident that occurs everywhere simultaneously.
- Dimension pollution compresses time-space into Now, challenging literate formations of individual critical thinking and the democratic public

sphere. This challenge is the crisis alluded to in the name of the consultancy—EmerAgency, whose motto is: "Problems B Us." Dromos (race) consists of three positions (moments, opportunities, openings): start, turn, finish. Konsult practices *Turn* (trope).

II. Prudence

- Konsult draws upon the experience of Arts and Letters traditions with immediate intuitive judgment to formulate *flash reason* as the logic needed for deliberation (community decision making) in the dromosphere.
- Prudence (Aristotle's *phronesis*) is the virtue of good judgment. A person with good judgment is able (*posse*)—in the midst of an ongoing situation —to draw upon past experience to make the right decision about how to act that brings about the best outcome for the community. In oral culture, this kind of judgment on the fly was associated with *metis*, a skill of *savoir-faire* demonstrated in its purest style in the conduct of a race.
- *Kairos* is the mode of temporality proper to metis (the term refers to the weaver's art of throwing the shuttle at just the right moment). Kairotic time displaces cyclical (oral) and linear (literate) models of time to become the primary temporality in electracy.

III. Flash Reason

- The lightning flash of insight (intuition, inspiration) has been fully theorized in Western thought, especially with respect to Moment (*Augenblick*). Moment is taken up in konsult as the answer to Now crisis. Sudden thought draws together all human faculties to take in a situation in one (augmented) glance. The limits of this glance relative to the human sensorium are codified as "beauty," however that experience may be understood in a given culture. The invention of Aesthetics as a separate faculty at the beginnings of electracy (Kant et al.) recognized and anticipated the challenge to Moment in the notion of the sublime. The conditions of the industrial city are sublime, producing shock experience of alienation, reification, objectification, in which denizens lose connection with agency (with the categories of experience: space, time, cause).
- The arts take up the dynamics of Moment, focusing on a poetics of epiphany. Epiphany (secularized revelation) is the formal structure of flash reason, transformed in Romanticism (German Idealism) as the "crisis poem" (Harold Bloom), reconfiguring the operations of allegory and symbol, promoting tropology as supplement of inference and narrative as primary skills of the cultural interface. The project evolved across the arts, leading to a new structural mode of correspondences addressing the disjunction of microcosm/macrocosm in the city.
- Relevant versions of epiphany include Baudelaire's correspondences, Rimbaud's illuminations, Rilke's world-inner-space, Eliot's objective correlative. Proust (involuntary memory) and Joyce (epiphany) extended

the function to the novel, as did Brecht (gestus, V [A] effect) and Artaud (cruelty) in theater. Freud's transference, Benjamin's dialectical image, and Merleau-Ponty's flesh are key instances of theoretical elaboration of flash reason.

IV. Mechanical Reproduction

- Manifesting a certain (happy) correlation across the levels of the apparatus, the invention of photography makes available one of the new supports of communication displacing alphabetic writing in the electrate economy. Photography was just the first in a series of major innovations lending technological augmentation to the sensorium, continuing today in digital computing (Web 3.0). Smartphones equip the sensorium for sublime conditions. The filmic shot is kairotic. The insight of apparatus theory is that a general electracy must be developed as institution and practice to coordinate digital equipment with flash reason.
- The aesthetics of Moment was formulated in photography by Henri Cartier-Bresson's "decisive moment" (shooting *a la sauvette*). This design principle has a long history in the visual arts, with painters choosing the telling instance of an action to lend a narrative dimension to a picture. The principle reaches its theoretical completion in Gestalt psychology and phenomenology—the principle of *Prägnanz*: the combination of expectation and perception to produce default continuities or groupings in experience. Gestalt manifests the limitations of glance, inadequate to dromospheric sublime that becomes formless (information sprawl).
- Avant-garde poetics invented during this same period (nineteenth-century Paris), whose prototype is Duchamp's readymades, such as "Fountain," extended Kant's Judgment to include the automatism of the snapshot. Chance as a formal device, coordinated with recording equipment and flash poetics, were integrated in support of a new attitude toward everyday life, beyond both knowledge and will (the constitutive stands of Pure and Practical Reason).
- Theoretical complements of vanguard poetics include Georges Bataille's *informe* (formless), Deleuze and Guattari's rhizome (swarm), Lacan's stain, and related engagements with sprawl complexity.

After the 2007 shootings at Virginia Tech, you may remember the commentary that was published in the New Yorker, about the heartbreaking experience of the police carrying the bodies out of the classrooms while the cell phones in the victim's pockets and backpacks kept ringing. *School Shootings eMorial*, shown in Fig. 4.8, consists of an of augmented reality scene including a virtual replica of the Sandy Hook School sign, 20 backpacks representing each of the students and six apples representing each of the teachers and staff who lost their life in the Sandy Hook Elementary School shooting in Connecticut on December 14, 2012. When people approach the backpacks, cell phone ringing sounds are triggered.

Fig. 4.8 *School Shootings eMorial* by John Craig Freeman with Gregory L. Ulmer, National Mall just west of the US Capital Building, Washington DC, 2013, Augmented reality public art

4.11 Quasi-object

Ubiquitous imaging—ubimage signifies within a digitally supported logic in the apparatus of electracy. There is a backpack (for example), an object ubiquitous as a commodity, a quasi-object (extimate entity, simulacrum) circulating for its use and exchange value, becoming signifier. Follow the trace (inference path): Cell phones were heard ringing in the backpacks of students murdered at Virginia Tech (04/16/ 2007). The backpacks of the children slaughtered at Sandy Hook Elementary School in Newtown, CT (12/14/2012) were designed for the imaginations of 6-year-olds, perhaps already beyond the whimsy of Dora the Explorer and her backpack friend. Backpacks were the disguise of choice by the Chechen brothers for the IEDs targeting the Boston Marathon finish line, detonated by a connection between a cell phone and a toy car (04/15/2013). Chechen separatists took hostage 1100 people (777 children) at a school in Beslan, Russian Federation (09/01/2004). Of the 334 killed in the 3-day siege, 186 were children. There is a certain inference trace passing through these events, bringing into appearance an opposition, a fundamental violence, archetypal, an irreducible polarity throwing apart two apparatuses—Oral and Alphabetic, Religion and Science. The emblem is made explicit in the name of a group responsible for burning down a school in Nigeria, murdering 29 students and a teacher (07/06/2013): *Boko Haram, The classroom as Frontier.* Recall the Khmer Rouge, the genocide of the killing fields of Cambodia (1975–1978, 1.7 million dead), in which anyone suspected of being educated was murdered. Is there a pattern gathering this path into a pathology? Is the Reign of Terror native to modernity (France 09/05/1793–07/28/1794): the guillotine (16,594

executions)? An eMorial translates one-at-a-time disasters into a public sacrifice on behalf of a national value. In the USA from 1960 to 2013, 1.3 million Americans have died from gun violence. These dead are commemorated today, martyrs to the Second Amendment to the Constitution, honored as members of a Minute Man Militia (three Americans killed each and every hour, each and every day). A society is measured by what it values.

References

Bataille G. The accursed share: consumption (Trans. Hurley R). New York: Zone Books; 1991.
Bateson G. Mind and nature: a necessary unity. New York: Hampton Press; 2002.
Baudelaire C. Correspondences. In: Henri D, editor. Symbolist art theories: a critical anthology. Los Angeles/Berkeley: University of California Press; 1994.
Benjamin W. The arcades project (Trans. Eiland H and McLaughlin K). Cambridge: Harvard University; 1999.
Debord G. The society of the spectacle (Trans. Nicholson-Smith D). Cambridge: MIT Press; 1994.
Deleuze G, Guattari F. What is philosophy?. London: Verso; 1994.
Derrida J. Of grammatology. Baltimore: Johns Hopkins University Press; 1998.
Falcon A. Aristotle on causality. In: Stanford encyclopedia of philosophy. http://plato.stanford.edu/archives/win2012/entries/aristotle-causality/ (2012). Accessed 18 Sept 2017.
Freud S. Three case histories: the "wolf man", the "rat man", and the psychotic doctor Schreber. New York: Macmillan; 1963.
Heidegger M. Introduction to metaphysics (Trans. Fried G). New Haven: Yale University Press; 2000.
Holmer R. The Aztec book of destiny. North Charleston: BookSurge; 2005.
James C. Little low heavens. Poetry Magazine; Sept 2008.
Jauss H. Toward an aesthetic of reception (Trans. Bahti T). Minneapolis: University of Minnesota Press; 1982.
Kant I. Critique of judgment (Trans. Bernard JH). New York: Hafner Publishing; 1951.
Lefebvre H. The production of space (Trans. Nicholson-Smith D). Oxford: Wiley-Blackwell; 1992.
Pamuk O. Snow (Trans. Freely M). New York: Vintage; 2005.
Plato Timaeus (Trans. Jowett B.) In: The internet classics archive. http://classics.mit.edu/Plato/timaeus.html (2006a). Accessed 18 Sept 2017.
Plato. Euthyphro (Trans. Jowett B). In: The internet classics archive. http://classics.mit.edu/Plato/euthyfro.html (2006b). Accessed 17 Sept 2017.
Proust M. Remembrance of things past, vol. 2. London: Wordsworth Editions; 2006.
Sartre (Trans. Alexander L) J-P. Nausea. New York: New Directions; 2013.
Šatskih AS. Vitebsk: the life of art (Trans. Tsan AS). Ann Arbor: Edward Brothers; 2001.
Thoreau HD. Walden. Boston: Shambbala Publications Inc; 1992.
Ulmer G. Internet invention: from literacy to electracy. New York: Longman; 2003.
Virilio P. Open sky (Trans. Rose J). London/New York: New Left Books; 1997.

Chapter 5
Augmented Interventions: Redefining Urban Interventions with AR and Open Data

Conor McGarrigle

5.1 Augmented Reality

In many ways, the term "Augmented Reality" (AR) is problematic in itself, but as with much in the field of "New Media" it appears that for the moment it has gained wide acceptance in the absence of a suitable replacement. The term was originally coined by Tom Caudell and David Mizell in 1992 for applications in aircraft manufacturing at Boeing. It was associated in the 1990s with virtual reality type headsets such as prototypes like the *Touring Machine* (Feiner et al. 1997) and *Map-in-the-Hat* (Thomas et al. 1998) which were accompanied by weighty backpacks carrying the necessary computing, GPS and communication equipment, which now fits in a cell phone. Even today, the HUD (Heads Up Display) paradigm still has traction as demonstrated by the interest in Google Glass;[1] however, despite Google's intervention, the HUD as a model of AR can be still said to exist in the nostalgia of "yesterday's tomorrows" (Bell and Dourish 2007).

This association of AR, situated somewhere along the real-virtual continuum, not quite real but not fully virtual either, serves to situate the practice in a scenario which I suggest looks towards the utopian values and ambitions of virtual reality and as such runs the risk of not attending to the real value of AR, which is its ability to contextually situate data. It is necessary to further distinguish the version of AR currently available for mobile devices from the richer conceptualisation of augmented space, as articulated by Lev Manovich (2006), which encompasses the

[1] See www.google.com/glass for the discontinued 2013 Explorer Edition and www.x.company/glass/ for the 2017 Enterprise Edition.

C. McGarrigle (✉)
Dublin School of Creative Arts, Dublin Institute of Technology,
Grangegorman Dublin 7, Ireland
e-mail: conor.mcgarrigle@dit.ie
URL: http://www.dit.ie/creativearts; http://www.conormcgarrigle.com

© Springer International Publishing AG 2018
V. Geroimenko (ed.), *Augmented Reality Art*, Springer Series on Cultural Computing, https://doi.org/10.1007/978-3-319-69932-5_5

gamut of distributed information resources and is not solely confined to adding context-specific information overlays to a specific location in a camera-view or HUD interface.

AR in its current popular implementation, working on mobile devices through platforms such as Layar and Wikitude[2] and through SDKs for Android and IOS mobile devices such as that offered by Vuforia, ARToolkit, Kudan[3], is a more prosaic affair (though Apple's recent entry to the field may change this). Designed as a device led experience, it offers a limited set of procedures involving the over-layering of dynamic, context-specific data over live "camera-view" of physical space. Typically, this information is served from geo-tagged databases, both static and real time, supplying information such as proximity of train stations, cinemas, commercial outlets, nearby tweets and so forth. More recent developments took advantage of enhanced processor speeds and improved motion tracking to more realistically augment real space. While AR achieved widespread recognition with the popular mobile game Pokemon Go, much development has been focused on a push to monetise the technology through AR brand tie-ins.

It is important, however, to look beyond the limited nature of many of the applications currently available for the range of AR browsers to attend to the affordances of these platforms. I draw attention in particular to the ability to import and situate geo-tagged databases which can attach contextual information to any site. This offers an unprecedented opportunity for the artistic and political activation of sites with large-scale data-led critiques, particularly in conjunction with physical intervention. Despite the constrained nature of the engagement possible with available AR browsers, they point to a growing convergence of a burgeoning world of open and accessible data, much of it geo-tagged or available for geo-tagging, with the ability to generate overlays which attach to specific sites in real space. As an emergent technology, the application of AR is still uncertain and open to reimagining and negotiation. Locative Media pioneer Ben Russell identified a similar openness in earlier locative technologies which he saw as seeking "grass-roots and consumer level interpretation of what these devices are" (2003); in these emergent AR systems, there is this sense of a technology seeking usages which are meaningful to the broadest constituency, seeking to expand rather than constrain these technologies as they begin to enter mainstream usage. This presents an opportunity to artists and activists to shape these technologies, establishing them as tools for location-based annotation and critique and expanding the range of applications and understandings for these technologies as they progress from new to mature technologies.

This opportunity coalesces around two factors. The first is Open Data; the European Commission (2013) estimated the direct open data market in the EU to

[2]See layar.com and wikitude.com.

[3]The leading SDKs (software development kits) on the market in 2017, Apple has recently released a beta version of its own ARKit SDK which has the potential to transform AR judging by early demos.

be worth €53.3 billion in 2016,[4] while McKinsey management consultants estimate it to be worth \$3 trillion globally (2013). In addition to the growth in economic activity from its enabling of innovation, the smart economy and increased government efficiency, it is also seen as integral to the promotion of democratic transparency. Whatever the merits of the Open Data discourse it has incentivised governments and city officials resulted in the release of vast swaths of open, machine readable data on all aspects of government and city operations resulting in a significant economic and cultural opportunity. AR platforms such as Layar and Wikitude represent the second factor. While technically limited and with limited opportunities for customisation they introduced AR to a wide audience through ease of use and widespread availability as smartphone apps. Recent improvements in AR SDKs, allied with improved processor speeds and camera-tracking techniques in smart phones, and the beta release of the Apple ARKit framework[5] in June 2017 seem to promise substantial improvements in the technology in the near future.

5.2 Data-Driven Art

In considering AR art and its relationship with data, it is important to locate the discussion within an artistic tradition of using data (open or otherwise) as a tool of political critique. I see the potential for the convergence of data space and real space which AR offers as existing within this tradition and will trace this through three artists who have exerted direct influence on the *NAMAland* project. These are Hans Haacke with his seminal *Shapolsky* et al. *Manhattan Real Estate Holdings, A Real Time Social System, as of May 1, 1971*, Mark Lombardi's data-based drawings and Josh On's *They Rule*.

The case of *Shapolsky* et al. is of particular interest as it was a data-rich installation detailing ownership of 142 tenement properties and sites in New York City in the ownership or effective control of the Shapolsky Family. The work was based on data derived from publicly available records, assembled and refined, in the case of obfuscated records designed to conceal effective ownership, by the artist. The work reveals the city as a real estate system, uncovering its complex structure and demonstrating the ways in which the physical fabric of the city and the arcane financial dealings designed to maximise the value of real estate holdings are imbricated. It expands the idea of site beyond physical location to include its associated data space. This serves to activate these sites through providing a sociopolitical narrative, transforming individual buildings through augmenting them with data and thus situating them within a complex network of property and financial transactions, with far-reaching repercussions for the space of the city and

[4]SMART 2013/0063 European Data Market.
[5]See https://developer.apple.com/arkit/.

the everyday lives of the people living in these slums (Deutsche 1996: 169–181). The piece was to be exhibited in the Guggenheim Museum, but the exhibition was controversially cancelled before its opening in April 1971 with the specificity of the work cited as the principle reason. The Museum Director held that social issues should be addressed "artistically only through symbolism, generalization and metaphor" (Deutsche 1996: 179). What caused the work to be suppressed was the specificity of the critique, which data supplied, whereas a generalised artistic critique would have been acceptable. This demonstrates the power of the data-based critique which through its attention to detail builds a framework, which goes beyond what can be thought of as a purely artistic stance though it is bolstered by this, upon which alternative narratives can be based.

The artist Mark Lombardi is known for his large-scale data-based drawings or "narrative structures" which detail the networks of power and money involved in various political financial scandals, such as the collapse of the Bank of Credit and Commerce International detailed in *BCCI-ICIC-FAB, c. 1972–1991 (4th Version), 1996–2000*. For each drawing, Mark Lombardi built a custom database culled from published information sources assembled onto cross-referenced index cards; according to his gallerist Deven Golden, he had around 14,000 of them (2003), which were then condensed to create his drawings. Lombardi considered these as a method of "reprocessing and rearranging" freely available information as a way of mapping the political and social terrain (Wegener 2011). The painter Greg Stone recounts the reaction of a friend, a reporter at the Wall St Journal, on seeing Lombardi's *George W. Bush, Harken Energy and Jackson Stephens* drawing, who although he was familiar with the characters in the narrative said he "hadn't fully understood the implications until he saw it all laid out that way" (Richard 2002).

Josh On's web-based work *They Rule* (Fig. 5.1) pursues a similar mission of making connections between networks of powerful individuals, this time connected through corporate directorships, once again drawing from publicly available databases. *They Rule* provides a front-end interface to its underlying databases which allows users to make their own connections and share them with other users. As a work of art, it presents a framework to interface with the data, inviting its audience to provide the narrative structure and co-construct the meaning. Originally powered from a custom database of directorships of the top 100 companies in the USA, it now employs the database of *Littlesis*, "a free database of who-knows-who at the heights of business and government".[6]

These projects illustrate that the power of data art lies in its ability to represent information in ways which make the connections evident, presenting the information as narrative and revealing the underlying structures and patterns. How then can the ubiquitous networked location-awareness of mobile devices and emergent AR techniques add to this tradition, and in an era where data and its use have assumed a greater importance than ever before, what has art practice to contribute to this field? This raises issues of site specificity and the reality of site being described

[6]See littlesis.org.

Fig. 5.1 Screen capture from Josh On's *They Rule* (2004)

not only as specific location, which the situated artwork addresses, but also as the invisible layers of data which extend our knowledge of the complex and multi-layered interactions between site, information and audience.

At this point, I introduce a case study of a project by this author which follows in the tradition of data art. It is a work which doesn't claim any technical innovation, created for an existing platform and built using free and open source software, but it offers a powerful example of the ways in which data can politically (and artistically) activate sites and, I suggest, a model for connecting data and space to create an activist hybrid space (Harrison and Dourish 1996; Kluitenberg 2006).

5.3 NAMAland

NAMAland is a mobile AR artwork, built on the *Layar* platform (Fig. 5.2), which uses open data and augmented reality to visualise and critique aspects of the Irish financial collapse through an over-layering of the city of Dublin with a database-driven data layer identifying properties under the control of NAMA (The National Assets Management Agency).

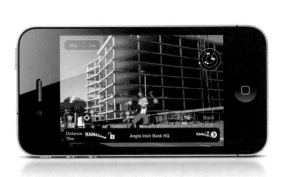
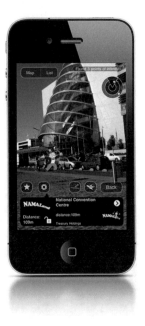

Fig. 5.2 *NAMAland* in operation on the iPhone, Conor McGarrigle (2010)

NAMA is an Irish Government agency[7] established in late 2009 to acquire bad property loans from Irish banks with the aim of removing them from the banks' balance sheets as a bailout mechanism. The agency, which was controversial from the start, acquired properties (or their related mortgages) worth €71 billion but failed in its stated aim of bailing out the banks, culminating in Ireland entering a Troika bailout program[8] in November 2010 due to the imminent collapse of the banking system. Despite (or perhaps because of) its pivotal role in the financial collapse, NAMA was very secretive in its workings. Legally exempted from freedom of information requirements, the agency was intent on shielding its property portfolio, and the individuals and corporations involved, from public scrutiny under the guise of commercial sensitivity.

It became obvious that mapping NAMA's property holdings was essential to gain an understanding of the organisation, and the events which led to its creation, in order to open it to scrutiny and critique. The *NAMAland* project, as originally conceived, was to build on Hans Haacke's treatment of the entwinement of the Shapolsky real estate holdings and New York City to create an AR portrait of Dublin seen through the lens of NAMA properties. Through the specificity of such an artistic treatment of the agency, it would, I hoped, be possible to build a more generalised critique of the financial bailout in all its complexity: a critique which could demonstrate an approach for addressing the politics of austerity which were sweeping Europe, and at that time concentrated in Ireland as one of the P.I.G.S.[9] countries.

To achieve these results, it was first essential to research alternative sources of data on NAMA and its property holding as all official channels were closed. I identified an activist source of information on NAMA properties published on the anonymous website *NAMA Wine Lake.*[10] Maintained as a Google Doc, the NAMA-bound spreadsheet was compiled from published sources of information connecting property developers known to be in NAMA, their directorships of companies and properties controlled by these companies. Through a process of collating available data sources and correlating them with known information on NAMA, the unknown author built a partial picture of the NAMA holdings from this public corporate paper trail. Each entry was well documented with links to its original public domain sources, important in a litigious climate, demonstrating the difficulties of retroactively concealing data already in the public domain. Whilst one can only speculate about the method employed to collate these data, it is expected due to its scale that it was produced from automatically data-mining newspaper records and public records of company directorships. These data were, however, locationally vague; street names were typically included with vague descriptors

[7]See nama.i.e./about-us.

[8]The Troika consisting of the IMF, the European Commission and the European Central Bank.

[9]Portugal, Ireland, Greece and Spain the countries at the centre of the EU's financial crisis.

[10]See namawinelake.wordpress.com, the title refers to the EU practice of sustaining agricultural prices by buying products into intervention storage during the 1980s.

such as "site on Mayor St" but lacked in sufficient detail to automatically geo-tag, especially with the precision required for an effective AR application. Building on the *NAMA Wine Lake* research, I enhanced these data by manually geo-tagging approximately 120 Dublin properties through visually identifying the sites in person and tagging them with a handheld GPS unit. For legal reasons[11], the database had to be confined to properties which could be located with a high degree of certainty for which sufficient documentary evidence of their ownership could be provided. These data were then used to create a geo-tagged mySQL database to be used as the data source for *NAMAland*.

The application was first built in October 2010 and has been updated on a regular basis since. It employs the *Layar* platform which provides a development environment and software platform to create AR applications which run on the *Layar* App for Apple IOS and Android devices. *Layar* provides a standardised user interface, with limited options for modification, supplying a fixed set of AR methods upon which layers can be built. It was selected for two reasons: the first was ease of use, it imports a database effectively and is a reasonably robust working AR app which can be used with a minimum of development; second, it provided a method of publishing a politically sensitive work on the iPhone (at the time the most popular smart phone platform in Ireland) as layers are submitted to *Layar's* own approval process and publishing through their proprietary iPhone app, effectively evading the appstore gatekeeping, essential for a politically sensitive app working with grey unofficial data.[12]

NAMAland in operation takes the location of the user's phone and compares it to this database of geo-tagged NAMA properties within certain defined ranges (Fig. 5.3). An overlay of properties within the specified range is then created which can be further interrogated for ownership details (the majority of properties in NAMA are associated with a small number of individuals with vast property holdings and billions in defaulted loans). The location of each response is indicated by an overlay of a cartoon "Monopoly Man" figure over NAMA properties in the camera-view of the user's device. It also generates a real-time map of localised NAMA properties along with a list of nearby properties and their locations. *NAMAland* thus visualises the extent of NAMA property ownership, allowing users to identify nearby properties and interrogate specific regions of the city for NAMA connections. It was the first mapping of NAMA properties available and for a long time the only list of NAMA properties available in Dublin.

[11]At the time it was unclear what the legal position on releasing this information was so I was advised to refer to properties that were "reported to be in NAMA" rather than in NAMA.

[12]See Zittrain (2011) for an account of Apple's gatekeeping.

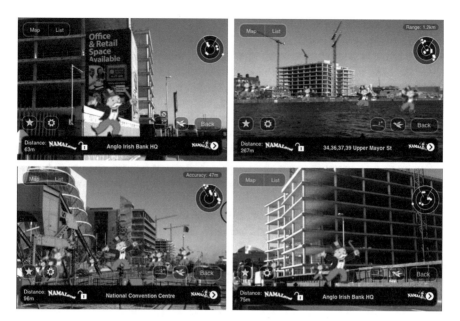

Fig. 5.3 Screenshots showing *NAMAland* in operation in Dublin city centre

5.4 Reception and Activation

NAMAland succeeded in capturing the popular imagination in Ireland. It was widely reported in the mainstream media, including a report on the Nine O'Clock TV News on RTE (the Irish national broadcaster); I was interviewed for numerous radio shows and the project was widely featured in the print media. The title *NAMAland* has even entered common usage as a descriptor for the post-IMF bailout situation. In the midst of this extended "15 min" of fame, the project has more importantly succeeded in focusing attention on its subject matter where more traditional approaches failed. It overcame official attempts to limit information and discussion on the subject and has acted as a conduit through which concerns over the lack of transparency inherent in NAMA could be expressed.

On one level, it operated as a mobile app, a ready-to-hand source of information locating NAMA properties, as a myriad of other apps locate coffee shops and restaurants, gaining in excess of 65,000 users in the process. However, as an intervention, a physical dimension to the work was of the essence. The data layer which was enabled though AR was only of significance when overlaid over real space; this is the essential quality of AR, a connection between the virtual geo-tagged dataset and the physicality of place. AR must of necessity operate in conjunction with physical actions to be effective, augmenting space rather than recreating or virtualising space, and as such is the ideal companion for interventionist practices as it redefines the practices through extending and supporting their

essential aspects rather than substituting a less effective alternative. The AR structure of the project was always designed to be an enabling framework upon which a range of additional actions, interventions, discussions and so forth could be based. *NAMAland* was extended to include real-world events such as walking tours, situated public discussion forums, public speaking engagements, media coverage and individual interventions with the work itself being an amalgam of all its constituent components. These were all supported and enabled through the data layer made visible through the application of AR technology and offered multiple points of entry and modes of engagement with the project which were not necessarily technologically dependent. This ensured that the work remained open to as broad a constituency as possible, including those without the requisite technology to view the AR.

Indeed, as the project disseminated, it became clear that many of the people who spoke to me of the project were not actually users, as they didn't have a phone capable of running the application. Their experience of the project was second hand, passed to them as a story which resonated as a tale of resistance. Somebody had used mobile technology to reveal a list of NAMA properties despite efforts to keep this information from the public. It didn't seem even necessary to see it in operation; it was enough to know that it had been done. The walking artist Francis Alÿs speaks of his work as myth making; he sets out to "keep the plot of a project as simple as possible so that it can be told as a story, an anecdote, something that can be transmitted orally without the need to have access to images" (Godfrey 2010). *NAMAland* similarly has a simple narrative that can be told as a story, which means that even without access to the requisite technology the project still succeeds at some level. Not only does *NAMAland* recount a story about NAMA and its consequences, but from the point of view of AR it speaks of the technology and its uses. For this emergent technology, this is significant for it is through practices that functions and usage modes of technologies come to light and their relative value and importance are revealed.

At another level, it acted as a catalyst, facilitating a range of conversations, debates and activities as part of a wide-ranging critique of NAMA and the sequence of events which led to it. The project crossed boundaries from art to geography, urbanism, activism, open data, economics and politics as one would expect from work which engages critically with the space of the city and international finance. As the project became known through publicity and word of mouth, another side of the project was revealed from the diversity of the discussions, from the Occupy Dublin camp one day to city-sponsored seminars on Open Data and the smart economy the next; this was its ability to function as a conduit which reconnected NAMA with the space of the city, a connection which had been deliberately severed, to preserve the idea of the agency as a by-product of obscure international financial dealings. What *NAMAland* contributed was an opening up of previously unavailable data and a reconnecting of these data with the fabric of the city itself. This served to add specificity in place of generalisation, fuelling debate through the provision of an infrastructure on which specific spatial critiques could be structuring. This specificity, that is the ability to overlay contextual information at the

site, enabled an alternative reading of the city providing a framework for intervention whilst countering the abstraction of space fostered by the narrative of the financial crisis as collateral damage of complex international financial transactions.

5.5 Peripatetic Activism

The project was accompanied by a series of walks informed by the mobile application which took place in Dublin City Centre and in Tallaght, two areas characterised by a high concentration of NAMA properties. These were public, as with the *NAMA-Rama* walk in conjunction with Market Studios (Fig. 5.4), the *In These Troubled Times* walk with RuaRed Arts Centre and *Ireland after NAMA* with The Exchange Arts Centre, and private such as the guided walks for RTE News and Channel Four News TV crews.[13] *NAMAland* is essentially a walking project; albeit facilitated through AR technology, it is necessary to deploy it on the street for it to operate at all. The guided walks, through careful selection of routes, were able to maximise this impact by proceeding through areas of the highest concentration of landmark buildings and, as participatory events, functioned as walking forums facilitating participants in discussing the issues represented by NAMA and its property portfolio. In this way, the project connected the abstractness of the dataset to the space of the city through a narrative contextualisation which emanates both from the framing of the walks supplied by the artist and in a more significant way from the engagement of the participants. NAMA represents a complex system of abstract financial dealings, transactions which have become so disconnected from everyday understanding but yet have significant and very real consequences. Whereas the narrative of NAMA was the narrative of the (now defunct) property market, international finance and IMF bailouts, *NAMAland* reconnects this to real spaces exposing their interconnectedness and the real consequences on the space of the city and in the lives of its inhabitants. The interventions which *NAMAland* facilitated are thus framed and enabled through the production of a hybrid space which deploys augmented reality and data overlay to reimagine the urban intervention as the generation of data-rich hybrid spaces which can materialise and dissipate with the ebb and flow of the chosen dataset.

NAMAland on one level exists as a mobile app which over-layered the city with a contextual data layer representing the city as a network of property and interconnected financial transactions which have bankrupt a nation. The ambition for the project was that it moves beyond a purely oppositional stance. Generalised protest had at this stage been normalised and was easily countered by a narrative which invoked the need to move forward and rebuild, for change to come from the crisis it seemed necessary to set the agenda and shape that change. This is the benefit of a

[13]See walkspace.org/namaland/news.html for details of these events.

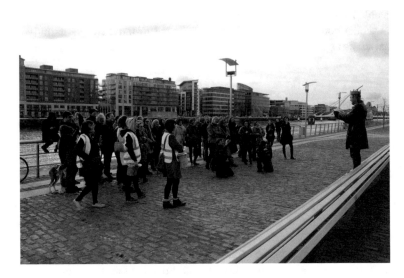

Fig. 5.4 NAMA-*Rama* walk in Dublin's docklands

data-led approach; because of the specificity of the data-informed critique, the alternative narrative is immanent to the critique itself.

Through data and the locational immediacy of AR, *NAMAland* sought to recount a narrative of the city which ran counter to the official version, through revealing, contextualising and crucially locating the NAMA data in the space of the city and letting the users' perform their own interpretation and form their own analysis. In this data-built account, the data established the foundation and the narrative was constructed, not by the artist, but through this act of participation. Themes which emerged from the project were the question of data transparency, in particular the need for NAMA data be made available for public scrutiny and the demand for vacant NAMA properties to be made available for community use. These themes, which were central to the project's public events, were widely taken up at a community, activist, academic and ultimately at a political level resulting in substantive changes to the situation.

5.6 Open Data

NAMAland was built on open data which was augmented with location information; in turn, these data inspired further projects demonstrating the power of data to enable a myriad of approaches and interventions from mobile apps to occupations (Fig. 5.5). In late 2011, I came into contact with groups associated with the Dublin Occupy movement who were at the time interested in extending their campaign into occupation of NAMA buildings. This was a research-based project which stressed

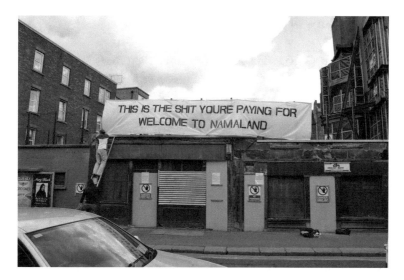

Fig. 5.5 Welcome to NAMAland banner in Dublin

the accuracy of their data. The focus of their campaign was to call for the unlocking of a public resource for community and social usage so it was vital that their targets were correctly identified. The campaign was built on *NAMAland* data augmented with additional research. Their campaign resulted in a series of short-lived occupations beginning in January 2012 which highlight the fact that many NAMA properties were vacant and decaying due to neglect, while there was a shortage of affordable space for community groups. A secondary guerrilla program of identifying NAMA properties through affixing banners to their exterior was begun which once more drew attention to the neglect of these properties calling for them to be made available to social and community groups. These became part of the general conversation on NAMA and have achieved results, both through foregrounding the issues of NAMA properties and their usage and in opening access to properties.

NAMAland through its activation of these sites has informed and influenced groups and through a focus on locational specificity supported by data has introduced new approaches to the urban intervention as artistic and activist tactic. The project has acted as a resource on which further actions can be built, and the cumulative effect of these interventions and their surrounding debate has achieved some concrete results. Dublin City opened direct negotiations with NAMA to access vacant properties under their control for social and cultural use. This has resulted in a city program which allocates vacant buildings for cultural uses with substantial premises being made available. This has been accompanied by the release of more information on NAMA property which, while not nearly complete, has fed the growing demand that vacant properties be opened for community use.

5.7 The Future of AR Art

I argue elsewhere (McGarrigle 2012) that artistic practices which engage with emergent technologies are involving in a process of shifting the understanding of these technologies. As Richard Coyne puts it "technologies do not conform politely to predetermined or intended functions" (2010: 4), rather it is through use that functions and usage modes come to light and their relative value and importance are revealed. AR as it stands is being promoted as a marketing, enhanced shopping and mobile gaming technology, with the principle AR browsers developing corporate tie-ins using image recognition to replace QR codes in conjunction with location-based AR applications. The technology is being thus presented and developed as a method of connecting companies with their customers in real space. As smart phone processor speeds and motion tracking sensors improve and AR development kits develop new methods to take advantage of these developments, attention is focused on new marketing techniques, enhanced mobile gaming, particularly after the 2016 success of AR game Pokemon Go, and industrial applications with the July 2017 rerelease of Google Glass as an enhanced industrial production tool.[14] Apple's augmented reality SDK ARKit beta released in June 2017 has the potential to expand the range of AR applications through the technical and marketing support of the Apple ecosystem. While these applications will be a feature of the mature practice of AR, their vision is to invoke the developers of the *Urban Tapestries* public authoring project, "unnecessarily impoverished" (Angus et al. 2008: 44–51).

Art practices have a role to play in broadening the understanding of technologies' application through expanding their range of application and permitted usages. *NAMAland* demonstrates one such application, but the potential for these tools is only limited by the datasets which can be accessed and the desire by artists and activists to engage with them as part of their practice. At an everyday level, this might be the difference between AR enabling a retailer to deliver location-aware special offers and deals to a customer's phone alongside the ability of the user to interrogate the retailer's history on a range of issues from health and safety to their environmental record or simply customer satisfaction. This is not necessarily to privilege one over the other. Both have their place but what is of the prime importance is that multiple options coexist as aids to informed decision making, where the user can offset say a welcome discount earned by checking-in against the company's anti-union policies.

NAMAland is an application of AR technology that reached a wide audience through usage, mainstream media accounts and word of mouth by addressing specific local issues (with arguably a wider import). This success establishes AR as

[14]See http://www.x.company/glass/.

a tool of political and artistic critique which can reveal and situate information of political and cultural significance. *NAMAland* points towards the potential for the development of artistic and activist practices which expand and redefine the praxis of urban intervention through the ability to identify and activate site through the deployment of AR techniques, supported by contextual static and real-time data, to produce a hybrid convergence of geographic space and data space. This ability to generate site-specific data-rich hybrid spaces assumes a greater importance when connected to the Open Data movement and the popularisation of data scraping techniques with services such as import.io,[15] and the growing community of data journalism advocates sharing techniques.[16] As new sources of data become available, there are opportunities for artists and activists to go beyond the rhetoric of the smart economy and develop critical narratives and interventionist strategies based on this newly liberated data. If AR art practices are to shape the technology, expand the range of practices and establish the technology as a tool for enhancing and critiquing everyday life, then these practices must resonate with their audience and assimilate themselves into the technology through establishing meaningful connections to the everyday. This is a challenge for AR art and one that can be addressed through the astute use of data.

References

Angus A, et al. Urban social tapestries. IEEE Pervasive Comput. 2008;7:44–51.

Bell G, Dourish P. Yesterday's tomorrows: notes on ubiquitous computing's dominant vision. Pers Ubiquitous Comput. 2007;11:133–43.

Caudell TP, Mizell DW. Augmented reality: an application of heads-up display technology to manual manufacturing processes. In: Proceedings of the twenty-fifth Hawaii international conference on system sciences, vol. 2. Los Alamitos: IEEE Computer Society Press; 1992. p. 659–69.

Coyne R. The tuning of place: sociable spaces and pervasive digital media. Cambridge, MA: MIT Press; 2010.

Deutsche R. Evictions art and spatial politics. Cambridge, MA/London: MIT Press; 1996.

European Commission. Communication from the Commission to the European Parliament, the Council, the European Economic and Social Committee and the Committee of the Regions: open data an engine for innovation, growth and transparent governance. European Commission; 2011. http://eur-lex.europa.eu/LexUriServ/LexUriServ.do?uri=COM:2011: 0882:FIN:EN:PDF. Accessed 18 Sept 2017.

Feiner S, Macintyre B, Höllerer T. A touring machine: prototyping 3D mobile augmented reality systems for exploring the urban environment. In: Wearable computers. Digest of papers; 13–14 Oct 1997. p. 74–81.

Godfrey M. Francis Alys: a story of deception. London: Tate Publishing; 2010.

Golden D. Mark Lombardi, art critical. http://www.artcritical.com/2003/11/01/mark-lombardi (2003). Accessed 18 Sept 2017.

[15]See import.io.

[16]See, for example, Data Driven Journalism publishers of the Data Journalism handbook datadrivenjournalism.net.

Harrison S, Dourish P. Re-place-ing space: the roles of place and space in collaborative systems. In: Proceedings of the 1996 ACM conference on computer supported cooperative work. ACM, New York; 1996, p. 67–76.

Josh, O. They Rule. Website; 2004. http://www.theyrule.net/.

Kluitenberg E. The network of waves living and acting in a hybrid space. Open. 2006;11:6–16.

Manovich L. The poetics of augmented space. Visual Commun. 2006;5:219–40.

McGarrigle C. NAMAland. Augmented Reality App; 2010. http://www.conormcgarrigle.com/namaland.html.

McGarrigle C. The construction of locative situations. Dissertation, Dublin Institute of technology; 2012.

Open data. Unlocking innovation and performance with liquid information. McKinsey & Company. http://www.mckinsey.com/insights/business_technology/open_data_unlocking_innovation_and_performance_with_liquid_information (2013). Accessed 18 Sept 2017.

Richard F. "Obsessive—Generous" toward a diagram of Mark Lombardi. Williamsburg Quarterly, Winter 2001/2002.

Russell B. Karosta workshop notes. RAM5 publication: Open Source Media Architecture; 2003. http://rixc.lv/ram5/en/public06.html. Accessed 16 Jan 2018.

Thomas B et al. A wearable computer system with augmented reality to support terrestrial navigation. In: Second international symposium on wearable computers, 1998. Digest of papers; 1998, p. 168–71.

Wegener M. Mark Lombardi—death defying acts of art and conspiracy. Dir. Mareike Wegener. Unafilm; 2011. Film.

Zittrain J. The personal computer is dead. MIT Technology Review. http://www.technologyreview.com/news/426222/the-personal-computer-is-dead/ (2011). Accessed 18 Sept 2017.

Part II
Augmented Reality as an Artistic Medium

Chapter 6
The Aesthetics of Liminality: Augmentation as an Art Form

Patrick Lichty

6.1 Introduction

Since its emergence as an art medium, Augmented Reality has developed as a number of evidential sites. As an extension of virtual media, it merges real-time pattern recognition with media, finally realizing the fantasies of William Gibson through goggles or handheld devices. This creates a welding of a form of perceptual vision and virtual reality, or optically registered simulation overlaid upon actual spatial environments. And even though AR-based works can be traced back into the late 1990s, much of this work required at least an intermediate understanding of coding and tethered imaging equipment from webcams to goggles. It is not until the advent of marker-based AR possessing lower entries to usage, as well as geolocational AR-based media through handheld devices and tablets that Augmented Reality as an art medium would begin to propagate. While one can make arguments that much AR-based art is a convergence between handheld device art and Virtual Reality, there are gestures that are specific to Augmented Reality that allows for its specificity as a genre. In this examination, we will look at some historical examples

Note to the Second Edition: In the years since the publication of the original essay, many advances have taken place in the genre, both technologically and aesthetically. However, in reviewing this essay, the author also notes that some of the examples given have become historical in nature, although the theory remains sound. Given that there is little history of Augmented Reality Art at this time, the author has decided to refine the theory somewhat, keep many of the examples as historical material, and add updated works as a bridge to the time of this publication. Although some of the older works may seem dated, it is my hope that when placed in context with newer work, a continuous timeline may be seen to unfold.

P. Lichty (✉)
Animation/Multimedia, Zayed University, Abu Dhabi, UAE
e-mail: patrick.lichty@zu.ac.ae
URL: http://www.zu.ac.ae/main/en/colleges/colleges/
__college_of_arts_and_creative_enterprises/faculty_and_staff/_profiles/Patrick_Lichty.aspx

© Springer International Publishing AG 2018
V. Geroimenko (ed.), *Augmented Reality Art*, Springer Series on Cultural
Computing, https://doi.org/10.1007/978-3-319-69932-5_6

of AR, and critical issues of the AR-based gesture, such as compounding of the gaze, problematizing the retinal, and the representational issues of informatics overlays. This also generates four gestural vectors analogous to those defined in *The Translation of Virtual Art* (see: Lichty 2014a, 445), which we will examine through case studies. Through these case studies, historical and recent to the time of this publication, we may determine the issues of the gestures and aesthetics of AR.

6.2 The Gaze, the Overlay, and the Retinal

In the creation and "performance" of AR works, there are often two actions in place in relation to the user, and those are of gaze and gesture/positionality. The reason why I separate the two, although related, is that in the five modalities/gestures that I wish to discuss (Fiducial, Planar, Locative, Environmental, and Embodied), each has different relationships between the user, the augment, and the environment. That is, in the experiencing/performance of AR, there is placement of one or many elements between the eye and the recognized target, and the gaze of the agent in experiencing the piece. I will refer to the AR media in question as a "piece" or "installation," as the bulk of this discussion has to do with art, but some exceptional commercial examples will be included. In *The Translation of Virtual Art*, I defined the gestural lines of intent, or "vectoral gestures" as being a line of flight between the origin of the work and the site of the intended audience. These consisted of four modalities, being wholly in the physical or virtual, or gesturing from one to the other (or a combination). AR is a different set of configurations.

The difference inherent in AR from VR is that while there is virtual content, that content is overlaid upon a visual representation of the physical. It would be simple to theorize an intermediate plane of representation between the viewer and the target as in the case of the Planar modality, but unfortunately, AR is not that straightforward. Depending on said modality, there could be a space matrix of Locative or interactive media, a space imposed on a marker, as well as one or more spatial planes between the viewer and the target (as in print, which I discuss as the Fiducial and Planar). In addition, there are a number of cases in which modalities overlap strongly (Fiducial/Environmental, Embodied/Planar, etc., as I hope to show later).

AR consists of a space of positional overlays, whether Locative or recognized, and a performative gestural gaze, especially in the case of headset- or handheld/tablet works, as we will observe in Darf Design's *Hermaton*. In addition, I would like to put forth a proposition regarding Duchamp's idea of the "retinal" and an argument for his *Fountain* being a predecessor to Augmented art in 1917 with his addition of the signature (Craft 2012, 202). The famous entry of Duchamp's inverted porcelain urinal as work of art inverts the notion of art object, but his signature of "R. Mutt" as a form of augment to the gesture would echo with Manifest.AR's interventions into art spaces like the MoMA and Guggenheim.

This comes into play only after considering notions of the gaze and of what I will call overlay-space. Before aiming a camera of any sort in media art, the argument of the "gaze" emerges in critical discourse.

In order to address the notion of lensed or gestural view (and perhaps I combine these two together a little casually, they are linked in the case of AR), Laura Mulvey's seminal essay, *Visual Pleasure and Narrative Cinema* (Mulvey 2004, 837–849) comes to mind. In it, she established the concept of the all-objectifying "male gaze" that gendered the vector of the film lens as one between the subject (female) and objectifier (male). However, with the pervasiveness of personal imaging through mobile devices, Queer Theory and other theoretical frameworks have complicated this discourse. It is for this reason that I feel that as the gaze has been democratized, but manufactured by hegemony, and the "Queering" of augmented space deserves its own essay (and I am surprised that it has not been written of much to this date). As such, I feel it is beyond the scope of this humble musing, but I will touch on the subject momentarily as an invitation for further discussion.

Since the age of writing *Visual Pleasure and Narrative Cinema*, there are a number of aspects to the human employ of imaging equipment that complicate the gendered subject/object relation. The first, and perhaps an alternative strategy to Mulveyan discourse, is that of personalization of the gaze. With the rise of personal imaging devices, such as iPads and smartphones, the politics of the gaze is bifurcated between the (relatively) "democratized" operator and the hegemonic institution of the manufacturer. While I feel it is more germane to consider the role of the operator in creating the gaze-vector or line of sight of the gaze, the manufacturer is important as well. For it is the manufacturer that designs, and if one still believes Bauhaus ideas of form and function, it also frames the narrative discourse of the device itself. And as a male-dominant culture, technology may reify Mulvey's assertion of a phallocentric gaze, even to AR, but this may shift in that the design field is more gender equal than Silicon Valley culture. The approval of the design by the manufacturer reinscribes the agenda of the device, and here I believe Mulvey still wields much power. However, my first notion of the locus of the operator is where this discourse diverges from gendered film theory (or at least Mulveyan discourse).

6.3 Queering Augmentation

The closest to the notion of queering of augmented space comes from identity-altering apps such as Meitu and Faceapp, and social media using overlay technology such as Snapchat and Facebook Messenger. Meitu's "Cutifying" function, which places the user in a sentimental environment, enlarging the eyes, whitening the skin, and adding lipstick to the face. While the gesture of cuteness can be a symbol of endearment, attraction, or latent aggression as Ngai has suggested (Ngai and Adam 2012), online discussions have also questioned the

embedding of racist narratives. However, as I have written in *The Mutant Cute* (Lichty 2017), the fact that Meitu is a Chinese program brings forth issues of politics and socioeconomics. This relates to the fact that the effects of Meitu rare as much Asian notions of class, thus making the politics of filtering and augmentation increasingly complex. Likewise, the issues related to the gender/age switching of FaceApp are also problematic as the results have certain gender stereotypes of attractiveness and feature stereotypes for youth/age, etc. But these are more filters than augments. Facebook and Snapchat, as such, are some of the first social media sites to incorporate augmentation into their apps. Snapchat, being the first of the two to offer social augmentation, would transform oneself into demons, puppies, and wearing fairy tiaras. In fact, my attention was drawn to it by the bredth of users, from porn stars to famous art curators—personal augmentation creates an "other" space that calls into question gender, race, and species. However, it is notable that the alterity of personal semiotic space is expanding under the visual regimes of augmentation, and I call for more research in this area.

6.4 The Semiotics of AR

The semiotic space of AR is peculiar in that it is a potentially fluid one, dependent on any number of factors. Depending on modality, Fiducial, Planar, Locative, Environmental, or Embodied, the relationship of the viewer's position to the subject can be quite relative, interactive, or locative. For example, consider a user in a geolocative installation with, for example, an iPad. Any media is relative to the viewer's location, point of view, and how the infoset overlays itself on the "picture plane" of reality as represented by the device's camera and the AR application. Consider if that interactive media is intrinsically dynamic, the chain of signification separates from what Duchamp called the merely "retinal" and becomes haptic as well. The relationship of the viewer, landscape and media infoset compounds the point of view through multiple points of interest (POIs) in the landscape, sliding into a Massumian constant state of becoming (Massumi 2002, 37), as the relation of the viewer and the multiple planes of subject constantly reconfigure into their new positionality. These are, at least in the case of locational and interactive AR, the problem of the fluidity of becoming-signification in relation to the landscape/mise en scene. In the case of the Planar mode of augmentation, the target is often static and the relation is a simple overlay of the augment over the given recognized signifier. Now that I have alluded to the complexities of the relation to media in augmented spaces, their modalities are subject to study.

6.5 The Structure of the Gesture in Augmented Reality Art: Fiducial, Planar, Locative/GPS, Environmental, and Embodied/Wearable

Augmented art is actually a catchphrase for at a number of different technologies for overlaying virtual content on actual scenery since the term's coinage by Caudell and Mizell at Boeing in 1992 (Caudell and Mizell 1992, 659–669). In this chapter, I will propose five categories of augmentation, and if any are overlooked, I hope it will be because of new developments since this writing. These techniques consist of the five categories mentioned above, Fiducial, Planar, Locative/GPS, Environmental/Spatial and Embodied/Wearable. While some of these categories overlap or may have indistinct boundaries, such as the intersection of the Fiducial and Planar recognition, it is hoped that they give the critical scholar studying augmentation a discursive toolset. Each of these modalities situates the viewer, content, and overlaid environment in ways that create specific gestures of media delivery.

When speaking about gestures in AR, I reference two of my other essays that take a similar analytical approach to examining situations involving virtual media, *The Translation of Virtual Art* (Lichty 2014a, 444–462), dealing with art in virtual reality, and *Art in the Age of Dataflow* (Lichty 2013a, 143–157), which examines the development of electronic literature since Joseph Frank's theorizing the notion of Spatial Literature in the 1940s (Frank 1991). My contention is that there is an origin, content, and Arakawa and Gins' concept of a "landing site" (Hughes 2012) for the augmented gesture, which is a destination in a process of communication, but not necessarily a basic sign/signifier relationship. The reason for this is that in AR, although there *can* be these simpler situations between the viewer and media, like Planar recognition calling forth video overlays, there are others such as dynamic media in GPS-based/Locative installations. These include AR like Richard Humann's *Ascension and* Pappenheimer/Brady's *Watch the Sky*, which I will discuss in the Environmental section. As in *The Translation of Virtual Art*, the AR gesture varies in its relationship between origin and receiver, from double signification in the case of Fiducial and Planar, to a dynamic semiotic matrix of constant becoming-meaning in the case of GPS/Locative applications. What I will attempt to do is to progress from a more basic/historical framing of AR mediations and 2D situations, unpacking the gesture into more complex sites of engagement, with the understanding that there will be some examples that overlap and double themselves within my categories. These categories are presented as propositions that are used as "handles" from which a discussion of the different forms of augmentation can be formed.

The "gesture", as specific to AR, consists of a line of attention/flight between the interactor and the superimposed media overlaid on the given environment, such as attention given to a piece of media situated in 3-space, or by orientation as in the case of Fiducial tracking. As one can imagine, the semiotic relationship between the interactor, the environment, and the augment becomes complex, as simple media overlays become multi-faceted interactive experiences to dynamic augmented spaces that can be updated on the fly.

6.5.1 Fiducial AR

One of the earlier forms of Augmented Reality is that which uses a specific digital, or *Fiducial*, marker that gives a unique signature to an objective "seen" by a computer camera. This was the primary form of tracking for the works I first saw in the mid-to-late 1990's, especially the work using the ARToolKit and the work coming from ATR Kyoto. The Fiducial marker gives information for six degrees of orientation (XYZ orientation, pitch, roll, yaw) and locates the AR content easily in 3-space. My first introduction to AR was Berry and Poupyrev's *Augmented Groove* (Berry and Poupyrev 1999), developed at the ATR Kyoto research lab (Fig. 6.1). This work was, in essence, an augmented DJ station in which participants could make audiovisual mixes through the manipulation of vinyl albums with Fiducial markers printed on them. From the documentary video, the user is presented with a character sitting atop the dial on the record, which changes orientation/values through tilt, rotation, etc. As Berry and Poupyrev write in the work's statement: "The performer modulates and mixes compositions by manipulating real LP records. The motions of the records control filters, effects, and samples dynamically mixed in and out of the groove. A composer can assign any element of composition to any record, and simply removing one record and bringing in another controls the song progression. Effects, filters and sample triggering are all assigned to any of the four record movements and can be controlled interactively using simple physical records rather than numerous dials and sliders" (Kaltenbrunner 2003–2014).

Considering this work was conceived in 1999, it radically predates environments like the Music Technology Group's Reactable in Fig. 6.2 (Jorda et al. 2005) and the work being done with "Hybrid UIs" being done with Feiner, et al. at Columbia (Sandor et al. 2005) Groove used an overhead camera, as opposed to the latter piece's use of cameras underneath a translucent table as in the case of the Microsoft Surface tabletop computers. Feiner, et al's Hybrid UI interface uses a combination of Microsoft Hololens, Leap Motion controller, and Perceptive Pixel desktop

Fig. 6.1 Augmented Groove
(Berry and Poupyrev 1999)

Fig. 6.2 Reactable (Jorda et al. 2005)

computer (formerly Microsoft Surface) to allow images to be used as markers for a vertical interface structure on the table from which the user can manually pick a hologram from the overlaid interface. Augmented Groove showed the use of Fiducial markers as controls, but one of the more popular demos of 3D overlaid media would emerge through videos of demos of ARToolkit proofs of concept using a particular animated character.

6.5.2 Fiducial AR: The Emergence of Miku

This viral example of a pop-cultural Fiducial AR application is the fusion of the free program Miku Miku Dance and AR Toolkit. To understand the confluence of elements to lead to the profusion of videos of "anime" character Hatsune Miku dancing on Fiducial marker cards, a little cultural unpacking is in order.

AR Toolkit is the product of Hirokazu Kato of the Nara Institute of Science and Technology in Japan, created in 1999. However, it took 2 years for it to be released by the University of Washington's HIT Lab, with over 150,000 downloads from SourceForge.net, according to that site's statistical tracking (Kato and Billinghurst 1999). It is a series of libraries allowing programmers to orient media to a Fiducial marker relative to its appearance through a webcam or other optical input device. By the mid-2000s eligible media included animated 3D content as seen in Fig. 6.3, which leads to the Japanese virtual pop idol, Hatsune Miku.

In many ways, Hatsune Miku is the realization of William Gibson's autonomous virtual pop Idol Rei Toei from his Bridge Trilogy (Williams 2012) in that "she" was released as a character representing a text-to-song program called Vocaloid (Vocaloid.com 2014) by company Crypton, released in 2008. Based on text-to-speech

Fig. 6.3 *Miku Hatsune AR,* late 2000s

technology developed by Yamaha, Hatsune Miku is the first of a series of Vocaloids to utilize granular synthesis of sampled vocalists (Miku being modeled from the voice of Saki Fujita). What would follow is a series of music videos, especially after the release of *Miku Miku Dance*, a character animation program starring Vocaloid characters, also released in 2008. High points for the Augmented persona in real space would be in Fig. 6.4 large-scale music concert using imagery developed by UK company Musion, which would also reflect Digital Domain's *Virtual Tupac* spectacle at Coachella 2012 (Verrier 2012) and large-scale performances based on the Miku genre, such as "Still Be Here" at Berlin's Transmediale festival in 2016 (Fig. 6.5).

The virality of the Miku/Vocaloid technology made her an ideal subject for an AR companion. Since 2009, numerous Hatsune Miku demos based on Fiducial

Fig. 6.4 Virtual Tupac (Image courtesy Digital Domain 2012)

Fig. 6.5 Miku Hatsune *Still Be Here* (Courtesy Ars Electronica)

markers on paddles would arise, even to the point of applications using the Oculus Rift headset to let you "live" with or sleep alongside Miku. This is more in the realm of what this essay terms as the Environmental or even Embodied/Wearable gesture of AR. This is a step more advanced than the GPS/Geolocative, placing the augment in space through *environmental feature* recognition rather than accessing and external GPS database of Points of Interest (POIs) linked to associated media.

New York artist Mark Skwarek created novel uses for the Fiducial marker on the body. The first example is the *Occupy Wall Street AR* project, (Skwarek et al. 2011, see Fig. 6.6) which was a political intervention by collective Manifest.AR. This intervention took place *in front of* the Stock Exchange, which is unique in that

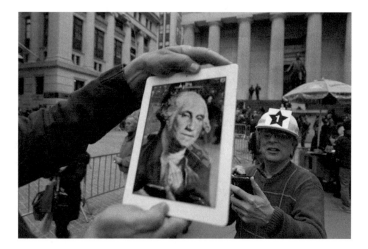

Fig. 6.6 Occupy wall street AR mask (Courtesy Skwarek 2011)

interventions and protest was only allowed in Zuccotti Park. The intervention was docented, as passersby were invited to don a helmet with a marker, and when the wearer views himself or herself with the front-aiming camera, they would see the engraved portrait of Washington from the US one-dollar bill instead of their head. Skwarek would reprise this gesture in creating markers for "Virtual Halloween Masks" (Poladian 2013), where anyone could download a given marker and app, and suddenly appear with a skull or jack-o-lantern head (or in their hand or wherever the marker would be placed). These are both wonderfully playful applications of the Fiducial gesture. One other artist has used the Fiducial and the Recognition gestures in his performance work and presents segues between these gestural modalities.

Jeremy Bailey (the "Famous New Media Artist") is a Toronto-based artist who uses markers-based AR in strange and unexpected ways. As Skwarek's placement of the marker on the body induced a straightforward semiotic swap, Bailey makes peculiar formal translations. His *Video Terraform Dance Party* (Bailey 2008), performed in Banff, Alberta shows him bobbing his head around, sculpting a virtual island and populating it with virtual birds and citizens as he narrates their creation. In Fig. 6.7, Bailey remaps his entire face as a faceted television with three "channels" that he controls with the tracking of facial markers that he tries to communicate while describing the piece through his stuttering, self-effacing banter in *The Future of Television* (Quaintance 2013). There are awkward moments, as he calls up a strobing stream and calls it "The Epilepsy Channel", and then thinking better, he tries to "save" and switches to portraiture of his wife. Bailey then slides into the Planar/Recognition modality with his *Important Portraits* (Smith 2013), which was a Kickstarter project that became a gallery exhibition at Pari Nadimi Gallery in Toronto. He invited "important" patrons to fund the project for a show in which he would use dramatic portraits of the funders as Planar markers for dynamic geometric augments. Bailey provides a segue and is important in his manic usage of AR modalities somewhere between a Japanese Mecha Epic and baroque portraiture

Fig. 6.7 Future of television (Image Courtesy Jeremy Bailey)

that has moved from usage of Fiducial markers to facial/feature recognition that is hard to categorize.

6.5.3 Planar Recognition AR

Although similar to the idea of the Fiducial marker in that it exists on a surface of some sort, the gesture of the Planar/feature recognition augment exists as a superset of the Fiducial modality. The Fiducial was specified for its historical significance, but the Planar/print/poster form of AR exhibits a broader scope than the digital marker, and in popular media, often performs a more straightforward function. In a TED talk presented in 2012 by the makers of the Aurasma, (now HP Reveal) AR technology (Mills and Roukaerts 2012), Matt Mills and Tamara Roukaerts demonstrate the recognizing gaze through aiming a mobile device at an image of the Scottish poet Robert Burns, as in Fig. 6.8. By scanning the image, a perfectly overlaid video of an actor, approximating the trompe l'oeil of the painting, appears and begins to orate. While more sophisticated than the Fiducial gesture, AR feature recognition of media is often an overlay of content onto print media. Other examples are of an IKEA AR experience, and even Fingerfunk's *Alien* chest burster experience which tracks from a t-shirt image (Woermer 2012). All of these augments are, in this writer's opinion, either simpler than or at best equal to a Fiducial, creating a simple semiotic swap, however lurid or graphic.

Esquire Magazine also uses this technique in a famous example in its Augmented Reality issue in 2009, "graced" on the cover by *Iron Man* star Robert Downey, Jr., as illustrated in Fig. 6.9. What was unique about this issue is not only the fact that the Fiducial markers summoned a mass of entertaining media through the issue, but reorienting the markers would elicit different responses. Turning the marker sideways would cause Downey Jr. to lounge on his side, playing the

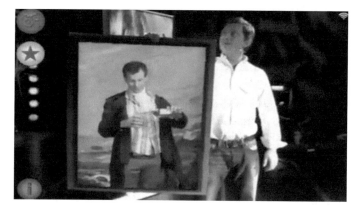

Fig. 6.8 Matt Mills' TED talk demonstrating Aurasma technology (Image Courtesy Aurasma 2012)

Fig. 6.9 Activated esquire AR issue cover (Image Courtesy *Esquire Magazine*, 2009)

raconteur in another way, cause the fashion models to be represented in another season, or call forth another "Joke Told by a Beautiful Woman". This publication used the potential of the Fiducial and Planar gestures extremely well in not using the orientation of the marker as for mere orientation (tilt, rotation, etc.). The Downey issue was an initial example of what is now a fairly common marketing application of AR.

As interactive interfaces emerge in all AR technologies unique possibilities. But as we unpack the representational modes of AR outward from interacting with Planar media, the user encounters AR in spaces. This is where the modalities of Environmental, Geolocative, and Embodied/Wearable AR come into play. The difficulty with studying these forms of mediation and interaction is that they both engage space in different, but equally valid ways. Because of Environmental recognition being closer to the Planar/Fiducial than Geolocative and Embodied AR, this will be our next category.

6.5.4 Locative/GPS-Based

The last gesture/modality in AR, and the most complex, is that of Locative/GPS. This is due to the dynamic relationship between the user, the media linked to points of interest in the landscape, and the objective background upon which the media is overlaid. Many variables are in play as the relationship between user, media and landscape as with the Environmental modality, and dynamic content creates a fluid matrix of representations, creating a sort of semiotic pinball machine. Fortunately for our analysis, and perhaps disappointingly for the work itself, most Locative AR work consists of overlaid imagery or video on static POIs (Points of Interest). This author understands as with all our gestural modalities that there are commercial

applications, like the Fiducial application used in the Esquire Magazine issue that has surpassed many of the artworks in our discussion in leverage of the potential of the medium. In addition, Locative AR art constitutes the majority of the medium, so only a brief number of works will be discussed here, and apologies to the mass of work in this gestural realm that is elided. For purposes of interest, I would like to discuss installations that address certain topics—politics and geographical annotation. Each throws content in useful or illegal/unexpected places and creates a double signification of the location through overlay and context.

Political work is one of the smaller genres in AR, although interventions like *We AR MoMA* (Sterling 2010) have used AR to create salons des refuses inside prestigious museums without actually sneaking into the space and nailing the work to the wall. Figure 6.10 *Occupy Wall Street AR* (Holmes 2012), organized by Mark Skwarek for the collective Manifest.AR, inserted technically illegal content over the Stock Exchange. The illegality of the gesture is marked by the fact that during the Occupy Wall Street campaign, intervention was only permitted in Zuccotti Park, as it private property. So, collective members, (Mark Skwarek, Alan Sondheim, et al.) "docented" the work to passersby, which included flaming bulls, Space Invaders, the Monopoly game plutocrat, and slot-machine wheels between the columns of the Exchange, playing on Brian Holmes assertion of "Market as Casino" (Holmes 2012). What I feel was unique was that the Occupy AR interventions are an art intervention where the "infopower" is not constrained by material or as I call it, "atomic" power (Lichty 2013a, b, c, 53). As mentioned in a 2013 panel on AR as Activism at the festival South by Southwest, the question was posed as to whether law enforcement could demand the reorientation of a Locative database if it was representing protest in a restricted space. This question was revisited as this author also penetrated controlled airspace with *Love Bombers*, in which Fig. 6.11 depicts

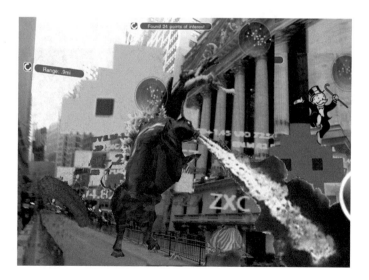

Fig. 6.10 Occupy wall street AR (Image Courtesy Skwarek 2012)

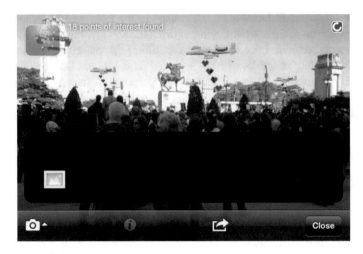

Fig. 6.11 Love bombers (Image Courtesy Lichty and Skwarek 2012)

NATO A-10 Warthog Ground Support Bombers, dropping video game 8-bit hearts on the NATO summit in Chicago and the corresponding protesting mobs.

Two other AR augment works that overlay historical content onto geographical environments are Annette Barbier and Drew Browning's group collaborative project 2012 *Expose, Intervene, Occupy (EIO)* (Tripp 2012). *EIO* used locative and recognition technologies to insert critical narratives into the downtown Chicago landscape. Examples of the eight AR collaborations include Barbier's *2070* as seen in Fig. 6.12, exploring the progressive invasion of the Asian Carp into the North American Great Lakes through the Chicago River, an alternate historical street sign narrative, and a Mario–Bros. romp by Mat Rappoport that invites the interactor to

Fig. 6.12 EIO: 2070 (Image Courtesy Annette Barbier 2012)

Fig. 6.13 EIO: Coin Chase (Image Courtesy Rappoport 2012)

chase coins through Chicago's Financial Sector in Fig. 6.13. Two other conversational pieces are *PolyCopRiotNode* by Adam Trowbridge and Jessica Westbrook that features an ominous cybercop, commenting on the law enforcement culture of Chicago, and *WeathervaneAR* by John Marshall and Cezanne Charles that has many instances of a "robotically-driven" chicken head, playing on post-Millennial paranoia. Where the *Occupy AR* series had more of a unitary format, *EIO* creates an "anthology" of works describing how AR can be used as a tool of psychogeographic inquiry. Of note is the unfortunate fact that due to the change in policy of companies providing the technological infrastructure for the work (similar to the removal of non-profiting movies from blip.tv in December 2013) *EIO* is now inactive.

Lastly, I want to mention another participatory and political work *Watch the Sky* (Fig. 6.14), by Pappenheimer/Brady. It uses GPS and a Web-based input to suggest a larger Harlem Watchtower in Marcus Garvey Park in Harlem, NYC. As Pappenheimer states, "It projects the need for a future much taller structure, "Harlem Watchtower+", to survey the global affects of anthropologist Arjun Appadurai's technoscapes as they intersect with other dimensions of the current multi-valent landscape in flux. Thus the original fire watchtower extends its functions to global vigilance and wide-ranging critical views as influences on the local neighborhoods and events" (Pappenheimer 2016).

It also uses a mobile app to invite participants to skywrite in AR over the Garvey park site. The project invites public commentary while using public architecture as political commentary, both historically (the fire watchtower) and contemporary (the notion of vigilance and surveillance in the age of political strife in the US). In some ways, this reflects works like Nathan Shafer's *Seward's Success,* based on unrealized megastructure plans in Anchorage, Alaska to comment on the human and political landscape of a given site.

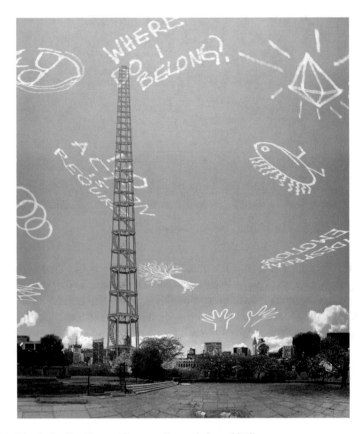

Fig. 6.14 Watch the Sky (Image Courtesy Pappenheimer 2016)

6.5.5 Environmental/Spatial Recognition

The next challenge that arises from recognizing an image as a Fiducial marker is that of recognizing a space from a given point of view. This introduces any number of problems, from perspective to time of day, weather, or occluding bodies in the scene, such as vehicles or other bodies. This has largely left the application of environmental AR to indoor applications that have fewer variables. Of course, outdoor applications in regards to machine repair are part of the original Boeing concept and military applications (Caudell and Mizell 1992, 659–669), but these are close-range situations with very specific, regular spatial configurations. Environmental/spatial recognition applications at the Embodied or the architectural scale can present more variables and present challenges in regards to tracking the environment. For the purpose of discussion, I will present examples that will expand in size, and explore a couple examples of intimate environmental experiences that refer to earlier examples

Fig. 6.15 Hermaton (Image Courtesy Darf Design 2013)

in this essay. I will begin with that I feel is still one of the best environmentally based AR game/apps, Hermaton by Darf Design.

Hermaton (Holmes 2013) is an environmental AR game developed by London-Based Darf Design, founded by Sahar Fikouhi and Arta Toulami that uses a half room-sized cut vinyl mural as marker when presented at an environmental size. There is a "tabletop" version that uses its own marker that fits very well into an advanced category of the feature recognition category, but for the sake of our conversation, the room-sized version in Fig. 6.15 is more germane. As their project statement describes *Hermaton:* "The project uses a buzz wire maze (think: the children's game "Operation") which people can navigate through in real-time, attempting to interact with the digital objects of the "Hermaton" machine. The design of this environment provides both an interactive and performance space which allows the user to fully immerse in a new augmented physical landscape" (Fikouhi and Toulami 2013).

The user controls a small red ball through the maze-like machine, switching on its lights, and progressively activating the *Hermaton.* In addition, the user is placed in what I would call a "performative" media space (Lichty 2000, 352) where the body has to physically stretch, crouch, and twist through the virtual machine. Where I draw the line between performance and performativity in media art, including AR, is the implication of audience in experiencing the piece. In the case of environmental AR, there is a becoming-action in navigating the work, but the existence of audience in the space or not is purely incidental, but there is activation of the space.

Another example of environmentally based AR works is Richard Humann's *Ascension* project. *Ascension,* based on the Membit AR platform is a mix of environmental and Planar AR art (Fig. 6.16). In installations in NYC and during the Venice Biennalle, Humann reenvisioned the constellations of the night sky. This was done by placing images that recognize a certain view and perspective as a site of image recognition for Humann's new mythologies. Instead of merely taking captured images and placing them at the GPS coordinates with the proper

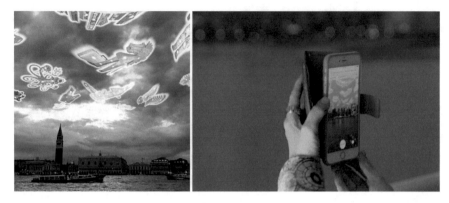

Fig. 6.16 Ascension (Image Courtesy Richard Humann 2017)

Fig. 6.17 Kenai Tapestry (Patrick Lichty 2014b)

orientation, Humann edited them and replaced them with the constellated images. As Membit founder Jay Van Buren says, the technology was originally meant to leave memories, but it can also be used to leave things that never were, which is a provocative element of AR (Membit 2017). One is led to wonder of the veracity of simulations in the landscape in the age od "Fake News", as one person's satire has become another's reality hack.

Another larger-scale VR object is the author's *The Kenai Tapestry* (Fig. 6.17). Although smaller, the 5-by-21 foot Jacquard-woven textile is a panoramic composite of online and actual photography taken by this author from a 2009 photographic project in Alaska on the Kenai Peninsula and Adak Island. The piece refers to instruments of power such as the *Bayeux Tapestry*, which depicts the Battle of Hastings, and the culturally transformative nature of the Jacquard Loom at the turn of the nineteenth century much in the way globalization and mechanization do today. The 5-by-21 foot size is appropriate for depiction of the grandeur of the Alaskan landscape. For augment tracking, it uses QR Codes as Web links or Fiducial markers, and features like bird flocks and sunlit highlights as recognizable features. The content (doubly accessible in the case of the QR Code) refers to the artist's experience of the Alaskan environmental embarrassment of riches while forces such as oil and mineral industries and global warming encroach this remote

Fig. 6.18 Exit glacier terminus AR (Image Courtesy Nathan Shafer 2013)

part of the world. *Kenai Tapestry*, in its own way, depicts another form of conquest that is the Enlightenment-era notion of the human subjugation of nature, currently termed as the Anthropocene Age (Crutzen and Stoermer 2000, 18). In this way, this work frames itself in a historical context while still forming a critical stance. But other applications root themselves even deeper in history and reveal exciting potentials for the illustrative power of environmentally-based AR.

Nathan Shafer's *Exit Glacier Terminus AR* shown in Fig. 6.18 reveals a history of the retreating terminus of the Exit Glacier on the Alaskan Kenai Peninsula. *Exit Glacier*, created for interpretive rangers with the Kenai Peninsula National Park, is a unique application that specifically recognizes the terrain from its own database, as there is little data connectivity at the site, and had to use its own tenuous Wi-Fi transceiver. Exit Glacier is also unique in that it is one of only two walk-up glaciers, and the AR application will show five distinct reconstructions of the glacier face from 1978 to 2013. The challenge connectivity problematizes the project with most AR frameworks. But conversely, the project's ironic Alaskan self-sufficiency presents a certain kind of utility that is particularly useful at the edge of the wireless world.

6.5.6 Between the Environmental, and Embodied: The Return of Hatsune Miku

In this section, the AR applications depicted have ranged from interior architecture to the geologic, but a peculiar subset of environmental applications have emerged in Japan, based yet again on our virtual pop idol, Hatsune Miku. I place them between the Environmental and the Embodied/wearable modalities as they entail both a Kinect-like spatial camera linked to the headset, making them Embodied, but specifically about orienting the subject in the environment. The subject in question

Fig. 6.19 Miku stay in park (Image Courtesy "alsione svx" 2013)

is Miku herself, and the applications are *Miku Stay*, a series of experiments to have Hatsune Miku as a happy live-in girlfriend, and another to take the interaction one step further and situate Miku as a sleeping partner.

In *Miku Stay* (svx 2013), created by a YouTube member named "alsione svx", Miku exhibits complex interactions like walking up to the viewer in a park as in Fig. 6.19, walking around a kitchen, and sitting in a chair (and impressively dealing with occlusion by walking *behind it*) and holding hands. Most of these are accomplished through spatial camera and Fiducial markers, but eventually alsione svx mentions that he cannot stand using these any more in the video, so he uses environmental cues such as the chair as a marker. She comes over, stands on the bathroom scale, holds hands and then jumps around laughing merrily. *Miku Stay* is a feminist's nightmare, as the app allows the user to live with a hopelessly idealized "waifu" creating expectations unattainable by flesh and blood. If this was not problematic enough, the *Sleep Together* app (*Miku Miku Soine*, Fig. 6.20) by Nico Douga (Tackett 2013) takes this one step further, as Miku becomes the user's bed partner, calling them "Master" and comforting them if there is restlessness in the middle of the night.

Awkward at this may seem, if we return to the gesture of locating the subject in space using environmental AR, we find that there is a *second* Miku-as-AR-girlfriend game for the PS Vita, entitled *Hatsune Miku Project Diva F* (Tolentino 2012). The "song-masher" game (as I call the genre of musical coordination games from *Dance Dance Revolution* to *Guitar Hero*) includes a markerless AR app that allows Miku to hang out in your apartment, as seen in Fig. 6.21, and sit on your bed. Is this the isolate hikikomori's dream, or as Josh Tolentino states in *Japanator*, "Mindless waifu ("*waifu*" being a fan term for idolizing an anime character as a possible mate) gimmickry." *Hatsune Miku Project Diva F* is definitely in the area of Environmental AR, but in all these examples, the question remains whether AR

Fig. 6.20 Miku Miku Soine (Image Courtesy Nico Douga 2013)

Fig. 6.21 AR Shot from Hatsune Miku Project Diva F (Image Courtesy Crypton, Sega 2013)

suggests what Bruce Sterling calls a "design fiction" (Sterling 2013) to alleviate technological isolation? As a note, in March 2017, the *Gatebox* Virtual Robot project (as in virtual "wife") announced that it would be releasing a Hatsune Miku version of its product shown in Fig. 6.22 (Crunchyroll 2017). It would allow the user to "live" with the character, trade SMS texts during the day, and have her control the lighting, etc. of the apartment. Although the Gatebox does not represent an AR application as such, it does talk about desires for us to live telepresently and with virtual companions and draws sharp questions about the role AR will play in our interpersonal relationships.

© Crypton Future Media, INC. www.piapro.net piapro / ©SEGA
Graphics by SEGA / MARZA ANIMATION PLANET INC.

Fig. 6.22 Gatebox Hatsune Miku (Image Courtesy Gatebox, 2017)

6.5.7 Body as Landing Site: Wearable AR

In my 1999 essay, *Towards a Culture of Ubiquity* (Lichty 2013c), I trace a trajectory of where interaction/delivery of media/mediated reality would be situated. First is the screen, then into the hand(held) device, then onto the body, and then onto space and architecture. Although wearables and Locative technologies have happened far more in parallel than I envisioned, the general trajectory seems on track. There are multiple platforms are overlapping, such as the Epson Moverio/ODG/Microsoft Hololens and Meta platforms, and have supplanted the long-dead Google Glass platform.

In *An Alpha Revisionist Manifesto* (Lichty 2001, 443–445), I theorize many years prior to this writing, in the future, companies will create pre-prototype narratives and what Sterling would term as "design fictions" to inspire the funders, developers, and consumers into willing their dreams into being. Of course, in the

mid-2010s this manifested itself as slick, slightly overpromising promotional videos of the coming platforms. In many ways, they reflected the tropes in current science (or near-future speculative) fiction, as we will see below.

In popular culture, the world of AR has given way from science fiction to design fiction, although there are excellent examples of AR as trope in books like William Gibson's *Spook Country* (Gibson 2007, 8), which features a subplot about AR artists depicting the deaths of celebrities at their place of demise. There are plenty of examples in movies as well, such as *Minority Report's* dressed-up version of Oblong's user interface (Underkoffer 2010). However, as it seems, science fiction is giving way to "design fiction" as a way to capture the popular near-future imaginary. The leading design fiction in 2013 involving the Embodied AR gesture, and ironically, the ultimate "chick device" (and I use that phrase with a healthy dose of derision) is *Sight* (Sakoff 2012), a dystopic AR fantasy by filmmakers Eran May-raz and Daniel Lazo. The opening scene finds our protagonist, Patrick, mime-flying in an austere room. In the next shot, we switch to his eyes, which have been equipped with Sight Systems' lenses, which show him playing a flying obstacle course. "Sight" technology has apparently revolutionized life as we know it, from augmenting the contents of the refrigerator to making such mundane tasks as frying an egg or turning cutting vegetables into a "Master Chef" game. The story turns darker as in Fig. 6.23, Patrick goes out on a date, using Sight to choose the ideal wardrobe and social approach using his "Wingman" app. After making a few initial gaffes, Patrick wins his date over, and we find out he is, in fact, an interface engineer for Sight Systems itself. They go back to his apartment for a nightcap, and his date notices that Patrick forgot to turn off his scoreboard on the wall, and sees that he has been using the Wingman, and storms off. This is actually not a problem, as he reveals that the secret feature of Sight is to be able to hack consciousness itself.

Fig. 6.23 Sight (Image Courtesy Eran May-raz and Daniel Lazo 2013)

Fig. 6.24 Black Mirror: Playtest (Image Courtesy *Channel 4 Television*)

This is also similar to a 2016 episode of the serial *Black Mirror* called *Playtest* (Fig. 6.24), in which a thrillseeker, accepting a job with game company SeitoGemu, experiences a neural interface AR system that inadvertently accesses the recesses of his psyche and renders him psychotic (Brooker 2016). This is where my axiom that most authors should not write their last chapter. This is due to the fact that although Sight and SeitoGemu offer marvelous insight into the probable future of Embodied AR, the worn trope of mind control sneaks in. It is also a commentary of technoculture's growing distrust of Sterling's notion of the five global vertical monopolies he calls "the Stacks" (Madrigal 2012), as *Sight* is an obvious commentary on Google Glass taken to its logical extent. The irony of this is that with the advent of Snap, Inc's *Spectacles,* for Snapchat, there has been little reaction to this device, perhaps due to its more "friendly" corporate profile.

In the world of art, the speculations are conversely much wilder and more constrained.

Keiichi Matsuda's *Hyperreality* (Fig. 6.25, Matsuda 2016) shows a near-future scenario of a contingent worker in Medellin, Colombia, doing menial jobs for "loyalty points". Her visual field is constantly polluted with game-like challenges, here virtual Shiba Inu puppy, offers, and encouragement from her virtual coach. She struggles through the hypermediated landscape until an indentity hacker stabs her in the hand stealing her points. Juliana, the protagonist, in desperation, finds the nearest shrine and becomes a Level One Catholic.

But the realities of wearable AR art are far more modest at this time, and apparently involve mind control or cybernetic psychosis. Artsy and Pace Gallery's Studio Drift through curator Elena Soboleva teamed up to create a work called *Concrete Storm* for the 2017 Armory Show. (Figure 6.26, Burdette 2017) It is a mixed reality installation with concrete constructions that act as registration points for the augmented sculptures. As the used wears the HoloLens, they see the

Fig. 6.25 Hyper-Reality (Image Courtesy Keiichi Matsuda)

Fig. 6.26 Concrete Storm (Image Courtesy the artists)

physical components of the installation as well as the augmented concrete pillars, that the users can manipulate, break and build. Although this is a relatively formal piece, this is a good example of early "Holographic AR" art.

6.5.8 Next Steps: Mixing Metaphors/Mixed Realities

Claudia Hart's *Alices* body of work (Fig. 6.27, Hart 2014) is one in which I hesitate to place into any of the previous areas because of its intermedia nature. Her use of Fiducial markers on ceramic plates, on bodies in motion, and in VR place her close to the genres of Fiducial and environmental recognition. But the use of AR in gallery, environment, and performance situations make the work unique in that AR is not a focus, but a facet of the work. From plates and napkins in *The Looking Glass Collection*, which place a reclining odalisque over the viewer's meal to *Alices Walking*, an Edward Campion-scored performance in which performers wear Planar markers that are activated with the artist's smart device app. In *Alices Walking*, the markers reveal the hidden narratives of the performers, such as "I wonder if I have been changed?". Also, motifs from the ceramic work reappears, creating a pastiche of relections on "… how queer things are today."

Hart's work is unique in terms of its multimodality—AR and its representative function is not the focus of the work but an aspect. AR is not the primary mode of delivery, but an aspect. In this way, this work escapes the genre as technofetishistic site and enters the zone of aspect of *gesamtkunstwerk,* which erases the focus on the viewing device. The use of AR in performance, as well as in public action, activates the form to something beyond a technological attraction.

Fig. 6.27 The Alices Walking (Image Courtesy Claudia Hart)

6.6 Conclusions

By looking at Augmented Reality as a delivery method for artistic content, then investigating it as a frame for mediation, a discussion is opened up that ties deeply into art-historical tradition and novel modes of "becoming." From Duchamp's notion of the "retinal" to Mulvey's masculinization of the gaze and pervasive imaging's fracturing and possible "queering" of the mediated gaze, AR and my proposed gestures/modalities of representation suggest ways in which artists are using AR in service of cultural production. By beginning with historical technologies like Fiducial tracking, we can trace an epistemic arc as AR unfolds into image recognition, spatial location, and Embodied interaction. Additional layers of interaction are embedded into AR in the handheld and wearable units, more layers of signification are stacked into augments. However, it is also important to note that AR as of 2014 is still a medium in its adolescence, as technologies in an "Alpha Revision" state rely on design fictions and crowdsourced bootstrapping to will them into being. This decade-later extrapolation of my idea of Alpha Revisionism has culture in a state where science fiction begins to pale in light of propositional videos and developer kits for *Star Trek*-like devices. In conclusion, it is this author's hope that he has left points for further discussion, made a discursive framework for the genre, and set up a number of propositional qualia for the study of Augmented Reality. In my first edition of this essay, I had hoped for the datedness of technological speculation to keep the essence of the principles of this essay, except for advancement of the technology and the creation of a larger historical framework, the primary tenets here remain. Again I hope that the ravages of time remain minimal as the genre of AR moves forward and the conversation continues.

References

alsione svx, Stay with Miku in augmented reality. web: Youtube video documentation, http://www.youtube.com/watch?v=yRWKFauD6_w&list=UUVUW_vUhHUd_UEtzEysNtCQ&feature=c4-overview (2013). Accessed 19 Sept 2017.

Bailey J. Video terraform dance party, Banff new media institute performance. Youtube performance video documentation, http://www.youtube.com/watch?v=vNO0l4ppgIY (2008). Accessed 24 Oct 2017.

Barbier A. In 2070, From "EIO" (from "Expose Intervene. Occupy"). Web documentation, http://iam.colum.edu/abarbier/Expose/EIO.html (2012).

Berry B, Poupyrev I. Augmented groove. ATR Research Labs, Kyoto, Japan. http://www.mic.atr.co.jp/sspace/ (1999).

Brooker C. *Playtest.* Black Mirror, (TV Series), Channel 4 TV, UK, 21 Oct 2016.

Caudell TP, Mizell DW. Augmented reality: an application of heads-up display technology to manual manufacturing. In: Proceedings of the 25th Hawaii international conference on system sciences, IEEE Computer Society Press. Manoa: University of Hawaii; 1992.

Craft C. An audience of artists: dada, neo-dada, and the emergence of abstract expressionism. Chicago: University of Chicago Press; 2012.

Crunchyroll. Gatebox To Demo "Living With Hatsune Miku" Hologram Communication Robot. http://www.crunchyroll.com/anime-news/2017/08/10/gatebox-to-demo-living-with-hatsune-miku-hologram-communication-robot (2017). Accessed 24 Oct 2017.

Crutzen PJ, Stoermer EF. The 'anthropocene'. Global Change Newsl. 2000; 41:17–8. International Geosphere-Biosphere Programme, Stockholm.

Crypton Inc. Vocaloid website. Web, http://www.vocaloid.com (2014). Accessed 19 Sept 2017.

Darf Design (Sahar Fikouhi and Arta Toulami). Hermaton documentation website. Web, http://www.darfdesign.com/132812/1318702/gallery/hermaton (2013). Accessed 19 Sept 2017.

De Boever A, Murray A, Roffe J. 2009. "Technical mentality" revisited: Brian Massumi on Gilbert Simondon. Web Journal, Parrhesia #7, http://parrhesiajournal.org/parrhesia07/parrhesia07_massumi.pdf (2009). Accessed 24 Oct 2017.

Esquire Magazine. Esquire's augmented reality issue: a Tour (Nov 9, 2009). Esquire Magazine YouTube Channel. Retrieved from http://www.youtube.com/watch?v=LGwHQwgBzSI (2009). Accessed 24 Oct 2017.

Frank J. Spatial form in modern literature, the idea of spatial form. New Brunswick: Rutgers University Press; 1991.

Gibson W. Spook country. New York: Berkley; 2007.

Hart C. Alices Walking/Alices projects. http://www.claudiahart.com/portfolio/aliceswalking/ (2014).

Holmes B. Profanity and the financial markets. A user's guide to closing the Casino. Berlin: Hatje Cantz Verlag; 2012.

Holmes K. AR occupy wall street: the augmented reality sit-in. Web, The Creators Project. http://thecreatorsproject.vice.com/blog/ar-occupy-wall-street-the-augmented-reality-sit-in (2011). Accessed 24 Oct 2017.

Holmes K. Hermaton: enter the grid is an augmented reality architectural maze. Web: The Creators Project, http://thecreatorsproject.vice.com/blog/ihermaton-enter-the-gridi-an-augmented-reality-maze (2013). Accessed 24 Oct 2017.

Hughes R. The reversible eschatology of arawakwa and gins. Web Journal, From Inflexions #6. Montreal: Concordia University; 2012.

Jorda S et al. In: Proceedings of the international computer music association. Ann Arbor: University of Michigan Press; 2005.

Kaltenbrunner M. Augmented Groove (description). From Tangible Music, http://modin.yuri.at/tangibles/?list=4 (2003–2014). Accessed 24 Oct 2017.

Karlin S. Rethinking public space: B.C. Biermann's augmented reality urban art. Web: Fast Company, http://www.fastcocreate.com/1682447/rethinking-public-space-bc-biermann-s-augmented-reality-urban-art (2011). Accessed 24 Oct 2017.

Kato H, Billinghurst M. Marker tracking and HMD calibration for a video-based augmented reality conferencing system. In: Proceedings of the 2nd IEEE and ACM international workshop on Augmented Reality (IWAR 99), October, 1999.

Lichty P. The cybernetics of performance and new media art. Leonardo. Cambridge, MA: MIT Press; 2000; 33(5):351–4.

Lichty P. An alpha revisionist manifesto: white paper. Leonardo. Cambridge, MA: MIT Press; 2001; 34(5):443–5.

Lichty P. Art in the age of dataflow. In: Currie M, Riphagen M, editors. Variant analyses: interrogations of new media art and culture. Amsterdam: Institute for Networked Culture; 2013a.

Lichty P. Digital anarchy, social media and WikiLeaks: or, Skynet doesn't look anything like we thought it did, in variant analyses: interrogations of new media art and culture. Amsterdam: Institute for Networked Culture; 2013b.

Lichty. P. The mutant cute: meitu, the selfie, and the rewriting of global identities. Digimag 16, (May 2017).

Lichty P. Toward a culture of ubiquity, in variant analyses: interrogations of new media art and culture. Amsterdam: Institute for Networked Culture; 2013c.

Lichty P. The translation of art in virtual worlds. In: Grimshaw M, editor. The oxford handbook of virtuality. New York: Oxford University Press; 2014.

Lichty P. Virtual Kenai/into the wild (AR Tapestries). Web documentation, http://www.voyd.com/ (2014b).

Lichty P, Skwarek M. Legible City2.0/OccupyAR May Day. Web Documentation, Web, http://aroccupymayday.blogspot.com/p/artists-and-projects.html (2012). Accessed 24 Oct 2017.

Madrigal A. Bruce Sterling on why it stopped making sense to talk about 'the internet' in 2012. Web: The Atlantic Online, http://www.theatlantic.com/technology/archive/2012/12/bruce-sterling-on-why-it-stopped-making-sense-to-talk-about-the-internet-in-2012/266674/ (2012). Accessed 24 Oct 2017.

Massumi B. Parables for the virtual: movement, affect, sensation. Raleigh/Durham: Duke University Press; 2002.

Membit (Van Buren, J.) Richard Humann's augmented reality art on membit, https://vimeo.com/215607961 (2017). Accessed 24 Oct 2017.

Mills M, Roukaerts T. Image recognition that triggers augmented reality. Web video: TED.com, http://www.ted.com/talks/matt_mills_image_recognition_that_triggers_augmented_reality.html (2012).

Mulvey L. Visual pleasure and narrative cinema. In: Braudy L, Cohen M, editors. Film theory and criticism. New York: Oxford University Press; 2004.

Ngai S, Adam J. Our aesthetic categories: An interview with Sianne Ngai. Fall: Cabinet Magazine; 2012.

Pappenheimer W. Watch the Sky, http://fluxfair.nyc/2016-artists/will-pappenheimer-zachary-brady/ (2016). Accessed 24 Oct 2017.

Poladian C. Virtual masks could be the future of Halloween costumes, thanks to augmented reality programs. Web, International Business Times, 29/10/13, http://www.ibtimes.com/virtual-masks-could-be-future-halloween-costumes-thanks-augmented-reality-programs-1445884 (2013). Accessed 24 Oct 2017.

Quaintance M. Patents pending: Jeremy Bailey and the future of gestural interfacing. Web: Rhizome.org; 2013.

Rappoport M. A game we play, (From "Expose Intervene. Occupy"). Web Documentation, http://expose-ar.com/?page_id=50 (2012).

Sakoff H. 'Sight': short film takes Google Glasses to their logical nightmarish end. Web: Huffington Post, http://www.huffingtonpost.com/2012/08/03/sight-short-film_n_1739192.html (2012). Accessed 24 Oct 2017.

Sandor C, Olwal A, Bell B, Feiner S. Immersive mixed-reality configuration of hybrid user interfaces. In ISMAR '05, pp. 110–113 (2005).

Skwarek M. AR occupy wall street. From Web Documentation, Web, http://aroccupywallstreet.wordpress.com/ (2011). Accessed 24 Oct 2017.

Skwarek M. arOCCUPY May Day. From Web Documentation, Web, http://aroccupymayday.blogspot.com/ (2012). Accessed 24 Oct 2017.

Skwarek et al. Occupy wall street AR. AR Installation, documentation website, http://aroccupywallstreet.wordpress.com/ (2011). Accessed 24 Oct 2017.

Skwarek M. Virtual masks could be the future of Halloween costumes. Thanks to augmented reality, Blog. http://markskwarek.blogspot.com/2013/11/augmented-views-virtual-masks-could-be.html; August 11, 2013. Accessed 24 Oct 2017.

Smith G. Important portraits—Jeremy Bailey Kickstarts a solo exhibition. Web, Creative Applications Network, http://www.creativeapplications.net/news/important-portraits-jeremy-bailey-kickstarts-a-solo-exhibition/ (2013). Accessed 24 Oct 2017.

Sterling B. Augmented reality; invading the museum of modern art. Web: Beyond the Beyond, Wired.com, http://www.wired.com/beyond_the_beyond/2010/10/augmented-reality-invading-the-museum-of-modern-art/ (2010). Accessed 24 Oct 2017.

Sterling B. Patently untrue: fleshy defibrillators and synchronised baseball are changing the future. Web: Wired.co.uk, http://www.wired.co.uk/magazine/archive/2013/10/play/patently-untrue (2013). Accessed 24 Oct 2017.

Tackett R. Wanna sleep next to Hatsune Miku? There's an app for that! Web: Rocketnews24.com. http://en.rocketnews24.com/2013/10/08/wanna-sleep-with-hatsune-miku-theres-an-app-for-that/ (2013).

Tolentino J. Get Miku into bed with Project Diva F's AR Gimmickry. Web: Japanator, http://www.japanator.com/get-miku-into-bed-with-project-diva-f-s-ar-gimmickry-23496.phtml (2012).

Tripp S. Response to expose, intervene, occupy: a collaboration of ten artists. Web, http://expose-ar.com/?page_id=240 (2012). Accessed 24 Oct 2017.

Underkoffer J. John Underkoffer: pointing to the future of UI. Web video: TED.com, http://www.ted.com/talks/john_underkoffler_drive_3d_data_with_a_gesture.html (2010). Accessed 24 Oct 2017.

Verrier R. 'Virtual 2Pac' image wins award for Digital Domain. Los Angeles Times Online, http://articles.latimes.com/2012/jun/25/entertainment/la-et-ct-digital-domain-tupac-20120625 (2012). Accessed 24 Oct 2017.

Virtual Tupac at Coachella Image, Digital Domain, Web, http://digitaldomain.com/projects/271 (2012). Accessed 24 Oct 2017.

Vlahakis V, Ioannidis N, Karigiannis J, Tsotros M. Archeoguide: an augmented reality guide for archaeological sites, Computer graphics and applications. vol. 22, Issue 5. Washington, DC: IEEE Computer Society; Sept/Oct 2002.

VML. Mobile Medic. Web Documentation, http://australia.vml.com/clients/australian-defence-force (2012). Accessed 24 Oct 2017.

Williams M. Gibson's bridge trilogy, Blog, Stories By Williams, http://storiesbywilliams.com/2012/02/05/gibsons-bridge-trilogy/ (2012). Accessed 24 Oct 2017.

Woermer M. Augmented reality chestburster t-shirt pops a xenomorph out of your torso, Web, https://io9.gizmodo.com/5938851/augmented-reality-chestburster-t-shirt-pops-a-xenomorph-out-of-your-torso (2012). Accessed 24 Oct 2017.

Chapter 7
Augmented Reality in Art: Aesthetics and Material for Expression

Geoffrey Alan Rhodes

7.1 Introduction

This essay proposes a simple question: What would be an avant-garde Augmented Reality art? And how can we get there? I'll call the object, "AR(t)"—an art of Augmented Reality that excites and challenges audiences with the same visceral charge that avant-garde structuralist film threw onto the microcinema screen… an AR(t) that liberates contemporary audiences by pulling apart and revealing the structures of the technology in which we live. This essay will not answer the question, but will follow a thread through cinema apparatus, video art, and augmented reality that points a way forward.

7.2 Film

Stephen Heath begins his introduction to the collection of essays, *The Cinematic Apparatus*, with an observation on proto-cinema advertisements:

> In the first moments of the history of cinema, it is the technology which provides the immediate interest: what is promoted and sold is the experience of the machine, the apparatus. The Grand Café programme is headed with the announcement of 'Le Cinématographe' and continues with its description: 'this apparatus, invented by MM. Auguste and Loius Lumiére, permits the recording, by series of photographs, of all the movements which have succeeded one another over a given period of time in front of the camera and the subsequent reproduction of these movements by the projection of their images, life size, on a screen before an entire audience'; only after that description is there

G. A. Rhodes (✉)
Department of Visual Communication Design, School
of the Art Institute of Chicago, Chicago, IL, USA
e-mail: garhodes@GARhodes.com
URL: http://www.GARhodes.com

© Springer International Publishing AG 2018
V. Geroimenko (ed.), *Augmented Reality Art*, Springer Series on Cultural
Computing, https://doi.org/10.1007/978-3-319-69932-5_7

mention of the titles of the files to be shown, the 'sujets actuels', relegated to the bottom of the programme sheet. (Heath 1980)

The context here, in a compilation of essays inspired by Jean-Louis Baudry's essay "Ideological Effects of the Basic Cinematographic Apparatus," is that after sixty years of critics analyzing film on the basis of dramatic text, aesthetic composition, photographed subject, and psychology, Apparatus Theory in the 1970s had finally codified an analysis of cinema based on its essential unique elements—it is material for expression taken as a whole; what McLuhan would term the Medium not the Message. In Baudry's 1970 essay, he draws a diagram of the 'cinematographic apparatus' delineating the path that spectators' perceptions normally travel, noting what is emphasized and what repressed. I redraw it here in Fig. 7.1.

The text in the diagram notes elements of the apparatus: the cinema screen, the projector, the montage/cutting of the film, the principal production of sound and film, the screenplay, the photo-emulsion-captured objects in past reality. We could add many more elements that make up The Film: the dramatic acting, the framing, the soundtrack and sound looping, the business machinations which create the theaters and distribute the film... The solid line draws the actual path of the cinema information, from staged scene, to framed shot on film, to the editing room,

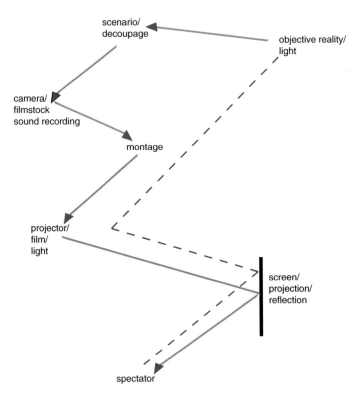

Fig. 7.1 Cinema apparatus (Baudry 1986)

projector, and cinema screen. The dotted line draws spectators' perception of The Film—that of which the spectator is aware; many of the apparatus elements are repressed in favor of 'suspension of disbelief' and 'persistence of vision' in the cinema experience.

In Baudry's diagram of audiences' perception, he emphasizes the analogic quality of cinema—the photographic actuality of it: he draws the dotted line to describe a viewer that feels like they are seeing the actual light reflected by the captured objects, not seeing a picture of a car, of a beautiful face, of a camel crossing the desert, but seeing a present car, face, camel. This is not an absolute cinema—the viewer is still conscious of the film-making—but the dotted line represents the extent to which these different elements are present in the mind of the spectator. They are mostly aware of the objects and the screen presenting them, and much less so the other apparatus that deliver it there. It is a sketch of the cinematographic ideology. In his drawing the spectator remains aware of the screen—if not, then they might run from the theater when a dinosaur enters frame or a gun is shot. Less so are they conscious of the projector and the beam emanating from it—if dust or smoke obfuscates the beam, or if the film shakes in the projector gate or even burns up, then this drawing attention to the projector would be a failure that 'takes us out' of the experience of the movie. Though vaguely conscious of the editing, the spectator is almost completely unconscious of the filmstock and sound recording choices—if these things are noticed at all it is a failure of production (such as in cheap B-movies where there are jarring changes between film stocks with different grains or scratchy soundtracks). And the same can be said of the scripting and acting—once we notice the acting of the drama or the scripting of the drama we are no longer *in the drama* where we are supposed to be. And while watching the film, the audience is completely unaware of the larger *dispositif*: the business operations of the studio, the transport operations of the cinema, the entertainment economy that has resulted in this film being presented on this screen.

Artists contemporary with Baudry subverted this standard perception through different techniques seeking in the elements repressed within the cinematographic apparatus a fresh material for expression—a material essential to cinema capable of an avant-garde *Acinema*. Anthony McCall created films that emphasized the projector beam. Stan Brakhage made films that emphasized the interaction of the projector light and the material of the film strip itself. Flickerfilm makers like Tony Conrad and Paul Sharits created metrical montage films that emphasized the cutting and rejoining of film strips and their mechanical movement through the projector light. Filmmakers like Jonas Mekus, Kenneth Anger, and Jack Smith made avant-garde films that turned upside down the emphasized and repressed areas of production, scripting, and performance. Avant-garde film sought to rupture the ideology inherent in the cinematographic apparatus, to create a fresh image capable of inspiring new thoughts, emotions, and politics.

This achievement is what we seek for AR.

7.3 Video Art (Live)

This achievement of film art arose in the television era. With the newly wired world, a media philosophy that could encapsulate the connections and circuits of contemporary technology into a conceptual whole was attractive and maybe necessary for survival. The arrival of television may have allowed for a clear perception of film. McLuhan's analogy in *Understanding Media* of sound waves becoming visible just as a plane approaches the sound barrier seems prescient—like much of his book—of the networked age:

> The sudden visibility of sound just as sound ends is an apt instance of that great pattern of being that reveals new and opposite forms just as the earlier forms reach their peak performance. Mechanization was never so vividly fragmented or sequential as in the birth of the movies, the moment that translated us beyond mechanism into the world of growth and organic interrelation. The movie, by sheer speeding up the mechanical, carried us from the world of sequence and connections into the world of creative configuration and structure. (McLuhan 2003)

We can transpose this analogy to another age and transition—to the networked electric image which began with live video and has been accelerated in AR. Augmented Reality, in all its permutations of live manipulated media, is the first truly network-age screen media—not just movies broadcast over electric wires, or recorded on to digital media, or enhanced through computer-calculated effects, but a medium which takes live media manipulation as its essence and material. With this acceleration, we can look back to excavate the material shift from the filmic image to the electric one.

The video art of the 1970s, one could call 'proto-AR'. Like the proto-cinema program cited by Stephen Heath, video art in the gallery is defined by its apparatus —the apparatus locates the genre. A Bill Viola video work, represented on James Cohen Gallery's Web site, describes the artistic material, "Color High-Definition video triptych, two 65″ plasma screens, one 103″ screen mounted vertically, six loudspeakers (three pairs stereo sound)" (for the work, *Ocean Without a Shore*, 2007). SFMoma, in their web catalogue, gives the genre or medium of Peter Campus' 1975 video art work *Dor*, "closed-circuit color video installation," but to truly locate the work they further note, "A discreet video camera is placed near the entrance, filming visitors entering and exiting the space; their live image is projected onto an adjacent wall." Then it goes on to the "sujets actuels." In description, these are not video works made of light, subjects, scenes, or even images; instead, they are configurations of wires, capture devices, and rendering screens.

In 1976, as video art came on the scene, Rosalind Krauss wrote the well-known essay, "Video and the Aesthetic of Narcissism," which addressed many of the new video works, including the above mentioned *Dor* by Peter Campus, and hypothesized a fundamental shift in the practice of art and its material for expression. In it, Krauss theorizes that these artists' expressions must be worked through "an object-state, separate from the artist's own being, through which his intentions must pass," like the pigment bearing substances of painting and the matter through space

of sculpture: a material for expression that was the artist enmeshed in the media apparatus—a psychological state as material. She defines the crucial element of the looping electric video circuit images of Acconci and Campus as the instantaneity of the communication from notion to message: "This is why it seems inappropriate to speak of a physical medium in relation to video. For the object (the electronic equipment and its capabilities) has become merely an appurtenance. And instead, video's real medium is a psychological situation, the very terms of which are to withdraw attention from an external object—an Other—and invest it in the Self." The object is bracketed out, and instead the artist is creating within a psychological state invoked by the mapping of the mind onto this network; the medium becomes the nervous system.

In her analysis, this self-gazing video art, such as Vito Acconci's long-take videos, are for the spectator like viewing an electronic and psychological loop between the artist, camera, and screen. Krauss differentiates the video works: installations like Campus' *Dor* which install the narcissistic circuit within the gallery, and works like Vito Acconci's *Centers* (a looping pre-recorded video in which Acconci, watching himself in his live video monitor, repeatedly points at the center of the screen, coincidentally at the viewer and the focal point of the art work) which use the narcissistic circuit as a stage for performance that is then played back in the gallery. One is documentation of an apparatus, and the other installation of apparatus in which the viewer is immersed. Like avant-garde film, these works sought to reveal the contemporary technological apparatus to the spectator by directly revealing the apparatus in the videos and installations. The perception and the construction are identical. In the fashion of the Baudry diagram, we could draw the video art apparatus like I have in Fig. 7.2.

There is no need for dotted lines in the diagram to show an alternate viewer perception because the perception of the viewer travels the same route as the wires.

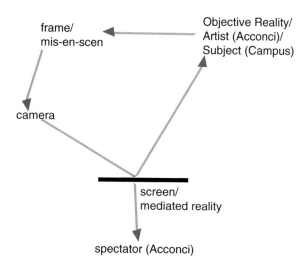

Fig. 7.2 Video art apparatus as described by Krauss

frame/
mis-en-scen

Objective Reality/
Artist (Acconci)/
Subject (Campus)

camera

screen/
mediated reality

spectator (Acconci)

Both types of works cited by Krauss are loops, one presented as an object in the gallery, the other actually installed so that it can be stepped within (and frustrated in the case of Campus' *Dor*). In *Dor*, the viewer's perception should grasp equally the presence of the screen and the camera and the wire between them; this is the point. In Acconci's *Centers*, the viewer is to be aware of Acconci watching both the camera and the screen attached to it and performing within that circuit. In both works, the frame of the camera is the context of the conceptual statement—the framed square of the gallery canvas for Acconci, the frame that separates the narcissistic projection from reality for Campus.

It is a surprisingly innocent diagram, where every trick is there to be revealed. Though Augmented Reality uses cameras streaming live to screens in a similar way, its construction is more complicated, and there are areas of the apparatus that are repressed in the audience's perception.

7.3.1 Augmented Reality

Media Art, as the media philosopher Lars Qvortrup has noted, could all be described as ready-mades where instead of R. Mutt's urinal there is now a computer, a projector, a screen, a camera (Qvortrup 2004). AR art has complicated this ready-made; it is an art of apparatus but not of the technical objects themselves; instead the objects are plugged into each other, broadcasting to each other and constantly looping in real live time. It is an art of circuits.

Ronald T. Azuma in an early 1997 survey of the Augmented Reality medium drew the diagram I have redrawn in Fig. 7.3. Missing in this diagram is the dotted line of perception—what the spectator expects and ignores—but the similarity to Baudry's 1970 diagram of the cinema apparatus is obvious. In place of cinema's manipulation of live objects through scripting, set design, dramatic direction, here there is a direct live stream from the camera, the 'reality' that is being augmented. In place of the screen there is the monitor or AR glasses—an invisible immersive

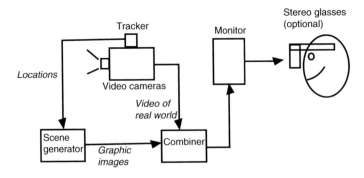

Fig. 7.3 Monitor-based AR conceptual diagram (Azuma 1997)

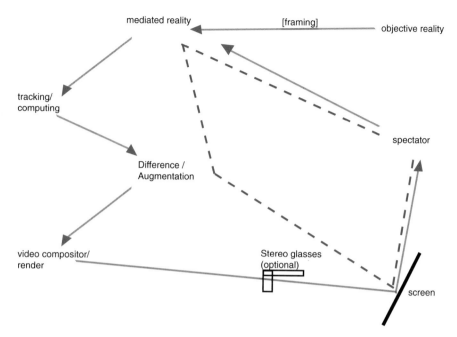

Fig. 7.4 Augmented reality apparatus (Azuma's diagram redrawn after Baudry)

screen that is not framed within a theater but *is* the theater enveloping the spectator. In place of cinema montage is the "scene generator" that creates the augmentations, those virtuals not truly present in the live video capture; and in place of the cinema projector there is a "combiner" that renders together the augmentation and the mediated reality of the video stream.

After the style of Baudry, we could redraw Azuma's diagram like I have in Fig. 7.4. Here, again, the solid line draws the path of actual AR information from the objective reality captured by the live video camera, run through a tracking process, augmented with special processing and graphics, then rendered out to a screen or AR goggles (I note goggles off to the left of screen because, as described above, goggles are meant to be an 'invisible screen' that envelops the viewer… something not noticed). The dotted line draws the normal spectator perception. They are aware of the screen as an image not reality; they are aware of the augmentation being done—such as the addition of graphics, animations, models, or other filters on the video stream—but are largely unconscious of the actual computational processing being done to the video; any severe tracking issues such as jitter in the augmentation, or render issues such as bad aliasing would be considered a failure of the medium and would 'take us out' of the experience. Most significant is the final destination of viewer perception, a mediated reality. Unlike cinema effects, where digital computation and compositing are used to create a simulacrum of reality (real looking dinosaurs attack the real flesh-and-blood actors on the screen), Augmented Reality plays with the combination of the evidently unreal and

the real. Its essence and raison d'être is that juxtaposition and border between two epistemologically diverse universes, the live mediation and the virtual augmentation, and that border must be evident. AR does not attempt to embed the viewer in an objective reality, the spectator identifies with a mediation—the mediation that stands in for reality. It is *supposed to be* a mediated universe.

The cinema screen is a window that lets on to another objective world. The AR screen is a media screen transparently performing the tricks of which it is able: manipulation, juxtaposition, and combination of live stream images and generated virtual. Augmented Reality is about combining live mediation with live computational augmentation, a medium whose essential material is not captured objective reality like cinema, but electric mediation itself. When experiencing Augmented Reality, unlike video art, we are no longer seeking to grapple with mediation, but have embodied it. We are, instead, grappling with our relationship to the interface and machine.

7.3.2 AR(T)

So here the question arises, what would be an avant-garde AR art?

Augmented Reality art has, in the past, traded off of its novelty. But as industry establishes AR experiences for commercial purposes such as Google Glass, Pokémon Go, Selfie AR beauty apps, or the proposition of AR advertising flashing to our screens and glasses in department stores, AR(t) is now challenged to stake out territory outside these newly established paradigms. An avant-garde AR art will expose and utilize the structures repressed in industry production to create experiences that deconstruct our contemporary relationship to reality, virtuality, and processing.

Returning to our diagram of AR perception, we can seek out ripe areas where standard AR production is designed to repress the apparatus. The areas noted on the left of the diagram, "tracking/computing" and "video compositor/render," have been used in early AR art for their expressive potential (as well, exposing the same apparatus in personal computers is a major exploration of 'glitch art'). Early AR art used fiducial markers—barcode-like patterns used for image tracking and robot-vision—as both a graphical key for tracking and a visible emblem of computer vision.

For example, my own installation, *52CardPsycho* (2009), which mapped the 52 film shots that make up the famous shower scene of Hitchcock's *Psycho* onto a deck of specially printed fiducial cards. The printed fiducials functioned as fetish objects and interface through which the audience could deconstruct and reconstruct the famous sequence from modern cinema (Fig. 7.5). The fiducial pattern reveals the apparatus—a code which only the tracker and scene generator can read—and exposes the obscurity of the computational process instead of hiding it. Manifest. AR's inaugural project published for iPhone, *We ARe MoMA* (2010), used compositing as a political statement. Through the live AR app, Manifest.AR virtually

Fig. 7.5 52*card Psycho* (Rhodes 2009)

placed a set of 3D graphical art works in the New York MoMA without permission to be discovered through a smartphone app (Fig. 7.6). The juxtaposition of virtual and real was the site for the conceptual expression; this juxtaposition of compositing played with subverting real-world boundaries with virtual boundaries, in this case the real controls of private property and museum curation.

These works, like proto-cinema, are initial experiments in the medium showing that of which it is capable. But a more mature AR(t), a truly avant-garde augmented reality art, must go farther in seeking out its essential material and unique expressive potential to grapple with the solidifying AR ideology. In the diagram, the repression of "objective reality" in favor of "mediated reality" offers an opportunity for deconstruction. Already recent science fiction, such as *Black Mirror* (2011–), has sought through fictional narratives to expose the blithe repression of reality implicit in the AR industry and the implications for social justice that come with reality being subservient to a mediated AR perception. Who has not given a

Fig. 7.6 We *AR in MoMA* (Manifest.AR 2010)

smirk when watching the Google Glass demo, imagining objective reality suddenly interceding in the utopian AR mediated world?

Live mediation is the 'reality' in augmented reality. And increasingly it is our own reality. This suppression of the real in AR seems fertile ground in which to explore our contemporary relationship with networked media—our virtual presence and lives made in relationship with machines that see before we see, read our digital codes and cookies and histories that we cannot know, then compile and render out their own selections of pixels and images... all without us seeing the process. Future AR(t) will question how to make mediation *not* seem real—to break, momentarily, the illusion of reality in mediation.

References

Azuma RT. A survey of augmented reality. In: Presence: teleoperators and virtual environments, vol. 6. Boston: MIT Press; 1997. p. 355–85.

Baudry JL. Ideological effects of the basic cinematographic apparatus. In: Rosen P, editor. Narrative, apparatus, ideology. New York: Columbia University Press; 1986. p. 287.

Heath S. Technology as historical and cultural form. In: Lauretis T, Heath S, editors. The cinematic apparatus1. New York: St. Martin's Press; 1980. p. 1.

Krauss R. Video: the aesthetics of narcissism, October. vol. 1., p. 52. (Spring 1976).

McLuhan M, Gordon WT. Understanding media: the extensions of man. Corte Madera: Gingko Press; 2003. p. 27.

Qvortrup L. Digital poetics: the poetical potentials of projection and interaction. In: Liestøl G, Morrison A, Rasmusse T, editors. Digital media revisited: theoretical and conceptual innovations in digital domains. Boston: MIT Press; 2004. p. 241.

Chapter 8
Digital Borders and the Virtual Gallery

Jacob Garbe

8.1 Introduction

This chapter develops my previous work and thoughts arising from the exhibition of augmented reality artwork (Garbe 2013), specifically in how digital mediums are in dialogue with physical space. As one enters the world of exhibition, it becomes apparent that the challenge of new media interactive artwork in general has become more and more familiar to the conversation of exhibition practice. These works have required new notions of both effective curation and preservation. But while radical in many ways, for the most part these pieces still establish their interactivity within a statically delineated physical space: a gallery, an installation, or an area created through the formulation of specific environmental parameters. They break down the fourth wall of passive experience through interactivity, but still—for the most part—partake of traditional exhibition space, and leverage that to provide boundaries for acceptable behavior. In many cases they are in active dialogue with that space and are engaging, co-opting, or subverting those spaces and their accompanying expectations. But for all this, they remain concerned with a specific physical location.

Augmented reality art, as a new media subset, distinguishes itself through its peculiar mechanics of exhibition and performative re-contextualization. It allows the artist to translocate the borders and constraints of the experience from physical to virtual, expressing the piece onto spaces in a way that is independent of physical or locative constraint, yet still tethered to the real world. This practice of anchoring virtual assets to the physical world allows artists to make use of virtual properties such as mutability and replication, while engaging with issues of embodiment,

J. Garbe (✉)
Center for Games and Playable Media, University of California Santa Cruz,
Santa Cruz, CA, USA
e-mail: jgarbe@ucsc.edu
URL: http://www.jacobgarbe.com

© Springer International Publishing AG 2018
V. Geroimenko (ed.), *Augmented Reality Art*, Springer Series on Cultural
Computing, https://doi.org/10.1007/978-3-319-69932-5_8

performance, and presence. In this way AR pieces show themselves as dynamic both in content due to their performativity and in physical location of experience due to their mediation. This has led to the perception of AR art as being subversive or independent of curatorial practice.

However, these qualities demonstrate not so much a removal of curatorial boundaries, as a translocation of them from the physical to the digital. The art installation occurs not in the gallery, but on the hard drive of mobile devices. In this way AR artworks align themselves more perhaps with movements like net.art, where one must look to the loading screen as the gateway to the gallery, a space which—while mutable and infinitely configurable—is still proscriptive. AR may allow the artist to set many more of the work's boundaries than in more traditional media, but even that freedom is still subject to the affordances of the software composing the work.

8.2 Borders of Experience

Engagement of the fourth wall occurs when an observed artwork changes or speaks directly to the audience. Many new media interactive artworks already challenge traditional notions of the fourth wall in that the viewer's participation is an integral part of the performativity of the piece. Artworks for their part are concerned with perlocutionary acts, which is to say acts described from the vantage point of their affect on the viewer: scaring, angering, beguiling. Specifically, perlocutionary is also a useful term in describing the actions required of the piece from its viewers— and the performances the pieces in turn respond with—and how this process creates an emotional affect in the viewer. The perlocutionary qualities of such new media pieces create a feedback loop of continual engagement that is only broken when the participant has exhausted the piece's ability to perform, or the engagement offered cannot compete with their diminished attention span. Dourish explored this in his investigation of 'engaged interaction' (Dourish 2001).

But how is this different from experiencing a non-interactive piece of artwork? While a painting or sculpture may seem different to a viewer who steps closer or spends longer with the piece, the critical point is that the artwork asks nothing from them in terms of embodied action. All demands are perceptual, ones they can comfortably respond to from their position behind the passive "fourth wall." In this method too one could consider a non-interactive work conceptually complete when sitting in a gallery space unobserved. Interactive works, however, have a critical component missing that robs them of their expressive voice when they are sitting unengaged within an exhibition space.

AR complicates this even further by adding intermediary devices into the interpretive and experiential mix. Augmented reality artworks provide a way in which the fourth wall of passive viewing is enriched by, at the most basic level, technology which is appended to the senses of the viewer. The "performances" or "texts" of the piece are first mediated through a device, usually a video feed

computationally modified and then displayed. This can take the form of a computer with installed gallery displays, or in the case of locationally diffuse works, the more and more ubiquitous smart phone (Fig. 8.1).

The most passive level of interaction takes place purely on the level of the machine, which provides a virtual frame for the interaction, with the viewer then moving or changing the view/focus of the machine, but not interacting with the primary components. The viewing device for the user becomes a digital prosthesis which allows them to "sense" artwork in a variety of ways unapparent to the unaided senses. The work required just to experience the artwork entails a kind of performance, albeit one which is passive in the sense of changing the piece's state. Viewers are "performative observers" (Morrison 2010) who can be affected by the

Fig. 8.1 A gallery viewer interacts with *From Closed Rooms, Soft Whispers*, wherein printed collages are made interactive through digital projection and AR, providing an experience mediated through several screens simultaneously

piece, and even be receptive to it in a perlocutionary way, but they do not affect significant change on the piece.

A good example is Camille Scherrer's *The Haunted Book* (Scherrer et al. 2008). Exhibition of this piece entails a book, a lamp modified to contain a video camera, and a computer screen. Through the experience of this piece, viewers see short movies overlaid on different pages of a physical book. It is a beguiling artwork that provokes a whimsical state of interaction with the viewer—one that is focused on the aspect of hidden content revealed through the appropriate digital prosthesis. However, we see here that while people interact with the book by turning the pages, they are not performatively engaged as co-producers of the piece. The singularity of its experience is mirrored in the singular experience of traditional artwork exhibited in a gallery or museum. Furthermore, the custom hardware necessary for its display means that this piece is tied to the place of its exhibition.

Not all augmented reality artworks are constrained through the physical embodiment of piece-specific hardware, however. One of the sub-genres of augmented artworks that takes advantage of those proclivities is locative literature pieces, such as those authored by StoryTrek software, which use smart phones as their artistic substrate.

In one such piece, entitled *Crisis 22*, viewers experience a story spatially, tied in physical location to a street in Ottawa. Viewers use a mobile device as a prosthesis for the communication of narrative and exhibit agency in the story through an exploratory framework: re-tracing their steps reveals backstory, while heeling off into an alleyway provokes narrative digression (Greenspan 2011). In this way the piece leverages augmented reality for an artistic experience that is closely tied to a specific place with precise boundaries, yet whose borders of experience are not clearly defined to the participant. Additionally, nothing more is being asked of the participant other than the exploration of physical space to yield narrative. They change nothing in the work for others through their interactions. They have agency only as far as their own experience and interpretation of the work goes—much like a viewer of a non-interactive work in a gallery. The key point of interest in pieces like *Crisis 22* is its engaging use of specific space, which at once seems delineated, yet open to ambiguity.

Another example of such work is *Frontera de los Muertos* (Freeman 2013), an AR piece that re-contextualizes the space of the US/Mexico border in Arizona. Freeman uses augmented reality to overlay effigies of human skeletons on locations where immigrants died in the process of attempting to cross into the USA. Again, it is enough with this piece that it engages in that re-contextualization, and the interactivity is restrained to perlocutionary acts of driving to the space, downloading the app, and starting up the channel in Junaio. In the sense of a curated space, the power of this piece derives directly from its location, and as such it would lose its critical context if the asset locations were moved. Therefore, while it partakes of very different parameters from traditional curation, it is still nonetheless a piece with explicit specifications.

8.3 Art Installation

Intrinsic to the unbound physical locativity unique to particular forms of AR is the concept of active perceptual re-contextualization, which is accomplished through viewer interaction. For example, in works such as Manifest.AR's gallery interventions (Veenhof and Skwarek 2010) or Phoenix Toews' sculptural app Pyrite (Toews 2013), the artistic interface becomes invasive in its deployment. Participants are engaging the real world through a mediated context which dramatizes spaces that are otherwise mundane. This not only breaks down the "fourth wall" in terms of active participation, it also eliminates the physical boundaries in which this art is experienced. Pyrite allows viewers to create and find persistent sculptures anywhere, turning even mundane locations into opportunities for artistic display. Manifest.AR's gallery interventions allow visitors to their website the ability to submit art and have it virtually displayed in any number of galleries worldwide. Thus, the performative approach that these pieces foster contextually redefines not just the conventional interactive spaces, but potentially any part of the real world.

It's tempting with focus on such work to see the medium of AR as one that's breaking down or eliminating the privileged space of the gallery in favor of more pervasive and revolutionary implementation. The interactivity which actively engages viewers both in the viewing of the piece and the expression of it through their creative action seems to break down most if not all of the gallery's proscriptions. Arguably however, the blurring of lines for exhibition space when considering AR is not so much the removal of the wall, but the translocation of it. Explanation or revelation of the experience's border parameters is always deferred, until the performative and perlocutionary components of the piece are exhausted. Only then do viewers, if they engage for an appropriate period of time, grasp the borders of what the piece can offer. In other cases the borders may be more apparent, in the affordances of where one can see the work, the degree to which manipulation or sensing of its elements is restricted by granularity of GPS sensors (for non-marker-based AR) or even short-comings of the technology itself, such as the quality of cameras and their ability to compensate for a variety of conditions.

But even setting aside these restrictions, there is still the underlying architecture, the operational logic of the piece which remains implicit, not explicit, to the viewer (Wardrip-Fruin and Mateas 2009). There is a body of computer code; one could even argue language, that is just as valenced and proscriptive as the visual language of curation in physical exhibition. But compiled programs can only be explored experientially, in a virtual manner. Thus, through the lens of software development, works which in terms of physical space seem limitless and inexhaustible are actually very clearly delineated on a code level. They have acceptable, supported forms of interaction (with all the affordances those entail) even if only visible to the artist. Indeed, there's much to be said about the parallels between gallery art installation—resulting from the configuration of elements in precise manners for an intended aesthetic effect—and art software installation—the arrangement of a

computational device's physical states into precise configurations for an intended aesthetic functionality. What confuses our perception of AR borders is that it is a medium seeking (or in dialogue with) embodiment. It inscribes a specific domain from the riot of virtual expressive possibilities, touching the physical world. And it asks of its audience that they engage these virtual elements in an embodied way.

8.4 Ergodic Performance

Espen Aarseth coined the term "ergodic literature" to refer to written works that require significant effort by the reader to decode in order to experience (Aarseth 1997). As touched on earlier, AR is arguably an especially ergodic art form—requiring real work from the viewers (usually in the form of technical proficiency) that can mean some succeed and others fail in grasping its embodied rules and thus exploring the piece to full expressivity. This challenge set before viewers gives rise to another layer of consideration when thinking about the performativity of AR pieces.

In non-interactive artworks there is generally one level of engagement the audience participates in. The differing layers and contexts of analysis each person brings to a piece of artwork may differentiate them when they are placed in dialogue, but for the most part the experience is a uniform level of engagement, even if there are different times and styles of attention and engagement on that level. The varying valences of content can go privately unresolved, while the only thing made public within the exhibition space is the piece of artwork itself.

For viewers of participative interactive artwork, however, interaction can change the perception of the piece for other viewers. Those who come forward to impact the work through interaction become part of the display, and their ability to tease out the performative, perlocutionary subtleties of the work can open them to critique from other viewers, giving rise to performance anxiety. This segments viewers into groups based on their willingness to interact, their willingness to perform the piece (Reeves 2005). Thus, there's an undeniably relational aesthetic element to these projects, especially since the mediation through a technological framing device demands—as a base requirement—perceptual performance from its audience. Holding the device just so, downloading this app, scanning that QR code, knowing to perform a specific sequence of actions, even outside a gallery setting, create a Bourriaudian "state of encounter" (Bourriaud 2009), while at an installation there's a sense of being part of a group, but even in one's home or outside a physical gallery, when accessing AR there's an element of being privy to secret knowledge, a hidden virtual world, that creates a sense of being "in the know." There's a feeling of membership in a distinct group of people, accented by the very fact that AR viewers literally see the world differently than those unaware of the virtual content anchored around them.

The technical demands for artwork utilizing augmented reality are fairly high, requiring either sophisticated software making use of machine vision algorithms, or

software and hardware which can make available to the creator the GPS position and heading of the viewing device. These technical hurdles were overcome for the most part first by companies seeking to monetize AR as a new media platform. As such, artists seeking to work in the medium frequently find themselves first needing to choose a software platform, which comes with its own set of constraints. It is here perhaps that most obviously one can see the restrictions and affordances which control the exhibition of AR work. Outside of licensing fees, the differences in the platforms become the differences in the artworks, much in perhaps the same way that galleries and exhibitions coalesce into a common aesthetic sensibility. Works created in one platform may tend to focus more on marker-based AR, or perhaps more easily incorporate different forms of media as their overlay.

Furthermore, many of these platforms, such as Junaio or Layar, frequently embed their pieces as "channels" which are found through a browsing section of the app. This in turn affects the artwork, whose code is encompassed by that of the framework, by placing it in context beside other pieces. The artist may create their own context independent of the platform, but it is also very likely that a channel used for artwork is listed alongside promotions for a new movie, or an interactive ad in a magazine.

8.5 Physical as Subscriptive

This concept of "channels" is one that is used in many different digital media services, providing a way to aggregate content viewers show interest in, or want to be continually exposed to as more is authored. The interesting twist that AR potentially provides to this arises through its conflation of digital assets and physical, both of which comprise the artwork in totality.

In works that use physical artwork (such as prints or sculpture) as their AR anchors through markerless tracking—such as *From Closed Rooms, Soft Whispers* (Garbe 2013)—the digital is overlaid to provide the second part of the piece (Fig. 8.2). Prints can be distributed, and the work experienced in a variety of locations outside the gallery once the exhibition is concluded. However, exciting new capabilities arise from the fact that the digital assets for AR pieces can be stored on a server, or in project files which remain on the artist's computer. Subsequently, the AR content can be modified, remixed, or even changed whole-sale at a later date by the artist, and those changes can be propagated out to the prints or physical objects owned by gallery viewers. This adds an entirely new valence to the idea of the print or reproduction as an art object, allowing it to function itself as a sort of "channel" to the artist, totemic or not, where new work can seep out from the artist's central server to affect the display and experience of their work long after the art object was acquired. This gives unprecedented control to the artist to affect work already existent in the world, but may also come with a price, in the increased ephemerality endemic to all work relying on the more transitory substrates of digital media.

Fig. 8.2 A digital print from *From Closed Rooms, Soft Whispers*, which serves as an anchor for the augmented reality assets hosted on a central server

8.6 Closing Thoughts

Interactive new media works challenge traditional interpretive methods in many ways—their exceptions and special cases are as variegated as the artists and mediums used in their composition. The addition of interaction complicates audience reception and segments viewers into active participants, and more passive receivers of the perlocutionary actions enacted by the piece. Augmented reality artworks, situated as pieces re-contextualizing the perceptions of the viewers

through intermediary devices, further show themselves as challenges—in the perception of the viewer if not in actuality—to not only the fourth wall of audience passivity, but to the borders and accepted limits of interaction. They accomplish this by translocating those borders into the more numinous virtual world, whose affordances provide a bewildering array of compelling expressions to artists. But although in content they partake of the digital, there is always an element of the physical to augmented reality artwork, something to tie it to the viewer and their embodied experience of the piece. In this way the borders are still very much so present, the affordances and proscriptions built into the very code of the work. Yet the ability to customize those boundaries, to draw one's own curatorial borders and parameters, is in itself a freedom drawing from augmented reality's strengths, inviting a model of the world as not one in which art happens, but one which is conditionally defined and experienced as an integrative work of art.

References

Aarseth EJ. Cybertext: perspectives on ergodic literature. Baltimore: Johns Hopkins University Press; 1997.

Bourriaud N. Relational aesthetics. Dijon: Leses Du Réel; 2009.

Dourish P. Where the action is: the foundations of embodied interaction. Cambridge: MIT Press; 2001.

Freeman JC. Frontera de los Muertos. https://bordermemorial.wordpress.com/ (2013). Accessed 17 Sept 2017.

Garbe J. Translocated boundaries + interview, statement, artwork. Leonardo Electron Alm. 2013;19(1):20–43.

Greenspan B. The new place of reading: locative media and the future of narrative. Digit Humanit Q. 2011;5(3):5.

Morrison A. Designing performativity for mixed reality installations. FORM Akademisk. 2010;3 (1):123–44.

Reeves S. Designing the spectator experience. In: Proceedings of 2005 SIGCHI conference on human factors in computing systems. New York; 2005. p. 741–50.

Scherrer C, Pilet J, Fua P, Lepetit V. The haunted book. In: Proceedings of the 7th IEEE/ACM international symposium on mixed and augmented reality, Cambridge; 2008.

Toews P. Augmented mountain- pyrite. http://www.augmentedmountain.com/pyrite.html (2013). Accessed 17 Sept 2017.

Veenhof S, Skwarek M. Augmented reality art exhibition MoMA NYC (guerrilla intervention). http://www.sndrv.nl/moma (2010). Accessed 17 Sept 2017.

Wardrip-Fruin N, Mateas M. Defining operational logics. In: Proceedings of DiGRA- Breaking new ground: innovation in games, play, practice and theory, London; 2009.

Chapter 9
Immersive Art in Augmented Reality

Todd Margolis

9.1 Introduction

This chapter addresses the emerging trend favoring socially immersive artworks via mobile Augmented Reality over sensorially immersive AR that was based on historical Virtual Reality ideals. It will first define the various types of immersion being discussed and make distinctions in how the same term has taken on a new connotation with modern information technology. Then, we will explore socially immersive artwork by looking at both the empowering head-mounted technologies and some early examples using Google Glass. This will lead to a discussion on collaborative locative media by investigating enabling toolkits and tracing its roots back from Land Art of the 1960s through early community-created gaming platforms to massively multiplayer online games and ultimately to the current phenomenon of collaborative "Field Art" taking place in the AR game Ingress. Then, we will conclude with a better understanding on how artists are exploring mobile Augmented Reality within an internet native culture focused on connecting people with each other through information sharing.

9.2 Definitions/Distinctions

9.2.1 Sensorial Immersion

The goal of immersion within Virtual Reality has been to surround participants with visual (and sometimes auditory, tactile or other) stimuli to evoke a sense of dis-

T. Margolis (✉)
Qlik, Berkeley, CA, USA
e-mail: tmargo@gmail.com
URL: http://www.toddmargolis.net

© Springer International Publishing AG 2018
V. Geroimenko (ed.), *Augmented Reality Art*, Springer Series on Cultural
Computing, https://doi.org/10.1007/978-3-319-69932-5_9

placement whereby the physical world is supplanted by an alternate reality. Sensorial immersion can be applied to Augmented Reality in a manner that bases this reality on the nearby physical world, but adds virtual objects into that world. Technically speaking, Tobias Höllerer (2004) defines an AR system as "one that combines real and computer-generated information in a real environment, interactively and in real time and aligns virtual objects with physical ones" (Höllerer and Feiner 2004). This form of mobile AR has been typified in science-fiction film and literature with examples such as Princess Leia's holographic avatar, William Gibson's AR tableau of River Phoenix in Spook Country and the user interfaces in Minority Report and Iron Man, to name a few. AR interfaces would know your physical position and head orientation so that an onboard microcomputer could determine how to correctly "insert" objects into your visual perception in such a manner as to convince you that they are as real as the physical objects they are next to.

9.2.2 Social Immersion

Margolis et al. (2012) expanded upon Jonathan Steuer's (1992) definition of Virtual Reality (Steuer 1992) to describe an emerging form of social immersion used in mobile AR as "the social richness of a mediated environment as defined by its interactive features, that is, the way in which an environment layers networked information via real and virtual means" (Margolis et al. 2012). This form of media is not simply virtual object overlays, but of stories that connect these objects to the people and places that imbue their meaning. This new view of immersion enables us to describe participatory practices within contemporary culture that use mobile social media networking applications which give us an unprecedented ability to share information with social groups and the world instantaneously. For example, Wikitude streams information about nearby events, tweets, Wikipedia articles and user reviews into the live camera view on smart phones. Also, transmedia storytelling creates a sense of social immersion by unfolding elements of a fictional story across different platforms to create an interactive narrative over time and space.

9.3 Socially Immersive Art

9.3.1 Head-Mounted AR (Wearable Smart Phones)

Head-mounted displays (HMDs) have been used as a means of displaying Virtual Reality content for decades. These systems present 3D computer graphics by placing small screens very close to the eyes. There are several devices that have come to market over the last few years such as Epson's Moverio, NEC's Tele

Scouter and the Oculus Rift which can be described using the sensorial form of immersion for AR since they overlay graphics onto the real world through see-through optics or by rendering CG over live video to opaque displays. It is important to understand these devices and the affordances they provide in order to explore what differentiates them from new platforms that are now forthcoming which are better categorized as providing social immersion for AR.

While technically the Oculus Rift is a VR HMD, given the fact that there are other vendors (Ovrvision 2014) offering camera modification attachments to enable real-time video overlays within the Rift display, it is worthwhile to compare and evaluate the Rift as a viable head-mounted AR device. The latest version of the Rift dubbed Crystal Cove incorporates markers on the outside of the Rift along with an external camera that enables head tracking so that as users move their heads in the real world, the virtual environment responds accordingly. This is a key feature for designing an AR system since the computer needs to know exactly where to position virtual objects on top of the live video stream as users move around. The AR-Rift (AR-Rift 2014) is also particularly interesting as it enables users to create virtual desktops within AR to create entirely new ways to work with standard applications.

As one of the most commercially successful HMD manufacturers, Oculus Rift raised ten times more than the original $250,000 Kickstarter campaign goal. It is therefore important to understand how they are focusing their business interests on the gaming sector as evidenced by hiring several of the most influential game developers such as Epic's John Carmack and EA's David DeMartini as key company strategists. This will likely make the device much more powerful and user-friendly than if it were intended primarily for scientific or military use like so many other VR headsets. It is then worth considering how game consoles have become increasingly social as they have become inherently networked. Both the PS4 and Xbox One have added built-in DVR systems to enable gameplay recording and playback as well as enabling sharing those videos to social media sites like Facebook. Perhaps even more importantly, Sony has added broadcast capabilities to the PS4 so that users can stream their live gameplay (with live picture-in-picture camera view of the player) to sites like twitch.tv and ustream.tv with the push of a button on the controller. Some of these home broadcasts reach tens of thousands of viewers and in the first 6 weeks since launch, PS4 users have already broadcast 1.7 million streams generating more than 55 million minutes while being watched by 22 million sessions (Twitch: PS4 streaming 2014). These broadcasts are accompanied by chat windows to enable discussion both within the virtual community and with the original player. It is then very likely that these highly established game consoles will influence the Rift and so we can consider how these emerging video sharing platforms may be integrated with a HMD like the Rift.

Google Glass, on the other hand, is a new device that might be best described within AR as a heads-up display (HUD) rather than a HMD like the Rift. HUDs were originally designed starting around WW II for military use to overlay navigational information onto aircraft windshields or helmets, but are now commonplace within most gaming user interfaces to display information such as health and

inventory as well as chat boxes and mini-maps to collaborate with teammates. Google Glass works in a similar way by showing various types of information in the upper-right section of your field of view. It can provide you with directions, look up facts, translate your voice or physical signage and of course help connect you with others. One of Glass's most powerful features is the ability to live-stream video from your own point of view anywhere and anytime. It is similar to a Google Hangout, but it is completely untethered. These features quite distinctly differentiate Glass from other forms of AR by creating what we can describe as social immersion rather than sensorial immersion like the Rift.

9.3.2 Socially Immersive Artworks

Google Glass art is like the new reality TV—Glass art through live streaming ties back to artist and Internet pioneer Josh Harris and his various 1990s projects like "Quiet: We Live in Public" which surrounded 100 secluded artists with webcams and broadcast their every move onto the Internet. Now Glass ups the ante by enabling completely untethered high-quality directorial power to broadcast your own life or the lives of those you think the public may covet.

Helpouts (Helpouts by Google) were released in November 2013 in order to create a public marketplace for purported experts to provide real-time video chats for a fee. They are in essence an extension of Google Hangouts which have been continuously evolving to provide better-quality multiuser video chat rooms with included screen sharing and embedded text chats. While the marketplace is only a couple of months old, there are already thousands of advertised services listed there grouped into the following categories: Art & Music, Computers & Electronics, Cooking, Education & Careers, Fashion & Beauty, Fitness & Nutrition, Health and finally Home & Garden. The specific services being offered tend to range from pre-made lessons (e.g. over 50 people offering Helpouts to Learn to Play Guitar) to more personal problem-solving sessions (e.g. over 70 people offering Helpouts to solve peoples' Computer Issues). These live video sessions are particularly well suited for use with Glass in that many of them require the instructor to be hands-free in order to help execute the Helpout.

New York artist Molly Crabapple made a drawing of porn star and circus performer Stoya while wearing a pair of hacked Glasses in a project entitled Glass Gaze (Artist gazes at porn performer 2013). The Glass enabled Crabapple to live-stream what she saw and thereby "to take the most classical, thousand-year-old way of looking: an artist looking at a model. It is the most undistracted, direct, unmediated thing. And then, run it through this super-mediated, captured, com-modified way of seeing that Glass represents." Crabapple reports that wearing Google Glass while drawing made it tempting to constantly look at the image in the corner of her vision of what was being recorded. Crabapple describes the uncanny drawing process by stating "Glass is all about distraction, and it's the ultimate in unphysical—it's light on a piece of clear plastic in front of your eye."

New York city curator Samantha Katz created Gallery Glass in September 2013 as a YouTube channel (Gallery Glass—YouTube) to highlight Brooklyn artists by filming 30 artists over 30 days while wearing Google Glass (Bushwick Artist Uses "Google Glass" 2013). Although the videos posted to YouTube are still edited and generally feel like they could have been filmed with a handheld camera, as shown in Fig. 9.1, Katz argues that Glass can give viewers a first person perspective that presents "what it is like to walk in a studio." At times Katz hands her Google Glasses over to the artists as they draw or paint, but unfortunately the videos have been edited so that the audio from the interviews is overlaid onto the visuals of the painting and drawing. While this is a standard editing technique for cinematic film, in the case here for Gallery Glass it tends to disrupt the attempt at experiencing the creation of an artwork from the artists' perspective. Katz admits the project was a "beta" test and is interested in continuing to explore the potential use of Glass for learning about art.

It could be argued that David Datuna's Viewpoint of Billions is perhaps one of the only works of art to date that is truly unique to Google Glass (David Datuna 2014). Datuna worked with mobile app developers BrickSimple to create an interactive installation that at first glance represents an American flag—see Fig. 9.2. However, as one approaches the artwork, you will see the surface is covered with found eyeglass lenses. Beneath the lenses is a collage of photographs and newspaper clippings as well as hidden cameras and microcomputers. The cameras can record visitors as they experience the artwork and then live-stream that video back to those same visitors wearing the Google Glasses. This creates a sort of feedback mechanism in which the artwork appears to be watching you back as you watch it. While other video artists like Steina and Woody Vasulka pioneered using video feedback, Datuna's use of Glass to transmit a live video of one's self via a camera hidden directly within the artwork perhaps takes this concept to a new level.

Fig. 9.1 First person perspective via Google Glass from an artist Katz interviewed as she created a new drawing

Fig. 9.2 Viewpoint of
billions by New York artist
David Datuna at Art Basel
Miami (DatunaGlassfeed)

9.4 Collaborative Locative Media

9.4.1 Handheld AR Platforms

In order to understand how mobile AR is evolving into a socially immersive medium, we will first present two exemplars of popular mobile Augmented Reality applications for smart phones and tablets. Both of these began with a traditional attempt at fulfilling the original AR goal of providing a platform for developers to create sensorially immersive AR experiences. However, they both continue to evolve to enable authors of mobile AR experiences to produce content in an increasingly more accessible manner as well as provide more and more hooks into social media platforms for quickly sharing content and experiences with friends, colleagues and collaborators.

Layar is a good example of a popular consumer mobile AR browser that allows developers to geotag a location with images, text, sound or other media (Layar). When a user is exploring the physical world through their phone or tablet, they are able to view nearby AR content overlaid on top of a real-time video feed via the device's camera. Layar enables developers to encourage end users to easily share their AR experiences with friends on various social media platforms such as Facebook and Twitter.

Over time, Layar has changed its business model as to how to best support mobile AR technologies. They have added computer vision based scanning to their toolkit of sensing technologies. So instead of finding content solely based on your physical location, you can now point your phone or tablet's camera at an image target. Historically, AR marker targets tended to be black and white geometric patterns that resembled 2D bar charts. Nowadays, Layar and many other computer vision manufacturers use markerless targets that can be defined by any natural image as long as it adheres to a few basic technical requirements such as non-repeating patterns, no motion blur, avoiding reflections and transparencies and

has generally flat illumination. This new sensing platform enabled Layar and others to support AR experiences within interior spaces where GPS satellites would not work reliably. However, from a demographics perspective, this new feature provides for countless new advertising and marketing opportunities as now companies can integrate mobile AR with their brand experience much easier.

Qualcomm's AR Software Development Kit, Vuforia, enables Android and iPhone developers to incorporate sophisticated natural image-based tracking into their mobile AR applications (Qualcomm Vuforia 2010). Vuforia also requires developers to specify an image target that users can then point their mobile phone or tablet toward to view a real-time augment. However, Vuforia also adds extended tracking to enable users to have continuous visual experiences even when the tracked target is outside of the camera view. While this might seem to be a trivial technicality, it provides for a much more seamless and immersive AR experience since now you are not required to keep your mobile device pointed at a particular physical object, but instead one can simply use their phone or tablet to explore the entire surrounding environment as well.

It is important to understand that Layar and Vuforia have taken different approaches to mobile AR development and publishing. As an AR browser, Layar requires that end users install a single official Layar application onto their smart device. Once the user has installed this app, they have access to all of the AR "channels" that developers have published using the Layar platform. Users can either scan an image target or search through keywords and categories to find results of what AR content might exist near them. Vuforia, on the other hand, is meant to be packaged as a custom application for each AR experience. This means that end users must download and install a different app for every application built using Vuforia. However, it also provides developers with much more control over the application and enables apps to utilize all available Android or iPhone services and libraries to build a highly rich and engaging mobile experience.

9.4.2 Handheld AR Media

These new socially based immersive media platforms provide affordances for new forms of locative artworks that were not possible before. Here we will discuss how geo-locative artworks and experiences have been emerging and where there may be precedents of artists and gamers working collaboratively within large-scale environments (both physical and virtual) that perhaps have laid the cultural landscape for artists today to explore these new socially immersive AR collaborations.

In the late 1960s, Joseph Beuys developed a theory of Social Sculpture that describes a society in which "Everyone is an artist." He illustrates the idea that art is meant to be participatory and can hold the power to transform society. Like Richard Wagner, Beuys strongly argued for a Gesamtkunstwerk in which society as a whole was to be regarded as one great work of art. This helped to lay the foundation for Land Art in the late 1960s where the landscape and the work of art were

Fig. 9.3 Spiral Jetty by
Robert Smithson (1970).
1500 ft in Utah, US

inextricably linked as seen in Fig. 9.3 documenting Spiral Jetty. Much like con-
temporary AR artwork, Land Art was meant as a protest against the traditional
museum and gallery art worlds in order to bring power back to the community.

Perhaps inspired by the well-known artists who have been transforming the land-
scape of our planet for the last 50 years, other lesser known artists have been trans-
forming the landscapes of virtual environments for the last decade. Perhaps most
famous of these online virtual worlds is Second Life (SL) which has had over 20 million
subscribers. Many SL users pride themselves on the creative design of space and objects
in SL and collaborate in groups on large-scale installations. Some of these installations
mimic spaces from the real world such as in Becoming Dragon (Cárdenas et al. 2009),
while others create psychedelic art installations like StormEye (Story and Enfield 2009)
out of giant moving shapes coated in video and sound. Artists build these virtual
installations and then share them with other citizens of Second Life to experience.

However, this idea of locative art within a virtual world is not new to online
platforms. Gamers have been designing their own levels for decades. Lode Runner
from 1983 was one of the earliest games to come with a level editor that enabled
level designers to create their own custom environments for playing within. The
website worldofleveldesign.com is built exclusively for this community to aid
sharing articles and tutorials for environment artists and level designers to help with
all aspects of working on level designs and 2D/3D environments. Also,
LEVEL-DESIGN.org has a reference database of tagged image screenshots to help
share ideas on level design.

Now, there are countless massively multiplayer online (MMO) games where
large groups of users collaborate together in teams and factions to move through the
game story. In addition to solving the challenges presented by the original game
designers, players often choose to create their own virtual art installations within the
game world. LittleBigPlanet is an example launched in 2008 on the Playstation 3
that focused primarily on user-generated content as evidenced by their tagline
"Play, Create, Share" and over 1 million user-created levels to play.

Ingress is a transmedia game by Google played out through live events, the web
and mobile applications. The players' goal is to capture "portals" which are
co-located with objects in the real world such as public art sculptures, landmarks
and libraries. Once captured, three or more portals can be linked together to create

(a) **(b)**

(c) **(d)**

Fig. 9.4 Field Art created with Ingress. **a** Flower in Germany. **b** Christmas tree in London is over two miles long (Monnington 2013). **c** Butterfly in Heidelberg, Germany (RNK Field Art 2013). **d** Woodpecker in Germany (Stadler 2013)

fields that give users points. Two factions players must choose between, the enlightened and the resistance, which battle each other to control these portals and fields. As of January 2014, over one million people are walking through cities around the planet capturing portals and linking fields.

There are no pre-defined rules on what the shape of these portal fields should look like and most of them are abstract shapes designed to maximize the amount of underlying land controlled with no consideration given to esthetics. However, having reviewed the history of locative art in Social Sculpture, computer gaming and science fiction, we might find it inevitable that players have begun to create specific designs within these Augmented Reality platforms so that they link portals together in a strategic manner as to form a representational image across actual cities. This so-called Field Art may connect dozens of points spanning entire cities. Given that every portal and field is in constant danger of being attacked, it is easy for one to appreciate the transient complexity of these undertakings and the need for large groups of people to help create them. We might perhaps expect to find that several Field Art installations utilize collaborations between factions to create even more complex designs. In the screenshots shown in Fig. 9.4, you can identify the two factions contributions by looking at the two colors on the maps.

In addition to esthetic designs created within Ingress, players have used the game platform for political and social commentary. After the Boston marathon bombing, MIT Ingress players from both opposing factions agreed to a temporary ceasefire on the MIT campus as well as erected a dual owned virtual memorial for the slain MIT police officer Sean Collier.

9.5 Conclusion

We are beginning to experience mobile Augmented Reality in a new context within a culture that has come to expect (and rely upon) persistent connections between people and information. Naturally then we architect systems to better connect with each other through the Internet. These new platforms are enabling us to create new worlds that bring us together through our common interests. So whether it is learning how to paint nudes with 100 strangers via Google Glass Helpouts or touring CERN via Glass or creating virtual landscape art installations on top of and in the middle of New York City, these new socially immersive media are changing the way we can create, share and play.

Acknowledgements Eternal thanks to my beautiful wife Tracy Cornish for her love and support as well as her critical discourse in exploring social immersion with me. Many thanks to Alexander Nano Horn for his help reviewing and guiding this article toward clarity as well as providing wonderful examples to help contextualize some of the history of level design in gaming.

References

Cárdenas M, Head C, Margolis T, Greco K. Becoming dragon: a mixed reality durational performance in Second Life. Proc SPIE. 2009; 7238:723807-723807-13.
David Datuna for Glass. 2014. http://datuna.com/. Accessed 13 Sept 2017.

Höllerer TH, Feiner SK. Mobile augmented reality. In: Telegeoinformatics: location-based computing and services. United Kingdom: Taylor & Francis Books Ltd; 2004. p. 1–39.

Margolis T, Cornish T, Berry R, DeFanti TA. Immersive realities: articulating the shift from VR to mobile AR through artistic practice. In: Proceedings of SPIE, the engineering reality of virtual reality, 82890F. San Francisco, California: SPIE Digital Library; 2012.

Monnington L. tl; dr: we made a purdy tree!; 2013.

Ovrvision. http://ovrvision.com/. Accessed 8 May 2014.

Qualcomm Vuforia. 2010. https://www.vuforia.com. Accessed 13 Sept 2017.

RNK Field Art. 2013. https://plus.google.com/communities/105136616454643645459. Accessed 13 Sept 2017.

Smithson R. Spiral Jetty. 1970. https://www.diaart.org/visit/visit/robert-smithson-spiral-jetty. Accessed 21 Jan 2018.

Stadler M. Field art Greifswald—operation woodpecker; 2013.

Steptoe W. AR-Rift. 2013. http://willsteptoe.com/post/66968953089/ar-rift-part-1. Accessed 12 Sept 2017.

Steuer J. Defining virtual reality: dimensions determining telepresence. J Commun. 1992;42: 73–93.

Story D, Enfield D. StormEye 2009. http://slstormeye.blogspot.com. Accessed 12 Sept 2017.

Chapter 10
Skin to Skin: Performing Augmented Reality

Kim Vincs, Alison Bennett, John McCormick, Jordan Beth Vincent
and Stephanie Hutchison

10.1 Introduction

Embedded throughout the work of media theorist Vilem Flusser is the observation that technologies create paradigms (Flusser 2011: 3–4). He argues that writing created linear historical consciousness, technical images such as photography created scanning, or thinking in two-dimensional planes, and he predicted that com-

K. Vincs (✉) · J. McCormick
Department of Film and Animation, Swinburne University of Technology,
Melbourne, Australia
e-mail: kvincs@swin.edu.au
URL: https://www.swinburne.edu.au/research/our-research/access-our-research/
find-a-researcher-or-supervisor/researcher-profile/?id=kvincs

J. McCormick
e-mail: jmccormick@swin.edu.au
URL: https://www.swinburne.edu.au/research/our-research/access-our-research/
find-a-researcher-or-supervisor/researcher-profile/?id=jmccormick

A. Bennett
School of Art, College of Design and Social Context, RMIT University,
Melbourne, Australia
e-mail: alison.bennett@rmit.edu.au
URL: http://www.alison.bennett.net

J. B. Vincent
Deakin Motion.Lab—Centre for Creative Arts Research, Deakin University,
Melbourne, Australia
e-mail: jordan.vincent@deakin.edu.au
URL: http://www.motionlab.deakin.edu.au

S. Hutchison
Creative Lab, School of Creative Practice, Queensland University of Technology,
Brisbane, Australia
e-mail: s2.hutchison@qut.edu.au
URL: http://www.stephhutchison.com

© Springer International Publishing AG 2018
V. Geroimenko (ed.), *Augmented Reality Art*, Springer Series on Cultural
Computing, https://doi.org/10.1007/978-3-319-69932-5_10

puters would facilitate complex networked or 'structural' thinking. Flusser goes
beyond Marshall McLuhan's 1964 dictum that 'the medium is the message'
(McLuhan 2013: 19) to assert that new media make new kinds of messages pos-
sible, because new technologies suggest and support new conceptual structures
which, in turn, influence how ideas are formed and what kinds of ideas can be
formed.[1]

The emergence of augmented reality then necessitates a consideration of the new
theoretical and conceptual implications this technology enables. This is not to say
that augmented reality must create new ways of thinking and making. It is possible
(and not always a bad thing) to simply recreate existing conceptual and artistic
paradigms using a new technology. However, to fail to consider how potential
conceptual and artistic shifts are made in relation to technologies such as aug-
mented reality limits both the opportunities involved and our understanding of work
that is made in these new technological spaces.

This chapter undertakes such an examination of augmented reality, using
examples from a series of investigations that took place at the Deakin Motion.Lab
over the last five years as a way of mapping the forms in which technology has
enabled conceptual shifts in both developing and finished art works. This is, of
necessity, a somewhat retrospective and iterative process. We work from a
practice-led perspective in which creation and conception occur together and in
ways that are not necessarily immediately apparent in the process of making work.
Conceptual shifts happen through the process of making, and it is only retrospec-
tively that it is possible (and then imperfectly) to begin to synthesize the strands of
thought and work in ways that create a coherent whole. We aim, in this chapter, to
circle in on some of the paradigms made possible by augmented reality in creative
practice through a dual analysis of the affordances, to use James Gibson's (1986:
127–128) term, we associate with augmented reality processes and of the perfor-
mative paradigms we are able to enact in our artworks.

10.2 Computational and Physical Spaces: A Digital Dualism?

There was a time when the conceptual space created by computers and digital
technology was limited to an elite. Personal computers emerged in the 1970s
(Atkinson 2010: 80–90). The Internet was opened beyond the military and aca-
demic spheres in the year of 1991 (Thomas and Wyatt 1999: 683). Until quite
recently, computers were something that one sat down to at a desk. There was a
distinct separation between engagement and disengagement from the technology
that was encapsulated in the notion of being 'online' or 'offline.'

[1]Indeed, Flusser went so far as to say that '… McLuhan … proposes an attitude towards the image
that I consider fascistoid' (Flusser 2011: 8.50).

Whilst cyberpunk author William Gibson is credited with coining and popularising the concept of cyberspace as an immersive and separate reality in the 1980s (Bell 2007: 2), since 2010, Gibson has noted the 'eversion' of the relationship between cyberspace and the physical world. Instead of sitting at a screen and disengaging from one's body into cyberspace, the digital world now overlays and engulfs the physical. Gibson's (2007) novel Spook Country created a compelling image of the digital that overlays the physical. In a 2010 interview with BBC technology correspondent Mark Ward, Gibson said 'Cyberspace is colonising what we used to think of as the real world... I think that our grandchildren will probably regard the distinction we make between what we call the real world and what they think of as simply the world as the quaintest and most incomprehensible thing about us' (Ward 2010).

Since the introduction of Internet-enabled smart phones accelerated with the introduction of the iPhone in 2007 (Goggin 2012: 11), the distinction between digital and physical space has rapidly converged. However, at this point in time, the conceptual models used to discuss and explore this technical/cultural shift are still in the process of recalibrating. What sociologist Nathan Jurgenson describes as 'digital dualism' is the tendency to conceive of the 'digital' and 'physical' as separate and distinct realities (Jurgenson 2009, 2011). We see digital dualism in the persistence of terms such as 'real' versus 'virtual,' which imply there is a disjuncture between the two conditions. These terms point to a lag in the cultural conceptual models we use to discuss this dynamic. Jurgenson proposes that augmented reality offers a more useful conceptual model with which to discuss and explore our contemporary relationship with digital technology. He proposes that, in addition to a technological application, augmented reality offers a useful conceptual model with which to discuss an emerging cultural paradigm (Jurgenson 2011).

Jurgenson argues that digital dualism is a faulty ontological conception that our online and offline lives are separate and that the former is somehow inferior to the latter. As Jurgenson points out, 'online' behaviour has real-world consequences, and this can be successfully traced through political activism like the Occupy Movement. Jurgenson does not suggest that our online and offline profiles are the same (as he points out, there will always be a distinction between flesh-and-blood interactions and our engagement through new media), but rather that the barriers between online and offline behaviours have collapsed and that we traverse multiple realities as part of a conceptual framework he refers to as Augmented Reality (Jurgenson 2012). 'I am proposing an alternative view that states that our reality is both technological and organic, both digital and physical, all at once. We are not crossing in and out of separate digital and physical realities, a la The Matrix, but instead live in one reality, one that is augmented by atoms and bits' (Jurgenson 2011).

We wish to consider Jurgenson's concept of digital dualism, and in particular, the argument that understanding 'real' and 'virtual' space as distinct conditions is an artefact drawn from a now outdated kind of computing experience, as elaborated by Boesel and Rey (2013), in relation to digital performance. Digital performance involves the integration of live, physical performance with digital image-creation techniques.

In dance, the advent of digital performance has generated new debate about the nature of 'virtual' dance. As we, along with many others, have argued, the concept of the virtual in dance predates digital technology (e.g. Vincs 2016). Art philosopher Susanne Langer suggested 'virtual force' as the primary means of symbol-creation in dance in the 1940s (Langer 1953: 169–207). Responding to the need to re-define 'virtual' dance in the light of digital performance works, Burt (2009: 442–467) and Boucher (2011) have argued that the term 'virtual' relates to 'what might be' rather than a specifically computer-based paradigm. This thinking is expanded by Erin Manning in her concept of 'movement-as-becoming' in which 'pre-acceleration' implies the possibilities of movement that constitute a virtuality that is temporal in nature, evocative of what a movement could become in the moment of its initiation, and destroyed as soon as actual displacement of the body takes place (Manning 2009: location 67–81). In this sense, dance theory aligns with Jurgenson's position in dismantling the idea that there is a fundamental difference between the idea of virtuality in physical and digital spaces.

Digital performance provides an example of a domain in which new kinds of technically-enabled artwork generate the need to explore and examine new conceptual paradigms. Just as Auslander argued in the 1990s (Auslander 1999: 38–39) that the technological process of mediatising performance created the notion of liveness in a way that was not possible before video recording technology, digitally enhanced dance performance generated new thought regarding the notion of the 'virtual' and the need to disassociate it from a purely digital, technological definition. A new conceptual model for valuing and discussing the work was needed that could then be fed back into discussions of dance work that does not use digital augmentation technologies.

However, despite the elegant synthesis of the term 'virtual' into a concept that can deal equally with physical and digital contexts, there remains a sense of anxiety about how digital technology impacts on the embodied movement experience that is fundamental to dance. What is the dramaturgy of the digital in relation to live performance? If virtuality, in Manning's sense of the incipiency of movement, can exist simultaneously in physical and digital domains, as in the case of dance performance that is augmented by digital image 'overlays', how are the sensory disjunctures between the two kinds of performance (physical body and digital image)[2] rendered meaningful?

The concern about a kind of 'incompatibility' between humans and digital technology seems somewhat magnified in dance. As an art form that has always celebrated the moving, physical body, dancers have expressed concern about the potential 'disembodiment' of the art form through the introduction of digital technology (Gunduz 2012: 309). Curiously, this fear does not seem to extend to the

[2]We refer primarily here to digital images; however, a similar argument can be made for digital sonification within dance performances.

notion of using digital technology as a means of generating movement material, nor is it as concerning in environments where digital and biological are overlayed, with the latter retaining both physical prominence (value) and/or serving as the dominant, or driving force within the circuit.

Whether in the form of hydraulic lifts and sunken floors, lighting effects or video projection, 'theatrical deceit' is a familiar part of the repertoire of performance experience. However, the use of digital imagery such as interactive systems as integral to the dramaturgy of a dance work seems more problematic. The difference here is a shift from technology serving the meaning or the narrative of a performance, as opposed to presenting a competing 'body' within the space. From the audience member's perspective, in the absence of the ability to taste, touch or smell the digital entities, both the biological and the digital are perceived visually. Both are 'real,' and both lay claim to playing an integral performative role in the work (Fig. 10.1).

Steve Dixon has described the tension this creates. 'The artificiality or falsehood of the digital image has therefore limited appeal to many live artists on aesthetic, ideological and political grounds. This is particularly the case in fields such as physical theatre and body art, where the primary aim is the enactment of 'embodied authenticity', realised through the 'no smoke and mirrors' and 'no-strings-attached' material tangibility of the visceral, physical body. There is therefore a tension, even conflict, between those within performance practice and criticism at either side of the digital divide, which should not be underestimated. This has been exacerbated by the paradoxical rhetoric of disembodiment and virtual bodies, which have turned

Fig. 10.1 *The Crack Up* 2014 by Kim Vincs

ideas of corporeal reality full circle by the claim that the digital body has equal status and authenticity to the biological one. The paradox that projected databodies and alternate identities enacted in cyberspace can be viewed as being just as, or even more vital and authentic than their quotidian referents, is now a source of belief and wonder to some and a totally unpalatable conception to others' (Dixon 2007: 24).

Underlying these divergent perspectives is a question of ontological cohesion. Observing a human performer is an experience of a different order to that of observing digitally created images. Dixon explains the disjuncture by referring to Susan Sontag. 'Taking the risk of extending Sontag's implied hierarchies of form, we would expand her idea further to argue that the sense of ritual and event is (or at least should be) far more marked in live performance than in cinema... Where film, video, or digital projections are used in conjunction with live performers in theatrical contexts, once the performers leave the stage, there is a marked difference in the mode of spectatorship' (Dixon 2007: 129).

For some, blending different modes of spectatorship is unproblematic, even, to take a Deleuzian view, simply to be expected (Deleuze and Guttari 1987: 9–28). For others, it appears to usurp the centrality of the (physical) body in performance, perhaps exposing an underlying anxiety about the status of the body drawn from the need to constantly re-assert the body's significance in the face of the ephemerality of performance. We suggest that these divergent views could be seen as an artefact of the change in the nature of the digital that Jurgenson suggests has left us with a concept of digital duality that pertains to a previous generation of technology.

A useful parallel for this argument is to look at the evolution of libraries. As Sarah Wanenchak (2013) has pointed out, ambivalence about the changes from mortar-and-stone buildings housing texts to digital access points assumes that there is a 'single ideal type of Librariness', even as it overlooks the historical evolutions of libraries since the Middle Ages. However, the parameters we associate with twentieth-century libraries are shifting. Though the 'Library' still accomplishes its purpose—namely to share information—sharing information is no longer limited by time and space. For example, accessibility to text is not constrained by opening hours, by competing interests from other readers or by geographical proximity to the library. The purpose of the institution has not fundamentally changed, but the physical, geographical and temporal parameters have shifted dramatically. As Wanenchak writes: 'We are accustomed to books being heavy with time. On some level, it's unnerving when they aren't—or at least not in the way that we're used to... When we hold an ereader, we are aware—if only subconsciously—that time is not there in the same way it is with a dead tree book. It doesn't connect to all the temporally-laden ideas of Bookness that we carry around in our collective cultural memory' (Wanenchak 2013).

Wanenchak talks about books as 'profoundly time-laden', within a 'world that seems both temporal and violently atemporal' (Wanenchak 2013). This example is useful when we turn to the evolution of live dance and particularly the integration of biological bodies with digital entities. As in the case with our nostalgia for a Library with its twentieth-century temporal, physical and geographical limitations, the shifts

towards inter-media performance throw up a number of questions. Removing dance from its embodied performative state alters the nature of the art form. Like reading a book, watching a dance performance is a time-laden activity. It takes time to watch a performance, and watching a performance foregrounds the temporal context of the performer herself (e.g. her age, career context). Removing the embodied condition also displaces the performance and hence the performer from its/her original geographical context. When physical and digital 'bodies' coincide in performance. One is confronted with the 'old' notion of the performing physical body, alongside the 'new' digitized version of that body. Definitions of both drawn from a now out-dated dualistic view of the physical and digital must be sifted through and responded to in the moment of watching such a performance.

10.3 Augmented Reality Performance

The concept of augmented reality acts as a point of disjuncture in this discussion. Augmented reality is usually thought of in terms of a particular technology that recognises images in the physical world, which then triggers image overlays to be projected as if coexisting with the scene the observer is viewing. However, in this discussion, we wish to broaden this idea to consider the concept of visually overlaying the physical and digital regardless of the technology used, in order to begin to map how augmented reality artwork both informs and is made possible by this concept. To do this, we discuss three digital performance works created at the Deakin Motion.Lab.

The first work, *Shifting Skin*,[3] created by Alison Bennett, provides a performative, embodied encounter with a series of photographs created using a flatbed scanner to create images of skin and specifically of skin with scars and tattoos (Bennett 2013). When viewers observe a series of photographic prints through an iPad, an augmented reality overlay appears, generating depth in relation to the colours in the image. As Fig. 10.2 demonstrates, the work creates an augmented reality overlay of screen-based content with fine art print. The print- and screen-based content presents alternatively flattened and expanded skin as a metaphor for surface. The augmented reality creates the illusion that the virtual content projects out of the print, and that print and virtual image are directly spatially connected. The 3D topology is an inversion of the surface data captured in the scans. The experience of viewing *Shifting Skin* is performative in the sense that observers are able to move in relation to the image and the iPad to obtain different views. The work generates a sense of physical play that may have seemed at odds with the digital and Web-based nature of the digital overlay. Internet content can potentially be omnipresent, in any place. However, when applied in an augmented reality context, it becomes tied to a specific place. This was a locative use of

[3]*Shifting Skin* opened at the Deakin University Art Gallery, 24 July–31 August.

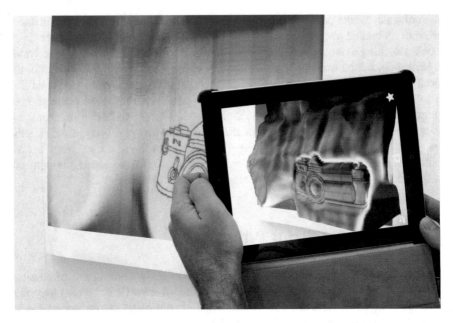

Fig. 10.2 Untitled (camera) from the series '*Shifting Skin*' 2013 by Alison Bennett

Internet application in a field in which content is normally widely disseminated and one that juxtaposes physical and digital worlds in a way that is performatively created by the viewers' physical actions.

The second example comes from the development of a section within the *The Crack Up*[4] (see Fig. 10.1), an evening-length work that used several different approaches to juxtapose live and digitally produced performance images.

This scene, created by John McCormick, Alison Bennett, Kim Vincs and Steph Hutchison, uses images from *Shifting Skin* as a basis for a different kind of physical/ digital juxtaposition. In this case, movement data from the Kinect is used to drive a depth map generated from the photographic image using real-time data from a dance performer (see Fig. 10.3), via a custom interface created by McCormick using the Unity game engine. This process generates large spikes, which, since the image is projected behind the dancer in stereoscopic (3D) mode, appear to rise out of the image like a bizarre collection of brightly coloured, needle-sharp spikes. The audience sees a dancer in dialogue with her own movement data, transformed into a kind of 'figure' formed from the spikes rising dynamically from the image. This work focuses on creating digital and physical overlays in the context of a live dance performance. As in *Shifting Skin*, the human form seems to arise out of the image of tattooed skin. However, in this case, the form is not supplied by data sent from a

[4]*The Crack Up* premiered at the Merlyn Theatre, The Coopers Malthouse, in Melbourne in October 2014 as part of the City of Melbourne Knowledge Week.

Fig. 10.3 'Spikey Guy' (The Crack Up) 2013 by John McCormick, Alison Bennett, Steph Hutchison and Kim Vincs

remote server, but is generated by the real-time movement of the performer. One effectively sees three 'performers': Hutchison as physical presence, a digital humanoid form created using depth mapping based on Hutchison's movement data and a digital 'skin' that moves across the dynamic topography of the spikes.

The third work is *Recognition*[5], created by John McCormick and performed by Steph Hutchison. This work, for us, most fully encompasses Jurgenson's definition of augmented reality as the embeddedness between the digital and the physical. In this work, a series of spheres move, again in 3D stereoscopic space, in response to motion capture data from a performer, again via a scene in Unity game engine created by McCormick. The spheres are wrapped in an image of the iris of one of the creator's eyes, as a way of embedding the physicality of the performer's physical body within the digitally generated aspects of the work. The movement of the spheres follows the performer's limbs and is mirrored to create a symmetrical yet highly readable rendition of the movement (see Fig. 10.4). In this work, however, the digital imagery can be driven either in real time by a performer or by an artificial intelligence choreographic agent developed by McCormick (2013). The

[5]*Recognition* was first shown at the Frankston Arts Centre, 4–28 September 2013 http://artscentre.frankston.vic.gov.au/Arts_To_See_Do/Exhibitions/Past_Exhibitions/John_McCormick.

Fig. 10.4 'Recognition' 2013 by John McCormick

agent, constructed using a self-organising map (Kohonen 1989) 'learns' from motion capture data input and is able to perform a rendition based on known movement phrases. The agent was given input from Hutchison's movement data and therefore has a dance vocabulary derived from her movement. This system created a more detailed and complex integration of physical and digital elements since the machine-based system, in this instance, shares not only a visual projected space with a human performer, but also shares a movement vocabulary which is not simply imposed upon the software, but which the software actively learns and reproduces in its own fashion.

This integration of digital and physical represents, for us, a high-water mark in a series of artworks that consider augmented reality as a conceptual model rather than simply a specific form of technology. Augmented reality is widely accepted as a technology based on recognition of specific images, which trigger pre-defined digital imagery. However, this definition only explains one part of the works. *Shifting Skin*, with its performative integration of viewers through the need to physically position and re-position the iPad in relation to the photographs, and its integration of the notion of skin through the images themselves and the movement of those images over an expanded, stretched and distorted topology embeds the physicality of skin and scarring across physical and digital domains. *The Crack Up*

integrates real-time physical performance with the 'performance' of a digital 'skin' that also references, through generating needle-like spikes projected out of the screen in 3D, the origin of the tattoo images. *Recognition* takes these elements and embeds an AI performer, trained by motion capture data from a human dancer, within this scenario so that the digital system performs in a very real sense alongside and in dialogue with a human performer.

10.4 Location Is Everything

Digital entities in performance demand a kind of 'collective hallucination', to borrow William Gibson's fictional description of a system that enables direct interface between mind and data (Rey 2012). Physical and digital 'dancers' must be simultaneously perceived as part of conceptual whole. Moreover, digital dance performances evoke a kind of hallucination that is predominantly visual to the audience, but invisible to the biological body (the dancer) who is inhabiting that shared space. Without perspective and glasses, the dancer is present physically, temporally and geographically—but she is fundamentally disengaged from the primary entry point to the 'hallucination'—what can be seen.

More recently, Gibson has argued against digital dualism and in favour of a 'reality where atoms and bits interact and continuously influence one another' (Rey 2012). The crux of Gibson's 'blended' reality, of Jurgenson's Augmented Reality and even of our anecdotal engagement with digital devices, is the increasing shift to a user-led experience. This goes back to the example of 'Librariness' as discussed by Wanenchak, namely that the evolution to a digital repository no longer necessitates a physical space, nor one that is limited by time of day, our physical proximity to the building, or the availability of material.

What is intriguing, however, when we turn to intermedia dance performance, is that the theatrical environment is, traditionally and fundamentally, not a user-led environment. Theatrical experience demands what Coleridge famously referred to as the 'suspension of disbelief' and to allow the action to unfold in front of us. The notion of the staged action as 'real' is crucial to an appreciation of the art form, but the structures that make for great theatre are often incompatible with a user-led experience. Artworks that allow for users to engage with a certain interface are increasingly available, but even these are often constructed within strict parameters. You may, for example, be able to interact with a digital entity, and therefore become part of a kind of circuit of movement and influence, but even that experience may need to be controlled in terms of physical proximity, geography, and of course, temporality. More often than not, artists such as Klaus Obermaier, Gideon Obarzanek and Anarchy Dance Theatre present a circuit between biological and digital bodies, which is then perceived, from the outside, by audience members. The elements and guiding principles of that individual circuit may be transparent or opaque.

The theatre has a long history of creating disjuncture in perspective between performers and audience. Speaking of renaissance theatre, Baugh argues that '(h)istorically, theatre technologies have come to represent powerful divisions between artists and their audience—the proscenium arch and the enclosed secrecy of the stage house clearly reflect this division'.

A similar division is enacted in digital performance in which a dancer 'drives' an interactive system. In this situation, is there a fundamental difference between the dancer's interaction between recorded media (e.g. video or still image projection) and interactive media that respond in real time to the dancer's actions? The situation could be likened to watching an avid gamer simultaneously play a MMORPG on one screen and watch a TV series streaming on another screen. Both are streamed, online experiences, yet engagement within a MMORG might be deemed more immersive, since it responds to the player in real time, whereas TV, be it delivered by radio transmission, cable or internet, might be deemed less physically engaging since it does not respond to the viewer's actions. Perhaps immersion for the player is enhanced by 'active' participation, the engagement of multiple senses, touch and proprioception added to the visual through the use of controllers to interact with the online scenario. TV is more 'passive', the player/viewer affording attention to the TV screen, yet with no discernible physical interaction.

However, the perspective of the spectator watching yields a different impression. From the perspective of the spectator, watching the player, the two screens seem to carry similar weights. The player's active participation in the 'virtual' environment yields a greater range of physical artefacts that state clearly their participation in the present moment in the real, perhaps more so than the moments of stillness attending to the TV show. However, the change of perspective from player to spectator watching the player in their environment affords a different view of the relationship between the physical and digital environments. The spectator sees the player in their environment as a single event, attention shifting from online game, subliminally or overtly to the TV show, a glance to any pending online notifications, a momentary check on the status of coffee level, then back to the game. The spectator or friend may in turn be predominantly concerned with the TV show, passively interested in the skill and conquests of the player, and closer to the source of coffee if replenishment is required. All are components of the real: physical, cerebral, digital.

The distinction between these two perspectives turns on the association of the virtual with the immersive. The concept of 'virtual reality,' which pre-dates augmented reality, is tied up with the concept of immersion. The virtual aspires to become the real through providing a truly immersive experience in sensory, perceptual, cognitive and affectual terms. Triggering, in the sense that a player/performer's actions cause an outcome, is a causality symptomatic of tangible interactions. Watching the player physically interacting with the game through a physical controller binds their physical actions to the digital environment. While this may be interpreted to add to the immersion of the player within the digital environment and remove them from the 'real' in favour of the 'virtual', from the friend/spectators perspective, the concentration and physical intensity of the player is palpable and serves to make them no less present to the spectator. The

interactions (triggering) enable the spectator to see further how the player is interacting within the game and how the player's physicality and the digital environment are bonded together. Our dancer shows similar symptoms, direct causal behaviour illustrating how the dancer and the digital environment are enmeshed together.

The spectator perspective is the one given to audience members in digital dance performance. The audience is privy to the dancer operating within their environment, inclusive of digital layers, and is able to construct meaning constituted from all the available elements. The dancer may have their own internalised view of the environment; however, it is the audience member who is in a position to evaluate the elements as a single reality, not as completely separate physical and digital experiences. Digital performances such as *The Crack Up* and *Recognition* evoke augmented reality experiences from the audiences' perspective, but not necessarily from the performers'. This is potentially one of the reasons that digital performance evokes such varied responses from dance artists themselves. The embodied experience that is fundamental to dance practice is normally understood first from within the dancer's own body and then shared with others through performance. Augmented reality, in the sense that we describe it here as a means of integrating physical and digital experiences, reverses this premise since the full experience is only available to the audience. *Shifting Skin* effects an even more complex transaction by conflating the roles of performer and viewer in a scenario in which viewers, in effect, physically perform the experience of viewing the work for each other.

Augmented reality experiences lie in the eye and, perhaps more importantly, the location of the viewer. Augmented reality is not an attempt to create an immersive experience, but precisely the opposite—a means of activating, simultaneously, multiple threads of experience across physical and digital domains. Augmented reality in the context of digital dance performance is generated from technologies that enable the sharing of embodied experience beyond the limits of the physical presence of a performer. We see this as one of the key enabling paradigms augmented reality technologies that offers digital artists. A consequence of this affordance, however, is that embodied experience, whether it is the phenomenological awareness of skin with all it entails; boundary, surface, implied volume, transgression, marking, piercing, scarring, embellishing, and/or the not unrelated awareness of physical movement; surface, volume, mass, gravity, speed, dynamic, physics, affect, contact, agency, can be simultaneously digital and physical.

Augmented reality is often understood as a digital overlay on a physically 'real' world. While this might describe the logistics of the technology with some accuracy, the conceptual affordances of augmented reality technology make possible artworks that do not position digital and physical worlds in an hierarchical relationship, but foreground the inevitable integration of multiple sources of experience. Artworks such as we have described, which articulate this integration via technologies that embed human movement and, more specifically, dance performance within an augmented reality framework, provide a demonstration of the inability of digital dualism to stand up even in relation to what might be considered

the most unlikely candidate for digital distribution—the embodied experience of the human body.

Acknowledgements This research was supported under Australian Research Council's *Discovery Projects* funding scheme (project number DP120101695) and by the Deakin Motion.Lab and the Centre for Intelligent Systems Research, Deakin University, Melbourne, Australia. The authors would also like to acknowledge and thank the dance and digital artists at Deakin Motion.Lab who contributed to the development of these works.

References

Atkinson P. Computer. London: Reaktion; 2010.

Auslander P. Liveness: performance in a mediatized culture. Abingdon: Routledge; 1999.

Bell D. Why cyberculture? In: London and cyberculture theorists: Manuel Castells and Donna Haraway. London/New York: Routledge; 2007. p. 1–14.

Bennett A. Shifting skin. AR[t]. 2013;4:26–31.

Boesel W, Rey P. A genealogy of augmented reality: from design to social theory (Part One). Cyborgology; 2013. http://thesocietypages.org/cyborgology/2013/01/28/a-genealogy-of-augmented-reality-from-design-to-social-theory-part-one/. Accessed 19 Sept 2017.

Boucher M. Virtual dance and motion-capture. Contemp Aesthet. 2011;9. http://www.contempaesthetics.org/newvolume/pages/journal.php?volume=45. Accessed 19 Sept 2017.

Burt R. History, memory, and the virtual in current European dance. Dance Chron. 2009;32 (3):442–67.

Deleuze G, Guttari F. A thousand plateaus: capitalism and schizophrenia. Minneapolis/London: University of Minnesota Press; 1987.

Dixon S. Digital performance: a history of new media in theatre, dance, performance art and installation. Cambridge, MA: MIT Press; 2007.

Flusser V. On writing, complexity and the technical revolutions: video of interview in OsnaBruck. Eur Media Art Festiv. 2011. http://youtu.be/lyfOcAAcoH8. Accessed 19 Sept 2017.

Gibson J. The ecological approach to visual perception. New York: Psychology Press; 1986.

Gibson W. Spook Country. New York: G.P. Putnam's Sons; 2007.

Goggin G. The iPhone and communication. In: Hjorth L, et al., editors. Studying mobile media: cultural technologies, mobile communication, and the iPhone. New York: Routlegde; 2012.

Gunduz Z. Digital dance: encounters between media technologies and the dancing bodies. In: Riha D, editor. Frontiers of cyberspace. Amsterdam/New York: Rodopi; 2012. p. 309–33.

Jurgenson N. Towards theorizing an augmented reality. Sociology Lens, The Society Pages. Wiley-Blackwell; 2009. http://thesocietypages.org/sociologylens/2009/10/05/towards-theorizing-an-augmented-reality/. Accessed 19 Sept 2017.

Jurgenson N. Digital dualism versus augmented reality. Cyborgology; 2011. http://thesocietypages.org/cyborgology/2011/02/24/digital-dualism-versus-augmented-reality/. Accessed 19 Sept 2017.

Jurgenson N. When atoms meet bits: social media, the mobile web and augmented revolution. Future Internet. 2012;4(1):83–91. https://doi.org/10.3390/fi4010083. Accessed 19 Sept 2017.

Kohonen T. Self-organization and associative memory. 3rd ed. Berlin/New York: Springer; 1989.

Langer SK. Feeling and form: a theory of art developed from Philosophy in a new key. London: Routledge & Kegan Paul; 1953.

Manning E. Relationscapes: movement, art, philosophy. Cambridge, MA: MIT Press; 2009. Kindle edition.

McCormick J, Vincs K, Nahavandi S, Creighton D. Learning to dance with a human. In: Proceedings of the 19th international symposium of electronic art, ISEA 2013, Sydney; 2013. http://hdl.handle.net/2123/9638. Accessed 19 Sept 2017.

McLuhan M. Understanding media: the extensions of man, e-book. New York: Ginko Press; 2013.

Rey P. The myth of cyberspace. The New Inquiry. 2012. http://thenewinquiry.com/essays/the-myth-of-cyberspace/. Accessed 19 Sept 2017.

Thomas G, Wyatt S. Shaping cyberspace—interpreting and transforming the Internet. Res Policy. 1999;28(7):681–98. https://doi.org/10.1016/S0048-7333(99)00016-5.

Vincs K. Virtualizing Dance. In: Rosenberg D, editor. The Oxford handbook of Screendance studies. New York: Oxford University Press; 2016 p. 263–82.

Wanenchak S. All libraries are 'Real'. Cyborgology. 2013. http://thesocietypages.org/cyborgology/2013/10/04/all-libraries-are-real/. Accessed 19 Sept 2017.

Ward M. William Gibson says the future is right here, right now. BBC News 12 Oct 2010; 2010. http://www.bbc.co.uk/news/technology-11502715. Accessed 19 Sept 2017.

Chapter 11
Augmented Reality Painting and Sculpture: From Experimental Artworks to Art for Sale

Vladimir Geroimenko

11.1 Introduction

The terms "Augmented Reality Painting" and "Augmented Reality Sculpture" can refer to a diverse variety of artworks. Because the digital allows the artist to go beyond the boundaries of traditional media, many of those artworks can be more related to computer games and other types of interactive installations than to painting and sculpture in their traditional sense.

This chapter will focus on use of Augmented Reality that is as closely related to traditional painting and sculpture as possible. In the wide spectrum of possible AR artworks, this area seems to be especially important, because it is rooted in the history of painting and sculpture as part of a universal human culture. In this context, novel game-like paintings and sculptures seem to be the continuation of a recent computer game history rather than thousands of years of traditional art. How can Augmented Reality enhance and extend traditional art without turning a painting into something completely different such as, for example, an interactive movie? Can Augmented Reality painting and sculpture inherit one of the most distinctive features of traditional art—incredible saleability of its pieces?

At present, Google Scholar provides just a few results for a search on "Augmented Reality Painting" and only two for "Augmented Reality Sculpture" (Google Scholar 2017). One of the oldest research papers is entitled "Augmented Reality Painting and Collage: Evaluating Tangible Interaction in a Field Study", and describes an AR environment for painting, with a physical brush, digital textures on physical models, and creating dynamic stages for the model with spatial collages providing different backgrounds (Jacucci et al. 2005). It deals with the

V. Geroimenko (✉)
Faculty of Informatics and Computer Science, The British University in Egypt,
Cairo, Egypt
e-mail: vladimir.geroimenko@bue.edu.eg
URL: https://www.bue.edu.eg/index.php/ics-staff/item/8426-vladimir-geroimenko

© Springer International Publishing AG 2018
V. Geroimenko (ed.), *Augmented Reality Art*, Springer Series on Cultural
Computing, https://doi.org/10.1007/978-3-319-69932-5_11

211

evaluation of a particular form of Augmented Reality in order to demonstrate the benefits of specific features of the environment and of its tangible interfaces. One of the latest works presents a tool for creating 3D photograph collages using mobile Augmented Reality, in which virtual pieces are textured with pictures taken with the camera and can be blended with real objects to create interesting works of art (Marzo and Ardaiz 2013).

Currently, some artists praise Augmented Reality painting and sculpture as the future of these art forms, but they are doing this on their websites and blogs rather than in academic papers (though with some excellent and convincing examples of their AR artworks). The blog entry "The Future of Painting?" by Trevor (2013) and the webpage and video "Between Physical and Digital: Augmented Reality Sculpture—2013" by Hutchinson (2013) are particularly worthy of note.

Among a variety of AR paintings and sculptures, the most common are the techniques of replacing a painting with an animated video that brings its content to life (see, for example, Baradaran 2011; Trevor 2013), and the 3D mapping projection on real-world sculptures or buildings (for some examples of Projective Augmented Reality, see Valbuena 2007; Roberto and Teichrieb 2012). Many examples of different types of AR sculpture can be found in other chapters of this book.

11.2 Augmented Reality Painting

In this chapter, a particular type of Augmented Reality artworks will be considered that is close to (or is based on) a traditional understanding of painting. We will refer to this type as "Augmented Reality Paintings" in more general terms, because Augmented Reality is in its very essence and also because the use of the term is consistent with the name for a similar type of books that are called "Augmented Reality Books" (see: Amazon 2017). An Augmented Reality painting comprises two parts: a conventional physical painting (such as an art print, or an oil or acrylic original painting) and an AR-based digital component that is integrated with the physical painting in such a way that only experiencing the both parts at the same time with an AR-enabled device makes the entire painting complete and meaningful.

To test this concept of Augmented Reality Painting, six experimental artworks were created. They were also intended to explore and exhibit some possible diversity of this novel type of painting in terms of both its content and form. As a result, paintings 1–4 used flat images with transparent backgrounds as their augments, which were visible using the Layar application. Paintings five and six were augmented with 3D objects, floated in the air in front of them that could be experienced with the Junaio AR browser. In both cases, a person just had to scan the physical part of a painting with their iPhone, iPad, or Android phone in order to see the entire artwork.

These six Augmented Reality Paintings constituted a solo exhibition *Hidden Realities* that took place in the Scott Building's Foyer Space (Plymouth, UK). All the paintings were gallery-quality framed A3+ art prints of original digital paintings, produced by the author. The following labels, placed on the wall near the paintings, included the title of a painting and a concise description of its main idea:

- Painting 1: "What Lies Underneath?" An Impressionist-style digital photo painting of the Link Café at the Eden Project, Cornwall. This artwork is a tribute to the Black and White Photography that was an historic starting point for today's Digital Photo Painting (Fig. 11.1).
- Painting 2: "The Half Kiss". A digital photo painting that brings up a question "Who is that girl kissing?" Augmented Reality provides the answer (Fig. 11.2).
- Painting 3: "This is not a Phone". A digital photo painting with a reference to René Magritte's "This is not a Pipe". Is the iPhone really a phone or is it something else? Look at the painting through the AR browser of your smartphone (see Figs. 11.3 and 11.4).
- Painting 4: "Augmented Quote". A digital photo painting that shows only the first part of a quotation. An Augmented Reality feature completes the quote, makes it funny and adds the name of the author.

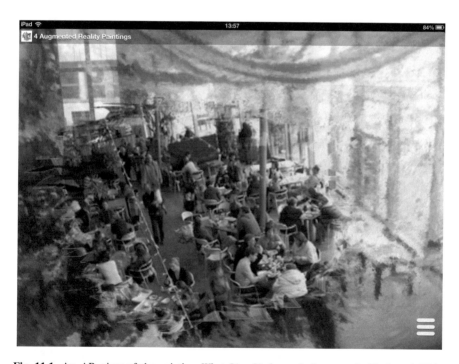

Fig. 11.1 An AR view of the painting *What Lies Underneath* that reveals Black and White Photography as an historic starting point for digital photo painting (iPad screenshot by Vladimir Geroimenko)

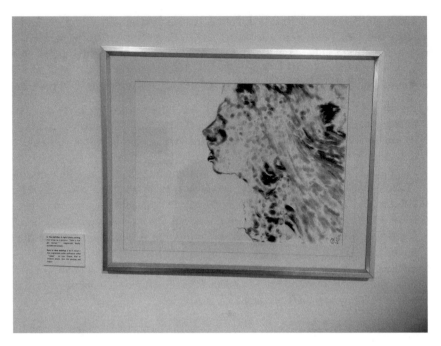

Fig. 11.2 *The Half Kiss* by Vladimir Geroimenko, 2013. An Augmented Reality painting at the *Hidden Realities* Exhibition

Fig. 11.3 *This is not a Phone* by Vladimir Geroimenko, 2013. An Augmented Reality painting at the *Hidden Realities* exhibition

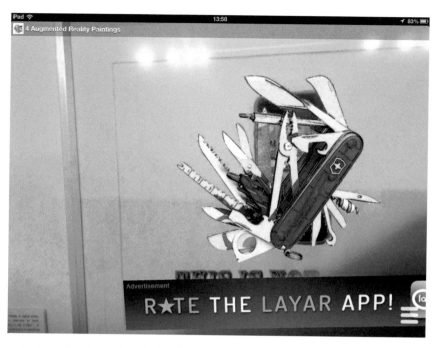

Fig. 11.4 An AR view of the painting *This is not a Phone* that reveals the hidden nature of iPhone (iPad screenshot by Vladimir Geroimenko)

- Painting 5: "Four Keywords Lost in Augmented Reality". A digital photo painting based on a constructed virtual environment. Where is the fourth key? Only your AR browser can find it.
- Painting 6: "The Hand of Moscow". A digital photo painting of Moscow's Red Square with a humorous AR parody on an infamous cold war cliché. Beware the invisible hand! (see Figs. 11.5 and 11.6).

The above creative production has revealed that in response to the question "What would make a good Augmented Reality painting per se?", the closest answer would be "Integration, integration, integration!" Creative integration of physical and digital is paramount for producing "a whole picture"—Augmented Reality paintings are about the integration of physical and digital worlds to produce a coherent whole. Consequently, painting, constructing and putting together Augmented Reality artworks is a new and exciting area of creative practice.

The physical part of an Augmented Reality artwork can, in principle, be a painting of any kind and technique, ranging from a specially produced one to an existing masterpiece, such as a Van Gogh. It is worth mentioning, for example, a research project in which visual AR-based information (e.g. the X-ray capture and the back of the painting) has been laid over the original of such a masterpiece (Van Eck and Kolstee 2012).

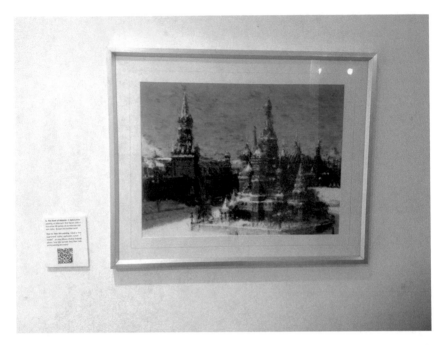

Fig. 11.5 *The Hand of Moscow* by Vladimir Geroimenko, 2013. An Augmented Reality painting at the *Hidden Realities* Exhibition

Having a deep respect for oil, acrylic, and other traditional painting, we nevertheless consider digital painting and particularly digital photo painting (Geroimenko 2011) as the most suitable for the implementation of painted AR artworks. Digital paintings can easily be constructed and then painted in such a way as to that allow the best possible integration between their visible parts and their hidden augmentations, because at the moment of their creation by an artist both parts are digital. The visible part can then be materialised as a printed artwork in order to be exhibited and/or to be sold. Usually, it would be a limited edition high-quality Giclée print that can last up to 100 years, and is individually signed and numbered by the artist.

11.3 Augmented Reality Sculpture

The precise definition of Augmented Reality sculpture is difficult, because, on the one hand, there is a wide diversity of AR-based sculptural artworks, and, on the other hand, not every three-dimensional AR object can be considered as a sculpture.

A basic classification of the main types of Augmented Reality sculpture could be for the time being as follows (other types will definitely come up in the future):

Fig. 11.6 An AR view of the painting that shows a hidden red hand of Moscow (iPad screenshot by Vladimir Geroimenko)

- Projected AR sculptures—3D mapping of 2D digital textures on real-world sculptures, buildings, and other physical objects.
- Hybrid AR sculptures that consist of two parts (physical and digital; both of them are three-dimensional), which produce a sculpture as a comprehensible whole.
- (Genuine) AR sculptures that are completely digital and have no physical part.

Many Augmented Reality artworks can include digital 3D objects in a variety of sizes. Some of them can be considered as sculptures. Which ones? This depends mostly on the artist's intention and the artistic perception of the viewer.

As comprehensively shown in the other chapters of this book, Augmented Reality sculpture can be implemented in a wide variety of forms. These possible implementations can be represented as a spectrum. At one end are Augmented Reality artworks that visually are very similar to traditional sculptures, but implemented as digital 3D objects. The opposite end of the spectrum has an unlimited diversity of possible implementations that include highly interactive and animated game-like AR sculptures based on the latest relevant technologies.

In this chapter, we focus only on the "traditional" end of the spectrum, because it seems to be of a significant importance for the following reason: AR sculptures that look like traditional ones (either classic or modern) are deeply rooted in the history

of art and have a more or less clear conceptual and cultural connection to their predecessors. AR sculptures of the "technological" end of the spectrum, on the other hand, can mostly be perceived by the viewer as interesting installations that are related to computer games rather than to conventional sculptures.

The following experimental work by the author can serve as an example of this kind of Augmented Reality sculpture.

The Enterprise Jigsaw was a sculptural artwork dedicated to a mission of the University of Plymouth as *the* Enterprise University. The sculpture has been exhibited in the City Jigsaw Garden in Plymouth, UK, since 24 March 2011. The Augmented Reality installation consists of a three-dimensional digital sculpture "erected" nearby the main campus, in front of the university's flagship building and right in the middle of the Jigsaw Garden (see Fig. 11.7).

Viewing of the artwork requires the Layar Reality Browser to be installed. The viewer can easily perceive that the Augmented Reality sculpture is *really* placed in the real-world environment—in the middle of the Garden. To be convinced of this, they should follow the pavement around the Garden looking at the sculpture from all possible viewpoints.

As such, the digital sculpture *The Enterprise Jigsaw* is a 3D Augmented Reality object, consisting of 11 jigsaw puzzle pieces that form a word that uses jigsaw-style fonts and reads *Enterprise* (see Fig. 11.8).

This Augmented Reality installation bears several symbolic meanings. It represents the developing enterprise relationships not only between the University and the City of Plymouth, but also between the real and digital worlds. The University of Plymouth (renamed to Plymouth University), *the* Enterprise University, is the key piece in the regional "enterprise jigsaw" with its "commitment to driving social inclusion, economic prosperity, and environmental quality in our local community and beyond". This sculptural artwork combines the artist's personal attitude towards enterprise with the strategic mission of Plymouth University. The enterprise is a puzzle, an adventure. Putting the jigsaw pieces of an enterprise project together is both challenging and fun.

11.4 The Saleability of Augmented Reality Artworks

One of the main problems that Augmented Reality Art is facing on its way to become a "legitimate" form of art is to make AR artworks saleable. This, for example, was clearly stated by Lanfranco Aceti in his Editorial to the LEA double issue on Augmented Reality Art: "Problems though remain for the continued success of Augmented Reality interventions. Future challenges are in the materialisation of the artworks for sale, to name an important one. Unfortunately, unless the relationship between collectors and the "object" collected changes in favour of immaterial objects, the problem to overcome for artists that use Augmented Reality intervention is how and in what modalities to link the AR installations with the process of production of an object to be sold" (Aceti 2013).

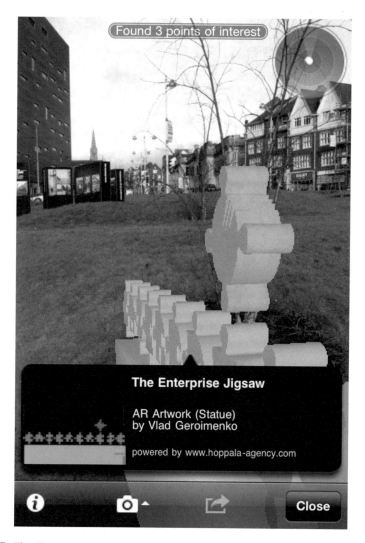

Fig. 11.7 *The Enterprise Jigsaw* by Vladimir Geroimenko, 2011. An Augmented Reality sculpture. An AR view in the real-world environment of the Jigsaw Garden (iPhone screenshot by Vladimir Geroimenko)

Although the problem is common for Augmented Reality Art in general (because of non-material nature of its augmenting objects), there are different types of AR artwork (Geroimenko 2012, 2013a) that may have a dissimilar commercial potential. Augmented Reality painting and Augmented Reality sculpture can serve as good examples of this: a particular type of Augmented Reality paintings described earlier in this chapter seems to be (at least, for the time being) the best candidates for "AR Art for sale" (Geroimenko 2013b), while the saleability of Augmented Reality sculptures is rather uncertain and questionable at the moment.

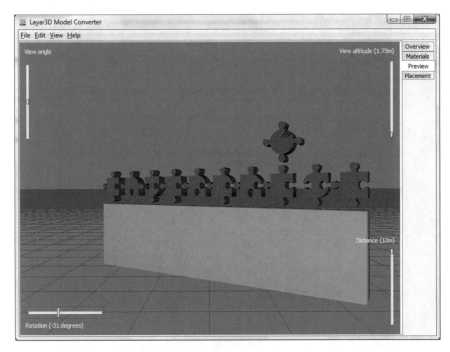

Fig. 11.8 *The Enterprise Jigsaw* by Vladimir Geroimenko, 2011. An Augmented Reality sculpture. A design view in the Layar 3D Model Converter (MacBook screenshot by Vladimir Geroimenko)

In general, the sale of Augmented Reality paintings can encounter particular difficulties, some of which are rather obvious and can be named a *priori*:

- The key technical issue is the availability of the AR component of the painting: the server can be unavailable for a while or shut down for good, a new version of the AR browser may have a compatibility issue with older content, and so on. However, an AR painter or seller has somehow to be able to provide (despite all possible and unpredictable technical glitches) a warranty that an AR painting will be "functional" for a certain period of time.
- The main creative problem can be the artistic merit of the physical component of an AR painting, as was discussed above. In other words, a limited edition print, hanging on a wall, should be "cool" in its own right. The AR component is intended to enhance it aesthetically, conceptually, and, of course, visually. Furthermore, it presents "the hidden meaning of a painting" in a completely new way, namely by "materialising" its concealed AR parts (i.e. by showing a hidden meaning *in a literal sense*).
- As of today, the major problem could however be the novelty of Augmented Reality paintings. It will obviously take some time before the current level of knowledge about this new form of art develops significantly to affect art buyers'

behaviour. The current situation seems to be a paradoxical catch-22: to become a popular form of art, Augmented Reality painting should be in the art market; to become a highly saleable art form, the acceptance and understanding of Augmented Reality painting should be widespread in advance.

In spite of these real and potential difficulties, the particular type of Augmented Reality painting, that combines digital painting and AR technology with gallery-quality limited edition prints, can provide rather realistic opportunities for breaking into the art market. Rephrasing Frank Lloyd Wright's humorous citation "If it sells, it's art" (Wright 2013), one can say about the emerging Augmented Reality Art in general: "As soon as it is on sale, it will become much closer to universal recognition as a new form of art". Augmented Reality paintings should and hopefully will find their way to private collections around the world.

The proof of the concept of saleability for this specific type of Augmented Reality paintings has been a success—some paintings from the *Hidden Realities* Exhibition are now available on Amazon (Amazon 2014). In fact, the painting *The Half Kiss* has probably become the first-ever Augmented Reality Painting for sale, and it was certainly the first ever AR painting for sale available on Amazon (see Fig. 11.9). At the time of writing of these lines, none of its copies have been sold,

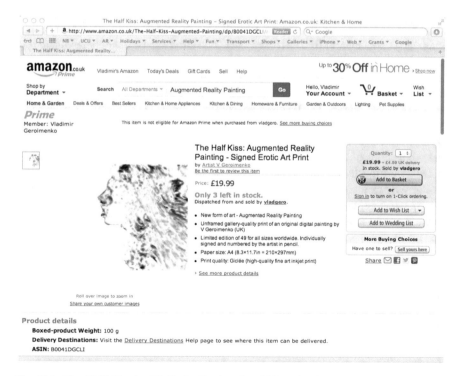

Fig. 11.9 *The Half Kiss* by Vladimir Geroimenko, 2011. The first-ever Augmented Reality painting for sale on Amazon (2014)

so how can we be sure a priori that some of them will sooner or later have been sold? All the previous experience of the author of this chapter indicates a strong possibility. He started selling his limited edition art prints in 2009 via the Online VG Art Gallery (Geroimenko 2009), Amazon and eBay. To date, many signed gallery-quality prints of his digital paintings have been sold to private collections in several countries (UK, USA, Canada, Australia, Germany, France, Spain, Switzerland, Holland, Finland, Malta, Brazil, Mexico, Russia, and Belarus).

Therefore, it is quite possible to conclude that this type of Augmented Reality painting is in principle saleable, because the physical part of an Augmented Reality painting is essentially identical to a regular art print sold by the author earlier. This also means that in a good augmented painting, the physical part (e.g. art print) should have a significant artistic value on its own, since it is supposed to be exposed on a wall all the time. Its Augmented Reality component may complete the painting in several ways (e.g. visually, conceptually or aesthetically), but only from time to time (when someone is viewing the painting through an AR-enabled device).

The saleability of Augmented Reality sculptures is much less certain, and presumably depends on the type and also the size of a sculptural artwork. Small Augmented Reality artworks (figurines, busts, carvings, and the like) that are based on the use of Augmented Reality markers and image recognition technology can in principle be put for sale in the same way as the Augmented Reality paintings described above. In such a case, an Augmented Reality sculptural artwork has to consist of the following two parts: a small-size Augmented Reality sculpture (the main part) and a marker (the auxiliary part). The latter can be a purely technical (but aesthetically good) pattern to trigger and to correctly place the 3D digital sculpture or it can be a printed or painted artwork that is meaningfully connected and artistically integrated with the main piece of art, namely the Augmented Reality sculpture per se. Figure 11.10 shows an experimental work of this type produced by the author: an abstract Augmented Reality statuette (a simple 3D shape) placed on top of a conceptually unrelated (meaningless) Augmented Reality marker—a black and white print of a surrealist painting by the author.

Our working hypothesis is that this type of sculpture could be saleable in a similar way as the described Augmented Reality paintings. The buyer would have purchased an augmented marker (that itself could constitute an artwork) and place it on the floor, on a table, on a wall, and the like. After this, the art collector can enjoy the "hidden" AR sculptural artwork by making it visible in an Augmented Reality browser and by moving himself or herself around it in order to see the 3D creative work from any possible angle.

An "opposite" large-scale type of Augmented Reality sculpture may include gigantic artworks that are placed into a physical location using GPS technology rather than visual markers. Such artworks are suitable for city squares, historic landscapes, and similar vast environments. It seems unlikely (at least, at the moment) that such Augmented Reality sculpture can be sold via Amazon or eBay. However, an artist could be commissioned to produce a sizeable Augmented Reality sculpture by, for example, a City or Art Council.

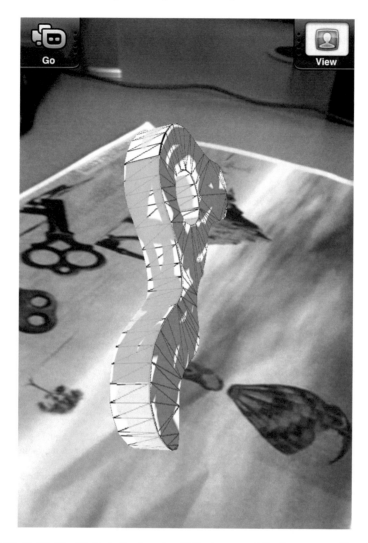

Fig. 11.10 *Untitled* by Vladimir Geroimenko, 2011. Augmented Reality statuette (Experimental work)

11.5 Conclusions

Augmented Reality Painting and Augmented Reality Sculpture are newly emerging forms of art that may encompass a variety of particular types of artworks. Some of them can be highly technological and interactive and to this extent bear resemblance to computer games. At the same time, some of them can intentionally not rely on interactive multimedia technologies and be closer to traditional forms of

paintings and sculptural works. In this case, conventional paintings and art prints can easily be extended, enhanced or embellished with hidden AR objects that are able to convey a deeper meaning of the artwork. This type of Augmented Reality painting possesses all necessary features to become popular and saleable art in a similar way as its traditional predecessors. Augmented Reality sculpture has a more modest sale potential, but in many cases can be commissioned to be "erected" in public places instead of expensive physical sculptures.

References

Aceti L. Not here, not there: an analysis of an international collaboration to survey augmented reality art. Editorial to not here not there. Leonardo Electron Alm. 2013;19(1 & 2):8. http://www.leoalmanac.org/vol19-no1-not-here-not-there/. Accessed 7 Oct 2013.

Amazon. Search for "Augmented Reality Books". 2017. http://www.amazon.co.uk. Accessed 28 Sept 2017.

Amazon. The Half Kiss: augmented reality painting—signed erotic art print by artist V Geroimenko. 2014. http://www.amazon.co.uk/The-Half-Kiss-Augmented-Painting/dp/B0041DGCLI/. Accessed 15 Aug 2017.

Baradaran A. Frenchising Mona Lisa. 2011. http://www.amirbaradaran.com/ab_monalisa.php. Accessed 15 June 2017.

Geroimenko V. The VG art gallery. 2009. http://www.geroimenko.com. Accessed 28 Mar 2017.

Geroimenko V. Digital photo painting as an artistic and cultural phenomenon. In: Proceedings of the 15th international conference on information visualisation (iV2011, London). 2011. p. 461–4.

Geroimenko V. Augmented reality technology and art: the analysis and visualization of evolving conceptual models. In: Proceedings of the 16th international conference on information visualisation (iV2012, Montpellier). 2012. p. 445–53.

Geroimenko V. Artistic visualisation of practical information using augmented reality. In: Proceedings of the 17th international conference on information visualisation (iV2013, London). 2013a. p. 404–9.

Geroimenko V. Augmented reality paintings: art for sale? In: AR[t]: augmented reality, art and technology, Issue 4. The Hague: AR Lab: Royal Academy of Art; 2013b. p. 68–71.

Google Scholar. 2017. http://scholar.google.co.uk/. Accessed 28 Sep 2017.

Hutchinson I. Between physical and digital: augmented reality sculpture—2013. http://www.ianhutch.net/work.html. Accessed 28 Sept 2017.

Jacucci G, et al. Augmented reality painting and collage: evaluating tangible interaction in a field study. In: Human-computer interaction—INTERACT 2005, Lecture Notes in Computer Science, vol. 3585. Berlin: Springer; 2005. p. 43–56.

Marzo A, Ardaiz O. CollARt: a tool for creating 3D photo collages using mobile augmented reality. In: Proceedings of the 21st ACM international conference on multimedia. New York: ACM; 2013. p. 585–8.

Roberto RA, Teichrieb V. ARBlocks: a projective augmented reality platform for educational activities. In: Proceedings of IEEE virtual reality conference 2012. Costa Mesa, CA, USA; 2012. p. 175–6.

Trevor J. The future of painting? 2013. http://trevorjonesart.blogspot.co.uk/2013/08/the-future-of-painting.html. Accessed 18 Sept 2017.

Valbuena P. Augmented sculpture. 2007. http://www.pablovalbuena.com/selectedwork/augmented-sculpture-v1/. Accessed 28 Sept 2017.

Van Eck W, Kolstee Y. The augmented painting: playful interaction with multi-spectral images. In: Proceedings of the 2012 IEEE international symposium on mixed and augmented reality (ISMAR-AMH), Atlanta, GA, USA; 2012. p. 65–9.

Wright FL. Quotes. 2013. http://www.goodreads.com/author/quotes/69188.Frank_Lloyd_Wright. Accessed 28 Sept 2017.

Chapter 12
Augmented Reality Graffiti and Street Art

Ian Gwilt

12.1 Introduction

Graffiti has always augmented real-world locations and environments, providing social commentary, unsolicited opinion, proof of occupation or simply by dint of adding colour and visual content to our utilitarian city infrastructures. Either through the opportunistic act of an addition to an urban surface or by invitation to create a site specific response to an existing form or predefined public space, 'traditional' graffiti and street art has always had a relationship with the architecture, street furniture, surfaces and materials that define and delineate our urban experience. Invited contribution or not, it could be argued that these interventions help turn Marc Augé's notion of urban non-places into inhabited environments, wherein today's 'supermodern' spaces are drawn back into a lived and lived in, imperfect experience (Augé 2008). These broadcast images and symbols also transition the public to the personal—an assertion of individuality for both the creator and the viewer—prompting us to question what is our role, interest in and connection to the community and place in which we live.

This chapter looks at how the concept of Augmented Reality graffiti (AR graffiti) enables us to experience an augmented view of the urban environment. By running Augmented Reality (AR) software on mobile devices such as smartphones and hand-held computers, virtual content including images, audio, messages and designs can be placed into a digitally enhanced view of a city scene. This facility allows us not only to switch between a personal and shared experience of an artwork or urban space but also to experience both digital and analogue versions of the same environment. In this chapter, I will examine how the intersection between graffiti, street art and AR provides us with a complex socially and technologically

I. Gwilt (✉)

School of Art, Architecture and Design, University of South Australia, Adelaide, Australia
e-mail: ian.gwilt@unisa.edu.au
URL: http://people.unisa.edu.au/Ian.Gwilt

© Springer International Publishing AG 2018
V. Geroimenko (ed.), *Augmented Reality Art*, Springer Series on Cultural
Computing, https://doi.org/10.1007/978-3-319-69932-5_12

encoded interface that has the potential to combine the first-hand experience of public space, digital media and creative practice in a hybrid composition. I will begin by looking at the tradition of graffiti and street art, followed by an investigation into the philosophical implications for the digital augmentation of this type of work. A number of key techniques and technologies for AR graffiti will then be explored and discussed through the use of two case studies.

12.2 Definition and History of Graffiti

The idea of graffiti in its conventional sense conjures up images of painted words or drawings, sprayed on a wall, possibly offensive, illegal certainly. Whereas the notion of 'street art' suggests a more urbane, legitimized activity with perhaps a greater level of artistic merit and community buy-in, we are increasingly seeing more examples of assigned wall spaces and public commissions for street art. For the purposes of this chapter, I use the terms graffiti and street art as a shorthand to describe the range of (non-corporate) visual languages we typically encounter in the urban landscape. However, this chapter does not attempt to justify or establish a position on a set of activities, which are seen to be by degree sanctioned and unsanctioned, legal and illegal. Indeed the legitimacy and cultural acceptance of graffiti and street art vary quite dramatically and are still very much under debate (Macdonald 2001; Rowe and Hutton 2012), while the works of some well-known artists fetch high prices in the art world, and other works are regarded as illegal acts. What we are interested in here is the way that graffiti and street art forms part of a shared visual language, and how this language can be adapted and developed in an increasingly technologized society.

It is useful, however, to briefly consider how the visual language of graffiti and street art has developed, as a precursor to thinking about how creative practitioners utilizing the potentials of AR technologies might begin to work with these conventions. Anna Wacławek traces the rise of contemporary graffiti back to the signatures, letters and words created by artists on the east coast of America in the 1960s (Wacławek 2011). By the mid-1970s, these 'tags', which tended to be quickly created, single-colour forms had also developed into more elaborate typographical designs called 'throw-ups' or 'throwies'. These in turn led to the further development of larger more complex 'pieces' or murals, often incorporating figurative elements and involved compositions (Wacławek 2011). These highly illustrative works are more closely associated with the idea of 'street art' and visually elaborate combinations of colour, shading, typography, graphic symbols, abstract patterns, cartoon elements and realistically drawn images, used in the formation of carefully constructed designs. As the visual languages of graffiti and street art have continued to expand, so have the materials and techniques used to create the works. The traditional use of spray cans and broad-tipped markers has been extended with amongst other things the introduction of paper and cardboard stencils, which are used as templates to quickly recreate a predesigned image by

spraying through the holes on the stencil. From the artist's perspective, this technique has an additional advantage in that it enables the easy creation of multiple versions of the same image. A variety of two- and three-dimensional materials which can be stuck on or applied to surfaces are now also being used to create work.[1] This includes the popular practice of pasting up pre-printed, sprayed or drawn, paper-based posters, which again have the advantage of being quickly repeatable so that large areas can be covered in a tile-like effect should this be desired. A number of other types of painting techniques are used in the creation of the more elaborate pieces, with bespoke processes such as the use of cleaning cloths, water and solvents to create monochromatic images on grimy urban surfaces being developed.[2] Lastly there are a number of new technology graffiti pieces that are created through the use and control of lights, laser beams, data projectors and other digitally facilitated interventions. AR graffiti continues this tradition of expanding the visual language of graffiti and street art by incorporating new techniques and technologies.

12.3 Philosophical Issues for Graffiti, Street Art and AR Graffiti

Aside from the issue of legality, there are a number of other issues worth considering in relation to the idea of AR-enabled graffiti. As Wacławek points out, one of the defining qualities of graffiti is that it both assimilates the city environment and recreates it (Wacławek 2011, p. 9). There is a natural vernacular inherent in graffiti and street art, which is played out between its physical location and the social cultural expectations of that environment, and through a dialogue and interplay with the other visual languages of the street, including formal signage, advertising posters and even other pieces of graffiti (Poynor 2001). Through this urban bricolage, created by the juxtaposition of images and surfaces, it is often difficult to establish a visual hierarchy of meaning, importance or legitimacy (Crow 2010). Adding further content to our experience of the urban environment through the use of AR technologies needs then to be considered in the context of this multifaceted ecology of image making and meaning. For example, will located access to extra digital content help to explain the existing physical environment or add to its complexity? Certainly the potential to add virtual layers of content and information to urban spaces speaks to Mitchell's polemic about digitally enhanced cityscapes. In his book 'City of Bits', Mitchell espouses the potential for digital technologies and

[1]See the work of Invader (http://www.space-invaders.com/) and the use of mosaic tiles to create images of space invaders on buildings. In some cases, a map of the sites enable people to follow the images around a particular city.

[2]See the work of Paul 'moose' Curtis who is credited with the idea of reverse graffiti (www. symbollix.com/).

technological platforms to hybridize both human experience and architecture, in a way that will help us process and navigate our urban surroundings (Mitchell 1995). Understanding and controlling the sociocultural, political and economic agendas attached to the addition of virtual content to our experience of the city should be high on the agenda of any emerging AR street artist. Iain Sinclair's politicized interpretation of the contemporary psychogeographical experience suggests that the detached wanderings of the flâneur are a thing of the past and that like our other encounters of the city today, any AR-facilitated experience of the urban will be loaded with expectation and purpose (Coverley 2010; Sinclair 2003).

In addition to changing our experience of the urban space, graffiti and street art also challenge notions of the ownership of these spaces, especially if the acts of the artist are seen as unsanctioned and interventionist (Wacławek 2011, p. 9). However, it is interesting to consider whether the qualities found in the virtual nature of AR graffiti go some way to disarming the criminal act inherent in physical graffiti. In a number of ways, the mediation of AR technologies produces a benign form of graffiti, since no physical content is added to the environment, and the work can only be seen while the viewer interacts with the space through the AR device. Moreover, the process of creating AR graffiti (through the use of the computer) is quite a different act compared to the visceral nature of creating physical graffiti, which is associated with the smell and sounds of spray paint, the feel and effect of different wall surfaces, and the influences of weather, lighting conditions, environmental population and other hazards. That said, AR graffiti inherently retains a close relationship with the physical environment, and the makers of AR graffiti still need to work closely with physical spaces, sourcing locations, working with a specific site and building an awareness of the environmental and social influences that impact on the space. Creators of an AR experience may also work with traditional street artists, and the hacktivist/open-source mindset of many of the AR makers is sympathetic to the counterculture positions taken up by many graffiti artists.

However, there is some debate about how and whether graffiti is changed when it is sanctioned by the art world—perhaps through the loss of adrenalin and sense of speed that is engendered through a fear of discovery (Ellsworth-Jones 2013; Macdonald 2001). Like the commodified graffiti of the art world, AR graffiti contains an inherent cultural legitimacy, if not economic value, created by the need for digital technology to enable the experience, and notions of the digital divide. But, although AR graffiti is not yet as ubiquitous in terms of accessibility to conventional street art, the dramatic rise in the use of smartphones, mobile technologies, tablet computers, etc. means that the possibility for making and viewing this type of work has the potential to rapidly expand, especially as these enabling technologies become increasingly available and commonplace. Interestingly, as AR street art becomes more popular, it remains to be seen whether the existing tension between a desire for anonymity and self-expression/recognition, which is played out between conventional graffiti artists, who communicate with each other through a common visual language and an unwritten code of practice, will be paralleled within AR-enabled graffiti (Macdonald 2001). Commonly with AR, and

particularly when it is used as an art form, there is no explicit instruction as to what the viewer will encounter when they follow an AR marker or launch an AR application to look at a piece of work. The viewer can be exposed to undisclosed content that is only revealed once the decision to view and the technological connection has been made. The relationship between the viewer and the creator of the work must be built on trust, experience and an understanding of the media form. Therefore, successful communication is contingent on establishing a context of use and the setting up of expectations that relate to what is anticipated and how a viewer might respond/behave when the AR content is revealed. Creators of located AR need to be mindful of both the viewer's expectations and the context of use.

In the following section, we will look at different techniques for the generation of AR graffiti and its potential in terms of storytelling through the creative use of media.

12.4 Augmenting What and Where: Markers and Clues, Techniques and Technologies

Early examples of AR used fiducial markers for the tracking and positioning of the viewer or the viewing device. This allowed virtual content to be displayed in relation to the point of view and position in physical space, and for the combining of AR content on a digital screen (Bimber and Raskar 2005). With the development of more sophisticated image processing software and the utilization of combined Wi-fi, cellular and GPS tracking, and 'simultaneous localization and mapping' technologies (SLAM), many AR applications that now run on mobile devices can directly recognize the visual patterns incorporated within the shapes and images of graffiti and street art. These technologies remove the need for physical/visual markers to be placed in the physical environment. Although abstract and nonsensical in human terms, the small black and white squares or geometric shapes of these conventional AR markers do operate as a useful device, in that they provided a visual clue for people to recognize that AR content is available. With the new types of 'transparent' AR markers—where almost everything you look at can effectively be tagged with virtual content—the question is, how do we know when and where to look for this content? In the urban environment, the existing visual language of graffiti and street art can operate as a useful device for indicating that virtual AR content might also be available in a specific place.

With AR graffiti, it is possible to make use of all the conventions of contemporary digital media. Drawn and photographic visual media, computer-generated 3D models, typographical and information graphics, video, animation and audio content can all be used in the creation of AR artworks. AR graffiti can use the potential of digital image making and effects to extend, create and reveal new and additional stories around conventionally made graffiti and street art. However, as observed in the uptake of digital visual effects in mainstream media, the mapping of

digital content into realistic scenes needs to be carefully considered, managed and applied in such a way that it adds to the experience of the viewer not detracts (McClean 2007).

A number of early exponents of AR graffiti experimented with ways of recreating the visual languages and techniques of traditional graffiti using the capacities of the digital. One very popular idea was to create spray-painting applications that allowed people to virtually tag and bomb buildings. This reimaging of the graffiti visual language has also more recently included the creation of 3D versions of throw-ups, which can be navigated in virtual space, literally adding another dimension to the work. These experiments demonstrate that the scope for creating AR graffiti is by no means limited to a small number of artists, and the displaying of pre-authored content. The phenomenon of social media and the potential to contribute, alter and comment on pieces of work is another aspect of AR graffiti that is being explored. Mobile apps are now available that facilitate user-generated content, which can be created and shared in line with social media conventions. Moreover, AR graffiti can also be generated remotely and realized at a specific location. In one example, a well-known street artist continued to create work after becoming physically incapacitated, using specially developed eye tracking software to generate work that was then digitally distributed and displayed.[3]

It remains to be seen whether and how the self-imposed codes of practice which govern the creation and 'overwriting' of physical graffiti and street art will transfer and be adapted to these virtual creations. However, one advantage with these types of technologically facilitated artworks is that they are virtual and temporary and do not damage or permanently hide the underlying surface or material.

As discussed, there are a number of different ways to create a piece of AR graffiti or street art. The techniques for relating AR work to the physical urban environment (and how we encounter it) can be divided into two main categories: first, by the generation of AR content that adds to and responds to existing pieces of physical graffiti or street art and second, by the generation of AR work that adds content to or responds directly to physical urban infrastructure or a public space. In the first category, existing graffiti typologies such as tags, throw-ups, stencils, stickers, murals and other interventions are added to through the use of AR technologies, which are viewed through a digital device such as a mobile phone or hand-held computer. In the second category, the physical infrastructure or public space is directly augmented with virtual content layered over, for example, the surface of a building, pavement, piece of street furniture or existing signage. Alternately AR content might be located and realized in 'empty' public spaces such as parks, alleyways or underpasses where it can be discovered and revealed with the aid of a digital device and the recognition of a particular location. In the following section, I will introduce two case studies: one that places AR content relative to existing public artworks as outlined in the first category and one that responds directly to everyday street furniture and urban structures as defined in the second category.

[3]See the work of the Graffiti Research Lab and the 'eyewriter' at http://eyewriter.org/.

12.5 Case Studies

12.5.1 Case Study One: BC Biermann and the Heavy Projects

In the work of BC Biermann and 'The Heavy Projects' initiative, highly illustrative paintings (produced by mural artists) are combined with virtual content to augment the original images (Biermann 2013). In these works mobile devices running the Re +Public AR app allow the public to view virtual additions by pointing a mobile device towards a real-world mural and looking through the digital screen (Fig. 12.1).[4] By doing this, AR content is mapped onto the screen image of the mural. The digitally generated content is used in two ways: first, to change the image content within the 2D picture plane of the mural by creating pictorial and animated sequences that 'overprint' and narrate parts of the original image and second, by adding substantive additional virtual content that appears to spill out into the urban environment, dramatically extending the work above and in front of the original image. In different examples, illustrations of people, plants, letterforms and geometric shapes create a temporal narrative around the original murals, as they are animated and move out into three-dimensional space. In some instances, virtual content sits on sequential layers such as the images in a pop-up book; in others, it hovers in space, in imitation of solid three-dimensional objects. In one work, the addition of luminescent waterfalls allows the mural to be seen in the dark; in another, oversize geometric shapes and patterns shimmer and move in front of the mural, reforming in different combinations for different viewers and different occasions. People and cars appear to move in out of the virtual layers as they go by, and the combined content as seen in the screen of the mobile device can be viewed as you would a painting in a gallery—allowing you to walk close to the work to examine a particular detail—or step back to see the whole piece. However, unlike painting or a conventional piece of street art, the viewer can move through the layers, giving the impression of being inside the artwork. With these AR works, the artists are very much concerned with rethinking the use, perception and boundaries of public space and they adopt mobile AR technologies to allow people to experience the urban landscape and their relationship with it in a different way.

12.5.2 Case Study Two: Shannon Novak

Shannon Novak describes himself as a synesthete, someone who can see colours and sounds in everyday objects. In many ways AR is the perfect medium for a

[4]A number of murals were augmented as part of a collaboration called 'Re+Public' (http://www. republiclab.com) which took place with Jordan Seiler, a NYC-based artist who also runs Public Ad Campaign.

Fig. 12.1 Heavy Projects, *How & Nosm mural augment* (2012). Full view [left], screenshot [right]. Images reproduced courtesy of the artist

digitally informed artist who can pick up on the resonances and cross-references between digital media forms. Novak's AR work builds a relation between compositions of staccato notes and geometric forms to not only create a discourse between audio and image, but also between digitally generated content and the physical environments that they are mapped onto (Novak 2013).

Novak describes his work as compositions for objects and spaces, and he uses the sides of buildings, public parks and street signage as canvases for his work (Fig. 12.2). However, these real-world artefacts and spaces are more than simply placeholders for virtual content, as the digital audio/visual animations that make up Novak's work are created specifically for each location. Each site is considered from a number of perspectives, which include the physical geometry, the surrounding environment, and other sociocultural and operational connotations that might be associated with the place. These factors are then used to inform animations consisting of formal compositions of abstract geometric symbols, colour and music, which unfold over the virtual surface of the physical location or artefact.

Interestingly Novak makes the point that unlike conventional graffiti, which can be physically removed or painted over, the evanescent nature of AR graffiti means that it is in some ways harder to regulate. Moreover, the virtual nature of AR means that it is relatively easy for the artist to change, adapt or update the work. Novak's observation that AR graffiti can also hide physical spaces or activities is an interesting proposition in relation to how graffiti and street art can shift the communal perception of a public space. In the work 'Manhattan Phrase', Novak creates personal AR responses to the musical history of 12 different sites on 14th Avenue, New York. Laden with cultural histories these sites are reimaged and reimagined through Novak's AR interventions that blur the empiric moment with augmented sound and image, and work as a sort of shorthand to the patina of personal and social memories and experiences that can build up over time in the same location.

In considering these two case studies, it should be remembered that the conventions and rules for this new media form (and how it might be experienced in the public domain) are as yet, not fully developed or broadly understood by the general public or indeed defined by the creators of the works. Informing people where AR content might reside in the urban environment and how it should be accessed and or

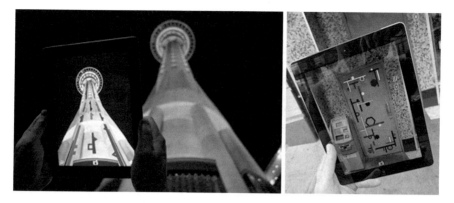

Fig. 12.2 Two works by Shannon Novak, *Transcription −36.848264, 174.762129* (2013) [left], *Manhattan Phrase Site 4: 40.737755, −73.997383* (2013) [right]. Images reproduced courtesy of the artist

responded too is still a work in progress. Novak is aware that audiences react differently to his AR creations as they experience them in situ: from the response of the techno-evangelist who is happy to embrace the concept of AR graffiti and willing to initiate others into the experience, through to confused but interested first time users, who find different ways of engaging with the work. This interest in how AR within a public space might begin to accommodate a broad level of social inclusion and meet the needs and the desires of the community is something that also resonates with the designers of the Re+Public app. As technological access improves and the public understanding of this type of work increases, more examples of work from practitioners in the field will help facilitate and define the potential of AR graffiti and its contribution to a shared urban visual language and culture.

12.6 Conclusions

Generally speaking, all graffiti is a form of addition (welcome or not) to the visual language of the public realm. Similarly the concept of AR graffiti allows us to reimagine and contribute virtual content to public infrastructures and shared spaces. Like traditional graffiti, there is always a connection between where we encounter the AR work and the physical environment. This relationship is made simply by the fact that AR graffiti has a 'fixed' geo-location or a specific viewing point that the viewer needs to occupy to activate the work. The 'located' nature of the AR graffiti, both in terms of place and context means that it is possible to create a dialogue between a physical location and the content and design of an AR work.

Within this chapter, we have looked at how the concept of AR graffiti has the potential to build on the visual languages of street art and graffiti, and the urban

infrastructures of a modern-day city environment, as part of the ongoing fusion between analogue and digital content. AR street art and graffiti contributes to the confluence of when, where and how we experience these two paradigms in tandem. The dialogic potential of AR graffiti marries urban social narratives and personal experiences with the dynamic potential of the digital and the tacit authority of material form. The difficulty for this type of located AR lies in ensuring that the relationship between the digital virtual and physical real is a symbiotic one that draws positively on the technical and cultural qualities and properties inherent in both analogue and digital paradigms, to fully make use of the potentials of the hybrid AR experience.

Advancements in the development of wearable head-mounted displays such as Google Glass are bound to have an impact on this fledgling practice. While immersive virtual reality (VR) has proved to be less popular than initially imagined, we are beginning to see some renewed interest in the use of VR outside of the conventional gaming or multi-user environments. However, within the urban environment the use of digital accessories, such as the headphones worn by cyclists or joggers that disconnect the wearer from the here and now, is still regarded with some consternation by most people. Perhaps the key strength of the use of AR in the public realm is realized through the capacity to rapidly switch between real-world and augmented experiences as necessary and as desired, and the ability to move between both a private and communal, shared experience of the urban environment.

References

Augé M. Non-places: an introduction to supermodernity. 2nd ed. London: Verso; 2008.

Biermann BC. 2013. http://www.theheavyprojects.com/augmentedreality/. Accessed 14 Sept 2017.

Bimber O, Raskar R. Spatial augmented reality: merging real and virtual worlds. Wellesley: A K Peters Ltd.; 2005.

Coverley M. Psychogeography. London: Pocket Essentials; 2010.

Crow D. Visible signs: an introduction to semiotics in the visual arts. 2nd ed. Lausanne: AVA Publishing; 2010.

Ellsworth-Jones W. Banksy: the man behind the wall. London: Aurum; 2013.

Macdonald N. The graffiti subculture: youth, masculinity, and identity in London and New York. New York: Palgrave Macmillan; 2001.

McClean ST. Digital storytelling: the narrative power visual effects in film. Cambridge, MA: MIT Press; 2007.

Mitchell WJ. City of bits: space, place and the Infobahn. Cambridge, MA: MIT Press; 1995.

Novak S. Works. 2013. http://www.shannonnovak.com/works/works.html. Accessed 5 Dec 2013.

Poynor R. Obey the giant: life in the image world. Basel: Birkhäuser; 2001.

Rowe M, Hutton F. 'Is your city pretty anyway?' Perspectives on graffiti and the urban landscape. Aust N Z J Criminol. 2012;45(1):66–86. https://doi.org/10.1177/0004865811431327.

Sinclair I. London orbital: a walk around the M25. London: Penguin; 2003.

Wacławek A. Graffiti and street art. London: Thames and Hudson Ltd.; 2011.

Part III
Cultural, Social, Spatial and Cognitive Facets of Augmented Reality Art

Chapter 13
Why We Might Augment Reality: Art's Role in the Development of Cognition

Judson Wright

13.1 Introduction

In discussing Augmented Reality, it is common to begin with art: the premise that art exists, that computers are one means to create it, and that AR is one motivation to create computer art. As art primarily assumes the domain of aesthetics, this further leads one to scrutinize computer art in light of a means of expressing aesthetics. While hardly inaccurate, this path is a misleading for us here. Behavioral Art (BA), and its relationship to AR, is profoundly different. To consider BA, we are required to abandon the notion of aesthetics, at least temporarily. We begin by thinking instead about a function involving linguistics and (cognitive) development in a somewhat novel way.

For instance, when discussing cars, it is hardly objectionable to tacitly assume that the car is used as mode of transportation. We do not ordinarily assume the discussion will be about the car as a (stationary) couch. When discussing seating in general, car seats are indeed likely considered. Likewise, the computer's unique and unprecedented ability to execute code is implicit in our discussion of computers. Just as one could freely purchase a car, only to be used exclusively as a couch, a computer certainly can be used for media. However, this possible case is not pertinent to our investigation here. Moreover, the influence of psychology on human experience is far more central to BA (Hoffman 1998).

Furthermore, media creation, presentation, and/or editing have long been accomplishable using analog tools. There would be no reason in a discussion to refer to media, but arbitrarily only to certain tools and not others (Reeves and Nass 1996: 193–210). On the other hand, when we discuss the process by which we conceive of some problem in terms of a logical syllogism or *algorithm*, notating the

J. Wright (✉)
Pump Orgin, New York, NY, USA
e-mail: art@pump.org.in
URL: http://www.pump.org.in

© Springer International Publishing AG 2018
V. Geroimenko (ed.), *Augmented Reality Art*, Springer Series on Cultural Computing, https://doi.org/10.1007/978-3-319-69932-5_13

logic into one of several particular formalized codes, to be rendered mechanically, only one such tool excels far above any previous invention. Regarding programming, there is little impetus to mention couches or media. Though these may possibly occur in isolated cases, they are unrelated to our discussion here regarding perception (beyond the visual) and this programming tool.

13.2 Development

We humans are unique from other species, in that we undergo an unusually long period of development. Since this is 'costly' in terms of survival fitness, it is unlikely to be accidental. It also indicates that the minds we enjoy are qualitatively different than minds assembled by biology, for briefer purposes. This is not to imply that turtles are "smarter" than dolphins, but that a longer juvenile period results in different needs. Shorter-lived organisms and machines function sufficiently without need to fine-tune behaviors much, if at all, to an unpredictable environment. The environment of many organisms can be expected (by evolution) to remain fairly static from generation to generation. Not long ago, it was then believed that if learning does seem to take place in other organisms, it must be due to a reward system. Though Behaviorism was generally abandoned decades ago, the model of *instrumental conditioning* (IC) remains deep-rooted in popular conceptions about learning. A ramification of IC is the view of communication proposed by Claude Shannon (Ash 1965; Shannon and Weaver 1949). Even that children are tested and receive grades is a form of reward/punishment aimed at training for a desired response. Though many children do benefit from this traditional methodology, it is hardly universally helpful and can even be debilitating for many students (Dewey 1910; Kohn 2008; Phillips and Soltis 2009; Tough 2012).

13.2.1 Machine Learning

No doubt, the inner workings of the pre-processor in the computer may strike many readers as unnecessarily esoteric. Unfortunately, the counterintuitive details addressed in this preliminary section illustrate are a fundamental premise in BA and give AR its role therein. Beyond casual conversation and speculation, the common-sense model of *machine learning* applies exclusively between machines and not to organic brains (further discussed in Wright 2012a, 2013a). Shannon's heavily influential notion of communication is prohibitively restricted from development, and thus learning, in any biological sense. We humans are in no position to insist learning is entirely synonymous with causality (Fischer 2011; de Waal 2016). In Shannon's defense, much more is known about the learning process, than was available to him at the time. Though we might refer to successful strategies of stimulus storage, transferal, retrieval, and broadcast, these are only

preliminary tasks, insufficient to account for "borrowed intelligence" (Wright 2013b). Particularly insightful has been the more recent distinction in linguistics between *signaling* and *communication*.

A qualitative difference lies between signaling, where a unitary message is sent and received and is not generalizable to other contexts, and communicating, where multitudes of messages effect the further stream of messages, as per the needs of all conversationalists involved. Both synchrony and self-synchrony are extremely relevant in that signalers, such as nonhuman animals and machines, do not render messages by other physical means than the medium specific to the message (Bavelas et al. 2002; Knapp and Hall 2006: 43–54). For instance, humans can speak the same text verbatim, employing a wide range of behaviors to ultimately convey very different things, or use a wide range of behaviors available at that moment to convey essentially the same message. In other words, a message can be fully formed, prior to being broadcast. In such cases, which are only conclusively evident in humans, and we have very little understanding of how this might be automated, the message is one of several means for directing (not causing) further interaction. Once we have better understood how problems are solved in organic minds, via some form of nonverbal communication, we can then revisit how the computer might be implemented as a prosthetic tool (Licklider 1960; Wiener 1950). Though it is popular to say that computers and brains are nothing alike, it is also popular to apply the same model of processing to the brain as to machines, with only a vague sense of how that processing might take place. For this reason, while we do not intend to outright debunk the notion that intelligence can be synthesized (Horzyk and Tadeusiewicz 2005), we do need to initially discuss a nuance of processing, which bears on a particular role of communication, consciousness, and ultimately AR.

Computers are mechanical tools, which engineers have adjusted to correspond to our concept of mathematics. Programmers then apply this numerical correspondence to concoct complexes of syllogisms, which can be further reformulated in very un-mathematical-looking graphics. Insofar as one might *metaphorically* envision circuits and transistors as hierarchical conditional tree diagrams (*as in* Lakoff and Johnson 1980), the same root assemblage of concepts in the mind that allow one to make sense of Boolean logic is applied to digital processing. The assumption is that this empirical scheme applies to any cognitive function may be more about personal perspectives than about a priori truths (Baron-Cohen 2009; Boyd 2004). The case is argued passionately both by those who feel this is obviously true (Shanahan 1997; von Neumann and Morgenstern 1944; Glimcher 2009) and those who feel this is ridiculously impossible, particularly considering human interaction (Ackerman and Bargh 2010; Edelman 1992; Koch and Tononi 2011). "Every Boolean function no matter how complex, can be expressed using three Boolean operators only: And, Or, and Not." (Nissan and Schocken 2005: 9) The question remains then whether every task can be expressed as a *conditional statement*, using one of several variants on the theme "if x, then y."

A less obvious point remains that the experiences presented in ordinary daily living are extremely unlikely to prove sufficient to account for the complex

concepts, which we entertain. It is further restrictive that, due to the evolutionary construction of the brain and DNA, a "lesson plan" must simultaneously be somewhat useful in our current environment, but applicable to some ancestral species-specific environment (Bjorklund and Pellegrini 2001). Olaf Sporns, in his overview of neural networking, states that "Nervous Systems do not converge onto a final stable pattern of optimal functionality, rather, their connectivity continues to be in flux throughout life." (Sporns 2011: 252) Thus, no matter how similar a neural network in an organic brain and one in software process computational tasks, there is still an additional, perhaps far greater task, which is not remotely addressed by mechanical means, in ongoing re-contextualization of data, from generalizing to other domains, to inferring detailed implications (Koch and Tononi 2011). Because this ability is not instantly formed (by phylogeny), but develops gradually via subjective learning (in ontogeny), it is not a candidate for the static instructions of software. Insofar as physical laws, the inner workings of the machine are chained merely like dominoes (Fig. 13.1). Accumulating more and more simple physical reactions can never yield an increase of intelligence to the system.

Fig. 13.1 Even at the detailed level of the internal workings of the computer processor, essentially a transistor of switches, physical laws merely operate in non-complex chain reactions. Mechanical intelligence can only be accomplished by the computer, as much as intelligence might by configuring dominoes

13.2.2 A Grouping Impulse

Humans also have a tendency to speak of messages metaphorically (in the non-technical sense) as packages that are designed by some external force, and travel to us, into our minds. Beyond the convenience it may provide in colloquial conversation, it is highly speculative and assumes dualism, where the mind and brain are linked by some mystical force, not subject to physical laws. Though a few researchers have questioned this Platonist view in the last 100 years or so, it would appear to remain the devout doctrine of uneducated laymen and the most educated scientists, in most every field. Firstly, we should point out that these messages need not come from intelligent sources. There need be no actual sender. Rather, a message received seems to indicate intelligence only in whichever source the recipient assumes authored the message. Of note here is *attribution theory*, in particular the famous experiment by Heider and Simmel (1944), where subjects were shown an animation of simple geometric shapes. Afterward, the subjects nearly unanimously described the events on screen as if the shapes had personalities and volition. Likely each individual did realize that these obviously drawn abstract shapes could not possibly behave in social ways. Regardless, it is notable that the subjects suspended belief to the extent that it becomes ambiguous exactly to what extent these subjects are certain their descriptions reflect their interpretations. But note, we would not insist these subjects were wrong, mistaken, or lying in their reports, merely that humans have an idiosyncratic perceptual/conceptual system that is usually effective (in the Pleistocene) but far from ideal (Wiener et al. 2011).

For instance, in attributing "intelligence" to entities that appear animated. Computers manage the assembly of computers. But *recursion* is hardly sufficient. What is intelligent is that the execution is not an end, but a means concocted, with no explicit connection provided between the goal and the strategy. In this scenario, there is no reason to believe the computers coming off the assembly line are intelligent. The computer/manager is only routinely obeying code. Only the human who designed this system as a solution to a personal need shows actual intelligence. The managing machine cannot be said to have needs. But the attribution of personality traits to the inanimate computer/manager often fools not only those in search of evidence of *artificial intelligence*, but many of us who merely engage in tool-use during play.

However, before we decide that this *impulsive projection of communicative meaning* (Wright 2012a) is an inaccurate—and thus "wrong"—view, consider alien abduction stories. In many cases, these theories hinge on false-positives. The truth of the matter is not actually provable, nor is ultimately relevant. What often is the case, these soon-to-be-abductees (StBAs) suffer from some experience that is inexplicable within the world they have constructed (Clancy 2005). This event need not be traumatic, but may simply be due to a life of accumulated mundane causes. However, in the larger scheme, the StBA may feel that life has been unusually difficult, disappointing, and depressing. Though alien abduction would hardly be their first explanation to justify the disconcerting event, eventually all other reasons

fail to satisfy the StBA. Alien abduction further has the benefit that the StBA, who previously felt undistinguished by luck, can now feel chosen. A peculiar result, that Susan Clancy found, was that once the dubious alien abduction story was accepted by the abductee, their outlook often changes for the better. The truth is irrelevant, and inaccessible, but this augmentation of reality serves a higher psychological purpose in creating a "patch" for a world-view.

A peculiar and unique tendency in humans, we discuss extensively elsewhere, is to impulsively elect to divide fluid stimuli, such was a rainbow into 2–8 colors, depending on the acquired culture, or sonic frequency spectrum into musical notes (Wright 2010, 2013b). These groupings are in no way real, but imaginary. Yet they remain salient by-products of a typical human perception process (and prove informative in atypical instances, as with lesion studies). Particularly, when we consider that the computer appears to calculate ideally, we are also forced to consider what purpose might this idiosyncratic grouping effect serve?

"One notable feature of the major scale is that it contains several intervals whose frequency ratios approximate small, whole-number ratios. For example, ... 3/2, 4/3 and 5/4 ... This is no coincidence. Western music theory has long valued intervals with simple, small-number frequency ratios, and these ratios play an important role in Western musical structure. The Western fascination with such ratios in music dates back to Pythagoras, who noted that when strings with these ratio lengths were plucked simultaneously, the resulting sound was harmonious. Pythagoras had no real explanation for this, other than to appeal to the mystical power of numbers in governing the order of the universe" (Patel 2008: 15; *see also* Levitin 2006: 37).

As any salesman will tell you, insisting that customers "buy it!" will not be nearly as effective as when customers come up with the idea to do so on their own. What is interesting is the very personalized ways in which each individual 'comes up with it'. Howard Gardner's *Theory of Multiple Intelligences* (Gardner 1983) is a good way to think about this. Gardner shows how children may learn better by seeing a colorful example or may learn better by singing a song in a group, but will tend to choose their own *learning style* in play (Humphrey and Gutwill 2005; Piaget 1962; Sfard 2008: 76–80). Unfortunately, these are inevitably restricted somewhat by which 'teaching styles' are readily available, given their teachers' methodology and within the child's culture (Castelfranchi 2011). However, parents might breathe a sigh of relief to know that this is only "somewhat" the case. In general, as many parents have surely experienced, children can be very clever in finding ways to explore these learning styles. Nonetheless, even if we concede that the practice of art *appears* to have grown out of markings of environs by artists. In the parlance of Chomsky (1957: 15; Hauser 1998; Chomsky 2000), art serves a far more crucial function as *deep structure* and less as *surface grammar*/effect/decor. It is a biological strategy that has evolved for cognitive development and maintenance.

13.3 Augmentation

Though it is popular to say that learning occurs socially, what we intend to investigate is the means by which cultural groupings of behaviors are distinguished from non-cultural events and behaviors. This subtle exchange requires not just dictating of factual data, but confirmations and clarifications to coordinate participants (Millikan 1995; Wright 2012a). Lev Vygotsky's influential theory (1986) describes how minds make reasonable assumptions about the relationship between social behavior and culture, but these are assumptions nonetheless. Firstly, it assumes that culture actually exists externally to the perceiver, rather than as an internal conceptual gestalt. Secondly, it does not take into account human's predisposition toward grouping as essential to perception, interpretation, and subsequent conceptualization. This is where AR comes in. What physical, concrete cues exist that might reveal that social behavior is manifested in intelligently organized clusters, which we might call culture? Before answering, consider that the man-made machine (i.e., a computer) can only detect and calculate exclusively employing concrete physical reactions. In other words, AR is a technique by which a computer views reality, devoid of the subjective associations which humans impulsively experience the world. At this point, we find that art serves all three crucial roles. An author (1) embodies a cultural concern. An audience member can either (2) show interest (e.g. visit the art gallery) or (3) further create embodied concerns that are essentially non-non-sequiturs. These culturally specific concerns are profoundly amorphous, and so we will begin with the simplest format, storytelling.

But we must not be too excited about the need to involve technology. For example, storytelling 3 as a linguistic exercise is useful for development of older children, who are comfortable with verbalizing thoughts. However, by "story telling" we refer to something beyond merely descriptions of imagined events. It is the ability to organization of conceptual objects and understood dynamics. Early training on the violin, or listening to Campbell (1997), was believed to enhance general intelligence, the impetus for this resting on dubious understanding of the brain. For these younger children though, this can be frustrating, as the necessary neuroanatomy has yet to be fully developed. There is even some informed speculation that pressure to conform to premature learning has long-term harmful effects. (Several criticisms are discussed in Bjorklund and Pellegrini 2001: 248.) Though intuitively one might think early academic exposure would be stimulating, the scant evidence does not indicate this. More precisely, not all expression is equally "good for you." Written storytelling may only be helpful to students who demonstrate a certain level of linguistic affinity. It likely only aggravates development to train earlier, whereas pre-language-fluent children would likely be better off making torn paper collages, in order to describe an event (a lesson my wife, who teaches art, does with her pre-kindergarteners).

It appears highly likely that art, as it is commonly understood, including organizations of kinesthetic movements as dance and sounds as music, is practiced

exclusively by humans. But even just to say this immediately calls to question, how we distinguish art from non-art. Not too long ago, the label "artwork" was primarily limited to paintings, sculptures, media that had long traditionally been identified as art. Only an occasional break of 'the fourth wall' would challenge these labels. Not long ago, serious reconsiderations were applied to architecture, craft, and so on (Benjamin 1929). John Cage, Jackson Pollock, Andy Warhol, and countless others had certainly revealed insufficiencies inherent in this labeling scheme (Cage 1961; Joseph 2003). Subsequently, it became popular to announce that, "anything could be art!".

However, this is equally disturbing. While originally, the label "art" was invoked in ways the audience was not fully acknowledging, this alternative rendered the label fairly meaningless. Perhaps, a precise definition is elusive and subtle, but a *distinction* is made. Certainly, the thermostats on the wall at the Metropolitan Museum of Art do not receive the same attention as the paintings (Fig. 13.2).

"In the early nineteenth century, theater, such as the plays of William Shakespeare, attracted rich, middling, and poor alike, each seated in its own section and all participating in the performance. Audiences maintained control of the show by demanding encores of favorite parts, throwing vegetables, and even leaping onto the stage to interact with the actors, As middle- and upper-class Americans became more uncomfortable mixing with the lower classes, they began to demand separate theaters in which the audience remained passive and silent [...] By the end of the nineteenth century, Shakespeare, along with opera, classical music and museum art exhibitions, became high art forms, and popular commercial culture emerged as entertainment opposed, and separate from, 'highbrow' culture" (Morrow 2006: 10).

However, this particular mythology, that there even is such an issue to defend or reject, as popular as such a scheme about classism has become, and threatens to dominate discourse about AR, is entirely distracting from the cognitive issue here.

Fig. 13.2 A thermostat at the Metropolitan Museum of Art in New York. Photograph by the author

13.3.1 Creativity

Just as optical phenomena (visual art) are subject to gestalt principals, so too are sonic phenomena (music) (Bregman 1999). But gestalt alone is not sufficient to impart meaning. It may often inform categorization of stimuli, but does not make the organizational scheme useful. Consciousness of a sensation is not simply the detection of sensation, supplemented later by the prefrontal cortex. Insofar as *frames* are cultural artifacts, human socialization (whether essential or not, lacking any practical alternatives) provides the initial step and direction of subsequent steps: even if that interaction is merely the internal mental shift of attention (Ackernan and Bargh 2010; Dewey 1910: 16–155; Schmeichal and Baumeister 2010: 29–50; Searle 2001: 33–60).

Like language, every culture it seems has a music theory that often differs in (learned) details, but between peculiarly limited parameters. This makes music a prime candidate to compare with language (Lerdahl and Jackendoff 1983; Patel 2008). Perception is culturally framed in composition and perception (Cohen 2006; Levitin 2006: 57, 73–79, 114). Thus, some system must be shared between composer and listener for the music to make any sense (Jourdain 1997: 74–78, 128–134; Becker 2004: 108–116; Doidge 2007: 303). And like language, the grammar is rather culturally specific. A musical piece for an American audience might sound meaningless to members of a tribe in Bali (Kartomi 1980; Gold 2005; Wright 2012b) or the Middle East (Zonis 1980; Arbabi 2000) where exposure to Western music is minimal. A key element is interest (Dewey 1910: 30–34; Allen 2004: 114), which is primarily interactively formulated by experience and culture. Noise must be potentially interesting before the brain determines that it is music and thus worthy of a fuller assessment (Humphrey and Gutwill 2005). The role of some music theory is similar to Chomsky's *deep structure*, as revealed in his famous quasi-sentences (Chomsky 1957: 15), such as "Colorless green dreams sleep furiously."

Babies make nonsensical babbling *en route* to becoming children, who invent nonsensical stories before growing into eloquent adults. Manipulation of symbols, graphic, vocal, and otherwise, is an essential technique, in order to communicate, but communication is not at all exclusively the manipulation of symbol systems. Recall that in a biological view even noise serves a function, unlike most sciences where 'signal noise' is considered a bad thing, with the unrealistic the desire to eliminate it entirely. In recent neurological work, what we might be tempted to disregard as a baseline of noise may also serve an intrinsic global networking effect (Sporns 2011: 149–169, 174–175). Both Vygotsky (1978) and Piaget (1929, 1971) further point out that at about four, the child will recite a narrative, termed *egocentric speech,* as that child approaches a problem (Crystal 2005: 83).

"For example, a four-and-a-half-year-old girl was to get candy from a cupboard with a stool and a stick as possible tools. [The] description reads as follows: (Stands on a stool, quietly looking, feeling along shelf with stick.) 'On the stool.' Glances at experimenter. Puts stick in other hand.) 'Is that really the candy?' (Hesitates.) 'I can

get it from that other stool, stand and get it.' (Gets second stool.) 'No, that doesn't get it. I could use the stick.' (Takes the stick and knocks at the candy.) 'It will move now.' (Knocks candy.) It moved, I couldn't get it with the stool, but the stick worked.' In such cases, it seems both natural and necessary for children to speak while they act; in our research we have found that speech not only accompanies practical activity but also plays a specific role in carrying it out" (Vygotsky 1978: 25).

It would also be reasonable to say that the child is actually attempting to use her limited linguistic ability as an initial step in problem solving. However, infants initially lacking conceptual concepts for their problems will merely 'babble' (Eliot 1999: 370–371). Importantly, Piaget also writes that children undergo a crucial transformation in distinguishing between internal and external worlds. Vygotsky's observations, quoted above, are all the more poignant when taking into account Piaget's *nominal realism*. This is the belief that words themselves are concrete substances, which are initially intrinsic 'appendages' of the objects named. Then, these words are located in the environment and, finally, conceptualized in the mind. At an early age, the word "lamp" is usually thought to be located initially in the young speakers' mouth (Piaget 1929: 71–72). A year or so later, the child may deduce that it is within the lamp (pp. 72–75). By about 9-years-old, the word is seen as located in the mind (pp. 78–80).

It has been theorized that the cave paintings of Lascaux were the remnants of a belief in magic, where these symbolic images were thought to influence hunting expeditions (Campbell and Moyers 1988: 79–81; Solso 2003: 52, 86–87). This is obviously an instance of AR, occurring long before the invention of computers. A hunt too can be seen as a problem-solving task, and thus in doing so, the hunters might narrate plans in a chosen symbolic system. Jourdain (1997: 305) and others have hypothesized that because the precise sites in those French caves where paintings were found had unusual acoustic properties, it was likely that the painters were accompanied by song. Theories regarding child development seem to reinforce the plausibility of these speculations. Singing may be a form of problem solving, as is painting or coordinating muscles in behavior (Curtis 1992).

This, coincidentally, is applicable to categorization of color perception, and exactly Campbell's point (1949), based on Jung (1935), mentioned previously, regarding mythologies throughout the world. The crucial step in all of this is for us to recognize that myth is not only culturally specific, taught and learned by culture, allowing the individual to membership that culture, but also allowing for neurological fine-tuning, as with trance. This describes music as well. In fact, music and myth serve essentially the same function and save the trivial matter of modality. That we might devoutly believe sonic events to be profoundly distinct from conceptual organization is ultimately a matter of how well we are fooled by our own human propensity to apply categorizations.

13.3.2 Utilizing Reality

A piece which gathers text from RSS feeds and converts the ASCII characters found into musical pitches would certainly qualify as AR. However, in the larger scheme, this experiment failed in the way it set up a relationship between the intelligently organized text and chaotic output of the musical composition software. In *Composomatic* (2008), information was gathered from multiple feeds and thus from multiple authors, with multiple unrelated contexts. No singular organizing scheme came through. Imagine if single notes (and rests) were selected from various compositions and strung together *at* random. The resulting music would not reflect what each note was leading toward. This is a peculiar relationship, where the individual notes are somewhat arbitrary out of context, but are essential building blocks in creating a context.

In *You've Got Bugs!* (2006), though the modalities involved are very different, the conversation is similar (Fig. 13.3). The screen depicts a closed-circuit video of the space in front of the screen, which includes the audience member. The scene is somewhat distorted and discolored but easily recognizable. One may wonder why this particular unappealing effect has been applied. An answer soon appears. Small virtual insects crawl onto the (live) scene. The audience member does not know at first, but the insects are crawling toward points of motion. Thus, wherever the observer moves, the bugs seem to follow. In the course of discovering what is happening on the screen, the audience member must behave in ways that the gallery setting would not predict. In fact, without this explanation, it would be rather unclear as to why the gallery visitor is ducking and swaying. But this "dance" is the viewer's spontaneous technique for understanding the environment, in this case facilitated by artwork, specifically AR.

Fig. 13.3 *You've Got Bugs!* Screen shot and picture of installation with and without audience member

13.4 Conclusions

We now consider why evolution bothered to favor the ability for beat detection? Firstly, whatever their authors' intention, mythologies are strategies used for culturally informed development. Any culture will do, none are intrinsically more or less ideal. This includes both traditional cultures, as well as ones invented in the course of a game. Nonetheless, we come to learn which patterns in the environment are significant to other members of that select culture. Ritual teaches us which artifacts to be revered, and in what ways reverence is expected to be shown. Symbiotically, the mythologist/artist, having assimilated the priorities of a given culture, arranges words and concepts into an explanation for these prioritized experiences. One might argue a piece such as John Cage's 3′44″ or AR highlights the experience (but is not intended to explain), though our point remains. Random sounds may be heard by the audience member, but the mythologist-as-musician having arranged several of these sounds into a rhythm provides the audience member with a means by which to discern meaning from chaos. The audience member can now exhibit solidarity with the culture by dancing, tapping or otherwise demonstrating the successful application of cultural cues, as appropriate given these cultural rules. For instance, one might move vigorously at a club in response to music, but is expected to sit still when hearing "Here Comes the Bride."

Likewise, the painter may be drawn to the medium of paint, due to some personal *intelligence*, and is provided with tools to embody some otherwise un-articulate-able problem. There is no possibility that an inanimate tool, such as a computer, actually "curates" the problem-solving task at hand, creating the mythology. In the same way, the abacus does not perform mathematics, but embodies a part of the cognitive process where limitations of the human mind are most apparent. Furthermore, in a minority of similar tool-using cases, there is clearly the sensation experienced of animate behaviors and anthropomorphic personalities attributed to some events on the screen and not others. These cognitive-perceptual-ability-enhancing cases are called "art." An audience member too may then be drawn by a personal *intelligence* to gaze longer at particular paintings. From the painting, that audience member culls the necessary clues to show solidarity. The essential trick, however, is that the painting is not literally an intelligent being with a message. At the cost of over-interpreting scenes on the computer, or even the printed page, utilizing AR we can come to submit to cultures, in instances when only scant clues as to the requirements of membership can be detected from literal, concrete sensations.

References

Ackernan J, Bargh J. Two to tango: automatic social coordination and the role of felt effort. In: Bruya B, editor. Effortless attention: a new perspective in the cognitive science of attention and action. Cambridge: MIT Press; 2010. p. 235–71.

Allen S. Finding significance. In: Finding significance, exploratorium research series. San Francisco: Exploratorium; 2004.

Arbabi F. Classical persian music (Radif). New York: Freydoon Arbabi/McGraw Hill; 2000.

Ash R. Information theory. Mineola: Dover; 1965.

Baron-Cohen S. Autism: the empathizing-systematizing (E-S) theory, cognitive neuroscience 1156. New York: New York Academy of Sciences; 2009.

Bavelas J, Coates A, Johnson T. Listener responses as a collaborative process: the role of gaze. J Commun. 2002;52(3):566–80.

Becker J. Deep listeners. Bloomington: Indiana University Press; 2004.

Benjamin W. Some remarks on folk art. In: The work of art in the age of its technological reproducibility and other writings on media. Cambridge: Harvard University Press; 1929.

Bjorklund D, Pellegrini A. The origins of human nature: evolutionary developmental psychology. Washington, DC: American Psychological Association; 2001.

Boyd D. Autistic social software. San Francisco: SuperNova conference; 2004. p. 35–45.

Bregman A. Auditory scene analysis. Cambridge, MA: MIT Press; 1999.

Cage J. Silence. Middletown: Wesleyan Paperback; 1961.

Campbell J. The hero with a thousand faces. Novato: New World Library; 1949.

Campbell D. The Mozart effect: tapping the power of music to heal the body, strengthen the mind, and unleash the creative spirit. New York: Avon Books; 1997.

Campbell J, Moyers B. The power of myth. New York: Doubleday; 1988.

Castelfranchi C. For a 'cognitive anatomy' of human emotions ad a mind-reading based affective interaction. In: Gökçay D, Yildirim G, editors. Affective computing and interaction: psychological, cognitive, and neuroscientific perspectives. Hershey: IGI Global; 2011. p. 110–32.

Chomsky N. Syntactic structures. Berlin: Walter Gruyter GmbH; 1957.

Chomsky N. New horizons in the study of language and mind. Cambridge: Cambridge University Press; 2000.

Clancy S. Abducted: how people come to believe they were kidnapped by aliens. Cambridge: Harvard University Press; 2005.

Cohen D. Perception and response to schemata in different cultures: Western and Arab music. In: Alderage D, Fachner J, editors. Music and altered states: consciousness, transcendence, therapy, and addictions. London: Jessica Kingsley Publishers; 2006. p. 60–73.

Crystal D. How language works: how babies babble, words change meaning and languages live or die. Woodstock: Overlook Press; 2005.

Curtis S. The joy of movement in early childhood. New York: Teachers College Press; 1992.

de Waal F. Are we smart enough to know hoew smart animals are?. New York: WW Norton; 2016.

Dewey J. How we think. Boston: Dover; 1910.

Doidge N. The brain that changes itself. New York: Viking; 2007.

Edelman G. Mind without biology. In: Bright air, brilliant fire: on the matter of the mind. New York: Basic Books; 1992. p. 211–52.

Kohn A. Education and democracy today, progressive education. Nat Assoc Indep Sch. 2008; Spring:1–7.

Eliot L. What's going on in there?: how the brain and mind develop in the first five years of life. New York: Bantam Books; 1999.

Fischer J. Where is the information in animal communication? In: Menzel R, Fischer J, editors. Animal thinking: contemporary issues in comparative cognition. Cambridge: MIT Press; 2011. p. 151–62.

Gardner H. Frames of mind: the theory of multiple intelligences. New York: Basic Books; 1983.

Glimcher P. Neuroscience, psychology, and economic behavior: the emerging field of neuroeconomics. In: Tommasi L, Peterson M, Nadel L, editors. Cognitive biology: evolutionary and developmental perspectives on mind, brain, and behavior. Cambridge: MIT Press; 2009. p. 261–78.

Gold L. Music in Bali. New York: Oxford University Press; 2005.

Hauser M. The evolution of communication. Cambridge: MIT Press; 1998.

Heider F, Simmel A. An experimental study of human behavior. Am J Psychol. 1944;2(57): 243–59.

Hoffman D. Visual intelligence: how we create what we see. New York: Norton; 1998.

Horzyk A, Tadeusiewicz R. Comparison of plasticity of self-optimizing neural networks and natural neural networks. In: Míra J, Álvarez J. editors. Mechanisms, symbols, and models underlying cognition, first international conference on the interplay between natural and artificial computation, Universidad Nacional de Educatión a Disrancia, De Ingenería Informática, Departmento de Inteligencia Artificial 3561. Berlin: Springer; 2005. p. 156–65.

Humphrey T, Gutwill J. Fostering active prolonged engagement. In: Fostering active prolonged engagement, Exploratorium research series. San Francisco: Exploratorium; 2005.

Joseph B. Random order: Robert Rauschenberg and the Neo-Avant-Garde. Cambridge: MIT Press; 2003.

Jourdain R. Music, the brain, and ecstasy: how music captures our imagination. New York: Harper Collins; 1997.

Jung C. The concept of the collective unconscious. In: St Bartholomew's journal, reprinted in The Portable Jung. Penguin: New York; 1935. p. 59–69.

Kartomi M. Musical strata in Sumatra, Java, and Bali. In: May E, editor. Music of many cultures. Los Angeles: University of California Press; 1980. p. 111–33.

Knapp M, Hall J. Nonverbal communication in human interaction. Belmont: Thompson Higher Education; 2006.

Koch C, Tononi G. A test for consciousness. Sci Am. 2011;6(304):44–7.

Lakoff G, Johnson M. Metaphors we live by. Chicago: The University of Chicago Press; 1980.

Lerdahl F, Jackendoff R. A generative theory of tonal music. Cambridge: MIT Press; 1983.

Levitin D. This is your brain on music. New York: Penguin; 2006.

Licklider J. Man-computer symbiosis. IRE Trans Hum Fact Electron. 1960; HFE-1: 4–11.

Millikan R. Pushmi-pullyu representations. In: Nuccetelli S, Seay G, editors. Philosophy of language: central topics. Plymouth: Rowman and Littlefield Publishers, Inc.; 1995. p. 363–76.

Morrow R. Sesame street and the reform of children's television. Baltimore: The Johns Hopkins University Press; 2006.

Nissan N, Schocken S. The elements of computing systems: building a modern computer from first principles. Cambridge: MIT Press; 2005.

Patel A. Music, language, and the brain. New York: Oxford University Press; 2008.

Phillips D, Soltis J. Perspectives on learning. New York: Teachers College Press; 2009.

Piaget J. The child's conception of the world. New York: Rowman & Littlefield Publishers, Inc.; 1929.

Piaget J. Play, dreams, and imitation in childhood. New York: W.W. Norton & Co.; 1962.

Piaget J. Genetic epistemology. New York: W.W. Norton & Co.; 1971.

Reeves B, Nass C. The media equation: how people treat computers, television, and new media like real people and places. Cambridge: Cambridge University Press; 1996.

Schmeichal B, Baumeister R. Effortful attention control. In: Bruya B, editor. Effortless attention: a new perspective in the cognitive science of attention and action. Cambridge: MIT Press; 2010. p. 29–50.

Searle J. Rationality in action. Cambridge: MIT Press; 2001.

Sfard A. Thinking as communicating: human development, the growth of discourse, and mathematizing. New York: Cambridge University Press; 2008.

Shanahan M. Solving the frame problem: a mathematical investigation of the common sense law of inertia. Cambridge: MIT Press; 1997.

Shannon C, Weaver W. The mathematical theory of communication. Chicago: University of Illinois Press; 1949.

Solso R. The psychology of art and the evolution of the conscious brain. Cambridge: MIT Press; 2003.

Sporns O. Networks of the brain. Cambridge: MIT Press; 2011.

Tough P. How children succeed: grit, curiosity, and the hidden power of character. New York: Houghton Mifflin Publishers; 2012.

von Neumann J, Morgenstern O. The theory of games and economic behavior. Princeton: Princeton University Press; 1944.

Vygotsky L. Mind in society: the development of higher psychological processes. Cambridge: Harvard University Press; 1978.

Vygotsky L. Thought and language. Cambridge: MIT Press; 1986.

Wiener N. Problems of sensory prosthesis. In: Selected papers of Norbert Wiener. Cambridge: MIT Press; 1950. p. 431–9.

Wiener J, Shettleworth S, Bingman V, Cheng K, Healy S, Jacobs L, Jeffrey K, Mallot H, Menzel R, Newcombe N. Animal navigation: a synthesis. In: Menzell R, Fitscher J, editors. Animal thinking: contemporary issues in comparative cognition. Cambridge: MIT Press; 2011. p. 51–76.

Wright J. Borrowed intelligence: observing and implementing the culture of the art world. In: Accolas S, Wanono N, editors. Paris: Création and transmission en Anthropologie Visuelle. Journal des Anthropologues December, AFA (French Association of Anthropologists); 2012b. p. 130–31.

Wright J. Discovering the non-self: the construction of language, trance, and space. In: Broadhurst S, editor. Body Space Technol J. 2013a;2(11):1–12.

Wright J. Can you tell me how to get, how to get to e-learning: development and complexity? In: Eletti V, editors. J e-Learn Knowl Complex. 2013b;3(9):41–53.

Wright J. Interaction's role as catalyst of synthesized intelligence in art. In: Aceti L, Jefferies J, Papadimitriou I (vol. editors) Munro J, Sahin O, editors. Leonardo Electronic Almanac, Publications: Touch and Go (18)3; 2012a. p. 190–99. Leonardo.

Wright J. Neuroacoustics: integrating the strengths of computer technology and human biology through music, Sonic Ideas/Ideas Sónicas 1(3). The Mexican Center for Music and Sonic Arts; 2010.

Zonis E. Classical Iranian music. In: May E, editor. Music of many cultures. Los Angeles: University of California Press; 1980. p. 269–83.

Chapter 14
Augmenting Wilderness: Points of Interest in Pre-connected Worlds

Nathan Shafer

14.1 Introduction

This is the second edition of the chapter on augmented reality artmaking. A few of the methods of AR artmaking have become obsolete, and some of the formalities for terminology have changed: internet is no longer capitalized, Mt McKinley is no longer used to refer to Denali and the junaio mobile AR app was bought by Apple and everything on that platform was taken offline.

Figure 14.1 was the QR code for this chapter, which launched a channel called "Augmenting Wilderness" when scanned using the Junaio mobile AR application, so that the reader could hear some of the audio tracks embedded in this essay, or follow some links to cited works. This chapter also made the same work available on an identical channel, on the Layar mobile app. These augments are either no longer available due to cost and technological availability.

Augmented reality art began gaining common relevance by recuperating into this type of commercially viable interactive print, which is based on targets instead of geolocation. It is easier to monetize and advertise with. AR in contemporary usage, however, remains an intrinsically global and viscous practice, whether it is functioning in this sort of consumerist enterprise or if it is a radical intervention of everyday life.

This chapter is going to look at a few projects that have constructed AR works in the worldwide public sphere—works steeped in the anti-tradition, practicing a flat ontology and presented on the borders of an increasingly connected world. They are unseen hubs in a worldwide social network; temporally localized, globally mobile —multiplicitous points of interest in the wilderness.

N. Shafer (✉)
Institute for Speculative Media and Shared Universe, Anchorage, AK, USA
e-mail: contact@nshafer.com
URL: http://nshafer.com

© Springer International Publishing AG 2018
V. Geroimenko (ed.), *Augmented Reality Art*, Springer Series on Cultural
Computing, https://doi.org/10.1007/978-3-319-69932-5_14

Fig. 14.1 Archived QR code for "Augmenting Wilderness," originally made for the Junaio AR app

Fig. 14.2 I am sitting in a room by Alvin Lucier (1969), audio, 15:23. All rights courtesy of the artist, *image source* Nathan Shafer in the Creative Commons

I am Sitting in a Room was produced in 1969, one of the earliest compositions to incorporate electromagnetic tape and feedback (Fig. 14.2). The piece takes Lucier's recorded voice and records the playback of it in a room, where the room itself restructures the work into ambient static, ultimately getting rid of Lucier's stutter and creating a resonant frequency.

Today, Lucier's work is an early representation of the way artists can intertwine digital media and physical location to develop mobile augmentations in the world. "Room" is a global work that can be accessed or recreated anywhere one takes recording equipment. When it was originally conceived, it came with a set of instructions on how to recreate the work hyperlocally, in one's own room. Participants started with the original recording of Lucier speaking and played it in a room, rerecording it, over and over until it becomes ambient static, shaped by the space they are temporally in.

14.2 AR, OOO

Augmenting wilderness is a practice in augmented reality art making—the process of enmeshing digital objects with pre-connected worlds. *Pre-connection* references the absence of wireless fidelity (Wi-fi) within an ecosystem or community, but not the effects of it, which are evident in its local manifestations and are ubiquitous in the augmented object's realm of attraction. Pre-connection precludes the idea that eventually the entire world will be universally connected to the Internet, so it is a temporal descriptor, albeit based on a very optimistic prediction about the future of technological ubiquity. Pre-connection is going to be a contemporary, temporal condition of some areas on the planet, where either a lack of human population or environmental factors keep the space signal from integrating with the local media ecosystem via ambient radio waves (Wi-fi). Radio waves, satellite signals, and space weather are part of the nonlocal intermedia landscape of human mobility from global to interplanetary, but presently are Anakin to the *social wilderness*, a wilderness completely outside of human construct or perception.

The use of the term *wilderness* in relation to AR adopts Levi Bryant's *wilderness onticology*, "(it) should not be conceived as the absence of humans, but rather in terms of a flat plane of being where humans are among beings without any unilateral, overdetermining role… humans dwell in wilderness without the wilderness being reduced to a correlate of thought," (Bryant 2011) looking at the wilderness as a multiplicitous "difference engine," in the context of object-oriented ontology (OOO), an aesthetic philosophy of being that takes the perceived reality of objects out of Kant's *Copernican Revolution*, which predicates the existence of objects on the human-world correlate of them (Kant 1781). Defining wilderness, for the sake of augmented reality as an artistic practice, is more a discussion than definition, as Oeschlaeger notes, "the issue involves the *theorie* upon which *praxis* will rest—the idea of wilderness itself. Whatever this idea, the conceptual difference will be reflected in practice" (Oeschlaeger 1991).

Certain theoretical aspects of augmented reality artistic collectivism are ecologically parallel to OOO, especially the metaphysical nature of the AR "art-object," which focuses "on the informational relationship between object and human viewer, or the political and economical context surrounding the artwork's reception" (Jackson 2011). OOO emerged at around the same time as mobile AR

collectivism (2009–2010), so it is no surprise that there are similarities due to their temporal proximity: There are issues of critical reception for both groups because of their incorporation of non-traditional platforms like social networks and blogging—both groups are also academically suspect in many circles (OOO is unconcerned with the Analytic vs. Continental beef, and AR is equally unconcerned with Modernism vs. Post-Modernism).

Early critical issues concerning augmented reality as an emergent art form are described as the "antiquated VR pipe dreams" via the new media blog, Rhizome. org, taken from fictional depictions of AR and the use of the "Web browser" as an artistic metaphor. The "VR pipe dreams," which William Gibson fictionalized in his 2007 novel *Spook Country*, as "cartographic attributes of the invisible," or "spatially tagged hypermedia," (Gibson 2007) are what viewers are truly expecting to see when they first experience AR. Augmented wilderness, then, is a good place as any to examine the basic instability of contemporary AR, in contrast to a virtual fantasy world overlaid on top of our collective expectations of it as an artistic medium. AR is a "specialized" subset of the global media ecosystem, what Ian Bogost describes as a *microhabitat* (in terms of media ecology) with the value of the specialized media being "less important than the documentation of its variety and application" (Bogost 2011). Like the health of a biological habitat, media ecologies measure their health in variety and application.

14.3 POIs

Singular augmented reality pieces, commonly referred to as points of interest (POIs), are augmented objects in a world of other equivalent objects, where humans are just one group of beings. Like other objects, or works of art, these POIs are not existentially contingent on human cognition—their being and their properties are different things. T.S. Elliott's *objective correlate* is viable for many artists working in the modernist or postmodernist traditions, but it is inconsequential when discussing the formal characteristics of AR artworks without their existences sharing an equal ontological footing with their properties or physical attributes. The function of juxtaposing AR and OOO is not to elucidate or explain formalist aesthetic philosophies, or to open a critical inquiry into any particular works given status as art, object/subject, or object/thing, but to illustrate how augmented reality art performs, when looked at in a flat ontology, in spite of Kant's correlate, a dated, homocentric view of the universe that is counterintuitive to our current worldview, where kids grow up knowing that things happen on exoplanets, like Gliese 436 b, a water planet the size of Neptune covered with "hot ice" (Gillon et al. 2007). Or that there are diamond volcanoes on hot carbon planets that have surface landscapes of duning pencil lead (Clark 2012). These amazing aspects of the literal wilderness in the known universe do not need human observation to exist, and we can guess at their existence mathematically or theoretically, but the literal local manifestations of

the objects themselves, these difference engines, are fine without us being physically present and observing them, especially since the practice of our observation is changing.

By now the thing of AR has become second nature to us—people wandering about; staring at the world through little glowing screens, looking for POIs—is commonplace, even treated with speculative disdain by an older generation, who see smartphones as brain-eating mobile pacifiers, working to devolve our sapience. As a process, mobile media observes the human aesthetic experience, enmeshing objects in the world, what Timothy Morton refers to as the *aesthetic dimension*. "(It) is the causal dimension, which in turn means that it has the vast nonlocal mesh that floats "in front of" objects (ontologically, not "physically" in front of them)" (Morton 2013).

AR is an art medium, literally and physically operating in the nonlocal causal mesh Morton elucidates. At the present moment, AR has two different ways of being, or documented varieties: by attaching augments to a target (something that is scanned by a computer, generating an AR object, or POI), or by attaching augments to a geolocation (your computer knows where it is on Earth, which generates an AR object/POI). Currently, most developers and artists are using AR browsers, which are proprietary mobile applications for smart devices.

14.4 Radio Babies

Before looking at some specific AR art projects, which illustrate a flat ontology in the wilderness, Fig. 14.3 is an artwork by George Ahgupuk, called *Radio Babies* from 1940. It is ink and watercolor on bleached animal skin, with a stitched red sinew border. The image drawn on the skin depicts a fully clothed newborn flying from the bell horn of a radio, through the air, across the unseen ether all around us, to an Iñupiat family with a radio antenna at their cabin many miles away in Bethel. The white man at the bell horn is Joseph Romig, an early doctor in territorial Alaska. He would help aid in deliveries via radio, a proto-telephonic version of action at a distance. Early telemedicine. *Radio Babies* shows an immediate technological connection between remote locations (pre-connected worlds) and the way information exists in an ecosystem as part of the human experience inside of it. One of the notable elements of the work is Ahgupuk's ability to take a technological marvel (radio communication), being used for good (family medicine) and illustrate it with a pronounced bit of magical realism (the baby flying on radio waves) personifying nonlocal action via technology.

Another poetic illustration of technology in *Radio Babies* is the gigantic see-through reel-to-reel screen on top of Denali in the background, titled the "J. H. Romig Radio Babies Pricelist," showing what people can expect to pay for family telemedicine services, boys and girls start out at $200, with discount prices for a twin, and notable discounts for triplets and quadruplets. Ahgupuk's written words in the painting are as much a part of the environment as the images of

Fig. 14.3 Radio babies by Ahgupuk (1940), ink and watercolor on skin. *Photo* Anchorage Museum at the Rasmuson Center

buildings and mountains, with the words "Umbrella Roadhouse" and "Rainy Pass" geolocated on their watercolor locations. *Radio Babies* practices a flat ontology where the ambient information in a place is equivalent to the other objects in it, without losing the complex humanness that is so apparent in the artistic depiction of the technology (the pricelist and the healthy family are both effected by the radio communicator). *Radio Babies* is a nonlocal networked media piece, made with locally available (and traditional) materials, which also places it firmly in the canon of Alaskan art history.

14.5 Anti-tradition

In 1996, when Nicholas Negroponte was looking at the future of digital media art from the beginnings of the MIT MediaLab, he wrote, "the digital superhighway will turn finished and unalterable art into a thing of the past. The number of mustaches given to Mona Lisa is just child's play" (Negroponte 1996). He was mentioning Duchamp's *ready-mades* tangentially, but more importantly, he invoked a spirit many artists refer to as the *anti-tradition*, which has been part of the networked or digital aesthetic since its inception. The anti-tradition is not an art movement, but

rather a variegated practice of producing counterculture art, which has been going on for a very long time, from Bouzingo to Pussy Riot. The Canadian poet Christian Bök places the historical onus of the anti-tradition on the *'pataphysical'* literature of Alfred Jarry (Bök 2002) whose major literary influence was the drunken dithyrambic fantasies of François Rabelais, a writer from the European Renaissance. Negroponte's enthusiasm for a society full of malleable cultural objects has been given a new technological tool for the anti-tradition with the advent of the "digital superhighway."

Regardless of when and where the anti-tradition emerged, its various practices and applications have usually aligned with revolutionary or countercultural political movements of the day—for example, members of the Situationist International were in the Latin Quarter during the 1968 riots in Paris and members of the Provo Group hijacked a balcony in the Vatican delivering an anti-religious Easter sermon before they were arrested. What is important to note is how works from the anti-tradition are quintessentially *of the time*, with each socially useful or relevant form these artists took to counter the dubious cultural dialectics of their time. As Gregory Sholette wrote, "If socially useful art is ultimately determined by the society it serves, the artist as tool maker must, by necessity, look to the public sphere, and not to the realm of art, for the logic of her work" (Sholette et al. 2004).

Apart from the anti-tradition, AR art has ancestors in Earth art and conceptualism; roots in Fluxus, punk rock, the Situationist International, Fin-de-siècle literature, cyberpunk and 1990s style Interventionism. It cut its teeth with the twenty-first-century's international Occupy movements. The Manifest.AR manifesto, from early 2011, posits that AR artists "create subliminal, aesthetic and political AR provocations, triggering Techno-Disturbances in the substratosphere of Online and Offline Experiences… Augmented reality is a new Form of Art, but it is Anti-Art… It is a Relational Conceptual art that Self-Actualizes" (Manifest.AR 2011). Since its inception, Manifest.AR has consistently produced collaborative projects from the public sphere, which have integrated with social movements and revolutions across the globe.

14.6 Usage

When AR browsers became available as mobile applications, it was a *memetic* shift in the usage of AR, from the preconscious imaginings in sci-fi novels with headsets and cyberpunks to the one from quotidian existence where tourists hold up mobile phones in shopping arcades. Initially, the works of art produced inside of this new usage of AR seemed like they would be a combination of locative media and digital sculpture, which by and large they are, but it has been adapting to the common usage in society. Gibson described the locative artist as "annotating every centimeter of a place, of every physical thing. Visible to all, on devices…" (Gibson 2007). The "device" referred to is the artist's mobile phone; which is not the preferred method for viewing "locative media" in *Spook Country* (VR headsets are),

the artist's mobile phone was a second best—an ad hoc example, put together to illustrate the important locative work the fictional artist made for VR helmets.

Just because an object has certain properties or features, does not preclude that they will be used, or used in the way they were intended. As Sheller notes, "Unlike commercial applications, artists often draw on more disruptive and critical traditions that seek to defamiliarize the familiar, or to heighten our sensual awareness of location, or to offer new forms of place making and public engagement" (Sheller 2013).

The unintended usage of objects being spread from local application to application is part of the nature of memetic reproduction and variation and is the way networked media aesthetics create niches in media ecologies. As biologist Richard Dawkins, who coined the term *meme*, explains, "Just as genes propagate themselves in the gene pool by leaping from body to body via sperm and eggs, so memes propagate themselves in the meme pool by leaping from brain to brain via a process, which in the broad sense, can be called imitation" (Dawkins 1976). This imitation of usage is evident in the way some youths are smashing the screens of their smartphones, in a stylish sort of identity protestation, like the torn jeans of the 1980s (Wax 2013), "a new meme will have a greater chance of penetrating the meme pool if it is consistent with other memes in that environment" (Distin 2005).

The anti-tradition political-aesthetic practices of the Situationist International gained a newfound relevance when Internet browsers became a widely used format. *Psychogeography* is one of these object-practices from SI, and it is a way of participating in the world based on the human situation within it, or developing an aesthetic that mitigates between the unseen history of the immediate environment or the psychic artifacts left in our ecosystems (this connection between Situationist *praxis* and locative media was referenced in *Spook Country* as well). OOO refers to these objects as reflexive objects. Or in Foucault's pre-OOO observation, "a form of reflection… that involves for the first time, man's being in that dimension where thought addresses unthought and articulates itself upon it" (Foucault 1970).

Geolocative AR is still currently in the public sphere, free for anyone to access, and no permits needed to put a POI in a secure location, as with Sander Veenhof and Mark Skwarek's collaborative work from 2010, *infltr.AR* (Fig. 14.4), which put virtual hot air balloons porting Twitter feeds from the outside world into the White House and the Pentagon. Essentially, the White House and the Pentagon are part of the public wilderness that viewers can see from an enclosure and take pictures of. Just like tourists on a road trip through the Midwest US, it is a true point of interest, in its original context, part of the American Landscape, made for visitor locations, or great places for an anamnestic photograph. Secured government facilities are not wildernesses that are protected per se, but definitely objects that are actively being preserved, and left relatively unknown to the normal citizenry.

Both augmented reality and the wilderness are difference engines, which create entanglements in communities; they are also object-ideas that are not anywhere in particular. They are "viscous" global objects, like the Internet and the World Wide Web. Morton refers to these sorts of global objects that are both "nonlocal" and "viscous" as *hyperobjects*. One of his key examples is global warming. It is an

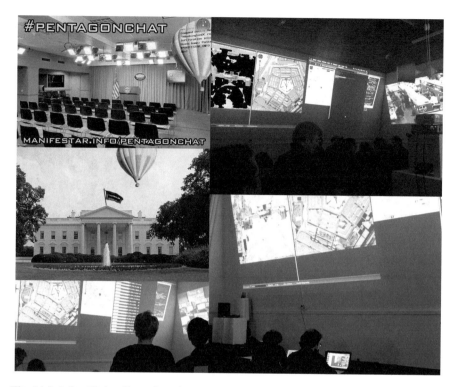

Fig. 14.4 infltr.AR by Skwarek and Veenhof (2010), AR intervention at White House and Pentagon using Twitter. *Photos* Sander Veenhof

object that cannot be reduced to a singular object one can touch—a happening and concept in the world that has visible effects and consequences, which can work to illustrate it. With global CO_2 at over 400 parts per million, global warming can be seen in extreme weather in the cities on the eastern seaboard, or in Alaska, with glacial retreat.

14.7 Anamnesis

Figure 14.5 is an AR work of mine, *Exit Glacier*, built on site, 120 miles from Anchorage in Kenai Fjords National Park. Exit Glacier is a glacial extension from the Harding Ice Field and derived its name because it was the glacier from which the first white explorers to travel the area used to exit the ice field. It has been in dramatic decline for a several decades now and has shrunk to quite a small size, compared to its former self, a physical manifestation of both the hyperobject called global warming and another hyperobject called the cryosphere (the sphere of frozen water on the surface of the Earth).

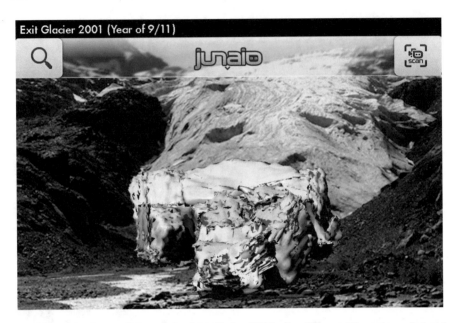

Fig. 14.5 Exit Glacier (2001 Terminus) by Shafer (2013), five different AR versions of glacial termini were built on location at Exit Glacier, and this is the terminus from the year 2001. *Source* Nathan Shafer

Exit Glacier is one of a very small number of glaciers in the world that are easily accessible from a highway. The US National Park Service has been aggressive in its work to illustrate global warming at this glacier. The AR project digitally reconstructs five of the former termini on location in Kenai Fjords National Park, based wholly on the glacier itself as a reflexive object: 2001 (year of 9/11), 1994 (premiere of Mosaic, the first popular Web browser), 1979 (the artist's birth year), 1964 (Good Friday Earthquake in Southcentral Alaska), and 1953 (The Wild One, starring Marlon Brando). These years were selected for their connection to the variety of human experience, relatable to the time frame of the glacier, setting up an anamnesis of the viewer's environment, projecting their memories and experiences onto the augments that are points of interest at the glacier. There is a viscous collective knowledge intrinsic to the human condition in viewing mediated wilderness, which is activated by language.

Exit Glacier also encapsulates one of the continuous multiplicities for the event of augmenting wilderness, the bits of code needed to make geolocation-based AR work on site. On contemporary mobile devices, the necessary elements, which must be active, are the compass, gyroscope, accelerometer, GPS, and Internet connectivity. Internet connectivity is the wild card is the group. GPS is usually faster than Wi-fi and universally accessible on mobile computers, though Alaska's latitude on the planet can create dead zones in valleys or mountains. The radio waves needed to create wireless fidelity get distorted in the wildernesses of the Earth, as do the

signals from GPS satellites. The basic write-around is downloading the entire augment before walking out of cell range into a pre-connected world, and hope that the GPS stays relative. This is not optimal and incredibly unstable. A portable Wi-fi signal must be brought into the pre-connected wilderness, like an iron lung, for AR to keep breathing on site.

This is one of the banes of the site-specificity for works of AR art. *Exit Glacier* is built on location. To experience the piece, viewers must drive to Seward, Alaska, and go through the entire process of loading the application and layer on their devices, then carry a Wi-fi hot spot out to the site with them. Once there, the ebb and flow of the GPS cause the piece to move as you are standing still viewing it. This is not unlike problems Earth art faced. It is a problem of being, the existence of the work itself, without even getting into the meaning or quality of the work. Few people literally went out to view earthworks in situ to evaluate them in person, or meditate in their presence, or whatever viewers do when they view works of art. One of the concerns here is that documentation of the work becomes a keen feature in the process of viewing it, since that is precisely how most viewers will experience it. It involves a certain sense of wandering and tenacity to get to a geo-coded POI in person, albeit one more in line with the nineteenth-century notion of the flânuer in the city, since metropolitan areas are where POIs tend to be most stable. Benjamin wrote, "the anamnestic intoxication in which the flânuer goes about the city not only feeds on the sensory data taking shape before his eyes but often posses itself of abstract knowledge—indeed, of dead facts—as something experienced and lived through" (Benjamin 1982). Hoy has written that "AR technology encourages a praxis-based approach to spatial knowledge. Its incorporation of mobile computing means that the body is activated in a process of movement and spatial exploration" (Hoy 2013). The "anamnestic intoxication" would be the theoretical body knowledge and inherited collective memory, flooding the viewer on location.

The fact that mobile AR must be viewed through a mediator (smart device) lends itself to a global aesthetic usage. When most AR works are viewed, they can be captured via screen grabs or photographs as they actually are. Reproductions of these works can be more artistically mannered, or through proper documentation, have a higher resolution than viewing on site. It is a portion of the human aesthetic that gets disturbed, the way we are intrinsically linked to the places we are at. Breathing on site, or observing a cloud pass in front of the sun, as the POIs stay digitally backlit, seemingly unaware of the solidity of the objects in the environment in which they are placed. The issue that remains for site-specific AR, and one that becomes important for the global audience, is how to experience a large-scale geolocation-based AR work, without having to travel there.

14.8 Variety and Application

Earth art experienced a similar problem in display, but Smithson's praxis of the *site/non-site* provides a way of adapting to the presentation of AR artworks in formal situations. An earthwork created on site in the mountains is visible to the few who get out there and see it, the GPS-equipped hiker, or tech-savvy flâneur. This is the *site* of the work of art, and it is the same format as a geolocation-based AR piece, like *Exit Glacier*. When the work is displayed in a gallery or museum, Earth artists would make an indoor earthwork, which they called a *non-site*. As Smithson states in *A Provisional Theory of Non-Sites*, "(it) is a three dimensional logical picture that is abstract, yet it represents an actual site…to understand this language of sites is to appreciate the metaphor between the syntactical construct and the complex of idea" (Smithson 1996). A non-site equivalent in AR works is the target-based POI, which locates a work with a displayable target. Ultimately, when AR develops significant collectorship with dealers, it will most likely be a target-based enterprise, with AR artists committing their extra energies to developing large geolocation-based works as their flagship projects that are not for sale. The thing about site-specific AR, however, is that no matter how intrinsically or technically the POI is tied to a literal geo-coordinate, the POI is digital, and it can be in a 1000 places at once, this is part of its regime of attraction; POIs are digital objects that overlay our mediated experiences of the world. AR is by nature, a nonlocal being and a global medium. It is pleasantly unstable and bound to the Earth the way vampires are bound to the moon.

Borealises (Fig. 14.6) is a collaborative work between Christopher Manzione's Virtual Public Art Project (VPAP) and myself and was included in a Manifest.AR group show called *Bushwick: AR Intervention*. It was originally conceived as an AR version of the northern lights to be displayed over Anchorage, which has horrible light pollution in the winter. The northern lights are rarely seen from within the city during our long dark months. AR browsers provided a way to see the borealises on mobile devices when the light pollution obfuscates them. With the global, multiplicitous nature of AR, the original animated POI went up in Bushwick, as part of the group show, at the same time it went up in Anchorage.

Geolocation does not have to be in a singular altitude, latitude, and longitude (the geo-code). Putting POIs up in an AR browser is like putting a blog post up on a Web site (third-party platforms). The direct observation of the work does not have to be on-site, and it rarely is. Gail Rubini and Conrad Gleber, of v1b3 (Video in the Built Environment), made *NEWzzzzz* (Fig. 14.7) as part of the annual *Wintermoot Mixed Reality Festival* (Fig. 14.8) in Anchorage, held during Fur Rendezvous, a festival held around the Iditarod sled dog race, at the close of winter in Alaska.

NEWzzzzz is a scrolling feed of red letters comprised of various headlines from newspapers in rural Alaska. It is relative geolayer; that is, it is visible to anyone who opens the layer, wherever they are, because it is geo-coded to be exactly where the mobile device connecting to the layer is. Location is the target.

Fig. 14.6 Borealises by
Shafer and the Virtual Public
Art Project (2011), digital/
animated AR version of the
northern lights, displayed
above viewers, and this screen
grab comes from the first
Wintermoot Festival in
Anchorage, Alaska from
2010. *Photo* Jared Chandler

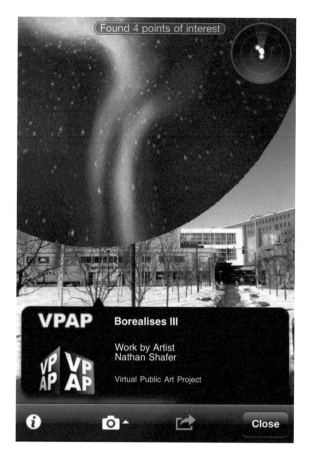

V1b3 works with the printed word in many of their projects, as well as the integration of projected video in the immediate media ecosystem. *NEWzzzzz* was able to blend these two formats into a mobile application, which illustrated cultural feeds, exterior to most viewers' expectations of them, the same issue of the "VR pipe dreams."

Several artists in Manifest.AR have made relative AR works; Tamiko Thiel's *Reign of Gold* (Fig. 14.9) illustrates the way the global economy occupies every centimeter of our world, for example.

Non-Local (Fig. 14.10) is an ongoing digital storytelling project of mine, set in a near-future Anchorage and based on the storytelling traditions of the circumpolar north, mixed with pulp science fiction and online gaming. The project is a series of short digital stories that group together as a larger narrative. In early 2013, *Non-Local* went up simultaneously in three geolayers on the Layar app in Anchorage, Seattle, and Skidegate, and one target-based layer on the Junaio app in New York. The geolayers were part of a solo show at Noxious Sector in Seattle (Fig. 14.11). They all have a global filter, so the audio tracks could be heard from anywhere in

Fig. 14.7 NEWzzzzz by
Rubini and Gleber (2013),
AR. *Photo* Nathan Shafer

the world, without having to see the local POI in person. Many of the POIs in *Non-Local* are placed in pre-connected worlds and accessible only with the global filter running. They cannot be seen onsite, unless portable Wi-fi is brought into the ecosystem, it was a way of attempting to make the wilderness accessible from a connected world.

The *Non-Local* augment that went up in New York was a singular audio track called *The Big Bad Broo*, which told the story of two kids who stumble onto a massive alien civilization via a confused avatar in a fictional MRPG called Cosmic Constant. The group show it was included in was by the v1b3 collective with Christopher Manzione, called *AR2View*. They took photographs in a Manhattan hotel, turned the photographs into targets, on which they built an AR show, brilliantly illustrating the way AR (from the aesthetic dimension) can literally lay over objects in the real world. They published this book with the target-photographs, and descriptions of the works. It was the second print project of three, the first, *Scan2Go*, published QR codes, which loaded artist projects. The third publication, *ART2Make*, is a series of g-codes, which can be used to 3D print the entire show of

Fig. 14.8 a and **b** Wintermoot mixed reality festival organized by the Institute for Speculative Media, pictured in **a** Mark Skwarek's Congressional Pizza (*Photo* Nathan Shafer), **b** Noxious Sector Collective, Haunting at 4th and E (*Photo* Nathan Shafer)

digital sculptures. Gleber has written of v1b3's use of the printed book in new media, "published books are uniquely capable of melding artist imagery with conceptual intentions, with audience curiosity and interaction in much the same way that media artists use the Internet" (Gleber 2013).

EEG AR: Things We Have Lost (Fig. 14.12) is a research/development project by John Craig Freeman and Scott Kildall, which "allows participants to conjure up virtual objects by simply imagining them into existence using brainwave sensor technology" (Freeman 2013). *EEG AR* represents a turning point in the subject matter of augmented reality art, placing more of the actual objects to be presented in the hands (or minds, in this instance) of the participants.

Creat.AR (Fig. 14.13) by Mark Skwarek et al. has a similar praxis, for allowing participants to produce personalized POIs relative to wherever they are on the planet.

The anamnesis intrinsic to both of these projects is procedural to their metaphysical being—existing to reflect the memory of something else. The databases behind both of these projects also mark an emerging method in distributed/relative AR. Instead of just targets or geo-codes, there is a relative AR, like v1b3's

Fig. 14.9 Reign of Gold, Tamiko Thiel, AR. *Photo* Nathan Shafer at Out North Contemporary Art House

NEWzzzzz, or Thiel's *Reign of Gold*, but it is also enmeshed with the participant who has loaded the AR layer. Users are able to choose the POIs around them.

When *EEG AR* was performed as a laboratory/clinic at FACT in Liverpool, they ran a room where test subjects would be plugged into a brainwave sensor, which measured their brainwaves, launching an SQL sequence to create POIs from a preloaded database.

Creat.AR lets participants turn anything they want into a POI, which will appear relative to their geo-coordinates. Participants do this by typing in what they would like to see on the local layer. Then, a database connected to that layer runs an Internet search, which formats the first image to pop up for the search phrase in the mobile browser.

These two projects are viscous and nonlocal—two properties of Morton's hyperobjects. They are viscous in that "the more you know about a hyperobject, the more entangled with it you realize you are" (Morton 2010). And nonlocal in that no participant in either project can accurately see the entirety of the work from where they are. Both works are distributed over the worldwide Wi-fi ecosystem, which is closing in on our pre-connected spaces as we draw air. Anywhere there is a radio signal that can host an Internet connection, AR exists, whether it is manifesting locally or not.

Fig. 14.10 *Non-local: Cosmic Constant MRPG* by Shafer (2013), AR with audio at Noxious Sector Projects, Seattle, Washington, pictured is an installation shot of the show where maps of the POIs were displayed. *Photo* Ted Heibert

14.9 Praxis

The *Augmented Inuksuit Project* (Fig. 14.14) is a K-12 education-based collaborative AR work in Alaska, I initiated in 2012. Inuksuit is the plural form of *inuksuk*, which are stone landmarks used by the Inuit across the circumpolar north. Inuksuit demarcated portions of the wilderness for human use, i.e., good caribou hunting or summer fish camps. With students we built collaborative inuksuit, using toy-style blocks we built in an open-source 3D modeling program—these blocks made a set, from which were built class inuksuit. Inuksuit are reflexive objects in an artistic application toward an anamnesis of the wilderness, which position the social wilderness in the literal, and are viscous difference engines in Arctic art history.

The variety and application of these objects inside of the microhabitat of AR, inside the larger media ecosystem, illustrate some of the praxis of augmenting wilderness—their usage entangled with OOO, working to decentralize the human mind as the metaphysical fulcrum upon which the existence of the cosmos hinges, making way for the equanimity for the wilderness outside of our infinitesimal pocket of the universe.

Fig. 14.11 *Non-local: Cosmic Constant MRPG* by Shafer (2013), AR with audio at Noxious Sector Projects, Seattle, Washington, pictured is the local POI at the show, an image of the Cosmic Constant MRPG story as a pulp sci-fi publication. *Photo* Ted Heibert

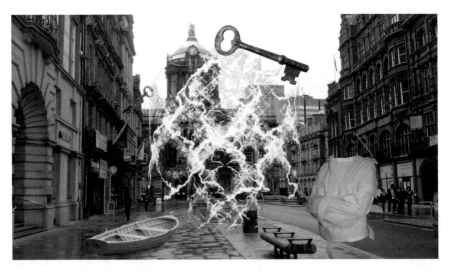

Fig. 14.12 EEG AR: things we have lost by Freeman and Kildall (2013), AR

Fig. 14.13 Creat.AR by Skwarek (2013), user-generated AR

Fig. 14.14 Augmented Inuksuit Project by the Institute for Speculative Media (2012), AR. *Photo* Nathan Shafer

References

Ahgupuk G. Radio babies. Ink and watercolor on skin. Anchorage: Anchorage Museum at the Rasmuson Center; 1940.

Benjamin W. The arcades project. Cambridge: Harvard University Press; 1982.

Bogost I. How to do things with videogames. Minneapolis: University of Minnesota Press; 2011. p. 7.

Bök C. Pataphysics: the poetics of an imaginary science. Evanston: Northwestern University Press; 2002.

Bryant L. Wilderness ontology. Larval subjects. http://larvalsubjects.wordpress.com/2011/06/02/wilderness-ontology/ (2011). Accessed 19 Sept 2017.

Clark L. New exoplanet is twice earth's size—and made largely of diamond. Wired UK. http://www.wired.com/wiredscience/2012/10/diamond-exoplanet/ (2012). Accessed 19 Sept 2017.

Dawkins R. The selfish gene. Oxford: Oxford University Press; 1976. p. 206.

Distin K. The selfish meme. Cambridge: Cambridge University Press; 2005.

Foucault M. The order of things. London: Tavistock; 1970.

Freeman JC. EEG AR: things we have lost. http://johncraigfreeman.wordpress.com/eeg-ar-things-we-have-lost/ (2013). Accessed 19 Sept 2017.

Freeman J, Kildal S. EEG AR: things we have lost. Augmented reality: Liverpool; 2013.

Gibson W. Spook country. New York: G.P. Putnam's Sons; 2007. p. 22.

Gillon M et al. Detection of transits of nearby hot Neptune GJ 436 b. http://www.aanda.org/articles/aa/pdf/2007/35/aa7799-07.pdf (2007). Accessed 19 Sept 2017.

Gleber C, editor. AR2View exhibition catalog. New York: College Art Association; 2013.

Hoy M (Contributor). AR2View exhibition catalog. New York: College Art Association; 2013.

Institute for Speculative Media. Wintermoot Festival. Anchorage: Augmented reality interventions; 2011–2014.

Institute for Speculative Media. Augmented inuksuit project. Augmented reality: Anchorage; 2012.

Jackson R. The anxiousness of objects and artworks: Michael Fried. Object-oriented ontology and aesthetic absorption. Speculations II.; 2011.

Kant I. Critique of pure reason. Penguin edn, 2007. London: Penguin Books; 1781.

Manifest AR. Manifesto. http://manifestar.info (2011). Accessed 15 Aug 2013.

Morton T. Ecology without nature. http://ecologywithoutnature.blogspot.com/2010/11/hyperobjects-are-nonlocal.html (2010). Accessed 19 Sept 2017.

Morton T. Realist magic: objects, ontology, causality. Ann Arbor: Open Humanities Press; 2013.

Negroponte N. Being digital. London: Hodder & Stoughton; 1996. p. 224.

Noxious Sector Collective. Simulated Hauntings. Augmented reality: Anchorage; 2013.

Oeschlaeger M. The idea of wilderness. New Haven: Yale University Press; 1991. p. 285.

Rubini G, Gleber C. NEWzzzzz. Augmented reality: Anchorage; 2013.

Shafer N. The virtual public art project borealises III. Anchorage: Wintermoot I, Augmented reality; 2011.

Shafer N. Exit glacier terminus project. Seward: Kenai Fjords National Park, Augmented reality; 2013.

Shafer N. Non-local cosmic constant MRPG. Seattle: Noxious Sector Projects, Augmented reality; 2013.

Sheller M (Contributor). AR2View exhibition catalog. New York: College Art Association; 2013.

Skwarek M. Congressional pizza. Augmented reality: Anchorage; 2012.

Skwarek M. Creat.AR. New York: Augmented reality; 2013.

Skwarek M, Veenhof S. infltr.AR. New York/Washington, DC; Augmented reality art intervention; 2010.

Sholette G, et al. The interventionists: user's manual for the creative disruption of everyday life. North Adams: MASS MoCA; 2004.

Smithson R. A provisional theory of non-sites. In: The collected writings of Robert Smithson. Berkeley: University of California Press; 1996. p. 364.

Wax E. Smashed smartphone screens become status symbol. Sydney Morning Herald. http://www.smh.com.au/digital-life/mobiles/smashed-smartphone-screens-become-status-symbol-20130520-2jwan.html (2013). Accessed 19 Sep 2017.

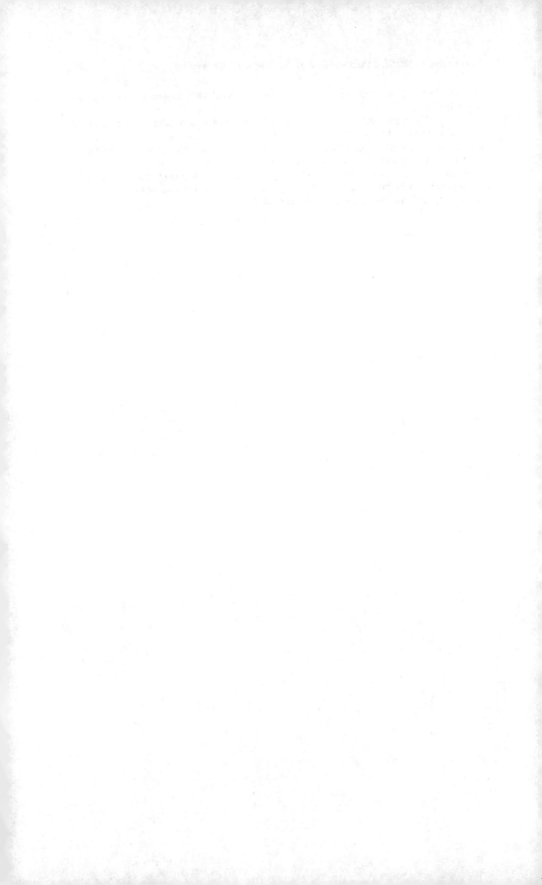

Chapter 15
An Emotional Compass: Emotions on Social Networks and a New Experience of Cities

Salvatore Iaconesi and Oriana Persico

15.1 Introduction

The map is not the territory (Korzybski 1933).

The map is not the thing mapped (Bell 1945).

The tale is the map that is the territory (Gaiman 2006).

We say the map is different from the territory. But what is the territory? The territory never gets in at all. [...] Always, the process of representation will filter it out so that the mental world is only maps of maps, ad infinitum (Bateson 1972).

When we experience territories, we create stories. We model these stories using mental maps, referring to one person's point of view perception of their own world, influenced by that person's culture, background, mood and emotional state, instantaneous goals and objectives.

If we move along the streets of my city in a rush, trying to find a certain type of shop or building, our experience will be different than the one we would have had if we were searching for something else.

Focus will change. We will see certain things and not notice other ones which we would have noticed otherwise. Some things we will notice because they are familiar, common, or because associate them to our cultures, to memories, and narratives. All this process continuously goes on as our feelings, emotions, objectives, and daily activities change, creating the tactics according to which we traverse places and spaces, to do the things we do.

S. Iaconesi (✉) · O. Persico
Department of Digital Design, ISIA School of Design, Florence, Italy
e-mail: salvatore.iaconesi@artisopensource.net
URL: http://www.artisopensource.net

O. Persico
e-mail: oriana.persico@gmail.com
URL: http://www.artisopensource.net

© Springer International Publishing AG 2018
V. Geroimenko (ed.), *Augmented Reality Art*, Springer Series on Cultural Computing, https://doi.org/10.1007/978-3-319-69932-5_15

In the density of cities, this process happens for potentially millions of people at the same time. In his "the Image of the City" (Lynch 1960), Lynch described cities as complex time-based media, symphonies produced by millions of people at the same time in their polyphonic way of acting, moving, interpreting, perceiving, and transforming the ambient around themselves: a massive, emergent, real time, dissonant and randomly harmonic, work of time-based art with millions of authors that change all the time.

In this, our mental maps—the personal representations of the city which we build in our minds to navigate them to fulfill our needs and desires—live a complex life as our perception joins into the great performance of the city.

Dissonance is the essence of the city itself and represents its complexity, density, and opportunities for interaction.

Harmony represents affordances, the things which are recognized and shared by different cultures. Those elements of the perceptive landscape onto which we can *agree* upon, which we recognize and attribute compatible meanings, allowing us to collaborate, meet, do things together. For example, Haken and Portugali (2003) have suggested a broad definition of landmarks to refer to any distinguished city elements that shape our mental map. Or as Appleyard (1969), Golledge and Spector (1978) who have conducted studies about the *imageability* of urban elements not because of their visual stimulus but because they possess some personal, historical, or cultural meaning.

We can imagine to design the affordances of places and spaces. We can use the understanding of what is consistently recognized and understood to design the elements of space/time which will describe to people what is allowed or prohibited, suggested or advised against, possible, or imaginable. Lynch's concepts of legibility and imageability are closely related to James J. Gibson's notion of affordances developed in his direct perception theory, according to which the objects of the environment can afford different activities to various individuals and contexts. And, again, in Haken and Portugali (2003), all elements of a city afford remembering, as they shape in the mental maps in human minds.

In a further step in the direction of citizen activation, we can also imagine to make this type of understanding widely known and usable, to enable people to express themselves more effectively and powerfully.

These scenarios have become radically viable with the widespread of ubiquitous technologies. Nomadic devices (such as smartphones) and their applications we are able to merge our physical understanding of the world with the digital one forming a new physicality, visuality, and tactility which shape our everyday experiences of the world.

According to Mitchell's "City of Bits" (1996), McCullough's Digital Ground (2005), Zook's and Graham's DigiPlace (2007), we are constantly immersed in emergent networks of interconnected data, information, and knowledge which is produced by millions of different sources and subjects in the course of their daily lives. This data and information radically shapes the ways in which we have learned to work, learn, collaborate, relate, consume, and perceive our environment.

If we are strolling in a park and we receive a notification of some sort on our smartphone, the natural environment could instantly transform into an ubiquitous, temporary office. If we want to make a decision about a certain thing we would like to purchase while in a shop, a quick look online will help define our opinion in ways that can be very powerful. If we receive a message on our smartphone, our mood could change for the rest of the day.

Situated and ubiquitous information is able to powerfully transform, in real time, the ways in which we experience places, objects, and services, by providing the wide accessibility of other people's stories, emotions, expectations, and visions.

This scenario is the one we have tried to address in our research: the conceptualization, design, and implementation of a tool for urban navigation, in which the emotional narratives expressed by people while inhabiting and using urban places, spaces, and objects become instantly and radically available, accessible, and usable, to design new types of affordances for our cities.

We have decided to start from the idea of a Compass.

15.2 The Compass

The compass is a historically understood, ubiquitously known object dedicated to navigation and orientation: it finds the direction in which one wants to go.

Compasses are very easy to use (or, at least, to understand how they work) and are capable of providing direct, immediately accessible insights about the information they convey.

Different cultures and civilizations have used compasses for very different reasons, such as in the case of the Qibla compass, which is used by Muslims to show the direction to Mecca for prayers, or the Feng Shui compass, through which one is able to understand how to better orient houses' furniture and elements to obtain optimal energies.

The Feng Shui example is of particular relevance for the objectives our research. In its construction, the cardinal points are matched with an overwhelming amount of other information: over 40 concentric circles of writing and detail used to define the *Bagua* of your home, the ways in which energy flows. In the Feng Shui compass, the cardinal directions are combined with information coming from entirely different domains, and this combination gives rise to a completely different concept of orientation.

This is the idea that we wanted to explore in our research.

Is it possible to use the ubiquitous *infoscape* (the informational landscape) which is constantly produced by human beings on social networks to design novel forms of urban navigation? Novel ways of experiencing places? New ways for making decisions, for relating to one another, for consuming, for expressing, and understanding emotions?

We started from the idea of emotions.

How is an emotional compass made?

How do you create a compass which harvests in real time as much data about the ways in which human beings express their emotions on social networks, and uses it to have insightful emotional experiences in the city?

Is it possible to identify "emotional landmarks"—those places/spaces where, at a specific or recurring time, a certain emotion is expressed powerfully and abundantly?

If they do exist: do emotional landmarks change over time? Do they change according to the culture you are observing? To language? To the time of day, week, month, or year? To the specific topic your compass is observing?

These, among many others, were the main questions which we asked ourselves in our research.

15.3 Previous Work

Abundant work exist which explores the idea of emotionally mapping cities and to propose forms of navigation that go beyond classical way finding.

For example, Christian Nold's work on Biomapping (2004a) and Emotional Cartography (2004b). In the project, a rather large number of people have taken part in community mapping activities in over 25 cities across the globe. In structured workshops, participants re-explore their local area with the use of a device which records the wearer's galvanic skin response (GSR), which is a simple indicator of emotional arousal, in conjunction with their geographical location. A map is created which visualizes points of high and low arousal. Nold's work can be considered to be a seminal one in exploring how devices can capture location-based emotional states and make them accessible through maps and other means. In our research, we wanted to focus more on more complex possibilities to interpret human emotions, coming from the usage of language, and on the possibility to not only record emotions, but to turn them into active, searchable, usable, knowledge which anyone could generate and access.

Another example, the Fuehlometer ('feel-o-meter') (2010), was produced by German artists Wilhelmer, Von Bismarck, and Maus in the form of a public face, an interactive art installation that reflects the mood of the city via a large smiley face sculpture. It was installed atop a lighthouse in Lindau, Germany. A digital camera along the lake captured the faces of passersby, which were then analyzed by a computer program and classified as either happy, sad, or indifferent. The cumulative results determine the expression of the sculpture, whose mouth and eyes shift accordingly via a system of automated motors. Von Bismark's thoughts on the artwork are particularly interesting in this case: "we wanted people to start considering if they want people to read their emotions, and if they want to know others' emotions; if they want to be private or they want to be public. That is what it comes to in the end—what is private, and what is public?" The artwork itself provided us with precious guidelines about what we set forth to achieve: an immediately readable and understandable service. Yet the techniques it used proved to be very

limited in terms of the possibility for interpretation of human emotions, and for the production of usable knowledge out of them, including considerations on people's cultures, behaviors, and relations in their interactions in the city.

Using a different approach, the City of Vilnius (2013) has found a way to track emotions on its territory using a social tool that gauges the average residents' level of happiness. Residents submit their overall level of happiness for each given day using their smartphones, or by scanning a barcode on the post-advertising the initiative dubbed the "Happiness Barometer." Votes are later totaled to determine the overall happiness level of the town—displayed on a large urban screen and on the Web site.

Another example comes from an artwork titled Consciousness of Streams (2011). In the work, the artists have set up a series of devices or installations in several cities. Users were able to contribute their geographic location, emotional state, as well as an image of their face or sound recording. The resulting information is constantly visible online under the form of a "real-time interconnected emotional map of the planet" (Iaconesi and Persico 2012) showing a topography of human emotions, adjacencies, proximities, and distances which are not physical, but emotional.

Another relevant project is Mappiness (2012), part of a research project at the London School of Economics. This mobile app and online system actively notifies users once a day, asking how they are feeling. The data gets sent back along with users' approximate geographical location and a noise-level measure, as recorded from the phone's microphone. In this way, the users can learn interesting information about their emotions—which they see charted inside the application—and the operator can learn more about the ways in which people's happiness is affected by their local environment—air pollution, noise, green spaces, and so on.

An interesting project is "Testing, Testing!" (2011), an experiment developed by Colin Ellard and Charles Montgomery, and conducted in New York, Berlin, and Mumbai. By inviting participants to walk through the urban terrain, and measuring the effects of environment on their bodies and minds, Ellard aimed to collect data in real, living urban environments. That data would then be available for application within urban planning and design to enhance urban comfort, increase functionality, and keep city dwellers' stress to acceptable levels.

Another project which we wish to highlight is the Aleph of Emotions, an experimental art project by Vigneshwara (2012): a camera-like interface allows users to point along a particular direction, focus to a place along that direction, and click to view a representation of emotions in that place. The intention is to explore and find patterns in human emotions with relation to space and time. Data are collected based on keywords that define certain emotions. The results are finally presented with an interactive object. We felt, to a certain degree, this project to be really close to what we wanted to achieve. The major limitations which we have identified in its conception lie in the impossibility to comprehend human emotions in significant ways—due to the keywords-based approach—and in the lacking sense of immersion in the information landscape.

In yet another example, the MONOLITT (2014) generative sculpture by Syver Lauritzsen and Eirik Haugen Murvold is a paint-emitting plinth that disperses color according to local mood on social media. The installation that quite literally paints the mood of the city using social media feeds as an input. The installation takes electronic signals and lets them manifest themselves in the physical world. Using sentiment analytics, the installation links tweets to corresponding colored paints in real time, feeding them out through the top of the sculpture, letting them flow into a procedurally generated three-dimensional painting. This is a form of environment-based Augmented Reality, much similar to something which could be done through projection mapping: a data phenomenon is taken and interpreted in terms of something that is "added" (or, as in this case, painted) to the architectural environment, allowing people to experience it and, thus, to experience the data phenomenon. While the emotional analysis technique used in this artwork seems far from optimal, the concept and implementation are very interesting in the fact that they produce a physical, tangible output that does not need people to use some technology to experience it. The emotional visualization is there, physical, painted onto the installation, and if properly labeled and explained (maybe through some information panel), is immediately experienceable from the users.

15.4 Concept and Methodology

Our goal was to create an Augmented Reality Compass on a smartphone showing the intensity of emotions in the directions around the user.

For this, we broke down the activity into different domains:

- the system to harvest messages from major social networks in real time;
- the geo-referencing/geo-coding techniques;
- the Natural Language Processing techniques;
- interface design and interactive information visualization.

15.4.1 A System to Harvest Messages from Major Social Networks in Real Time

There are many different techniques and technologies using which a system of this kind can be implemented.

The main issues we were faced with during the design and implementation process were both legal and technical.

Starting from the legal issues: users and developers wishing to use the features of major social networks have to abide to the rules dictated in the providers' Terms of Service (ToS), which are very complex legal documents.

Most social networks offer application programming interfaces (API) of some sort, which developers can use to build their own applications by interacting with the social network's ecosystem (users, communities, content, etcetera).

These APIs offer an opportunity for service designers and developers, as they permit accessing a vast amount of data about people's expressions and positions, the topics they discuss and the relations which they maintain, allowing for the creation of a variety of useful services.

APIs usage is constrained by ToS, which limits the degree to which any developer or company is able to capture, process, use, and visualize information coming from social network operators.

Limits are mainly imposed on:

- ownership of the data;
- number of interrogations over time;
- storage of the captured information;
- processing of the harvested information;
- visualization and branding.

These legal limits are different across different providers and also change quite frequently and arbitrarily.

Furthermore, it must be said that the issue of expectation for publicness also represents a very important legal aspect. Just as it happens when we go to malls and shopping centers, we perceive them to be public spaces and, thus, we conform to what we have learned to be our rights and acceptable behaviors in public spaces. But this is not the case, as different sets of rules apply in these spaces affecting anything from privacy, freedom of expression, and basic rights. We have often clashed with this kind of issue, for example in trying to harvest all the user expressions on their feelings toward public policies enacted by governments and administrations.

That said, with the help of legal consultants, we have managed to design a replicable model which includes clusters of rules which transform the legal specifications into technical and technological ones, and which we have been able to successfully use in these kinds of scenarios over the past 3 years.

Some limitations exist on the purely technical side, too.

In the first instance, the APIs allow for limited degrees of freedom in the querying and interaction with the databases of operators: not all of the information is made available and limitations on how developers are able to formulate the queries also exist.

Furthermore APIs frequently change, forcing development teams to constantly maintain and adapt the source code of the applications.

Once in a while, entire sets of features and possibilities disappear or change in form or availability, forcing designers and developers to go back to the drawing board and re-think or re-frame their services.

It can be said that the ideas of access and of interoperability are currently not among the priorities of social networking service providers.

Table 15.1 Number of UGC harvested from social networks in different experiments

City	From date	To date	No. of UGC
London	Jan. 1st 2011	Feb. 1st 2011	5,143,500
Rome	Oct. 15th 2011	Oct. 16th 2011	91,538
Turin	Aug. 1st 2011	Sept. 20th 2011	240,982
Berlin	Jan. 4th 2012	Jan. 20th 2012	1,699,240
Hong Kong	May 1st 2012	Jul. 1st 2012	5,732,487
Cairo	Jul. 27th 2013	Sept. 2nd 2013	3,466,388

We resolved most of these issues adopting a radically modular approach, using interoperable connectors to take into account the different scenarios with the different operators, and to abstract the main service logic from their implementation details. And providing us with the possibility to limit the damages whenever ToS or regulations changed on the operators' side. Table 15.1 shows the amount of data which we were able to capture using these methods in various occasions and experiments, across different cities.

This part of the activity has revealed to be a truly fundamental one, as we have actually developed a service layer which implements an easily maintainable abstraction and interoperability among different social network providers, and we are thinking to dedicating to it a separate research effort, to design the ways in which it could be offered as a service or as a novel source of real-time Open Data.

15.4.2 Geo-referencing/Geo-coding Techniques and Named Places

A number of different possibilities exist in trying to attribute a geographical context to UGC:

- users employ the features offered by social networks for geo-referencing their own messages (either using GPS on their smartphone, or providing additional information);
- users include in the message information which can lead to finding out a location that they are talking from or about;
- users may use none of the previous possibilities, but include an indication of their geographical position (either current or by default) in their profiles;
- users do none of the above: in this case, it is not possible to gather the user's location.

The third case has a low level of reliability. For a number of reasons, users may lie about their current or "home" location. For example, they commonly choose their favorite city, or a "cool" city, or a totally fictional location: on the popular

social network Foursquare we currently reside in Mordor (taken from Tolkien's "the Lord of the Rings"), which we have placed, using the standard features offered by the system, a few meters away from our lab.

For these reasons, in our research we do not use these kinds of location specification (the "home" location or the current location as specified in the user's profile).

The first case is also very easy to deal with: a geographical location (often paired with extensive sets of meta-data, such as in the case of Facebook and Foursquare) is explicitly provided in the messages. Thus, we are able to use it.

From the analysis of the results of our experiments, the geo-location features offered by social networks are not very commonly used. The most common user behavior is to either turn on the location sharing features when they download the applications to their smartphone, or to forget about them.

From what we have been able to understand, the most location-aware social networks are Foursquare and Instagram, with respectively 92 and 30% of the messages which have a location attached to them. Then comes Twitter, with 10–15%, according to time and context. Then Facebook: if we exclude the posts related to events (which have a location attached to them), the percentage drops to about 4%, and comes almost completely from messages generated using the mobile applications. These results are based on the messages we have collected over time in our experiments and vary a lot across time and context. For example, many more messages with a location are generated on holidays and in times of vacation, and in the case of special events, such as the riots and revolts in Cairo, Egypt, during 2013. In this last case, for example, Twitter messages with a location specified rises up to as much as 18%.

The second case in the list is more complex and interesting. It takes place when users do not use the platforms' features to include their location in the message, but, rather, mention the location which they are talking from or about in the text of the message itself.

First of all, it is important to try to understand whether the mention of a geographical location in a message is indicating that the message was produced in that location, or if it was talking about it: these two possibilities may completely change the relevancy of the message.

We have tried to formulate a working procedure with which to try and add location information to these kinds of messages.

We:

- built databases of named places for the various cities, including landmarks, street names, venues, restaurants, bars, shopping centers, and more, by combining the information coming from

 - publicly available data sets (for example for Italy we have used the named places provided by ISTAT, Italy's National Statistics Institute 2013);
 - the list of named places contained in the OpenStreetMap databases, for example as described in OpenStreetMap (2013a, b);

- the list of named places provided by social networks themselves, which allow using their APIs to discover the locations used by users in writing their messages, for example on Facebook (2013) or Foursquare (2013);
- lists of relevant words and phrases, such as event names or landmarks;

- used the text representation in various forms of the named places in a series of phrase templates to try to understand it the user writing the message was in the place, going to the place, leaving the place, or talking about the place;

 - for example, the template "*going to [named place]*" would identify the action of going, while "*never been in [named place]*" would identify the action of talking about a place;
 - templates have currently been composed in 29 different languages, for a total of more than 20,000 different templates;

- each template was assigned a degree of confidence, evaluating the level of certainty according to which the sentence could be said to identify the intended information;

 - for example: "I'm going to [named place]" has a relevance of 1 (100%), while the "[named place]" taken by itself has a relevance of 0.2 (20%) as it might be a false match (imagine a bar with the same name of a famous landmark, for example);

- a threshold was established; if the sum of relevance degrees for templates matched to sentences was above the threshold, the information about content location was kept, else it was thrown away. Currently, the threshold we use for this is of 90%.

In the application we have, thus, chosen to gather geo-location information through explicit use of the location-based features of the services and, should they not have been provided, by combining them the results of the named places analysis.

15.4.3 Natural Language Processing and Artificial Intelligence to Recognize Emotions and Topics in Text

There is an extensive amount of research about the possibility to automatically interpret text to understand the emotion expressed by the writer, either on social networks or on more general texts.

We approached the possibility to recognize emotions by identifying in text the co-occurrence of words or symbols that have explicit affective meaning. As suggested in by Ortony et al. (1987), we must separate the ways in which we handle words that directly refer to emotional states (e.g., fear, joy) from the ones which

only indirectly reference them, based on the context (e.g., "killer" can refer to an assassin or to a "killer application"): each has different ways and metrics for evaluation.

For this, we have used the classification found in the WordNet (Fellbaum 1998) extension called WordNet Affect (Strapparava and Valitutti 2004).

The approach we used was based on the implementation of a variation of the latent semantic analysis (LSA). LSA yields a vector space model that allows for a homogeneous representation (and hence comparison) of words, word sets, sentences, and texts. According to Berry (1992), each document can be represented in the LSA space by summing up the normalized LSA vectors of all the terms contained in it. Thus a synset in WordNet (and even all the words labeled with a particular emotion) can also be represented in this way. In this space, an emotion can be represented at least in three ways: (i) the vector of the specific word denoting the emotion (e.g., "anger"), (ii) the vector representing the synset of the emotion (e.g., {anger, choler, ire}), and (iii) the vector of all the words in the synsets labeled with the emotion.

This procedure is well documented and used, for example in the way shown in Strapparava and Mihalcea (2008), which we adopted for the details of the technique.

We adapted the technique found in Iaconesi and Persico (2012) to handle multiple languages by using the meta-data provided by social networks to understand in which language messages were written in and using a mixture of the widely available WordNet translations and some which we produced during the research for specific use cases.

An annotation system was created on the databases to tag texts with the relevant emotions (as, within the same message, multiple emotions can be expressed). For example, Fig. 15.4 shows the results of a full week of emotional harvesting in the city of Rome, for the emotion "trust."

We also tried to deal with the wide presence of irony, jokes, and other forms of literary expression which are difficult to interpret automatically. To do this, we have followed the suggestions described in Carvalho et al. (2009) and in Bermingham and Smeaton (2010) with varying results.

15.4.4 Interface Design and Interactive Information Visualization

Given the intensive preparation phase, the information was, at this point, ready to be visualized and the interaction designed. We chose a very minimal layout, to allow the user to focus on the interaction mechanism, providing little-to-none additional detail beyond the emotional compass.

The interface development followed a two-phase sequence. First was designed a rough interface to understand the accessibility and usability of this kind of tool. The

design was created in occasion of our Rome-based tests, following a city-wide riot which had happened the previous year, and of which we had been able to capture the social network activity.

In this first scenario, a mobile application was designed that would poll the database for new updates, which came under the form of a list of basic emotions and their intensity in the various directions, relative to the user's current position.

In the first instance, we tried to use a standard AR canon, with the information being displayed on top of the live camera feed. In this layout, an arrow constantly showed the "forward" direction on the and was color coded as to indicate the level of danger for the current direction: from a vivid green showing a lack of evidence about violence, to a full red denoting the presence of many violence-related messages in that direction (see Fig. 15.1).

While this configuration of the interface turned out to be really usable and accessible, it did not satisfy us for its readability. The information shown was extremely synthetic, bringing down the complexity of the available information to a single color. Of course, this was in line with the idea of implementing a compass, showing information about the direction in which the user is facing. But we felt that the trade-off represented by loosing all of the missing information (such as the declination of the different emotions involved in determining the output, or the possibility to show the messages taken into account to make the decision) was too steep.

In the next design iteration, the information was, then, drawn on screen using a radial diagram, while the on board magnetic compass and accelerometer controlled the diagram's rotation, to keep track of the user's heading and the device orientation (see Fig. 15.2).

Fig. 15.1 First iteration of the design: the arrow shows the predominant emotion in the current direction

Fig. 15.2 Second iteration of the design: a rotating radial diagram highlights the danger zones

The focus in this interface was to highlight the potentially dangerous scenarios, so that users would be able to avoid going in their directions. For this, the default setup was pre-configured highlighting emotions of fear and grief, followed by anger and sadness. The user was able to use the settings button on the interface to choose from a drop-down (a scroll-wheel, on most smartphones) to choose from the other available emotions, so that the experience and goal of the experience could be personalized.

The third iteration of the interface was more general purpose (Fig. 15.3).

In this new form, the color-coded emotions would surround the white center, radially indicating the intensities of the emotions as they emerged around the user.

The result was a multi-compass, with each color showing an emotion, its thickness around the center indicating its intensity in the relative direction. In the picture, the color purple, indicating boredom, is thicker in the upper right and lower left, showing that the emotion has been recently manifested on social networks to the front-right of the user, and to his back-left.

A pull-up menu can be dragged up by the user to toggle on/off the various layers, also obtaining a visual legend for the meaning of the colors. From the same menu, cursor sliders can be used to configure the sensibility of the emotional compass: in distance, from 100 m to 1 km (e.g., if you choose 500 m, only the emotions generated within a 500 m radius will be taken into account); and in time, from 5 min to 1 month (e.g., if you choose 2 days, only the emotions expressed during the past 2 days will be used).

The transformation of the emotional color blobs around the center take place using smooth, interpolated transitions, both to give the user a clear vision of what is

Fig. 15.3 Third iteration of
the design: the emotional
multi-compass

changing, and to achieve a "blobby," organic look, which is able to visually
communicate a situation in constant evolution.

Whenever the user reaches a location in which a certain emotion has recently
been expressed with particular strength, the background starts pulsating in the color
of the corresponding emotion: an emotional landmark has been reached.

15.5 User Experience of the Artwork

The artwork is currently available as a prototype application for iOS and Android
smartphones. It will be available on major stores as soon as the final beta-testing
stages are complete (estimated late January 2014), and interested parties can request
beta access by contacting the authors.

Throughout the interface design process, we performed regular walks in the city
which we observed on social networks to better understand how the application
would transform our perception of the city.

The experience itself can be compared to the one of Rhabdomancy. While
walking amidst the spaces of the city while using the compass, the ordinary
way-finding reference items become less important. The color-coded intensity
indicators for the various emotions provide the sensation of being able to access a
Geiger counter, or some sort of field intensity measurement device, showing the
directions in which a certain emotion is stronger.

The impossibility to access street and topography-based directions, for example,
is strange at times sometimes. On the other hand, it gives the exact perception of

being able to access a different kind of geography: one that is based on the intensity of emotions in a certain place, rather than its name or street number. It is definitely the perception of an energy field, of a radiation. As an example, while following the peak level of a certain emotion, we were faced with a wall, or a building or block that was standing in our way. In this kind of situation, the system did not provide any clue about the fact that the peak itself was to be found inside the obstacle (for example in the building) or beyond it. As we tried to go around the building, we would be able to gain better understanding: if the peak reversed its direction once we were around it, it would clearly mean that the peak emotion was inside the building; if it kept on pointing in the same direction, it meant that the peak intensity was beyond the obstacle.

A similar effect could be achieved by acting on the slider which regulates the sensibility in terms of distance. Once faced with an obstacle, it was possible to act on the slider to lower the senseable distance. By doing this, it was sufficiently clear that if the peak disappeared at when the slider was lowered to the point of being nearer than the obstacle's perpendicular thickness, it would mean that the emotional peak was to be found within it.

Identifying emotional peaks in closed spaces proved to be quite a challenge: the lack of GPS coverage in closed spaces allows to easily identify the buildings in which a certain emotional peak can be found, but not to continue to search within them.

Using the application to follow multiple emotions at the same time has proven to be somewhat hard: with the different peak indicators all being independent, it has come out to be much easier just to follow one main emotion, and to eventually check the other emotional levels once arrived at a certain location.

The addition of sounds has also proven to be extremely useful. A different drone-based sound loop of specific tones and texture was associated to each basic emotion, and its volume was connected to the instantaneous intensity of the emotion at the current user location. By wearing headphones users get a really accurate sense of the compresence of the emotions in the place they are currently in, also being able to momentarily switch off the various emotions/tones to associate each tone to the relative emotion. Creating sounds which have a drone like, constant tone, but with evolving texture has been proven to give the best effects: users can create a generative song by walking around, depending on how social networks users expressed in that location (Fig. 15.4).

Also, the pairing of the sounds with the indicators, with specific focus on the color-coded on-screen alert which appears when an emotional peak is reached, has proven to be really effective, with the alert matching the maximum volume of the relative sound: when users heard these kinds of high volumes, they consistently checked the application display to see if the alert appeared. This also allowed users to use the compass from their pockets, navigating the city by following volume augmentations, and pulling the smartphone out only when the volume would be high, to check the visual confirmation that the emotional peak had been reached.

Since its creation, we have tested and used the Emotional Compass a number of times, at festivals, conferences, events, workshops, and even in public scavenger hunts whose purpose was to navigate the city in a different way, and to try to

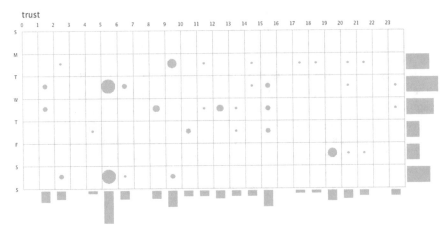

Fig. 15.4 An example of emotions captured in a city: "trust" in Rome, during the days/times of a full week

establish readable connections between the emotions detected on social networks and the things that were physically happening in the city.

All times, this was complex matter. As it is understandable through common sense and through detailed research (Barberà and Rivero 2014), what happens on social networks relates only partially to what can be understood by physically traversing the city.

This is due to multiple reasons: the different geographies of online cities, in which people express "for," "from," and "about" the locations of the city in a variety of ways, only some of which require them to be actually present (and, thus, physically "readable") in the location itself.

Different forms of expression also characterize such activities, in which the measure and proportions of the different emotions expressed are determined sometimes and to some degree by the architecture and interfaces of the social networks themselves (Stieglitz and Dang-Xuan 2013), where on some social networks some forms of emotional expression appear to be definitely more frequent than others.

And, more in general, the form of the public, private and intimate spheres change on the different social networks, ranging from the Habermas-type "private-publics" of social applications such as WhatsApp, to complex hybrids such as Facebook, in which multiple forms of public, private, and intimate spheres coexist and compenetrate each other, depending from users' complex privacy settings and ways of publishing (for example, a certain user may publish a post to be visible only to some of their connections).

These limitations also turn out to be opportunities, as they provide us with tools to materialize, through Augmented Reality, other, different, physically unforeseen layers of reality to the world, improving the ways in which general reality may be read, understood, and experienced.

15.6 Conclusions

We have found this research path to be rewarding for its implications in terms of the possible artworks and services that could be designed by using the proposed methodology, and of the possibility to observe and experience urban environments in truly innovative ways. We can imagine highlighting the sense of security, of enjoyment or satisfaction, with enormous potentials for tourism, real estate, entertainment, events, and for public administrations wishing to discover and expose the ways in which people feel in the city.

On the other side, using these kinds of techniques, we are now able to understand cities better, in how people live their daily lives across cultures, languages, occupations, and interests. For example, by simply filtering the meta-data about language, we would be able to know the emotions of people in the city coming from different countries and cultures. We could see how they move around the city, we could compare them and the emotions they express, finding the ways in which they feel the same, or differently, at the different times of the days and weeks. We could use this information to better understand our cities, providing ways to empower multicultural ecosystems to form in more harmonious ways. The concept of the emotional landmark has proven to be very interesting. Which are the places in which different cultures more powerfully express a certain emotion, in different times of the day? How can we use this information? How can we design a city for emotions? These and more will be the questions which we will try to answer in the next phases of our research, together with the idea of opening up the process, promoting the accessibility and interoperability of this novel source of real time, emergent Open Data that we have helped to shape: publicly expressed human emotions.

References

Appleyard D. Why buildings are known. Environ Behav. 1969;1:131–56.

Art is Open Source. Consciousness of streams. http://www.artisopensource.net/2011/01/12/cos-consciousness-of-streams/. Accessed 1 Sept 2013, and http://cos.artisopensource.net/ (2011). Accessed 20 Sept 2017.

Barberà P, Rivero G. Understanding the political representativeness of Twitter users. Soc Sci Comput Rev. 2014.

Bateson G. Form, substance and difference in steps to an ecology of mind. San Francisco: Chandler Publishing Company; 1972.

Bell ET. Numerology: the magic of numbers. New York: United Book Guild; 1945.

Bermingham A, Smeaton AF. Classifying sentiment in microblogs: is brevity an advantage? In: CIKM'10 Proceedings of the 19th ACM international conference on information and knowledge management, Toronto; 2010. p. 1833–6.

Berry M. Large-scale sparse singular value computations. Int J Supercomput Appl. 1992;6(1): 13–49.

Carvalho P, Sarmento L, Silva MJ, de Oliveira E. Clues for detecting irony in user-generated contents: oh…!! it's "so easy";-). In: TSA'09 Proceedings, CIKM workshop on topic-sentiment analysis for mass opinion, Hong Kong; 2009. p. 53–6.

City of Vilnius. The happy barometer. http://happybarometer.com/ (2013). Accessed 20 Sept 2017.

Ellard C. Testing, Testing! http://www.bmwguggenheimlab.org/where-is-the-lab/mumbai-lab/mumbai-lab-city-projects/testing-testing-mumbai (2011). Accessed 20 Sept 2017.

Facebook. Obtaining a list of places in a geographical area. https://developers.facebook.com/docs/reference/api/search/ (2013). Accessed 1 Sept 2013.

Fellbaum C. WordNet. An electronic lexical database. Cambridge, MA: MIT Press; 1998.

Foursquare. Obtaining a list of places in a geographical area. https://developer.foursquare.com/docs/venues/search (2013). Accessed 20 Sept 2017.

Gaiman N. Fragile things. New York: HarperCollins; 2006.

Golledge RJ, Spector A. Comprehending the urban environment: theory and practice. Geogr Anal. 1978;10:403–26.

Haken H, Portugali J. The face of the city is its information. J Environ Psychol. 2003;23(4): 385–408.

Iaconesi S, Persico O. ConnectiCity: real-time observation and interaction for cities using information harvested from social networks. Int J Art Cult Design Technol (IJACDT). 2012;2 (2):14–29.

ISTAT. Territorial Data Sets, including named places. http://sitis.istat.it/sitis/html/, http://www.istat.it/it/prodotti/banche-dati, http://www.istat.it/it/archivio/44523 (2013). Accessed 20 Sept 2017.

Korzybski A. A Non-Aristotelian system and its necessity for rigour in mathematics and physics, American association for the advancement of science 1931. In: Conference proceedings. Reprinted in Science and Sanity, New Orleans; 1933. p. 747–61.

Lauritzsen S, Murvold EH. MONOLITT. https://www.youtube.com/watch?v=8a7BNgDfRXo (2014) Accessed 20 Sept 2017.

London School of Economics. Mappiness. http://www.mappiness.org.uk/ (2012). Accessed 20 Sept 2017.

Lynch K. The image of the city. Cambridge, MA: MIT Press; 1960.

McCullough M. Digital ground: architecture, pervasive computing, and environmental knowing. Cambridge, MA: MIT Press; 2005.

Mitchell WJ. City of bits: space, place, and the Infobahn. Cambridge, MA: MIT Press; 1996.

Nold C. Biomapping. http://biomapping.net/ (2004a). Accessed 20 Sept 2017.

Nold C. Emotional cartography. http://emotionalcartography.net/ (2004b). Accessed 20 Sept 2017.

OpenStreetMap. Key:place. http://wiki.openstreetmap.org/wiki/Key:place (2013a). Accessed 20 Sept 2017.

OpenStreetMap. Map features. http://wiki.openstreetmap.org/wiki/Map_Features (2013b). Accessed 20 Sept 2017.

Ortony A, Clore GL, Foss MA. The psychological foundations of the affective lexicon. J Pers Soc Psychol. 1987;53:751–66.

Stieglitz S, Dang-Xuan L. Emotions and information diffusion in social media—sentiment of microblogs and sharing behavior. J Manage Inf Syst. 2013;29(4).

Strapparava C, Mihalcea R. Learning to identify emotions in text. In: SAC'08 Proceedings of the 2008 ACM symposium on Applied computing, Fortaleza; 2008. p. 1556–60.

Strapparava C, Valitutti A. WordNet-affect: an affective extension of WordNet. In: Proceedings of the 4th international conference on language resources and evaluation (LREC 2004), Lisbon; 2004. p. 1083–6.

Vigneshwara M. Aleph of emotions. http://www.mithru.com/projects/aleph.html (2012). Accessed 20 Sept 2017.

Wilhelmer R, Von Bismarck J, Maus B. Fuehlometer. http://richardwilhelmer.com/projects/fuhl-o-meter (2010). Accessed 20 Sept 2017.

Zook MA, Graham M. Mapping DigiPlace: geocoded internet data and the representation of place. Environ Plan B Plan Design. 2007;34(3):466–82.

Chapter 16
A Fractal Augmentation of the Archaeological Record: The Time Maps Project

Dragoş Gheorghiu and Livia Ştefan

16.1 Introduction: Augmentation as a Solution to the Problem of Representation Versus Evocation

The current chapter is the result of the transdisciplinary collaboration between an experimentalist (anthropologist and visual artist) and an IT engineer, aiming to validate the existence of different levels of augmentation during the process of recovery and communication of the Past, and to propose an educational use.

As nowadays the science and art conjunction (see Ede 2000; Antunes 2012; Freeman 2016) frequently appears in the frontline research of complex subjects (see the *Leonardo* journal for instance), the authors believe it could also be applied to the study of the Past.

The question is how can art and science be successfully merged with archaeology? One instance could be the application of the rhetoric process (Huys and Vernant 2012) of augmentation generated by art (Gheorghiu 2012a, 2016), to amplify with metaphors the meaning of an archaeological site, using land-art, installations or performances. Such a work of art, which could influence the perception of a place, is not only *site-specific* (for an extended bibliography see Suderburg 2000: 1ff), but also *site-augmentative*.

In the ethnographic/anthropologic research (for an extended bibliography see Pink 2006), as well as in the archaeological one (see Bonde and Houston 2013; Renfrew 2006), the last decade has seen the emergence of art topics such as

D. Gheorghiu (✉)
Doctoral School, National University of Arts, Bucharest, Romania
e-mail: gheorghiu_dragos@yahoo.com
URL: http://www.timemaps.net

L. Ştefan
Vauban IT Services, Bucharest, Romania
e-mail: livia.stefan@yahoo.com
URL: http://www.timemaps.net

© Springer International Publishing AG 2018
V. Geroimenko (ed.), *Augmented Reality Art*, Springer Series on Cultural Computing, https://doi.org/10.1007/978-3-319-69932-5_16

evocation (Pink 2006, but see also Tyler 1986), allegory (Clifford 1986), and image (Ifantidis 2013; Bradley 2010), due to the limitations of the representational process in science.

The augmentative character of art can be exploited to evoke complexity and replace a simple visual representation with a fractal-like augmentative series of images that will enhance the meaning of the initial image in a flow. In this perspective, a mix of art and science, like art-chaeology (Gheorghiu 2009a, b, c, d; Gheorghiu 2012b, 2016), can, through the rhetorical use of augmentation, function as an evocative instrument to approach the archaeological record (Gheorghiu 2012a). This is the central idea of the current chapter, which intends to present the techniques of Augmented Reality (AR) as an artistic process, labelled ARt-chaeology or ARt.

The knowledge of the Past is important not only for science but also for the more practical purposes of local communities (Ştefan and Gheorghiu 2015; Delfino et al. 2016), in the case of the latter especially for the development of a local identity, as well as for economic development arising from tourism. Another aspect, also very important, is the salvaging of the immaterial heritage. It is well known that (UNESCO 2003 Convention[1]) the immaterial heritage is as important as the material one, as it captures the know-how of contemporary traditional and urban societies.

We will present a case study regarding the salvage of immaterial heritage using AR techniques carried out within the research project "Time Maps. Real communities, Virtual Worlds, Experimented Pasts" (www.timemaps.net). This project examines the rescue of the immaterial heritage and its transmission to future generations, while attempting at the same time to evoke the complexity of the Past through AR techniques. Although "Time Maps" is being developed simultaneously in several locations across Europe, the current discussion will be limited to only one site where the ARt-chaeology strategy was applied for a longer period of time, namely the Vădastra village, situated in the Danube Plain in the south of Romania (Gheorghiu 2001).

"Time Maps" extends the search area for immaterial heritage up to ancient technologies, which today are not yet considered "heritage". Today's archaeological approach is still limited to the process of conducting the scientific experiment (Mathieu 2002, but see also Gheorghiu and Children 2011), rather than preserving the resulting technology. A way of presenting the immaterial heritage to the public is through re-enactments, currently not recognised by the archaeological discipline as scientific approaches. Therefore, the two extremes that frame the access to the immaterial heritage of ancient technologies are, on one hand, the scientific experiment which insists on the "objectivity" of the approach, and on the other, the re-enactment which insists on the phenomenological experience of the art performance.

[1]https://ich.unesco.org/en/convention#art2 [accessed 10 August 2017].

Consequently, a mix of the two strategies would create a synthesising approach to ancient technologies, since it would simultaneously include their representation and evocation. The question then becomes, how can one render ancient technologies comprehensible and attractive for a twenty-first century public?

To achieve this goal, an ARt-chaeological approach could provide a practical solution to the problem, since the recovery of the immaterial heritage presents itself as a process where representation is not operable all the time, and where the augmentation created by art could fill the voids of information through a process of art evocation.

The ARt-chaeological approach was applied to the Vădastra rural community, to recover their traditional and ancient immaterial heritage, thus helping it revitalise the local arts and crafts, and to develop a participatory tourism. This strategy was based on the exploitation of the capabilities of augmentation of a context with virtual information offered by modern mobile devices: processing power, rear camera and larger displays.

Vădastra is a village with a very rich stratigraphy, beginning with the Palaeolithic and continuing up to the modern epoch. Since the most significant level of dwelling is represented by the eponymous Chalcolithic culture, dating from the 5th millennium B.C. (Mateescu 1978), characterised by splendid incised ceramics (Burghelea et al. 2001), this level was chosen to exemplify the Time Maps' viewpoint.

16.2 An Archaeological Fractal-Like Perspective on the Past (From a Macro- to a Micro-Level)

16.2.1 Augmentation and Context

Our opinion is that augmentation, which is a palimpsest-like process of overlapping information, could also be creatively used under a fractal form. Fractals are characterised by the fact that every detail unveils new ones (see Mandelbrot 1983; Ball 2016: 49ff), each detail being more important than the whole image (Mandelbrot interview, in Albers and Alexanderson 2008: 213–34). In archaeology, a search for fractals was achieved by Zubrow (1985) and Brown et al. (2005).

A difference between a classical fractal, where the observer "should envision an infinite regression of smaller and smaller images that constitute a whole that is similar to its parts" (Brown et al. 2005: 40), and the one we propose is, in our instance, that the detail-images (or "parts") are icons different from the source-image (or the "whole"), but their meaning augments the whole.

When one decomposes in a fractal way an archaeological complex (i.e. a prehistoric settlement like Vădastra), this operation creates an immersive regressive (Brown et al. 2005: 40) trajectory (Benford and Giannachi 2011: 230ff), where the relations between parts and whole, and between real and virtual/immaterial,

repeat themselves at different dimensional scales. From a semiotic point of view this trajectory of the fractal-like decomposition of the whole into parts is an antinomy to that of the functioning of Vico's (1744: 129–31) rhetoric tropes. It is well known that the basic tropes, synecdoche or metonymy, create the whole from fragments, the part evoking the whole (Chandler 2007: 123ff). In our approach to evoke the Past, especially its immaterial aspects, we propose for the whole to successively decompose into its significant parts, thus augmenting the information about the context.

In the current approach, the emphasis is placed on the importance of the context (i.e. the "whole"), whose main role is to augment the information about the objects and different human actions performed within it. In the previous research (Gheorghiu and Ştefan 2014), the authors started with the identification of the place of the archaeological contexts on the village site, followed by a GPS survey performed with mobile phones and tablet PCs with the support of available Android applications (e.g. My Traces), and the positioning of the referenced points on Google Maps. The previous ARt-chaeology fractal concept (Gheorghiu and Ştefan 2014) was based on the concept of Points of Interests (POIs) and the solution was a geo-based AR browser application, called *ARt-chaeology*.

To extend the utilisation area of the fractal application, the authors abandoned the multiple POIs design, and instead chose the image recognition AR paradigm, with a pattern specific to the local prehistoric culture, i.e. the one is intended to be presented, as an image trigger, which was promoted by the local media.

For the new version of the fractal AR application, a new AR platform was employed where a context with a single POI was defined, which covers a radius currently set to 50 m around the reconstructed Chalcolithic house.

This geographical context surrounded the archaeological one, a wattle-and-daub dwelling inspired after the architectural remains excavated, ethnographic sources, and the iconography of the prehistoric architectural miniature ceramic objects (Gheorghiu 2010, 2013). A total reconstruction of the shape of the prehistoric settlement surrounded by a ditch and a double palisade was completed in VR. All the architectural features were modelled in Autodesk 3Dmax, with a high resolution of details. For creating a realistic atmosphere of the settlement, special attention was given to the nocturnal illumination and textures of objects. A version of this model was designed with a lesser degree of complexity, i.e. mesh-based with fewer polygons, in order to be optimised for the use in restrictive environments (e.g. transmission via mobile communications and rendering on mobile devices).

The augmentative mix of real objects and virtual reconstructions, like the one created for Time Maps, is a method practiced in contemporary art (see Paul 2011: 71ff). This particular case is an application of the Augmented Reality (AR) and Augmented Virtuality (AV) techniques. Both AR and AV belong to a real-virtual continuum, as Milgram and Kishino (1994) defined it. While AR allows a real time synchronised overlapping of virtual objects over a real image captured with a live video camera, AV only performs an enhancement of the virtual world either with real or virtual information. Another difference is that AR involves more complex technical processes. According to Azuma's definition (1997), AR requires a

registration process, collision detection while performing a synchronisation between the digital and the real objects. Instead AV could be more easily implemented through a simple mixing process.

To obtain efficient effects with augmentation, both technologies were applied in a creative way to generate a cognitive and aesthetic impact on the user.

16.2.2 Between Scientific Experiment and Re-enactment

The recapture of a technology means primarily the identification of the *chaînes-opératoires* through experiment. For the purpose of recovering Vădastra's prehistoric technologies of ceramic vase and textiles making, a series of campaigns were organised between 2000 and 2016. As a result these technologies were recuperated and transferred to the local community. But for transmitting these technical processes to the persons outside the circle of experimentalists, and to make them attractive to the young people who were supposed to learn them and transmit them to the future, the simple recovery of the technical gestures was not sufficient. Here the reconstructed contexts came into play, where the prehistoric wattle-and-daub constructions, ceramic vases, or the textiles woven on different kind of looms, as well as the performances of producing these objects, were introduced as augmented information. One such example of a performance in context concerns a woman decorating a pot, inside a wattle-and-daub house.

If in the previous experiments all performances were shot with professional video cameras, after which the films were post-processed, to render in a suggestive way the technological processes, and employed as augmentations in the conceptual fractal AR application, in the present research the characters that performed the re-enactment were 3D scanned and digitally transposed into the virtual environment.

16.2.3 The Reconstruction of Objects in Reality
and in Virtual Reality

The following stage of approaching the Past in a fractal way was the utilisation of virtual and real objects resulted from experiments, to populate the hybrid contexts created, augmenting them with important information about the spatial organisation and use of ancient spaces, and creating a good medium for the immersion of the viewer.

To present real and virtual objects together on mobile phones, we created an AR application, possessing the capability of presenting a sequence of augmentations under the form of images, video films, virtual tours and simplified 3D models. In an AR view, all these objects can be displayed overlapped on real context,

or in full-screen, producing an effect of immersion into the newly created real-virtual environment.

16.2.4 Light

It is well known that light (Parraman 2010) and shadow (McCauley 2009) were used in art to augment the reality of the representations. For example, shadows highlight the augmentation of the textures and shapes (see Cavanagh and Leclerc 1989; Mamassian et al. 1998); therefore, tangential lighting was used to emphasise textures. In the areas with insufficient archaeological data shadows were an evocative instrument, the sources of light being focused on those parts where the reconstruction was scientifically valid. In the night scenes, by moving the light sources dramatic effects were created (Gheorghiu 2017).

16.2.5 Materiality: Textures and Colour

A final level of the fractal approach is represented by the visualisation of the attributes of the objects created through the recovered technologies. Besides the shape, the objects' other characteristic, from the perspective of sensorial perception, is their materiality, i.e. their texture and colour; consequently, the rhetoric augmentation of the textures of a virtual object could create tactile sensations similar to the ones generated by a real object (see Brogni et al. 2011: 235ff).

We believe that the augmentation of textures does not alter the reality of the scenes, but on the contrary, it acts upon the sensoriality of the individual, stimulating the tactile sensations (Gheorghiu 2015), evoking the materiality of the ancient dwelt spaces.

This is the reason why, for the prehistoric period, a collection of textures and colours of the specific materials was made, containing the colours of the local dye plants, soils, ceramics, flints, woods, hemp, charcoal, wool, and many other materials from the archaeological record and ethnographic sources, together with the coloured textures of these materials.

16.2.6 The Augmentation of Virtuality: Introducing the "Real World" into Virtual Reality

The results of the experiments with the *ARt-chaeology* application, together with other experiments carried out during the last two years (Gheorghiu and Ştefan 2015, 2016), have demonstrated the interest of the end-users in a higher augmentation of

the reality of the 3D reconstructions. At the same time, we took into account the hyper-realist trend in archaeological representations (see Shanks and Webmoor 2013), which is supposed to generate for the viewer a strong sense of "authenticity" and a "high fidelity" (McNamara et al. 1998; Roussos and Chalmers 2003).

To pursue this idea, objects and real characters (actors dressed according to each historical epoch presented) have been scanned in 3D and inserted in the virtual reconstructions of the architectural contexts, their naturalness augmenting the immersivity of the visitor in the 3D simulation (Fig. 16.2).

16.3 Authoring Tools

The development of AR applications on mobile devices currently benefits from the availability of a limited but specialised set of development tools. The technical complexity behind the AR technology, on one hand, and the requirement that these tools be accessed by a broader range of users, on the other hand, has allowed AR platforms to evolve to rapid authoring or prototyping platforms, i.e. to conceal the complexity of the AR processes, e.g. tracking, 3D aligning in the real scene (Gheorghiu and Ştefan 2014; Ştefan 2012), or the management of the digital content.

Over time, the development tools market has undergone rapid change, i.e. some AR platforms have disappeared or merged. Such examples are Metaio which was overtaken by Apple, or the GeorgeFeed Wordpress plugin which was discontinued. Currently, the AR market is more mature and offers better defined tools. Nevertheless, the selection process of the tools for a specific project is not easy. In the case of creative domains, when special functionalities and interfaces are to be implemented, the authoring tool selection has to be combined with content and AR scenario design.

In the present section, the authors outline a summary of the most important AR application authoring tools and platforms.

AR platforms are specialised on vision-AR, geo-AR, for both geo- and vision-AR or on more complex human-machine interactions under the form of 3D animations, AR collaborative or gaming applications.

For vision-AR options are offered by PTC Vuforia[2], Augment3D[3], Gravity Jack (former BrowsAR)[4] and Aurasma[5] which can be employed for the creation of interactive catalogues and books with multimedia content, such as 3D animations and videos.

[2]https://developer.vuforia.com/ [accessed 31 July 2017].

[3]www.augment.com/ [accessed 31 July 2017].

[4]https://gravityjack.com/ [accessed 31 July 2017].

[5]https://www.aurasma.com/ [accessed 31 July 2017].

Wikitude[6] and Layar[7] are among the first/older AR platforms to support the development of both vision and geo-AR types, but Wikitude is able to support both paradigms in the same application. Geo-AR platforms allow the development of AR browsers for situated experiences. Argon[8] is an AR browser for iOS devices.

BrowsAR was based on an online management of the digital content, i.e. content management system (CMS). The same approach is embraced by Aurasma which offers a free online cloud-based CMS platform (Aurasma Studio) for vision-AR applications, also called "auras". Aurasma also brings an innovation allowing that an image recognition be limited to a geographical context.

Integration (mash-up) of AR applications with other network or data services (social networks, touristic and city information), allows the increase in complexity of the AR applications.

16.4 Mobile AR Applications

Mobile AR applications extend the initial AR concept based on image recognition (Milgram and Kishino 1994; Azuma 1997) to location-based services, due to an integration with mapping services (Butchart 2011). Geo-AR applications are context sensitive (Reid et al. 2005) and support a discovery and situated based AR visualisation. The information is synthetically visualised under the form of points of interests (POIs) which can be extended with details under the form of images, aural or video information.

Closer to the initial theory of AR, vision-AR can perform marker-based recognition, either 2D or 3D, as well as visual searches among high volumes of reference images for triggering-specific augmentations (Butchart 2011).

State-of-the-art geo-AR applications were developed for tourism and cultural heritage: *Pompeii* (Papagiannakis et al. 2005), *Rome Reborn* or *Archeoguide* (Vlahakis et al. 2002). In art AR was applied to museum projects (British Museum in London[9]), personal augmented exhibitions (Sheffield Gallery[10], Omi International Arts Center[11]), or digital art creations (Geroimenko 2011, 2012). More examples of AR applications across art and academia can be found in Craig et al. (2009), Geroimenko (2014) and Morey and Tinnell (2016).

Creations of ARt-chaeology using AR were previously proposed by the authors (Gheorghiu and Ştefan 2013a, b), consisting in the augmentation with videos and

[6]https://www.wikitude.com [accessed 31 July 2017].

[7]https://www.layar.com [accessed 31 July 2017].

[8]https://www.argonjs.io/ [accessed 31 July 2017].

[9]https://econsultancy.com/blog/63929-the-british-museum-five-lessons-in-augmented-reality [accessed 31 July 2017].

[10]https://sheffdocfest.com/articles?tag=alternate_realities [accessed 31 July 2017].

[11]https://www.apollo-magazine.com/augmented-reality/ [accessed 31 July 2017].

images of a printed map after scanning it with a smartphone, or in the creation of virtual palimpsest (Gheorghiu and Ștefan 2016).

Recently, Augmented Reality games (ARGs) have attracted growing attention due to the dynamic and participative experience they offer. In Gheorghiu and Ștefan (in press), a treasure hunt game was designed for educational purposes.

Despite the existing state-of-the-art applications, we consider that the number of the AR applications must still increase in order to have a noticeable impact and promote wider usage by a broader public.

16.5 The Methodology

16.5.1 AR Application Development

Some authors (Arth and Schmalstieg 2011) state that the development of an AR system is concerned mainly with the implementations of the interfaces. Other authors (Bimber and Raskar 2005) consider that Augmented Reality is a new human-machine interface, which "has the potential to become more efficient for some applications than for others". The AR application development (which is different and more complex compared to other software applications) is strongly linked to users' experience, because it involves the human senses. Recent authors (Pietschmann and Ohler 2015) see AR as a technology to support the design of natural user interfaces, i.e. allow a non-mediated interaction.

Many authors stress the importance of prototyping the AR application (Mullen 2011; Schmalstieg and Hollerer 2016) as a method of elaboration of an AR application, i.e. the design and implementation of the general application structure, as a different stage from the one of authoring and adding the augmentations.

There are different possible approaches for the development of an AR application: (a) employing rapid development or authoring tools, usually as an online CMS, which does not require programming skills. In this case, the development effort will be focused on the creative part of authoring the augmentations and the sequence scenario; (b) employing Software Development Kits (SDKs), i.e. set of specialised functions, which allow the integration of the AR functionality in other general purpose mobile software applications or frameworks, such as Apache Cordova or Xamarin; (c) integration of AR SDKs in Unity3D engine, which allows the development of customised applications AR applications having complex 3D content and interaction.

More important is to define the purpose of the application, the target audience, the AR scenario, the design and meaning of the augmentations, i.e. the highly creative stage.

In a previous research (Gheorghiu and Ștefan 2014), the Layar AR platform combining geographical with vision-AR tracking methods was employed to implement a concept of fractal-like evocation of the Past.

Fig. 16.1 The *ARt-chaeology 2017* application for mobile devices on Aurasma

ARt-chaeology2017
timemaps's Public Auras

The current version of Layar platforms does not support the mix of the two AR paradigms, i.e. geo- and vision-AR. Therefore, for the present research work, the authors chose the Aurasma platform, for its online authoring and content management environment. Aurasma allows sequences of augmentations, under the form of one "aura", which best supports the fractal concept. In contrast with other AR platforms, e.g. Vuforia, Augment3D, which are customised only for 3D content, Aurasma supports all kinds of augmentations, including 3D.

In Aurasma a single POI was created, its only purpose being to mark on a map the localisation of the prehistoric settlement and the place of the experimental reconstructions. The trigger of the augmentations was an image chosen to represent one of the patterns specific to the prehistoric culture of Vădastra (Fig. 16.1).

The new version of the AR fractal application was authored on Aurasma, *ARt-chaeology 2017*.

16.5.2 The 3D Reconstructed Objects

The models were optimised (as polygons and textures) in order to reduce the costs when these models are downloaded from the remote database through mobile communications. The digital dimensions are correlated with the real ones, taking into consideration that 1 digital unit corresponds to 1 mm (in real physical measurements). For the 3D objects, we used the DAE format, which is a standard for the exchange of graphic data, in the case of Aurasma.

Fig. 16.2 A 3D scanned character

16.5.3 The Real Objects and Characters Scanned: An Improved Type of Augmentation

As already explained, in order to increase the degree of immersion of the subject in the virtual space, 3D scanning of real characters and objects was performed (Fig. 16.2).

This was implemented with photogrammetric techniques, i.e. 3D models resulted from a set of photographs taken from different perspectives around the model, followed by a complex post-processing process to optimise the models to be used on mobile devices or online environments. In our case, the objective was to obtain a cost-effective model, i.e. as dimension and quality, for the AR application which is both a mobile and an online system.

The different working versions were organised and stored on the Sketchfab platform[12], which is using cloud and web visualisation technologies.

16.5.4 The AR Application as a Fractal Flow

The process of immersion was implemented through the augmentation of each fractal-like stage. These augmentations are initiated by a trigger image (Fig. 16.3)

[12]https://tinyurl.com/y7u2exnj [accessed 31 July 2017].

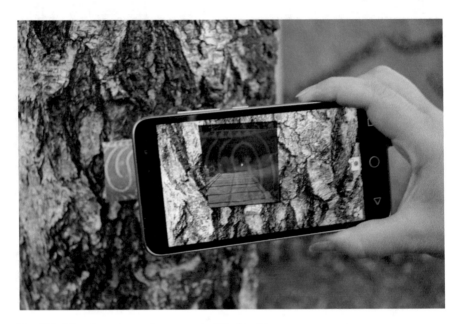

Fig. 16.3 The trigger image that opens the 3D virtual tour

within a 50-m radius around the defined context (a reconstructed prehistoric house as an archaeological experiment, in the Vădastra archaeological site) and allow the subject's immersion in a range of contexts, from the whole of the archaeological complex, to the materials' qualities (colours and textures).

Each augmentation leads to another one in a flow (Ball 2009). The explanatory texts were removed in order to provide users with a seamlessly flowing experience.

A fractal immersion from the macro- to the micro-level involved the following steps:

- The presentation of the context (the reconstructed prehistoric house) (Fig. 16.4); at this stage, the user had to enter an immersive experience, represented by a 3D virtual tour which led him around the prehistoric house on a pre-defined route.
- The presentation of the interior of the house; the user experienced the internal spatial organisation as a 3D virtual tour (Fig. 16.5).
- The augmentation of the spatial organisation by introducing real characters scanned in 3D. The characters were presented with the specific gestures of each technology to be analysed (in this case the decoration of a pot) (Fig. 16.6).

Fig. 16.4 The reconstructed prehistoric house as a 3D virtual tour

- The augmentation of the spatial organisation by introducing real objects scanned in 3D. Each object was presented in its functional relationship with other features of the interior of the house (Fig. 16.7).
- The augmentation of the objects already presented; each object presented its functional and symbolic characteristics (in the current example the texture and decoration of a ceramic vase) (Fig. 16.8).

After completion of this route, the application allowed the visitor to re-access the fractal immersive experience.

Fig. 16.5 The internal spatial organisation as a 3D virtual tour

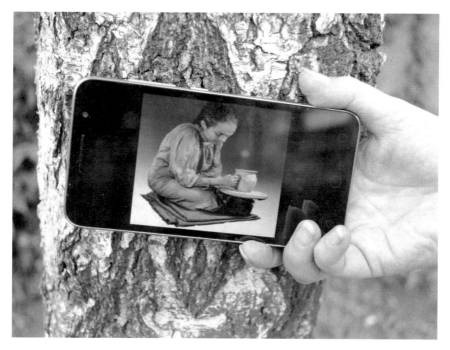

Fig. 16.6 A 3D scanned character showing a technological gesture of decorating a pot

Fig. 16.7 Decorated vases inside the house

Fig. 16.8 The emergence of a Vădastra pattern and ceramic texture from the image of the decorated pots

16.6 Conclusion: Fractal, Immersion and Flow—A Mix of Science and Art

The present chapter offers an argument in favour of augmentation as an evocative instrument, in a mixed strategy combining art and science, as ARt-chaeology. It also presents fractals as a possible augmentative process in this strategy.

As experiments demonstrate, the fractal flow process has shown itself to be an immersive, as well as an augmentative process of knowledge. Each augmentation was a representation that created the following evocation in a flowing transition between virtual and real worlds, and between macro- and micro-levels of reality.

The fractal, as an immersive flow, allowed the scientific information about prehistory to become a continuum of evocations that evoked the beauty and the materiality of the Neolithic world, linking the geographical context with the cultural one, or the technological gestures to materials. In this fashion, a fluid link between science and art was created, through the joint use of representations and evocations, producing at the same time an augmentation of the scientific knowledge and of the artistic creation, by means of the augmentation of virtuality. The latter was produced by the combination, in the same visualisation, of the real objects and characters scanned in 3D.

The Aurasma platform was successfully applied to our ARt-chaeology experiment and allowed rapid development and the testing of the fractal concept.

The application developed provided an interactive and engaging way of transmitting historical information.

Finally, our method and technology also had an educational impact on the viewers. The process of explaining the real environment with augmentations and the use of art as an instrument to augment the reality had a noticeable educational effect.

The method proposed in this chapter, namely the exploitation of the potential of augmentations in a fractal-like analysis, also demonstrated its pedagogical efficiency when applied to school children, during the course of the campaigns conducted in 2012, 2013 and 2017.

From the application experimentation we can conclude that the augmentation of the contexts had a powerful impact on the observer, allowing a deeper understanding of the Past, and can be an educational and learning tool, as well as a method for future knowledge transmission. The complexity of the stored data collected from the archaeological record and archaeological experiments, combined with some artistic processes, gives ARt-chaeology the opportunity to also become a present-day working instrument for saving and transmitting the immaterial heritage.

We can conclude that the augmentation itself can be an artistic process (i.e. ARt), as yet still unexplored, with great artistic potential. The advantages of an application for smartphones and tablets are that it allows the user to experience a flowing immersion, thus learning in a particular historical context and directly relates the observer to the archaeological record and immaterial heritage.

Acknowledgements The authors thank Dr. Vladimir Geroimenko for the kind invitation to contribute to this book. Many thanks to the Director of the Vădastra School, Professor Laura Voicu, and to Ph.D. student Marius Hodea for the 3D scanning. Our gratitude goes also to Mr. Bogdan Căpruciu for his useful remarks.

The present research was financed by an exploratory research grant PN II IDEI ("Time Maps. Real communities, virtual worlds, experimented pasts", Director Professor Dragoş Gheorghiu). Images by D. Gheorghiu.

A first variant of the present text was published in Geroimenko 2014.

References

Albers DJ, Alexanderson GR, editors. Mathematical people: profiles and interviews. Wellesley: A K Peters; 2008.

Antunes F. Where is Lourenço Marques? A mosaic of voices in a 3D virtual world. In: Aceti L, Şahin Ö, editors. Leonardo Electronic Almanac. 2012;18(3):114–21.

Arth C, Schmalstieg D. Challenges of large scale augmented reality on smartphones, workshop ISMAR 11: enabling large-scale outdoor mixed reality and augmented reality, Basel, 26 Oct 2011.

Azuma RT. A survey of augmented reality. Presence Teleoperators Virtual Environ. 1997;6 (4):355–85 (Malibu: Hughes Research Laboratories).

Ball P. Flow: nature's patterns. A Tapestry in three parts. Oxford: Oxford University Press; 2009.

Ball P. Patterns in nature. Why the natural world looks the way it does. Chicago: The University of Chicago Press; 2016.

Benford S, Giannachi G. Performing mixed reality. Cambridge: The MIT Press; 2011.
Bimber O, Raskar R. Spatial augmented reality, merging real and virtual worlds. Wellesley: A K Peters; 2005.
Bonde S, Houston S. Re-presenting the past. Archaeology through text and image. Oxford: Oxbow; 2013.
Bradley R. Image and audience. Rethinking prehistoric art. Oxford: Oxford University Press; 2010.
Brogni A, Calwell DG, Slater M. Touching sharp virtual objects produces a haptic illusion. In: Shumaker R, editor. Virtual and mixed reality new trends. Berlin: Springer; 2011. p. 234–42.
Brown CT, Witschey WRT, Liebovitch LS. The broken past. Fractals in archaeology. J Archaeol Method Theor. 2005;12(1):37–78.
Burghelea V, Melinescu A, Brăileanu A, Gheorghiu D, Lăbus A. The ceramics of the Chalcolithic Vădastra culture. In: Key engineering materials, vol. VII. Euro Ceramics; 2001. p. 206–13.
Butchart B. Augmented reality for smartphones—a guide for developers and content publishers. JISC Observatory; 2011.
Cavanagh P, Leclerc Y. Shape from shadows. J Exp Psychol Hum Percept Perform. 1989;15:3–27.
Chandler D. Semiotics. The basics. Abington: Routledge; 2007.
Clifford J. On ethnographic allegory. In: Clifford J, Marcus GE, editors. Writing culture. The poetics and politics of ethnography. Berkeley: University of California Press; 1986.
Craig AB, Sherman WR, Will JD. Developing virtual reality applications. Burlington: Morgan Kaufman; 2009.
Delfino D, Gheorghiu D, Ştefan L. Archaeological research and applied arts for Public Archaeology in a Final Bronze Age hilltop walled station of Castelo Velho da Zimbreira (Mação-Portugal). In: Quagliuolo M, Delfino D, editors. Quality management of cultural heritage problems and best practices. Proceedings of the XVII UISPP world congress (1–7 Sept, Burgos, Spain), vol. 8/Session A13. Oxford: Archaeopress; 2016. p. 21–34.
Ede S. Strange and charmed. Science and the contemporary visual arts. London: Calouste Gulbenkian Foundation; 2000.
Freeman JC. Emergent technology as art practice and public art as intervention. In: Aceti L, Şahin Ö, editors. Leonardo Electronic Almanac. 2016;21(1):60–71.
Geroimenko V. Digital photo painting as an artistic and cultural phenomenon. In: Proceedings of the 15th international conference on information visualisation (iV2011), London; 2011. p. 461–4.
Geroimenko V. Augmented reality technology and art: the analysis and visualization of evolving conceptual models. In: Proceedings of the 16th international conference on information visualisation (iV2012), Montpellier; 2012. p. 445–53.
Geroimenko V, editor. Augmented reality art: from an emerging technology to a novel creative medium. Springer Series on Cultural Computing. Cham: Springer; 2014.
Gheorghiu D. Le projet Vădastra, Préhistorie Européenne. Liège: Université Libre de Bruxelles; 2001. p. 16–7.
Gheorghiu D. Art-chaeology. A sensorial approach to the past. Bucharest: UNArte; 2009a.
Gheorghiu D. De l'objet à l'espace: Une expérience art-chéologique de la préhistoire. Etudes Balkaniques (Cahiers Pierre Belon 15), Paris; 2009b. p. 211–24.
Gheorghiu D. A study of art-chaeology, Centro Studi Archeologia Africana, Archeologia Africana – Saggi occasionali 2005–2009, (11–15), Milan; 2009c. p. 45–50.
Gheorghiu D. Experimenting with prehistoric spaces (Performance, experience, evocation). In: Nash G, Gheorghiu D, editors. The archaeology of people and territoriality. Budapest: Archaeolingua; 2009d. p. 235–54.
Gheorghiu D. The technology of building in Chalcolithic southeastern Europe. In: Gheorghiu D, editor. Neolithic and chalcolithic architecture in Eurasia: building techniques and spatial organisation. Proceedings of the XV UISPP world congress (Lisbon, 2006 Sept 4–9)/Actes du XV Congrès Mondial (Lisbonne, 2006 Sept 4–9), vol. 48/Session C35, BAR International Series 2097. Oxford: Archaeopress; 2010. p. 95–100.

Gheorghiu D. Metaphors and allegories as augmented reality. The use of art to evoke material and immaterial objects. In: Back-Danielsson I-M, Fahlander F, editors. Encountering imagery. Materialities, perceptions, relations, Stockholm studies in archaeology, vol. 57. Stockholm: Department of Archaeology and Classical Studies, Stockholm University; 2012a. p. 177–86.

Gheorghiu D. eARTh vision (Art-chaeology and digital mapping). World Art. 2012b;2(2): 211–7.

Gheorghiu D. Experiment and indirect evidence [the reconstruction of Chalcolithic architecture]. In: Palomo A, Pique R, Terradas X, editors. Experimentacion en arqueologia. Estudio y difusion del pasado. Girona: Serie Monografica del MAC; 2013. p. 431–35.

Gheorghiu D. Sensing the past. The sensorial experience in experiential archaeology by augmenting the perception of materiality. In: Pellini J, Zarakin A, Salerno MA, editors. Coming to senses. Topics in sensory archaeology. Newcastle upon Tyne: Cambridge Scholars Publishing; 2015. p. 119–40.

Gheorghiu D. Imagining and illustrating the archaeological record: the power of evocation and augmentation of linear drawing. In: Chittock H, Valdez-Tullet J, editors. Archaeology with art. Oxford: Archaeopress; 2016. p. 113–26.

Gheorghiu D. Lighting in reconstructed contexts: archaeological experiments and experientiality with pyrotechnologies. In: Papadopoulos C, Moyes H, editors. The Oxford handbook of light in archaeology. Oxford: Oxford University Press; 2017.

Gheorghiu D, Children G, editors. Experiments with past materialities, British archaeological reports international series 2302. Oxford: Archaeopress; 2011.

Gheorghiu D, Ştefan L. In between: experiencing liminality. In: Aceti L, Rinehart R, editors. Not here, not there. Leonardo Electronic Almanac. 2013a;19(1):44–61 (Istanbul: Sabanci University).

Gheorghiu D, Ştefan L. The maps of time project: a 4D virtual public archaeology (poster). In: 19th EAA annual meeting 2013, Pilsen, Czech Republic, 4th–8th Sept 2013; 2013b.

Gheorghiu D, Ştefan L. Augmenting the archaeological record with art. In: Geroimenko V, editor. Augmented reality art. From an emerging technology to a novel creative medium. Springer Series on Cultural Computing. Cham: Springer; 2014. p. 255–76.

Gheorghiu D, Ştefan L. Augmenting immersion: the implementation of the real world in virtual reality. In: Börner W, Uhlirz S, editors. The 20th international conference on cultural heritage and new technologies CHNT 2015. Vienna: Museen der Stadt Wien – Stadtarchäologie; 2015.

Gheorghiu D, Ştefan L. Virtual palimpsests: augmented reality and the use of mobile devices to visualise the archaeological record. In: Quagliuolo M, Delfino D, editors. Quality management of cultural heritage: problems and good practices. Proceedings of the U.I.S.P.P. congress 2014. Oxford: Archaeopress; 2016.

Gheorghiu D, Ştefan L. Transdisciplinary teaching and learning using mobile technologies. Leonardo Electronic Almanach. (in press).

Huys V, Vernant D. L'Indisciplinaire de l'art. Paris: Presses Universitaires de France; 2012.

Ifantidis F. Archaeographies. Excavating Neolithic Dispillo. Oxford: Archaeopress; 2013.

Mamassian P, Knill DC, Kersten D. The perception of cast shadows. Trends Cogn Sci. 1998;2 (8):288–95.

Mandelbrot BB. The fractal geometry of nature (updated and augmented edition). New York: W. H. Freeman; 1983.

Mateescu C. Contribution to the study of Neolithic dwellings in Romania. A dwelling of the second phase of the Vădastra culture. Dacia NS. 1978;XXII:65–71.

Mathieu JR. Introduction: experimental archaeology. Replicating past objects, behaviors and processes. In: Mathieu JR, editor. Experimental archaeology. Replicating past objects, behaviors and processes, British archaeological reports international series 1035. Oxford: Archaeopress; 2002. p. 1–12.

McCauley D. Night and shadows: the space and place of darkness. In: Environment, space, place, vol. 1. Bucharest: Zeta Books; 2009. p. 51–76.

McNamara A, Chalmers A, Troscianko T, Reinhard E. Fidelity of graphics reconstructions: a psychophysical investigation. In: Rendering techniques; 1998. p. 237–46.

Milgram P, Kishino AF. Taxonomy of mixed reality visual displays. IEICE Trans Inf Syst, E77-D (12). 1994. p. 1321–9.

Morey S, Tinnell J, editors. Augmented reality: innovative perspectives across art, industry, and academia. Anderson: Parlor Press; 2016.

Mullen T. Prototyping augmented reality. Indianapolis: Wiley; 2011.

Papagiannakis G, Schertenleib S, O'Kennedy B, Arevalo-Poizat M, Magnenat-Thalmann N, Stoddart A, Thalmann D. Mixing virtual and real scenes in the site of ancient Pompeii. Comput Anim Virtual Worlds. 2005;16(2):11–24.

Parraman C. The drama of illumination: artist's approaches to the creation of HDR in paintings and prints. In: Proceedings of the SPIE, vol. 7527, Human Vision and Electronic Imaging XV; 2010. http://dx.doi.org/10.1117/12.845083. Accessed 9 Aug 2017.

Paul C. Digital art. London: Thames and Hudson; 2011.

Pietschmann D, Ohler P. Spatial mapping of physical and virtual spaces as an extension of natural mapping: relevance for interaction design and user experience. In: Shumaker R, Lackey S, editors. VAMR virtual, augmented, and mixed reality. In: Proceedings of 7th international conference Los Angeles 2015, Springer International Publishing Switzerland; 2015. p. 49–59.

Pink S. The future of visual anthropology. Engaging the senses. London: Routledge; 2006.

Reid J, Geelhoed E, Hull R, Cater K, Clayton B. Parallel worlds: immersion in location-based experiences. In: Proceedings of the SIGCHI conference on human factors in computing systems, New York; 2005. p. 1733–6.

Renfrew C. Figuring it out. The parallel vision of artists and archaeologists. London: Thames and Hudson; 2006.

Roussos I, Chalmers A. High fidelity lighting of Knossos. VAST 2003; 2003. p. 195–202.

Schmalstieg D, Hollerer T. Augmented reality, principles and practice. Boston: Pearson Education, Inc.; 2016.

Shanks M, Webmoor T. A political economy of visual media in archaeology. In: Bonde S, Houston S, editors. Re-presenting the past. Archaeology through text and image. Oxford: Oxbow; 2013. p. 85–108.

Suderburg E. Introduction: on installation and site-specificity. In: Suderburg E, editor. Space, intervention. Situating installation art. Minneapolis: University of Minneapolis Press; 2000. p. 1–22.

Ștefan L. The art of collage and augmented reality 2D/3D techniques. In: Proceedings of 10th international conference on applied mathematics APLIMAT 2011. Bratislava: Faculty of Mechanical Engineering STU; 2012.

Ștefan L, Gheorghiu D. E-cultural tourism for highlighting the "Invisible" communities—elaboration of cultural routes using augmented reality for mobile devices (MAR). In: Musteață S, Caliniuc Ș, editors. Current trends in archaeological heritage preservation: national and international perspectives. Proceedings of the international conference, Iași, Romania, 2013, BAR International Series 2741. Oxford: Archaeopress; 2015.

Tyler S. Post-Modern ethnography. From document of the occult to occult document. In: Clifford J, Marcus GE, editors. Writing culture. The poetics and politics of ethnography. Berkeley: University of California Press; 1986. p. 122–40.

Vico G. The new science. Ithaca: Cornell University Press; 1744. (1968).

Vlahakis V, Ioannidis N, Karigiannis J, Tsotros M, Gounaris M, Stricker D, Gleue T, Daehne P, Almeida L. Archeoguide: an augmented reality guide for archaeological sites. IEEE Comput Graph Appl. 2002;22(5):52–60.

Zubrow EBW. Fractals, cultural behavior, and prehistory. Am Archeol. 1985;5(1):63–77.

Chapter 17
Wearable Apocalypses: Enabling Technologies for Aspiring Destroyers of Worlds

Damon Loren Baker

17.1 Introduction

While art is the most fundamentally creative human activity, it is my contention that artists themselves have more to gain out of breaking worlds than in building them. To clarify (and to head off any fears that I am calling for acts of mere terrorism or genocide), by worlds I mean the interlocking systems of conceptions we use to organize and explain our experiences (*Weltanschauung* and *Erschlossenheit*—not planets. Ontology not geology) and by breaking I mean introducing elements that defy enclosure within those systems (*Reductio ad absurdum* and *non-sequitur*—not bombs. Glitches not deletion). While these tactics of destructive augmentation have a long and noble history in the arts going back to surrealism, Dada and beyond, recent advances in several technologies (and even more importantly, in the access and distribution of these technologies in the form of mobile devices) have made them especially effective and worth re-examining for those artists working in the medium of Augmented Reality.

It is my contention that in much the same way that the fundamentals of computer technologies were laid out by Babbage, Lovelace, and Turing long before there were systems to enable their theories to be put into practice, these early artistic antecedents such as this essay enable current artists to explore the affordances of currently embryonic technologies. By reaching backward, we are able to look farther forward than merely drawing upon the ideas of the present moment. With this in mind, what follows is an investigation of a collection of specific approaches drawn from the writings of the author William S. Burroughs about the conceptual possibilities created by visual artist Keith Haring's graffiti-inspired work and a

D. L. Baker (✉)
Augmented Reality Laboratory, York University, Toronto, Canada
e-mail: damonlbaker@gmail.com
URL: http://damonlorenbaker.com

© Springer International Publishing AG 2018
V. Geroimenko (ed.), *Augmented Reality Art*, Springer Series on Cultural Computing, https://doi.org/10.1007/978-3-319-69932-5_17

discussion of the emerging technologies that can enable and extend them into use in today's world and inspire future explorations.

17.2 Origins and Influences

William Seward Burroughs II (February 5, 1914–August 2, 1997) was born in St. Louis, Missouri, to a wealthy family (he was the namesake of his grandfather the founder of the Burroughs Corporation) and died in Lawrence, Kansas, where he spent the last 15 years of his life with several pet cats. In between, he became a drug addict, a novelist, an essayist, a painter, a spoken word performer, was elected to the American Academy and Institute of Arts and Letters, awarded the Ordre des Arts et des Lettres by France, graduated from Harvard, seduced boys in bathhouses in Weimar era Vienna, enlisted in the army, murdered his wife, lived in exile in Tangiers, Morocco, was a central member of the Beat Generation of writers along with Allen Ginsberg and Jack Kerouac, developed the cutup technique of literary collage and juxtaposition with the painter Brion Gysin and used it to write several of the most influential novels in twentieth century American literature, and was prosecuted for violating obscenity laws in multiple states over the blatant homosexual imagery of his work as part of an equally influential legal battle over his works (Morgan 1988). In 83 years of life, he participated directly in multiple generations of artistic movements and influenced countless others in a wide range of media (Grauerholz et al. 2000). This is an incomplete list of his travels and areas of endeavor.

Keith Haring (May 4, 1958–February 16, 1990) was born in a small town in Pennsylvania, moved to New York City as a teenager and lived there until he died in his early 30s from AIDS-related complications (Gruen 1992). Despite his brief life, he became an extremely influential and popular artist, drawing early inspiration from the explosive growth of graffiti in New York City of the 1970s and the pop art of Andy Warhol from the 1960s. His distinctive stylized and pullulating figures have become icons, not merely iconic but the actual (and often official) representation of social issues such as the AIDS epidemic (in "Silence = Death" 1989), Gay Pride ("National Coming Out Day," 1988), and the crack epidemic ("Crack is Wack," 1986) that defined life in New York City during the 1980s and shaped Haring's life and work (Reading Public Museum 2006).

Haring was directly inspired by the conceptual possibilities opened by Burroughs' writing as well. Some examples from his personal journals discussing this influence include: "The major influence, although it is not the sole influence, has been the work of William S. Burroughs. His profound realizations, which I encountered in radio broadcasts of the Nova Convention, and in the book. The Third Mind by Burroughs and Brion Gysin, which I have just begun to read, are beginning to tie up a lot of loose ends in my own work and thinking" (Haring 1996). The Nova Convention being "three days and nights of readings, panel discussions, film showings, and various sorts of performances that sought to

grapple with some of the implications of the writing of William S. Burroughs" that "…drew an interesting cross-section of people, and one suspected that only Mr. Burroughs could have brought them together. There were more or less conventional poets, novelists, performing artists, composers as diverse as John Cage and Philip Glass, rock musicians, serious students of American literature, street types, and others" (Palmer 1978).

Also: "All of a sudden (now) some things became clear to me in a way that was similar to my introduction to the work of William Burroughs and Brion Gysin in 1978. I mean, that things that existed in my head as ideas I thought to be my own were given form by seeing their embodiment in the life and work of someone else. It is hard to believe I only discovered Burroughs, Ginsberg, etc. in 1978. I 'accidentally' stumbled across the Nova Convention at the Entermedia Theatre in New York City and the effect was astounding to me. Like my 'accidental' meeting with Andy Warhol and Pierre Alechinsky's work and New York City graffiti…" (Haring 1996).

In 1988, William S. Burroughs was asked by the publisher George Mulder Fine Arts to write text to accompany a series of 10 silk screen images by his, by then, friend Keith Haring which juxtaposed borrowed images with Haring's graffiti-inspired curving lines (see Fig. 17.1 for an example of Haring's visual style) titled "Apocalypse." (The copyrighted images are available online at the Keith Haring Foundation's Web site http://www.haring.com/!/keyword/apocalypse). Unlike their later 1989 collaboration "The Valley" which consisted of a story by Burroughs with illustrations by Haring (Burroughs and Haring 1989), "Apocalypse" contained an essay that was only thematically connected to the content of the specific images it was paired with. While it referenced New York City, graffiti, and some visual elements of Haring's work (Le Compte 1992), it drew upon imagery from much of Burroughs' earlier works and starred as the central figure not Haring but the Great God Pan. What follows is an attempt to unpack some of those sources to clarify the message of the essay and its connection to not just the practice of street art in the 1980s but to current work in Augmented Reality art as well.

17.3 The Birth of the Death of Pan

Mariners sailing close to the shores of Tuscany heard a voice cry out from the hills, the trees and the sky: "The Great God Pan is dead!" Pan, God of Panic: the sudden awareness that everything is alive and significant. The date was December 25, 1 A.D. **But Pan lives on in the realm of the imagination, in writing and painting and music**. Look at Van Gogh's sunflowers, writhing with portentous life; listen to the Pipes of Pan in Joujouka. Now Pan is neutralized framed in museums, entombed in books, relegated to folklore (Burroughs and Haring 1988).

Juxtaposed narratives that become gradually more inter-spliced are a common element in many of Burroughs' works, so beginning an essay about New York City in the year 1988 with a story from Tuscany, at the beginning of the first century and

Fig. 17.1 Keith Haring's "Tuttomondo" 1989—Mural in Pisa Italy. http://commons.wikimedia. org/wiki/File:Tuttomondo_-_Haring_front.jpg

using it as a central symbol is recognizably Burroughsian. He even ties it in with his beloved Master Musicians of Joujouka so it is apparent that this essay is at least as much about Burroughs' work and aims as it is about Haring's pictures. And as is common with Burroughs' cutup-based writing, this story was not written entirely by him but spliced together from several sources.

The original textual source for the death of Pan is the first-century Greek-born Roman magistrate and essayist Plutarch. Tucked into a collection of 78 of his essays and speeches titled "Moralia" (loosely translated as "Customs and Mores") in between philosophical essays on the duty of siblings toward each other, and a comical dialogue between Odysseus and an enchanted pig is an essay titled "On the Decline of the Oracles," as the introduction to the Loeb English translation explains:

Plutarch's answer to the question why many oracles in Greece have ceased to function is that the population is now much less than it was, and so there is less need for oracles now than in earlier times. For example, at Delphi there used to be two prophetic priestesses with a third held in reserve; now there is only one, and yet she is sufficient for every need.

The statement of this simple fact hardly requires twenty-nine folio pages, but in this essay, as in the two preceding, there is much of the conversation of cultured persons which is not directly connected with the subject. Thus we find a discussion of whether the year is growing shorter, whether the number of the worlds is one or some number not more than five or is one hundred and eighty-three. We have further discussion of the number five, some astronomy, and a good deal of geometry, some interesting bits of information about Britain and the East and a rather long discussion of the daimones, the beings a little lower than the gods and considerably higher than mortals; perhaps the translation 'demi-gods' might best convey the idea in English. These beings are thought by many persons to be in charge of the oracles; certainly the god himself does not appear personally at his oracles; and in the case of the oracle at Delphi some account is given of the accidental discovery by a shepherd of the peculiar powers of the exhalation from the cleft in the rocks (Loeb Classical Library 1936).

To spare the reader from having to search through the rambling (yet thoroughly charming) essay, (as Loeb accurately describes it: "Some parts of the essay make rather difficult reading, but it also contains passages of considerable interest and even beauty" (Loeb Classical Library 1936). I have isolated the sections specifically describing the death of Pan and the decline of the oracles:

> "…it it is not the gods," said Heracleon, "who are in charge of the oracles, since the gods ought properly to be freed of earthly concerns; but that it is the demigods, ministers of the gods, who have them in charge, seems to me not a bad postulate; but to take, practically by the handful, from the verses of Empedocles sins, rash crimes, and heaven-sent wanderings, and to impose them upon the demigods, and to assume that their final fate is death, just as with men, I regard as rather too audacious and uncivilized."

> …As for death among such beings, I have heard the words of a man who was not a fool nor an impostor.

> The father of Aemilianus the orator, to whom some of you have listened, was Epitherses, who lived in our town and was my teacher in grammar. He said that once upon a time in making a voyage to Italy he embarked on a ship carrying freight and many passengers. It was already evening when, near the Echinades Islands, the wind dropped, and the ship drifted near Paxi. Almost everybody was awake, and a good many had not finished their after-dinner wine. Suddenly from the island of Paxi was heard the voice of someone loudly calling Thamus, so that all were amazed. Thamus was an Egyptian pilot, not known by name even to many on board. Twice he was called and made no reply, but the third time he answered; and the caller, raising his voice, said, 'When you come opposite to Palodes, announce that Great Pan is dead.' On hearing this, all, said Epitherses, were astounded and reasoned among themselves whether it were better to carry out the order or to refuse to meddle and let the matter go. Under the circumstances Thamus made up his mind that if there should be a breeze, he would sail past and keep quiet, but with no wind and a smooth sea about the place he would announce what he had heard.

> So, when he came opposite Palodes, and there was neither wind nor wave, Thamus from the stern, looking toward the land, said the words as he had heard them: 'Great Pan is dead.' Even before he had finished there was a great cry of lamentation, not of one person, but of many, mingled with exclamations of amazement. As many persons were on the vessel, the story was soon spread abroad in Rome, and Thamus was sent for by Tiberius Caesar.

> Tiberius became so convinced of the truth of the story that he caused an inquiry and investigation to be made about Pan; and the scholars, who were numerous at his court, conjectured that he was the son born of Hermes and Penelopê (Loeb Classical Library 1936).

This lays out the basic element of the story related by Burroughs in the opening of "Apocalypse" except for one crucial detail, the exact date. Further clues are provided by the Loeb editors:

> Students of English literature will be interested in the dramatic description of the announcement of the death of Pan; and students of religion will be interested in the essay as a very early effort to reconcile science and religion. That the essay had an appeal to theologians is clear from the generous quotations made from it by Eusebius and Theodoretus (Loeb Classical Library 1936).

The particular importance of this section to English literature will be examined later but working forward to the theologians who quoted from it so heavily we find one such quotation of this very passage in Eusebius of Caesarea's (a Roman historian, bishop, and Christian polemicist born roughly 260 AD, died roughly 340 AD) "Preparation for the Gospel" which is a series of fifteen books which he wrote to introduce Christianity to pagans and persuade them of his new religion's inherent superiority. As is common with this work, he quotes large pieces of other's works to illustrate his view of historical information and then follow with his own comments. After relating the story of the death of Pan (mostly identical to the version in Plutarch so I will not repeat it here), he concludes with:

> So far Plutarch. But it is important to observe the time at which he says that the death of the daemon took place. For it was the time of Tiberius, in which our Saviour, making His sojourn among men, is recorded to have been ridding human life from daemons of every kind: so that there were some of them now kneeling before Him and beseeching Him not to deliver them over to the Tartarus that awaited them.

> You have therefore the date of the overthrow of the daemons, of which there was no record at any other time; just as you had the abolition of human sacrifice among the Gentiles as not having occurred until after the preaching of the doctrine of the Gospel had reached all mankind. Let then these refutations from recent history suffice (Oehler 1851–1854).

As previously mentioned, this particular image of the death of the old gods, exemplified by Pan, fading out at the birth of Jesus was particularly important to many English authors and poets. A prominent example would be John Milton, who draws upon this image in his first major English poem "On the Morning of Christ's Nativity" (Lewalski 1966) written in 1629, beginning with a description of the birth of Jesus which includes a description of shepherds in their ignorance of the momentous event that has just occurred:

> The Shepherds on the Lawn, Or ere the point of dawn, Sate simply chatting in a rustic row; Full little thought they than That the mighty Pan Was kindly com to live with them below: Perhaps their loves, or else their sheep, Was all that did their silly thoughts so busie keep (Lewalski 1966).

And then proceeding in a description of the decline of the Oracles and the disappearance of all the old gods one by one, starting with a retelling of Plutarch via Eusebius spliced into the narrative:

> The Oracles are dumm, No voice or hideous humm Runs through the arched roof in words deceiving. Apollo from his shrine Can no more divine, With hollow shreik the steep of Delphos leaving. No nightly trance, or breathed spell, Inspire's the pale-ey'd Priest from the prophetic cell.

> The lonely mountains o're, And the resounding shore, A voice of weeping heard, and loud lament; From haunted spring and dale Edg'd with poplar pale, The parting Genius is with sighing sent, With flowre-inwov'n tresses torn The Nimphs in twilight shade of tangled thickets mourn.

> In consecrated Earth, And on the holy Hearth, The Lars, and Lemures moan with midnight plaint, In Urns, and Altars round, A drear, and dying sound Affrights the Flamins at their service quaint; And the chill Marble seems to sweat, While each peculiar power forgoes his wonted seat (Lewalski 1966).

This goes on for several more verses with an extensive list of pagan gods which are no longer worshiped and concludes with the triumph of the new order over the old with the birth of Christ:

> He feels from Juda's land The dredded Infants hand, The rayes of Bethlehem blind his dusky eyn; Nor all the gods beside, Longer dare abide, Nor Typhon huge ending in snaky twine: Our Babe, to shew his Godhead true, Can in his swadling bands control the damned crew.

> So when the Sun in bed, Curtain'd with cloudy red, Pillows his chin upon an Orient wave. The flocking shadows pale Troop to th' infernall jail, Each fetter'd Ghost slips to his several grave, And the yellow-skirted Fayes Fly after the Night-steeds, leaving their Moon-lov'd maze.

> But see the Virgin blest, Hath laid her Babe to rest. Time is our tedious Song should here have ending, Heav'ns youngest-teemed Star Hath fixt her polish Car, Her sleeping Lord with Handmaid Lamp attending. And all about the Courtly Stable, Bright-harnest Angels sit in order serviceable (Lewalski 1966).

Burroughs takes the intentionally humorous overly literal step of asserting that this happened on Christmas Day AD 1, in a sort of homage to Eusebius' overly literal treatment of the story related in Plutarch. The primal age of savage mystery and wonder is replaced with an age of orderly science and reason as one world view is enclosed and subdued by a new one, drawing its imagery and metaphors from the stories of a passage of a Greek-dominated world to a Roman-dominated one. Each world building itself out of the pieces of the previous one most useful to it, and then carefully discarding the remaining bits lest they clog up the machinery of power and explanation. A new world has been created on the ruins of the old. A place for everything and everything in its place.

17.4 Off the Canvas, Out of the Galleries, and into the Streets

Unsurprisingly, queer artists whose work defied easy categorization such as Burroughs and Haring did not feel that they fit into this neatly ordered world and were rooting for the opposition. After laying out the old stories, a new way out of this maze is presented:

> But art is spilling out of its frames into subway graffiti. Will it stop there? Consider an apocalyptic statement: 'Nothing is true. Everything is permitted.' – Hassan i Sabbah. Not to be interpreted as an invitation to all manner of restrained and destructive behavior; that would be a minor episode, which would run its course. Everything is permitted because nothing is true. It is all make-believe, illusion, dream…ART. When art leaves the frame and the written word leaves the page – not merely the physical frame and page, but the frames and pages of assigned categories – a basic disruption of reality itself occurs: the literal realization of art. This is a very different direction from Duchamp, Klein and Manzoni, of appropriating everything in sight by signing it or putting it on a pedestal. Instead of appropriating by framing and signing, remove the frames and the pedestals, yes, even the signatures. Every dedicated artist attempts the impossible, Success will write APOCALYPSE across the sky. The artist aims for a miracle. The painter wills his picture to move off the canvas with a separate life, movement outside of the picture, and one rent in the fabric is all it takes for pandemonium to sluice through (Burroughs and Haring 1988).

Burroughs correctly identifies the graffiti-inspired street art that Haring and others are developing as an escape hatch from the controlled galleries and dead museums into the streets and beyond. Enabled by the relatively humble technology of the spray can artists were able to juxtapose their creations with the real world. A form of the cutup techniques Burroughs and Gysin had perfected with words could now be practiced upon the world itself. It was a narrow crack but one that could spread and grow. The beginning of an end. A revelation. An Apocalypse. "Neither the modern disruption of traditional structures of value, nor the post-modern disruption of modernist mythologizing; rather, it is the 'literal realization of art,' a realization which simultaneously requires the destruction of art as a separate category, as a mirror to nature and life" (Murphy 1997).

17.5 Conclusion

All of this is intended as a collection of tactics and approaches to be used or reacted against by contemporary artists working in the media of Augmented Reality seeking to maximize the impact of their work, particularly those using systems that function on now commodity electronic devices such as smartphones. By a conservative estimate, there are over one billion smartphones in use in the world today (Bicheno 2012). This puts a previously unthinkable amount of computational power, sensors, and display systems into the hands and pockets of people from all walks of life all over the world. There are now widely available platforms for the

creation of interactive art that escapes the boundaries of galleries and museums into the world in which real human beings live and breathe. Simply re-creating electronic versions of past masterpieces or adding virtual bits and pieces on to the world like some sort of virtual decorator isn't an effective use of the affordances of this new situation. By seizing upon the opportunity to cut up the real world with virtual worlds, with make-believe, illusion, dream, ART, we can break the bounds of our frames. Instead of pulling bits of the real world onto virtual pedestals and signing them, we can aim, once again, for a miracle.

References

Bicheno S. Global smartphone installed base forecast by operating system for 88 countries: 2007 to 2017. London: Strategy Analytics; 2012.
Burroughs WS, Haring K. Apocalypse. New York: George Mulder Fine Arts; 1988.
Burroughs WS, Haring K. The valley. New York: George Mulder Fine Arts; 1989.
Grauerholz J, Silverberg I, Douglas A, editors. Word virus: the William S. Burroughs reader. New York: Grove Press; 2000.
Gruen J. Keith Haring: the authorized biography. New York: Fireside Press; 1992.
Haring K. Journals. London: Fourth Estate; 1996.
Le Compte R. A memorable collaboration. Lawrence Journal – World Newspaper. 1992 Aug 9.
Lewalski B. Milton's brief epic: the genre, meaning and art of paradise regained. Providence: Brown University Press; 1966.
Loeb Classical Library Edition. Plutarch Moralia. vol. V. London: William Heinemann Ltd; 1936.
Morgan T. Literary outlaw: the life and times of William S. Burroughs. New York: Avon; 1988.
Murphy TS. Wising up the marks: the amodern William Burroughs. London: University of California Press; 1997.
Palmer R. 3-Day Nova convention ends at the enter media. The New York Times; 1978.
Reading Public Museum. Keith Haring: journey of the radiant baby. Piermont: Bunker Hill Publishing; 2006.
Oehler QSF. Tertulliani opera omnia, vol. 3. Leipzig: T.O. Weigel; 1851–4.

Part IV
Living, Acting and Expressing Yourself in Augmented Worlds

Chapter 18
User Engagement Continuum: Art Engagement and Exploration with Augmented Reality

Matjaž Kljun, Klen Čopič Pucihar and Paul Coulton

18.1 Introduction

In the majority of cases, our experience of artworks in galleries and museums is as passive observers. While this is a widely accepted practice in terms of the preservation of the artworks, it limits the engagement potential with visitors who could use others' artists work as inspiration to express their own creativity. Such activity has been considered in Chap. 3 of this book highlighting how a number of AR applications and prototypes in the field of art have enabled greater interactivity from the audience (Coulton et al. 2014a). However, the vast majority of AR applications in the context of art have thus been created to address the needs of the cultural sector in terms of creating guides for cultural sites (Caarls et al. 2009; Miyashita et al. 2008; Papagiannakis et al. 2005; Tillon et al. 2011), to provide alternate representations of the museum content, or as a novel means of providing additional meta-data (Angelopoulou et al. 2011), to view artworks (Kolstee and van Eck 2011), and even

M. Kljun (✉) · K. Čopič Pucihar
Faculty of Mathematics, Natural Sciences and Information Technologies,
University of Primorska, Koper, Slovenia
e-mail: matjaz.kljun@upr.si
URL: https://pim.famnit.upr.si

K. Čopič Pucihar
e-mail: klen.copic@famnit.upr.si
URL: http://klen.si

M. Kljun · K. Čopič Pucihar
Faculty of Information Studies (FIŠ), Novo Mesto, Slovenia

P. Coulton
Imagination, Lancaster Institute for the Contemporary Arts,
Lancaster University, Lancaster, UK
e-mail: p.coulton@lancaster.ac.uk
URL: http://imagination.lancs.ac.uk/people/Paul_Coulton

© Springer International Publishing AG 2018
V. Geroimenko (ed.), *Augmented Reality Art*, Springer Series on Cultural
Computing, https://doi.org/10.1007/978-3-319-69932-5_18

329

provide alternate infrared or ultraviolet (van Eck and Kolstee 2012; Kolstee and van Eck 2011) views of a painting. It is clear that AR is most often explored from technological point of view and not from the view of the user.

The advantage of AR, compared to other mediums, is that AR allows to blend real and virtual objects and create real-time augmentation in the context of the physical space where personalisation of artworks has taken place. Moreover, AR does not physically change the artworks and places they are exhibited, but it digitally augments them allowing personalised versions and interpretations. Augmented art objects are thus observable only to their creators, people with whom these augmented artworks have been shared, and people interested in what other people have made publicly available and search for traces others have left in the context where artworks are shown and observed (e.g. galleries, museums and cities). Augmented reality presents an excellent opportunity to allow users to play with art in a personalised way, allow them to be creative and explore art not only as passive observers but rather as active participants.

In this chapter, we present different ways in which users can engage with art content by utilising AR through the consideration of a number of different prototypes that support expression of users' creativity at different levels. We will not focus on how these solutions have been technologically implemented since technology advances at a fast pace and each of the below solutions could be built in novel ways with novel (e.g. hands-free) technologies that since entered the market (for example, Microsoft HoloLens[1] and more affordable Mira Prism[2]). Rather, we will consider potential use cases and results of the studies if these were carried out.

18.2 AR Use Cases for Engaging Users in Art Creation and Consumption

There are several ways of engaging users with art (and cultural heritage) creation and consumption. Below are presented some of the examples that allow for exploration, creation and building upon artworks and try to engage users with artworks in novel forms. Note that this is not a definite collection as describing all such prototypes would exceed the purpose of this chapter. For other AR solutions see the review chapter of this book about AR applications taxonomy.

[1]https://www.microsoft.com/en-us/hololens.

[2]https://www.mirareality.com/.

18.2.1 *User-Curated Augmented Reality Art Exhibitions*

Displays and exhibits of artwork collections in the museums and galleries are most commonly left to art curators employed specifically for this job. Visitors have thus the possibility to see the curator's interpretation of what is being displayed in the context of a physical environment in which the exhibition is held. Curators often hold high academic titles meaning they have spent years to acquire a required knowledge for this job. However, visitors are also "curators" of their own living spaces and the authors of the "Taking the Artwork Home" application have given them the possibility to take digital representations of the artworks (seen in visited museums or galleries) and curate them in their own home (Coulton et al. 2014a, b).

To create exhibitions, users can either define their own AR markers (e.g. existing paintings they have on the walls of their home) or use predefined markers (Fig. 18.1). Next, the artworks need to be selected and the exhibition needs to be given a name and description (Fig. 18.2). At this point, the user can also define how they wish the artwork to be displayed in relation to the AR marker. There are four display options available: proportional to the height of the marker; proportional to the width of the marker; display at the original dimensions; and define a custom display size. To view an exhibition, the user can select one of the exhibitions they created or one created by the community. Once an exhibition has been selected, it can be viewed by pressing the view button. Digital representations of the artworks are then displayed or augmented over the markers for the user.

The main goal for building this application was to study the implications it would have on users, artists and galleries. Users in the study engaged more with the content in the application than with the content in the gallery. They, for example, enjoyed the possibility to zoom in the pictures and explore them in great details, such as brush strokes within the paint, and rotate artworks as they desired. In contrast observing artworks in the gallery space allowed them only to passively acknowledge that there is a painting. While users enjoyed using the app, the gallery and artists in the study were concerned about copyright and privacy issues, which are complex enough to be obliged in one country, let alone globally.

Since the study has also a planned longitudinal aspect, data generated by the application could provide a valuable insight of which parts of gallery collection users are most interesting in. The approach also gives users the access to artworks not displayed at the gallery at the given time of the visit, since galleries do not have enough space and the curated collections on display often change.

18.2.2 *Playing with the Artworks*

During organised school trips to museums and galleries, children are often given working sheets and are expected to describe the exhibit material, write down

Fig. 18.1 Taking the Artwork Home application: defining AR markers

Fig. 18.2 Taking the Artwork Home application: creating exhibition: selecting artworks to be displayed, giving the name and description to the gallery and selecting the display relation to AR markers

answers to questions related to the exhibit and/or write an essay about the trip. These tasks bear a high notion of seriousness which children and youngsters generally dislike. The participants in the study emphasised their positive experiences when such visits were interactive and playful. One of the examples given was playing a game in the museum in which children were given parts of exhibited paintings in the form of puzzle pieces and had to go through the museum to find which paintings they belonged to.

Based on these facts, the authors used AR technology to create engaging and personal art experience for younger audience (Čopič Pucihar et al. 2016b). To achieve this, the application resembles a treasure hunt style game. The game starts by assigning users a contour drawing, which they are asked to colour. Users do not know exactly what object is they are colouring, but are made aware that these segments, if placed correctly, should wrap up on a statue or overlay a painting (see Fig. 18.3).

Once a contour is coloured, each user embarks on a treasure hunt through the exhibition and tries to fit the coloured contour to various artwork (e.g. sculptures, buildings, paintings and statues) by pointing the AR device at the object. The device identifies the artwork, presents user with the object's information (i.e. audio and/or text) and notifies them if the contour matches the artwork. If the contour

Fig. 18.3 Playing with the artwork: user colours a given contour. After finding the corresponding artwork the patches from the contour wrap onto it creating a unique personalised version of the artwork

does not match, the user may be given extra information to lead them to the artwork or simply be encouraged to keep exploring. If the matching artwork is identified, the coloured patches from the contour wrap onto the artwork creating a unique personalised version of the artwork (which can be saved and shared online).

The application supports the concept of playful learning with engaging users in active participation rather than passive consumption (Bruner and Lufburrow 1963). It gives children the opportunity to actively explore and creatively expand on existing artworks. For example, by colouring contours children might think about geometry, underlying shapes, forms and particular elements that form the basis of the artwork. In addition, the application offers a possibility to provide audio or video information, context-aware quizzes and similar multimedia content that children need to see or solve in order to proceed and/or gain points in the game.

18.2.3 Time-wARpXplorer: Creating Own Stories in Urban Environment

Substantial research has been conducted for the use of AR for navigation, search and augmenting historical artefacts (see Chap. 3 of this book) based on location-based services (LBSs). Time-wARpXplorer (TARX) (Lochrie et al. 2013) similarly offers by default a collection of historical photographs provided by the local museum that users can explore in an AR view over the present physical world. Additionally, the application provides people of local communities the platform to expand the collection by adding their own stories and accounts of history of their living spaces. This permits for a variety of personal interpretations and POIs (point of interests) of the local people about their living environment. Users can contribute personal historical photographs (e.g. of a family-run business, their school when they were children). For each photography, they can provide a name of the location, a brief description, a date when it was taken, latitude and longitude, the direction from where it was taken and its incline.

The second group of users are tourists who are able to explore the city in spatial and temporal dimensions in a playful manner by discovering the cracks within the

history over a modern-day city with augmented photographs of historical locations over the present-day physical locations (see Fig. 18.4 right).

The application lets users explore a city with a map within it (see Fig. 18.4 left). Upon arrival at the warp destination, users have the ability to warp back to a random time by clicking on the marker to reveal the augmented photograph (see Fig. 18.4 centre). Users can also view details such as the location, a brief description, information relating to the warp, and have the ability to store the photographs and data in their own sticker album enabling them to revisit the warp. Players can share these stickers by posting them to several social networking service sites.

To encourage playfulness, players can be awarded achievements and ranks by fulfilling application objectives such as the amount of interaction they have with the application and other specific requirements. The tracked journey and achievements can be taken as a digital souvenir by the users.

The authors of the TARX application say that the purpose for opening up to the community "was to provide a sense of ownership and to increase the perspective of varying photographs, seeking to engage audiences by supplying a piece of history ..." (Lochrie et al. 2013).

18.2.4 I Was Here: Digital Graffiti for Tourists

Since ancient times travellers and tourist are leaving marks and writings on sites they visit. This is manifested across cultures and covers simple inuksuit built by Inuit peoples for navigation and as a point of reference marking routes or sites, leaving D locks with declarations and messages on bridges in cities all over the globe, to scribbled messages on the walls of ancient buildings denoting one's presence and appreciation of the site. The latter are unacceptable acts by today's standards since this kind of behaviour can leave permanent and irreversible damage on historical sites.

One possible solution to prevent permanent marks on historic landmarks is to allow tourists to create their mark in a digital form and augment them on a desired location of the historic site. One possible solution is to allow tourists to create digital graffiti and project them onto historical sites (Kljun and Pucihar 2015). Another solution is to use augmented reality and augment historical sites with digital graffiti just for the user (Šimer 2016) as shown in Fig. 18.5.

The solution using AR has been tested and studied by the authors in terms of how would the usage of the application be accepted by others present at the same location, while a graffito was being made as well as how would people react seeing such graffito on social media sites. People walking in front of the AR device (a phone in this example) have not been bothered by the author despite holding the phone in the air for prolonged periods of time to create the desired graffito. This

Fig. 18.4 TARX application: map, AR and warp view. TARX has an automatic interface switching implemented, to switch the AR view to a traditional map view based on the orientation of the device to save battery life

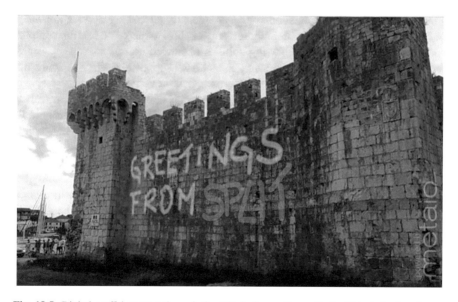

Fig. 18.5 Digital graffiti as seen through the AR device on the wall of a historic landmark

graffito also received positive feedback: some users have wondered whether such application uses augmented reality, while others asked about the origin of the captured images.

The author noted that such application could greatly benefit by incorporating advanced functions for drawing, a set of pre-built templates and a functionality to zoom in the object's texture map, which would allow users to draw a more complex graffiti.

Similar solutions have already been developed and made commercially available such as Autography,[3] which lets people leave their mark at the Florence Cathedral. The virtual marks people leave are saved and can be seen by visitors that are interested in them. Other applications offering the same or similar functionality include WallaMe[4] and LandmARk.[5] There is also an indoor application that allows users to leave virtual notes on walls called Wally Augmented Reality Notes.[6]

18.2.5 Virtual Tracing Tool

The virtual tracing tool allows users to transfer any contour (including the works of art) onto a 2D (Čopič Pucihar et al. 2016a) or 3D (Gombač et al. 2016) surfaces as shown in Fig. 18.6. Looking through the screen of the handheld device, users can see the contour or a transparent virtual image on a mobile device that can be transferred to the surface seen through the screen. This approach could be used in different use cases one of which is recreating the artworks and supporting art generation and/or reinterpretation. For example, virtual tracing application has a potential to serve crafting communities and support expert users with complex contours while also improve drawing abilities of novice users.

Recently, a commercial application SketchAR[7] supporting virtual tracing has been released on all major mobile platforms. It is advertised as an art assistant useful for all users who cannot draw but want to start with such activities as well as for professional artists, as a fast way to trace sketches to a chosen surface. Its database contains a collection of various sketches including works of art, which users can transfer to the physical surface. Currently, the application only supports virtual tracing on flat surfaces.

Besides virtual tracing images to a surface, we can envision applications that assist users in sculpturing. For example, users would have a piece of clay in front of them and looking at it through an AR device, they would be guided as where to add or take the material to achieve a desired sculpture. The shapes of sculptures could be the works of art in a gallery and users would be encouraged to recreate them.

While virtual tracing is not directly related to experiencing existing art collection or cultural heritage, it presents an example of how users could be supported in

[3]https://autography.operaduomo.firenze.it/the-project/.

[4]https://play.google.com/store/apps/details?id=com.wallame.

[5]https://play.google.com/store/apps/details?id=com.mitchellaugustin.landmark.android.

[6]https://play.google.com/store/apps/details?id=com.wally.augmented_reality_virtual_notes.

[7]http://sketchar.tech/.

Fig. 18.6 The mobile device renders a virtual template image together with a live video stream of the drawing surface. Left: paper. Right: Easter egg

building upon existing artworks and be engaged in adding their physical content or leaving (even temporarily) their physical marks at museums or galleries.

18.3 Discussion

Game-like activities in art education, such as described above in Playing with the Artworks, can contribute to a richer, educational and entertaining experience. The idea of mixing learning with play and technology is not new (Brosterman 1997). In 1837, Friedrich Froebel came up with an idea to teach children the concepts of numbers, size, shapes and colours with toys developed specifically for this purpose. Recently, studies have shown that children quickly learn how to express themselves creatively with new technologies (Resnick et al. 1999). And there are several examples on how technology enhances creativity through playful explorations instead of serving just as passive consumption tool—a too often perceived role of technology (Resnick 2006).

User Engagement Continuum
AR provides an excellent opportunity for engaging with artworks in playful, entertaining and educational ways as described by examples in previous sections. AR allows for leaving digital marks and augmentations of physical artworks and exhibitions while preserving original work. There are several levels of engagement that can be used in AR solutions related to art creation and consumption. These levels are placed on a continuum and vary based on how engaged are users when interacting with artworks using AR applications as shown in Fig. 18.7.

In more detail, the user engagement continuum can be described as follows:

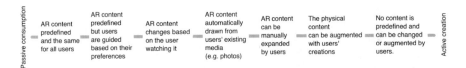

Fig. 18.7 The user engagement continuum

User engagement none (passive consumption)

– The physical and AR content is predefined and the same for all users.
– The physical and AR content is predefined, but it guides users through an exhibition based on their preferences. An example would be an application that would guide users through an exhibition in a personalised way based on user's preferences (e.g. available time, personal interests, previous activities).
– The physical content is predefined, but it changes using AR based on the user watching it. An example of this level is an application that shows users the artworks based on their preferences such as the favourite artistic periods. Such exhibitions would be curated by professional curators.
– The physical content is not completely predefined, and it automatically draws additional content presented in AR mode from users existing creations. An example of such a solution would be an application that would place user's photograph and place them among the other physical photographs in the exhibition.
– The content is predefined but can be manually expanded by users. An example is TARX that allows users to add their own content to an existing predefined collection. This content is curated by curators and made visible to all other users.
– The content is predefined, but users can augment it with their own marks. An example of this application is Playing with the Artworks where users can personalise, build upon and change existing physical artworks. Another example is leaving digital graffiti. However, this level could also involve commenting on artworks, leaving thoughts about artworks for future visitors, etc.
– The content is not predefined and can be changed by users. An example of this would be enabling users to curate their own exhibition with existing and/or own creations.

User engagement high (active creation)

Copyright issues
There are several issues that arise with allowing users augmenting artworks. Building upon other artists' work can cause confliction in terms of copyright infringement. As have been discussed in Coulton et al. (2014a, b), galleries, museums and artists often rely on laws relating to publication and copyright that were established for physical artefacts and struggle to adapt to the implications of the digitalisation of their content. What is seen as archaic in the technological world is still a norm in the creative industries. Any augmented reality application intending to use or allow to build upon digital representations of copyrighted material must take these conditions into account if the application is to be used outside a purely research context. Note that while

following discussion is related to UK law, it is important that those developing such applications consider the corresponding laws of the countries within which they may wish to make the application available.

In the UK, copyright lasts for the lifetime of the artist and is transferred to their heirs for 70 years after artist's death. When an artist sells his work to a collector, gallery or a museum, the copyright for that work does not transfer unless an explicit agreement is reached. After the mentioned 70 years period the copyright extension in the EU is automatically given to the person or body that publishes the work for the first time. The meaning of "publication" in this situation includes any communication to the public by: issuing copies of the work to the public; making the work available via an electronic retrieval system; renting or lending copies of the work to the public; exhibiting or showing the work in public, televising the work via broadcast, cable or satellite.

These laws obviously directly affect a gallery's ability to use artworks from their collection using AR as a specific permission had to be obtained for all the works featured in this application that were still subject to copyright law. In terms of publication right, things are potentially more complex in cases where copyright expires during the time period that the artworks are being used by an application. This dictates that museums, galleries and collectors should ensure that any applications created should be done through their own developer accounts.

While the previous discussion suggests that artists are very well protected in relation to their work, it was evident in Coulton et al. (2014a, b) that many view the digitisation of their work with great suspicion and despite this protection one artist in particular insisted an explicit statement in the application that the artwork must not be used outside the application (such as taking a selfie with the artwork and sharing it on social networking sites).

Curation of user-generated content
Another issue is user-generated content (UGC) if it is to be viewed by general public. Contributing content to a curated collection for example might change the collection in an unacceptable way for the curator who put up such a collection with a purpose in mind. Another problem might present messages with political, social or other such connotation. Also, showing inappropriate or sensitive content to any age groups can also be a potential problem. No museum, gallery, city council or any such organisation in charge of a particular collection in which such messages would appear would wish to be associated with it.

If an AR application enables user engagement in any way in which users can contribute their content, this would have to be subjected to verification and filtration. It has to be noted that any curation limits the expressivity of users and needs to be carried out in appropriate ways. Explaining to users what is acceptable and what is not upfront might avoid any potential issues with users creating sensitive or inappropriate material.

There are several ways to moderate user-generated content. Simple approaches include registering users, restricting content creation to only organised groups of tourists or restricting the content creation from dedicated locally placed devices

(which would eliminate the need of public Internet access, app installation, using one's own device and would simplify moderation). Another possible way would be to engage public to up or down vote UGC, which would also mean that the public would see such content. A potential approach to this would involve manually verifying UGC by employees who work for exhibitor of a collection. This might inevitably present additional cost. However, it would enable users to express their creativity in a safe and playful environment.

Exploiting other fields
Support for users' creativity has been explored in other fields as well. For example, in the field of Artificial Intelligence (AI) new computer vision techniques allow people to amplify their artistic sense with a possibility to transfer artistic (Chen et al. 2017) and visual styles (Liao et al. 2017) between photographs. The first technique called StyleBank allows users to transfer an artistic style from one image to another. A user can for example transfer the style of impressionism to a photograph of an old house. The second technique named deep image analogy can search for similar visual content or perceptually similar semantic structures between photographs and swap them. A user can for example swap a face of Leonardo's Mona Lisa with a face of a character from the *Avatar* film.

Coupling such technologies with AR provides an opportunity to create a medium with rich and numerous possibilities to support creativeness in all sorts of ways.

18.4 Conclusion

The role of art in humans' development is well known. Creating, contemplating and possessing art in all forms sparks users' exploration of their imagination (which in turn takes a tangible form), playfulness and enhances entertainment—art is what makes us human (Scharfstein 2009). Engaging users with existing art and helping them to experience artworks in a different way has not been yet widely explored since we usually consume art in a passive way. AR presents a useful approach for extending user interactions with existing artworks within a mixed reality space; nevertheless, it is important for designers of AR applications to consider practical uses within environments rather than novelty explorations.

Acknowledgements The research was supported by Slovenian Research Agency ARRS (programme no. P1–0383).

References

Angelopoulou A, Economou D, Bouki V, Psarrou A, Jin L, Pritchard C, et al. Mobile augmented reality for cultural heritage. In: International conference on mobile wireless middleware, operating systems and applications; 2012. p. 15–22.

Brosterman N. Inventing kindergarten. 1997.

Bruner JS, Lufburrow RA. The process of education. Am. J. Phys. 1963; 31(6):468–9 (1st ed). http://search.ebscohost.com/login.aspx?direct=true&db=eric&AN=EJ043959&site=ehost-live. Accessed 22 Sept 2017.

Caarls J, Jonker P, Kolstee Y, Rotteveel J, van Eck W. Augmented reality for art, design and cultural heritage—system design and evaluation. EURASIP J Image Video Process [Internet]. 2009; 2009:1–16. http://jivp.eurasipjournals.com/content/2009/1/716160. Accessed 22 Sept 2017.

Chen D, Yuan L, Liao J, Yu N, Hua G. StyleBank: an explicit representation for neural image style transfer. accept. by CVPR 2017 [Internet]. 2017. http://arxiv.org/abs/1703.09210. Accessed 22 Sept 2017.

Čopič Pucihar K, Kljun M, Coulton P. Using a mobile phone as a 2D virtual tracing tool: static peephole vs. magic lens. In: Kreps D, Fletcher G, Griffiths M, editors. 12th IFIP TC 9 international conference on human choice computers HCC12 2016 [Internet]. Salford, UK: Springer International Publishing; 2016a. p. 277–88. http://link.springer.com/10.1007/978-3-319-44805-3_22. Accessed 22 Sept 2017.

Čopič Pucihar K, Kljun MM, Coulton P, Pucihar KČ, Kljun MM, Coulton P, et al. Playing with the artworks: engaging with art through an augmented reality game. In: Proceedings of the 2016 CHI conference extended abstracts on human factors in computing systems—CHI EA '16 [Internet]. New York, New York, USA: ACM Press; 2016b. p. 1842–8. http://www.research. lancs.ac.uk/portal/en/publications/playing-with-the-artworks-engaging-with-art-through-an-augmented-reality-game(3f549016-a1c3-4214-b52e-6bb612aea974).html. Accessed 22 Sept 2017.

Coulton P, Murphy E, Pucihar KČ, Smith R, Lochrie M. User curated augmented reality art exhibitions. In: Proceedings of the 8th Nordic conference on human-computer interaction: fun, fast, foundational—NordCHI '14 [Internet]. New York, New York, USA: ACM Press; 2014a. p. 907–10. http://dl.acm.org/citation.cfm?doid=2639189.2670190. Accessed 22 Sept 2017.

Coulton P, Smith R, Murphy E, Pucihar KČ, Lochrie M. Designing mobile augmented reality art applications: addressing the views of the galleries and the artists. In: Proceedings of the 18th international academic MindTrek conference: media, business, management, content and service—academic MindTrek '14 [Internet]. New York, New York, USA: ACM Press; 2014b. p. 177–82. http://doi.acm.org/10.1145/2676467.2676490. Accessed 22 Sept 2017.

Gombač L, Čopič Pucihar K, Kljun M, Coulton P, Grbac J. 3D Virtual tracing and depth perception problem on mobile AR. In: Proceedings of the 2016 CHI conference extended abstracts on human factors in computing systems—CHI EA '16 [Internet]. New York, New York, USA: ACM Press; 2016. p. 1849–56. http://dl.acm.org/citation.cfm?doid=2851581. 2892412. Accessed 22 Sept 2017.

Kljun M, Pucihar KČ. 'I Was Here': enabling tourists to leave digital graffiti or marks on historic landmarks. In: Proceedings of the 15th IFIP TC 13 international conference on INTERACT '15 [Internet]. 2015. p. 490–4. http://link.springer.com/10.1007/978-3-319-22723-8_45. Accessed 22 Sept 2017.

Kolstee Y, van Eck W. The augmented Van Gogh's: augmented reality experiences for museum visitors. In: 2011 IEEE international symposium on mixed and augmented reality—arts, media, humanities [Internet]. IEEE; 2011. p. 49–52. http://ieeexplore.ieee.org/document/6093656/. Accessed 22 Sept 2017.

Liao J, Yao Y, Yuan L, Hua G, Kang SB. Visual attribute transfer through deep image analogy. ACM Trans Graph [Internet]. 2017 Jul 20;36(4):1–15. http://dl.acm.org/citation.cfm?doid= 3072959.3073683. Accessed 22 Sept 2017.

Lochrie M, Pucihar KC, Coulton P. Time-wARpXplorer : creating a playful experience in an urban time warp. In: Physical and digital in games play seminar. 9th Game Research. Lab Spring Seminar; 2013.

Miyashita T, Meier P, Tachikawa T, Orlic S, Eble T, Scholz V, et al. An Augmented Reality museum guide. In: 2008 7th IEEE/ACM International Symposium on Mixed and Augmented Reality [Internet]. IEEE; 2008. p. 103–6. http://ieeexplore.ieee.org/document/4637334/. Accessed 22 Sept 2017.

Papagiannakis G, Schertenleib S, O'Kennedy B, Arevalo-Poizat M, Magnenat-Thalmann N, Stoddart A, et al. Mixing virtual and real scenes in the site of ancient Pompeii. Comput Animat Virtual Worlds [Internet]. 2005 Feb;16(1):11–24. http://doi.wiley.com/10.1002/cav.53. Accessed 22 Sept 2017.

Resnick M. Computer as paintbrush: technology, play, and the creative society. In: Singer D, Michnick Golinkoff R, Hirsh-Pasek K, editors. Play = Learn. How play motivates and enhances children's cognitive and social growth. 1st ed. New York City, NY: Oxford University Press; 2006. p. 192–208.

Resnick M, Rusk N, Cooke S. The computer clubhouse: Technological fluency in the inner city. In: Schön DA, Sanyal B, Mitchell WJ, editors. High technology. Low-income communities prospects for the positive use of advanced information technology, 1st ed. MIT press; 1999. p. 411.

Scharfstein B-A. Art without borders: a philosophical exploration of art and humanity. 1st ed. Chicago, IL, USA: The University of Chicago Press; 2009.

Šimer E. I was here: a system for digital grafitti in public places. University of Primorska; 2016.

Tillon AB, Marchal I, Houlier P. Mobile augmented reality in the museum: can a lace-like technology take you closer to works of art? In: 2011 IEEE international symposium on mixed and augmented reality—arts, media, humanities [Internet]. IEEE; 2011. p. 41–7. http://ieeexplore.ieee.org/document/6093655/. Accessed 22 Sept 2017.

van Eck W, Kolstee Y. The augmented painting: playful interaction with multi-spectral images. In: 2012 IEEE international symposium on mixed and augmented reality—arts, media, humanities [Internet]. IEEE; 2012. p. 65–9. http://ieeexplore.ieee.org/document/6483990/. Accessed 22 Sept 2017.

Chapter 19
Living and Acting in Augmented Words: How to Be Your Own Robot?

Sander Veenhof

19.1 Introduction

As a technology that allows anyone to turn any imaginable concept into reality and change the world, it is obvious why artists have been early adopters of augmented reality. But it is no longer just artists seeing the value. With the rising global enthusiasm for AR, the domain of AR is growing and the possibilities are still expanding as well. Related to that, the spectrum of AR art is expanding too. Just like there are many types of art, there are also many types of AR art and different approaches to using the technology with an artistic purpose. Artists working with AR have been pushing the boundaries of the technology by discovering new use-cases and creative ways to merge the virtual and the physical. Along with the evolving scope of AR and its expanding influence on the world around us, the artistic explorations of what can be created have turned into exploring what can be achieved with AR. In this chapter, I will be describing this shift with references to some of my own projects to illustrate the various ways in which AR art can manifest itself. Foreseeing that augmented reality is gradually becoming an integral part of reality and having an impact on us and society, AR art is not just a valuable but even a crucial instrument to reflect on this development from within.

S. Veenhof (✉)
Independent AR Researcher, Amsterdam, The Netherlands
e-mail: sander@sndrv.nl
URL: http://sndrv.nl

© Springer International Publishing AG 2018
V. Geroimenko (ed.), *Augmented Reality Art*, Springer Series on Cultural
Computing, https://doi.org/10.1007/978-3-319-69932-5_19

19.2 Evolving AR Art Practice

At first glance, the most predominant progress in the field of AR appears to be hardware oriented. AR escaped the research laboratories when webcam AR could be created using regular hardware and open-source software. With the changes in the technology, changes in the field of AR art followed. Initial works of ARt were experiments in crossing the boundary between the physical and the virtual space, exploring how materials, surfaces, and shapes could be given another appearance and function when viewed through a webcam. The availability of augmented reality software for smartphones leads to a further expansion of virtual material into space, especially when AR could be viewed independent from the 2D marker surfaces.

But mobile AR did not only change the visual and spatial possibilities, it also changed the impact AR could have. When compass-oriented and GPS-based augmented reality was introduced, creations could be positioned anywhere, including places where attaching a marker would not be an option. As a demonstration of this freedom, the augmented reality artists collective Manifest.AR launched an uninvited guerrilla exhibition in the MoMA in New York (Manifest.AR 2010). The relation and the interaction with a specific space became a key theme in various AR artworks. It was becoming clear that it was an essential characteristic of meaningful augmented reality: AR should not just be virtual reality with a transparent background, but it should relate to the environment in which it is embedded. But what if a site-specific design is a no-go, for example when launching an app for a global audience? In some cases, one single replicated item being viewed by numerous people across the world can become a new entity, especially when each individual viewing becomes more than just a plain viewing experience, when it has impact at the spot where it appears.

As an example of AR impacting physical space, the Global Choreography (Veenhof and Vogels 2012) by Sander Veenhof and choreographer Marjolein Vogels was an attempt to trigger action (see Fig. 19.1) in the physical world with something invisible. This distributed synchronized dance app involved people across the world by combining placelessness with a sense of location. The app instructed the participants to stand still with their feet pointing to the north, look through the AR app on their phone, and follow a virtual 3D cube floating around their head. In the art scene, something can be called art once it exists in the mind of one person. And that is how, in a conceptual way, participants experienced the global scale of the dance. On their screen was a real-time display of the number of participants and the list of the countries where people were participating. However, despite this being a worldwide event, people who were not participating in the dance just saw a single individual staring at his or her phone.

For the general public, it wasn't until the global Pokémon GO craze that it became clear that the AR phenomenon was capable of having an influence on the 'real' world. Whereas early AR artworks relied on mediocre hardware which caused the appearances to be shaky layers on top of reality, the viewing experience was very conceptual. But improvements in hardware are now helping the virtual

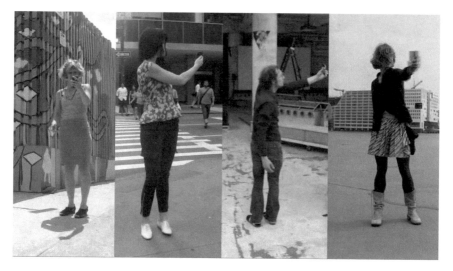

Fig. 19.1 Global Choreography (Veenhof and Vogels 2012)

material to have a seemingly real presence in the physical environment. During the Pokémon craze, huge crowds on the streets further contributed to the apparent merge between the virtual and the physical. In today's reality people move through a world that is affected by a virtual layer. But when will we be ready for a world that can be designed differently because of the presence of virtual adaptations? When will that be possible, what are the impediments to that possible future, and what can be done to overcome those hurdles?

19.3 Problem Solving

A fundamental aspect of any art practice is exploration, discovering or creating what does not exist yet. Artists working with new technologies are often trying to extend the boundaries of what is possible. Not only do artists open new possibilities, but they also stumble upon limitations that they can choose to turn into a topic of an artwork. The placement of a virtual traffic light (Veenhof 2011) on the Dutch island Terschelling is an example of that approach (see Fig. 19.2). Despite the inherent promise and ambition of AR to become a reality, it cannot fulfil that role yet because it still confronts us with an optional situation. Putting our smartphone back in our pocket means the world is back to its physical-only state. We cannot yet design our reality differently, leaving out items that will only appear virtually. Smartphone AR isn't suitable for scenarios in which a permanent view on the hybrid reality is a requirement, which would be necessary for a virtual traffic light to have a real effect.

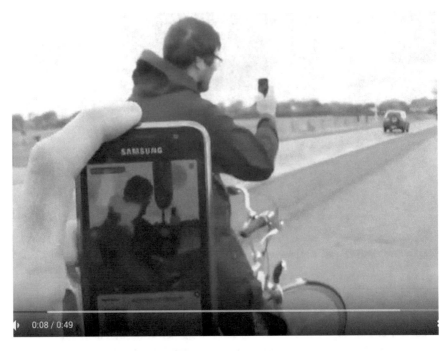

Fig. 19.2 Augmented reality traffic light (Veenhof 2011)

Artists excel in finding creative solutions to make things work in alternative ways. In the case of this traffic light, the envisioned alternative solution was: What if enough people who know about this one specific virtual traffic light at this one specific spot will stop to pull out their phone to open the AR app? Then they will block this narrow bike path and therefore fulfil the promise of a working virtual traffic light: a scenario that has too many dependencies to make it work for real. But failure can be part of the toolset of artists. Even a 'failed' project can be a success if it succeeds in illustrating a point. In this case a statement about the unfortunate limits of the present-day augmented reality technology in relation to ambitious smart city plans with virtual city signs.

Although new hardware might solve some user interaction problems, improving the technology does not solve everything. Technical developments are pushing new use-cases that were not possible with earlier technologies. Despite advancements in technology, other factors remain that lead to limitations in the advancement of AR. As an example, consider augmented reality fashion. The phenomenon can now be presented with an acceptable viewing format due to developments in holographic AR hardware (Ensemble de Solution 2017). This is an improvement on the former tablet based viewing experience (see Fig. 19.3 left). For the fashion industry, AR offers many opportunities, such as presenting a fashion show consisting of AR catwalk appearances with scans of real people wearing real outfits. AR can be beneficial while designing, prototyping, and fitting clothes in life-size 3D, but the

Fig. 19.3 Left: Hyperfabric, Marga Weimans in collaboration with Augment and Weimans (2013); right: Haphazardme HoloLens app (Ensemble de Solution 2017)

true potential will be unlocked when there is no need to convert the virtual creation back to a physical format. Only then can the designs go beyond what we have considered fashion thus far. Unfortunately, for the time being, this will not be viewed as real fashion as it lacks a fundamental characteristic of fashion: a viewing audience with which to share in the self-expression. What if there are no others to impress yet? First, wearables need to be on the face of everybody. Fortunately, the lack of a mass audience is not a concern relevant within an art context. The role of art and in particular AR art can be to show a lively preview of what's possible when no constraints apply and presuming a world that's ready for it.

For some AR to function properly, a threshold in the amount of fellow users is crucial. But even when such a criterion is matched it is not a guarantee that a concept will work as expected. AR is not simply a replacement of physical material, but it radically changes the way we deal with what we see and what we perceive.

Even when a majority of people would observe the world through a wearable, most probably everyone will view a personalized version of reality. You might not be in control on how other people see you or your virtual clothing. In a world that's half physical half digital, everyone will view something different. This alternate reality might even change dynamically based on data gathered by sensors and wearables. A project developed in collaboration with FACT in Liverpool was an implementation of this principle (see Veenhof 2013). The mission of that Google Glass project was to adapt the augmented reality environment of individual viewers in relation to their concentration state. Meant to be used during lectures and talks, a sensor measured the heartbeat of someone wearing a heart rate sensor. Based on the relative changes in heartbeat, a drop-in concentration would be detected triggering a higher level of augmentation with stimulating visuals, aiming to bring the concentration back to a normal level.

Quantified self data sometimes result in a graph or a list of numbers, and based on this visualization of data we have to decide to act. The augmented reality application mentioned above (Fig. 19.4) went one step further, forcing the user to act according to measured data. It is indicative of the rising impact of AR in our daily life. And it's not just the visuals doing the trick. The AR in front of our eyes

Fig. 19.4 Quantified self meets augmented reality (Veenhof 2013)

will be relevant and influential because it will be a visualization of the exchange of inputs and outputs with a huge range of related technologies such as computer vision, face recognition, AI or cloud-based processing of what we see.

Being part of a whole ecosystem of smart innovative technologies is changing the challenges for AR. It's is no longer a matter of improving the visual experience or how to get the gestures or speech control right, it is about how AR can or should interfere with our physical reality. AR is going to play a crucial role in the permanent two-way exchange between people and their environment. When done right, this will bring us a world that's perfectly tailored to our needs and wishes. On the World Wide Web, we can escape from our filter bubble by leaving the Web and going offline. But once AR becomes our new reality when we're wearing AR goggles throughout the day, there's no escape because the virtual domain and the physical domain have merged into one.

If this future scenario will gradually become our reality, it will not be one huge disruptive change we'll be confronted with. Because of this, we might be blind to the key moments in this process. AR is a perfect medium to simulate a speculative world that's not there yet and present it in a lively way. By fast-forwarding into the future, we can have a better perspective on the possible outcome of developments that are occurring right now. Wearables will influence the physical reality in a radical way by controlling and directing people, and by showing notifications that alert, inform, and instruct us. The in-your-face communication of the wearable devices will be far more efficient and effective than the way we presently receive notifications on our smartphones or smartwatches which use a sound or vibrating signal to alert us about something that might interest us. Wearables will radically

change the type of apps and the type of AR art that can be created, because of the different way we can react and act on what we see.

19.4 Hands-on Future Explorations

If wearables will not only define what we see, but also our behaviour, what kind of behaviour will that be? How will it impact inter-human dialogues and relations? And how does it feel? We will become scriptable agents, ready to act according to the instructions given to us by a system. This sounds at the same time frightening but also powerful as a tool to create fictional realities. A project that incorporated both those viewpoints into one experience was the Cyborg Dating (Veenhof et al. 2014) project by Sander Veenhof in cooperation with Rosa Frabsnap, Paul Siegmann and Rudolf Buirma (see Fig. 19.5). It used the mechanism of scriptable behaviour to tell a story about our cyborg future, to be experienced in real life.

The concept of the project consisted of a narrative in which one participant was the cyborg of the present, holding a smartphone. The other participant was wearing

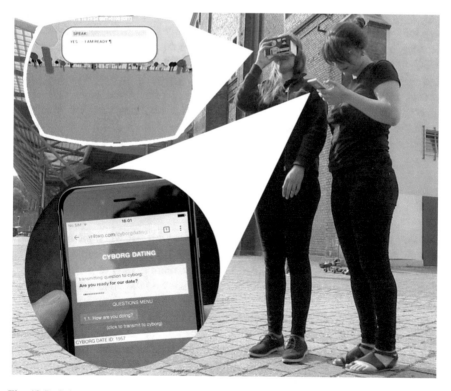

Fig. 19.5 Cyborg Dating (Veenhof et al. 2014)

a headset. An introductory story explained how the future cyborg had gotten to the stage of full emotional and visual enhancement of reality. Looking at the huge amount of dating apps in use today, people are already accustomed to online systems and GPS information to meet new people. What if a date could further be enhanced, not just with suggestions on what to say but by better visuals such as an instant romantic night sky? That was one of the immersive visuals appearing in one of the acts of the Cyborg Dating experience. Some sort of 'augmented reality to the extreme' was created by moving a VR landscape based on GPS data. The participant was walking through the virtual landscape, but he/she was very present in the physical reality too, hearing the city sounds and walking a large distance while accompanied and guided by the other participant. During the walk, the cyborg was being told what to think and what to say. During the walk a story unfolded. Some dialogues were initiated by the system based on a combination of time passing and distance walked. Some milestones caused buttons to appear on the smartphone that could be used to teleport questions to the cyborg. 'Asking' the questions was done by clicking and teleporting them to the cyborg, which instantly reacted by speaking out aloud the lines showing up in the headset. Halfway the experience, after various questions and answers about the future world, the VR device was swapped to the other participant. The smartphone user gets a peek into the future, and the future cyborg was able to see the real world once again.

Our cyborg future in which our daily activities will be monitored and enhanced by cloud-based systems has been a topic in science fiction books and series for decades, but often we judge it to be a story about a faraway and distant future. With the Cyborg Dating project we showed that the morph into a cyborg is a continuum and that the process turning us into cyborgs has already started with the smartphones in our hands. The fully immersive VR world at the other end of the spectrum is an exaggeration. Probably, we will not be living in a VR world permanently. Let us assume our future will be somewhere halfway this spectrum: mixed reality.

19.5 Impact

One day we might not even be aware of encounters with AR when the merge of the virtual and the physical will be so real that it is no longer possible to spot the difference, although that might take a while. Creating picture-perfect AR will always remain a challenge because of the dependency on the unknown territory that the users might be in. But an alternative approach to interfere in reality is text-based AR, ignoring the challenges of embedding the visuals perfectly in the 3D representation of the environment of the user. Google Glass is considered to be a failed product, but in fact it was visionary. With just a tiny informational display for plain text or images appearing at an approximate distance of about a metre in front of people's eyes, it was enough to create contextual AR: providing meaningful data at

the right time and the right location. What seems low-tech at first sight might not be low on impact.

Besides thinking about how to create picture-perfect AR and how it looks, it is also relevant to be thinking about what can be achieved. AR can move people to places and invite them to interact with the AR. But to what extent can an app trigger people to act? Initiate action between people? With a system that instructs people what to say to each other, there is a new step to take for augmented reality art. With performance incorporated into the experience, it's not just about the virtual creations, but it's about what is happening. Testing the capability of AR to initiate conversations amongst strangers in a do-it-yourself theatre situation was the aim of the Meet Your Stranger project (Veenhof and Freyssen 2012). Because it was staged in an augmented reality environment, no venue was required to let people perform a play. With an autocue on their phone people were instructed what to say to each other. The first version for mobile still was a highly unnatural performance, with people staring nervously up and down at their screens to read and be prepared for their next line. The Google Glass follow-up of the project to let people re-enact movie scenes while driving a car was a huge improvement. Meet Your Stranger was theatre, but soon we will have an autocue for our real life too. It will then be unclear whether people are improvising based on their own thoughts, or if there's a script instructing them what to say. It will make these theatrical encounter interactions resemble reality, i.e., a reality in which we're all wearing AR headsets.

Will we all be wearing an augmented reality device in the near future? Probably yes. With a new parallel world to conquer and a billion-dollar business looming, it can be expected that the big tech firms will do their best to bring this market to life. Developing affordable devices with a design that people find acceptable is a hardware issue, so Moore's law will take care of that. But creating the right software and content is of course the real challenge. When will people want to be wearing a device that confronts them with an always-on augmented reality? Experts think it will happen as soon as the ultimate killer app is found. But one killer app will not be enough. For every different circumstance and context there will be a different killer app. Featuring the right app at the right time at the right place is what counts, and that will differ from person to person. Context understanding will be a crucial quality of these devices. With enough insight and tracking people's life carefully and with a powerful AI from the cloud the big tech firms will manage. Probably, they will manage so well that the wearable devices, once they're on our nose, will become a default extension of our body, like the smartphone is today, providing notifications in time and giving helpful insights, tips, suggestions and directions. The more these interactions are applicable, relevant and useful, the more the people's trust in their device will grow. It might turn us into tractable and governable human robots, taking any notification into consideration and acting accordingly. Wearables are going to control our life. But are we in control of the way these devices work and how they operate us? Is it going to be a challenge to be your own robot?

19.6 Worries

Unfortunately, it is time for worries. Humans and thereby audiences will change under the influence of this new technology. For artists, there will be unparalleled opportunities to create experiences in which real life and fictional universes are blurred. But will audiences ever be confronted with experimental creations? Meaning AR creations that are not resemblances of physical art in a virtual format, but art that deals with the new opportunities arising from the role AR will play in our life? What will be possible when artists can make use of the wearable to interfere in our daily routine in an artistic manner? Based on which principles will our AR wearables show us what's relevant? If spending time on an artistic experience does not serve a clear purpose, it might be judged inefficient based on rules streamlining our perfect life using optimization and avoidance of unexpected situations. With art often centred on the unexpected, chances are that the rules on our device will never bring up any art project, unless we explicitly configure ourselves to want that. But even if it will be possible to customize the rules in use by the algorithms managing our life, how often will we be inclined to interfere and change the settings and parameters, when the apps defining our life are already flawlessly doing their job?

A world full of flawlessness is what we can expect our future mixed reality to be. To guarantee a successful ignition of the wearables revolution, the main stakeholders are aware of the need of perfect content and clear use-cases, which is what lacked with the failed Google Glass launch. A way to enforce this is through their app store mechanism, specifying technical, content, and design criteria and requirements. Will art experiences pass through the rigid quality control of those portals? Will there be only one set of criteria which applies to all of the content? Does every creation need to build the polished, engaging, and intuitive apps that customers expect? An accessible clear user interface and a clear description of the workings do not necessarily coincide with the way an artistic AR experience is created. Is art not often about hidden meanings, usage scenarios that are not obvious and not graspable at first sight? How often will that conflict with the rules and quality specifications of the portals? Are the app store tech portals the right entities to define the future of mixed reality art? What will be the art they will understand and approve for viewing?

19.7 Hope

Hopefully, there will be alternative app stores, and users accessing them, so artists can keep publishing their apps. So, we will occasionally engage in mixed reality scenarios with artistically scripted human behaviour and interaction. Unfortunately, that may not be as easy as it sounds. Despite the perspective of an amazing future ahead of us, with people getting superpowers capable of experiencing out of this

world narrative scenarios, it does not look good for mixed reality art that wants to be embedded in this new world. With a huge business potential on the horizon, a rush on augmented reality patents is taking place and a growing number of situations that could occur in a hybrid reality are now claimed and patented. Some remarkable registered patents are, for example, the placement of virtual elements on a physical surface, or using a mid-air interface, or assistance with finding lost items in your house. Much of our future behaviours as cyborg in an AR world will be restricted by numerous patents owned by a small number of patent-collecting corporations. What if an artist designs a concept for a narrative scenario which includes patented behaviour?

Fortunately, there is hope for art because it might escape the constraints with its tendency for a subversive approach, using technology in ways it was not meant to be used, not foreseen. An example of an app that is operating in an unforeseen way is the Patent Alert (Veenhof 2017) app for the HoloLens device (see Fig. 19.6). It is a computer vision application that scans the environment of the user to detect and recognize objects. Based on this analysis, an online patent database is queried for matching patents. Often, these patents are interpreted as signs of innovation, but this app presents the patent information in the opposite way. The app warns the user about activities that cannot be performed while wearing the AR device, in this case the HoloLens. It describes how a patent owned by Apple (for example) will lead to restrictions on all devices by other manufacturers, such as Samsung, Microsoft, or Google.

This issue has been a known fact in the world of smartphones. For example, it is a minor nuisance that Android users could not search for a specific app straight from their home screen. But what will be the impact of patents on apps that guide us through our future life? What if artists cannot create works in this new domain,

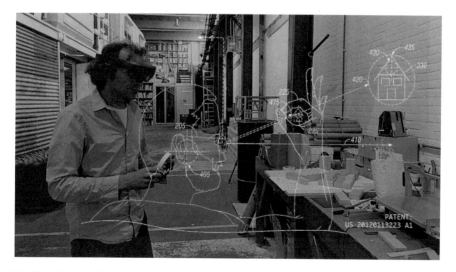

Fig. 19.6 Patent Alert HoloLens app (Veenhof 2017)

because of restrictive patents? Wouldn't it be sad if the technology that was meant to open up an unlimited amount of possibilities for everyone eventually turns out to be the technology that enforces the opposite?

The Patent Alert app raises awareness about this by turning the doubtful speculative future scenario into a hands-on experience. The statement the app is communicating is a critique on the doubtful way businesses are claiming an AR domain that will define our future life. Artists can do what no company would ever consider doing. It's highly improbable that this app will ever be a commercial success. There will not be an audience paying for an app that limits behaviour. But not having to wait until the world and the audience is ready, not having to wait for a profitable business model, not even having to wait until the technology is fully ready, AR art can already be exploring and making statements about our world of the future.

19.8 Conclusion

Augmented reality artists have played an important role in researching the boundaries of AR as a medium. With the changes occurring within the field of AR, the role of AR art is changing too. After the creative exploration of the possibilities and limits from a spatial and aesthetic perspective, the focus of AR art shifted towards researching a more fundamental question: How to create AR with an impact on our physical reality? That aspect is getting more relevant with the growing adoption of the technology and the upcoming advancements in software and hardware, such as AR wearables. With AR devices in front of our eyes, the way we will relate to the world around us will change fundamentally. Wearable devices will control what we see, they will guide us around and instruct us what to say and do. From an artistic perspective, this could lead to exciting new ways in which AR art could manifest itself. But unfortunately, the future of AR art does not look bright. What kind of experimental and artistic apps will be allowed in the app stores, when AR is playing such an important role in the life of people? How much choice will people be having anyway? Will it be a challenge to be your robot? AR can be used to peek into the future by turning imaginary scenarios into hands-on experiences. With better understanding of these future issues and problems, they can be addressed in time, and solutions can be sketched and explained in interactive AR scenarios. Having a positive impact on the proper integration of AR into society seems to be the next challenge for AR art.

References

Augment NL, Weimans M. Hyperfabric. http://augmentnl.com/augmented-reality-fashion/ (2013). Accessed 20 Sept 2017.

Ensemble de Solution. HapHazardme. http://augmentnl.com/fashion (2017). Accessed 20 Sept 2017.

Manifest.AR. WeARinMoMA, http://sndrv.nl/moma (2010). Accessed 20 Sept 2017.

Veenhof S. Quantified self meets augmented reality. http://sndrv.nl/quantifiedselfmeetsaug mentedreality/ (2013). Accessed 20 Sept 2017.

Veenhof S. Patent alert. http://beyourownrobot.com/patents (2017). Accessed 20 Sept 2017.

Veenhof S. Virtual traffic light. https://www.youtube.com/watch?v=4cnPFApUyKA (2011). Accessed 20 Sept 2017.

Veenhof S, Frabsnap R, Siegmann P, Buirma R. Cyborg dating. http://cyborgdating.com (2014). Accessed 20 Sept 2017.

Veenhof S, Freyssen A. Meet your stranger. http://meetyourstranger.com (2012). Accessed 20 Sept 2017.

Veenhof S, Vogels M. Global choreography. http://sndrv.nl/globalchoreography (2012). Accessed 20 Sept 2017.

Chapter 20
Post-human Narrativity and Expressive Sites: Mobile ARt as Software Assemblage

Rewa Wright

20.1 Introduction

Treading a fine line between intimacy and extension, there is no doubt that mobile media devices such as tablets and smartphones, have been making a serious contribution to the expressive power of human bodies. The threshold that has traditionally separated human and machine has shifted, so that the virtual and physical are no longer separate topologies, but rather embodied together in the immediacy of the everyday: the body, like the smartphone, is an interface. But that is not all, because, bit by bit (or byte by byte) mobile media devices have been turning us into post-humans (Hayles 1999; Braidotti 2013). It is not that the devices are some kind of Cyborgian appendage to the human body, although an argument for this could certainly be made. Rather, these new threads weaving themselves into the geocultural fabric of humanity are created through the increasingly dominant organisational force of software. The data network, cloud, or Internet have many uses in life, and perhaps the least of these is artistic. Yet, it is art that is now being revolutionised by the same data networks that produced pervasive computing. Through these innovations artists have been given the capacity to transport audiences into complex meshworks of narrative and experience. The pervasive use of smartphones has created many new lines of critical inquiry that intersect with notions of post-humanism, such as the shaping of human culture through a myriad of physical, embodied, and perceptual connections with the technological machines we use regularly. One such line of inquiry is posited by the radical and highly experimental artistic practice of mobile Augmented Reality Art [ARt]. When used creatively, mobile ARt acts as a vector through which to generate embodied meanings in the user-turned participant, by manifesting aspirational or progressive

R. Wright (✉)
UNSW Art and Design, The University of New South Wales, Sydney, Australia
e-mail: rewawright@gmail.com
URL: http://unsw.academia.edu/RewaWright

© Springer International Publishing AG 2018
V. Geroimenko (ed.), *Augmented Reality Art*, Springer Series on Cultural
Computing, https://doi.org/10.1007/978-3-319-69932-5_20

concepts that can perhaps be dreamed, shaman-like, into existence as narratives, images, and stories that suggest emergent lines of inquiry and creative modes of being in the world.

Exploring a recent selection of the most intriguing examples of mobile ARt, I will filter these through the concept of the software assemblage (Wright 2014), using this concept as a prism through which to illuminate selected aspects of the works discussed. Here, I float the software assemblage as a theoretical formulation that may assist in articulating some of the critical lines of inquiry brought forth by experimental ARt. Built conceptually around Gilles Deleuze and Felix Guattari's conception of the machinic assemblage (1987)—which was in turn built upon Gilbert Simondon's pragmatic notion of the technical ensemble—a software assemblage is an open relational assemblage that can facilitate the complex and mutual interrelation of both concrete and virtual world systems. Deleuze and Guattari located the compositional drive of an assemblage in its capacity to attract material flows (such as those comprising people, objects, or energies) through principles of self-organisation. Primarily, a system of material elements drawn from a common technological lineage would achieve organisation by way of procedural operations vested in movement, intensity, scale, and flux. These systems were described as assemblages, since they meshed existing materials together in unexpected ways, allowing highly unique connections to emerge. Dynamic and provisional, an assemblage has a side facing 'vertical content' (control, authority, stratification) as well as a side open to new connections with other machines of expression, so that the shape of an assemblage is never fixed but always engaged in movements of reassembly. This makes the assemblage an extremely useful strategy in regard to experimental art, with its emphasis on provisional arrangements of things rather than static models, and relational compositions that use emergence to reassemble their structures. Parallels to this way of thinking can be found in quantum physics. Deleuze and Guattari note: 'We will call an assemblage every constellation of singularities and traits deducted from the flow—selected, organised, stratified—in such a way as to converge (consistency) artificially and naturally; an assemblage, in this sense, is a veritable invention (1987: 406)'.

20.2 AR Beyond the Information Overlay

Thinking AR as a material and relational topology is an ecologically inflected strategy that affords a position where research can remain open to shifts in AR as a dynamic system, interconnected with a range of entangled matter flows. Assemblage as a compositional force allows diverse material elements to coalesce according to particular affordances, intensities, thresholds, and attractors. An understanding of assemblage in relation to mobile ARt and the software that drives its compositions, facilitates an examination of the AR medium as a nascent cultural force that has the power to leverage virtuality to shift our current perceptions, to introduce future potentials of political and ethical import into existing conversations

about the material world. Imbued with a micropolitics that explicitly values and enhances qualities of experimentation, participation, and critical inquiry, software assemblages in ARt challenge the accepted industry-driven perceptions of AR as information overlay, and perhaps can operate to undo some of the trivial paradigms that have beset AR in fields such as mainstream gaming and entertainment. Shortly, we will explore some of the distinct developments made by experimental artists using ARt as a citizen-oriented form of critique. Bespoke AR by artists presents a creative opportunity to eschew the more common commercial products of the AR medium and reposition its associated technologies as companions to a radical micropolitics. Additionally, approaching ARt as a software assemblage installs a medium-specific analysis into the field, and removes the need to resort to 'fine art world' terms like site-specific installation, which do not adequately convey the precise technological aspects of networked and mobile ARt. Situating itself outside of mainstream fine art has allowed mobile ARt to take on an activist role, where it has developed the capacity to articulate concepts that have been sorely neglected by many of its institutionalised peers. From this fluid cultural position, the power dynamics that underlie many complex planetary relationships—such as those that flow between cultures, societies, economies, environments, and people—can be unfolded with accuracy and sharpness.

In the technical process of mobile ARt, the artwork itself is executed from a server, the content relayed by the network to the participant's local device, and displayed on screen using an application such as Layar, BlippAR, or any custom-made AR app. Notable in this process is the level of extra commitment that the viewer (turned participant) must embrace in order to engage with the artwork. Prior to the experience they download the app then navigate to the correct layer. This extra labour, rather than discouraging the participant, has the effect of fuelling a meaningful encounter: before they have even experienced the work, they are engaged in a relational experience that goes beyond the 'easy access' model advanced by the art museum or gallery.

20.3 Biofeedback and Décollage

Biomer Skelters (Thiel and Pappenheimer 2014—ongoing) uses the Zephyr heart rate monitor, to connect a bespoke smartphone app to the participant's heart. Networked in this way, the participant's physiological data has the capacity to trigger a virtual biome as they traverse physical space. The frequency of the signal generated by the beating rhythm of their heart is converted into the augments that populate the biome. The shifting pace of the heartbeat effects the rate these virtual plants propagate, the goal being to achieve a relaxed pace and thereby trigger the planting process. Affective computing has long experimented with embodiment, and it was from scientists at Liverpool John Moores University that Thiel and Pappenheimer received their technical guidance. However, the concept of combining an art-game form, an affective computer network, with algorithmic botany

Fig. 20.1 Player of *Biomer Skelters*, and her 'biome'. Image courtesy of the artists, Virtuale Switzerland 2015

produced through AR, was a complete breakthrough. As a result, *Biomer Skelters* has been widely shown in a number of influential artistic research and public forums around the world (Wright 2015).

For the participant, *Biomer Skelters* offers a completely new experience. As they move the camera sensor, they perceive a biome appearing around them in real time, generated by the frequency of their heart rate (Fig. 20.1). Competing with another team to propagate the most extensive biome, virtual plants are traced into the city across a physiologically inflected data network. Operating as a kind of walking self-organising system conjoining real and virtual, the participant of this art-game becomes a vital part of the 'natural' rejuvenation of the city. As the game never unfolds the same way twice, each experience is highly differentiated and multiple meanings layer on top of one another at the same geographical sites. Which species are propagated and where, who placed this biome, where are 'my' plants, where is my own map? During this active movement across an urban landscape, tangible changes are made by the participant, and each player is involved in a lively botanical reinscription of the city. Regular people are accorded a meaningful role as ecological change makers in their own community.

In *Biomer Skelters*, the participant is part of a self-organising dynamic system, where their heart rate visibly generates the composition of the virtual biome. One cannot help but find a correlation between the ephemeral heart rate of the participant, where each beat overwrites the next in a constantly paced sequence, and the appearing and disappearing plant life, overwritten in the ephemera of gameplay, as the competitive aspects of the game take hold. Beyond the game, Thiel and Pappenheimer's real-time reassembly of a virtual biome has the ability to enhance some of the negative design patterns that have influenced urban environments to the occlusion of nature. By producing the conditions under which our urban concrete jungles can give way to lush, algorithmic gardens, there is a suggestion (and an implied critique) of what cities could do to improve their physical ecology. Speaking to the interventionist aspects of their practice, Pappenheimer and Thiel state:

In the context of Wright's concept of software assemblage, we additionally foreground the artistic strategy of décollage that triggers a transformative, perceptual re-assemblage in the viewer: the tearing away or re-configuration of layers of situational assemblage to reveal meanings more profound than the superficial physical or material layers alone. It is in this sense that our work becomes an interventionist space for critical thought. Virtual augmentation therefore is not utilized to enhance or commodify objects or space, but rather to reveal problematics of public or institutional site and memory. The virtual artwork, integrated into the actual Cartesian environment that claims a specific functional or ideological territory, reveals what is otherwise hidden, functioning not merely as a technological apparition but also as an index of suppressed social objects or strata of allusion. (Pappenheimer and Thiel 2016: 2)

The approach is taken by Thiel and Pappenheimer—both collectively and as individuals—can be discerned in earlier examples of artist-led research. Especially, their methodology resonates with the Situationist International's 'detournement', as well as the radical performances of Groupe de Recherche d'Art Visuel (GRAV), whose participatory events in the streets of Paris (circa 1960) advanced an experimental art practice that exceeded prior aesthetic and cultural limits. Such artwork of the everyday, removed the ego of the artist from the situation of the artwork's reception. Audiences were transposed from the passive role of viewer, to the active role of participant, a shift that encouraged regular people to exceed their status as simply inhabitants of their environment, and take on the mandate of change maker. In these radical performances, art took on a function that was neither aesthetic nor didactic, where participants could actively create their own version of events, their own story as the artwork itself. Experimental ARt—generated by complex conjunctions of algorithms, code and software—is a particular instance of computational logic deployed on technical devices. Those devices (be they smartphone, tablet, or another mobile media variant) have a continuous connection to a data network, the Internet and possibly also the cloud. However, at all times these extensive connections between technical assemblages are generated by the real-time presence of the participant, whose gesture of exploring the data embedded by geolocation, spawns the material manifestations of the artwork itself. Without the participant, there can be no software assemblage.

20.4 Software Assemblages as Swarms

Tamiko Thiel's *Gardens of the Anthropocene* (2016) extends her work on *Biomer Skelters*, this time to the physical garden space hidden in various sprawling urban ecologies. At the Olympic Sculpture Park in Seattle, Thiel geolocated swarms of invasive and indigenous plants, from bull kelp to red algae, from delicate flowers to aggressive weeds. Participants could follow the unusual behaviours of these algorithmic plants, some of which would attached to street signs of swarm over paths, never performing quite as they should. At other locations, such as during 'the Augmented Landscape' exhibition in Salem, swarms of red algal bloom invaded the ocean, a virtual harbinger of the ecological imbalance turning healthy water systems into festering swamps (Fig. 20.2).

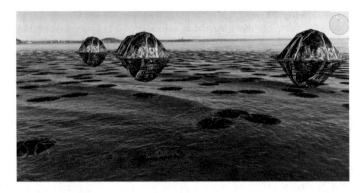

Fig. 20.2 Red algal bloom invading the Waitemata Harbour captured by the author using 'fixed location' in the Layar browser. Auckland, New Zealand, 2017

The unexpected nature traced as virtual by Thiel raises a number of questions about the actual relations between humans and nature in the shared ecological space of planet Earth. How might we better nurture both plants and ourselves in an ecology that is increasingly threatened by pollution, greenhouse gases, and climate change? Offering a rare glimpse of a future where balance has given was to unbalance, Thiel's virtual ecology is far from idealised. Here, she uses décollage to provoke a visceral confrontation with the impact of human carelessness. *Gardens of the Anthropocene* reveals that, when related to software, an assemblage is a swarm just as much as a constellation of precisely composed parts. Yet software swarms are controllable by their programmer, and natural swarms are outside of control. In filtering the concept of uncontrollable nature through the symmetry of algorithmic structures, Thiel uses Cartesian logic to destabilise the prevalent conception of nature as an entity we can mould for the advancement of humanity, or take for granted as an unlimited resource.

More swarm behaviour emerges in a recent work by Will Pappenheimer. Biologists speak of 'fish assemblages', where swarming behaviour across underwater topologies begets a tornado composed of aquatic bodies. Will Pappenheimer's *Ascension of Cod* (Fig. 20.3) is a software assemblage that interpolates a virtual fish assemblage, where the swarming of the fish is produced through the movement of algorithms. Vortex-like in their trajectory, what in real-life would be an underwater tornado is deftly transposed by Pappenheimer into the sky as a meteorological event.

Pappenheimer is no stranger to atmospheric (or ARtmospheric) intervention, with his *Sky Petition City* (2013) (with Zachary Brady) allowing participants to write their opinions and concerns in a cloud-like font across the great blue yonder. Using real-time graphics generated by a participant's handwriting, this work simulates the practice of skywriting from aviation, where temporally fleeting messages are traced by a single-engine plane. In *Sky Petition City*, Pappenheimer and Brady designed an app to strategically place messages written by the public over key institutions in Washington D.C., coalescing on the iconic Washington Monument (Fig. 20.4).

Fig. 20.3 Pappenheimer's *Ascension of Cod* (2017), screen capture courtesy of the artist. Salem Maritime National Historic Site, Massachusetts, U.S.A.

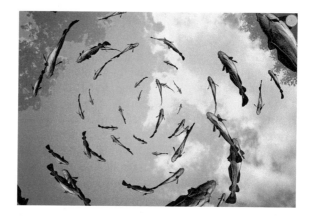

Fig. 20.4 Pappenheimer and Brady, *Sky Petition City* (2013), screen capture courtesy of the artists'

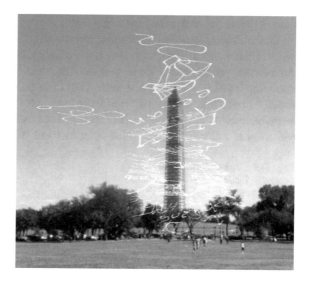

Working on the premise that the voice of the people is too frequently neglected, the artists' sought to include the dreams, hopes, thoughts, and desires, of all who wished to participate. The message left behind operated not only as a subtle act of civil disobedience but also as an informal political forum, where the voices of a people dismissed and ignored are left in situ and accorded respect. Exploring the AR medium as a mode of critical inquiry, blends digital art, affective computing, public participation, and political activism. Placing messages at the site accords the participant an interventionist role in an otherwise abstract political network. Here, ARt creates experiences that interpolate the participant in extensive and intensive sensorial modes of embodied being, modes that go beyond the normal interactions they may experience with technological networks.

20.5 Interventionist Portals

A recurring interest in John Craig Freeman's work is his use of visual imaging technologies such as photography, in combination with its digital offspring photogrammetry, to instantiate virtual portals that link diverse geographical locations. Part-icon, part-totem, these portals trigger a situational meshwork that illuminates the specific cultural concerns of the people and places whose images they convey. Portals can be either physical sculptural structures—as Freeman has made in San Jose and New York—or purely virtual. In a sense, however, even the virtual portals are already physical, because the mobile device needed to access them is itself an object with a screen linked to a network: the phone itself becomes the iconographic portal to another dimension. Places as different as Taipei, Wuhan, Mexico, Arizona, Switzerland, and Russia have been imaged by Freeman, images which are then incorporated into AR to be viewed either at the location of the art experience, or by 'remote location' using the Layar browser.

Paseo Portal, Securing the Virtual Border (Fig. 20.5) is designed as an 'access point' (Freeman 2017) through which the public can encounter people they would not normally come across: the disenfranchised, the homeless, those displaced by the spiralling housing shortage, and those who have fallen with no safety net to catch them. Approaching these citizens as more than just statistics, Freeman's work aims to produce actual meaningful encounters between their culture and ours. Leveraging virtuality to articulate the occluded circumstances of the denied and downtrodden,

Fig. 20.5 John Craig Freeman, *Paseo Portal*, screen capture courtesy of the artist 2017

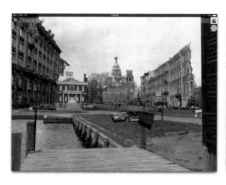

Fig. 20.6 John Craig Freeman, *Virtual Russia* and *Virtual China*, screen capture courtesy of the artist 2017

allows the (privileged) viewer a reflexive space through which to explore the troubled waters of this urban culture of displacement, a culture that they may not encounter in real-life and which has become, shockingly, accepted as the norm. The portal is a meeting place between the cultures of the viewer and the imaged, and generates a visceral encounter when accessed through the realist imaging of photogrammetry, as well as the lifelike qualities afforded by AR as a communication medium. In this space, the participant to such experiences takes away the memory of their virtual encounter, to reflect on and retain long after the ARt experience has ended. Insodoing, the artwork is complicit in activating a micropolitics that goes beyond pure aesthetics to reveal the submerged realities of urban society, bubbling through the material flows of an ARt that asks 'Why'. For those of us who have never experienced such a dramatic displacement as homelessness, an unseen perspective emerges, nascent with questions and begging further answers. Perhaps such artwork holds the power to shift public opinions crystallised by a lack of contact with homeless culture? Through this portal, we are able to access the struggles of a body of citizens caste out from power, a forgotten polis disenfranchised from their rightful access to civic well-being.

In *Virtual Russia* and *Virtual China* (2017), Freeman geolocated virtual portals captured on location in St. Petersburg, Russia and Wuhan, China at the Salem Maritime National Historic Site in Massachusetts (Fig. 20.6). These multilayered geographies are not merely topographical: rather, they are a precise comment on the geopolitical tensions between local and global, manifest in many contemporary nation-states. Freeman comments:

> During its early history, the Port of Salem conducted trade with both the Baltic and China. This history is relevant today as the world struggles to reconcile the discord between globalization and the rise of nationalistic protection and isolationism. We tend to think of globalization as if it were something new. (Artist's statement 2017)

Freeman's work brings diverse events together as narratives that overlap and inform one another to evoke shared stories from multiple perspectives. In assembling these images as living events rather than historical narratives, Freeman's AR experiences

encourage the participant to use their own analytic and expressive thinking, to involve themselves in the story as a co-construction with the artist.

Freeman's practice in AR is connected to his earlier networked art (from 1997) with the Florida Research Ensemble (FRE), where his contribution to the project *Imaging Place: Miami River* developed sophisticated methods of socio-cultural art making that incorporated documentary, environmental imaging, archival collection, and mapmaking methods. Interestingly, Will Pappenheimer was also part of FRE from 2001, locating both artists in a socially engaged practice of inquiry. Gregory Ulmer, the eminent theorist of the group, has written extensively on chorography and electracy (Ulmer 2002; Ulmer et al. 2012; Ulmer and Freeman 2014), and through practice-led artistic research with FRE, attempted to produce a method for choragraphic research in art. Freeman explains the method:

> Chora is the organizing space through which rhetoric relates living memory to artificial memory. It is the relation of region to place. Chora gathers multiple topics associated with a geographical region into a scene whose coherence is provided by an atmosphere. This atmosphere or mood is an emergent quality resulting in an unforeseeable way from the combination of topics interfering and interacting with one another. (Freeman 2008)

The enduring influence of Ulmer's electracy on Freeman and Pappenheimer, who went on to introduce those conceptual threads into ARt, can be seen in Freeman's interest in developing an understanding of electracy that could reach outside of academia, and Pappenheimer's interest in networked memorials. This seed of chora, migrated via Ulmer, has certainly assisted in the relatively fast progression of ARt as a citizen-oriented cultural form and an activist practice. Ulmer's eschewal of an art of pure aesthetics, and his proactive shaping of the Internet as a civic sphere, influenced artist's like Freeman and Pappenheimer, who along with many other members of Manifest. AR has contributed to the fine-tuning of ARt as a radical formation, latent with the potential to influence public opinion toward ethical practices of culture and society.

One of Pappenheimer's collaborative works with Ulmer was a 'memorial' (Ulmer 2005) called 'Soft Wishing Y', designed as a networked memorial to 9/11. Situated simultaneously online and physically in New York City, thousands of orange pom-poms were networked in the formation of a giant wishbone or letter Y. Ulmer has theorised the making of memorial's as a powerful instantiation of chora, where people use the Internet as a potent civic sphere. Using mapping and textual techniques to create personal monuments, adds the people's voice to what are often abstract political events, affording a space for the specificity of local experience to shine through. In this sphere, networked art becomes a communal modality that can help process incomprehensible acts. Here, social conscience conjoins with an aesthetics attuned to the people, using strategies that shift to accommodate an engagement with the issues at hand. Mapping, walking, tracing events through images, or placing symbols (such as the pom-pom) as virtual data *and* in the physical world, are all examples of the various strategies used in this form of networked art. Such practices aim to pull the public toward more challenging forms of engagement, like the making of a personal story *as art itself*. The personalisation

of politics becomes a way to reassemble a multitude of potentially pressing questions, be they cultural, ethical, or political. Isolation is the enemy of networks. Crucially, the public are engaged not simply as an audience, but as agential to the production of the artwork, whose aim is to draw these participants into vocalising their concerns in the civic sphere. Now, more than ever, as we find ourselves in an increasingly tumultuous geopolitical landscape, the imperative of social critique filtered through a culturally engaged aesthetics brings with it a powerful imperative to act. Action, in the context of ARt, is not didactic or dogmatic, it is creative and involved with culture from the inside out.

Take, for example, Will Pappenheimer's recent series *Boon* (2016–17) an augmented artwork that envelopes the participant in an unseen aura, as they are simultaneously pictured in the frame of a tablet or smartphone by their co-participant. Pappenheimer reveals:

> These invisible body works offer contemporary Dada relief and protection against very bad psycho-political conditions staining our consciousness these days. (Artist's statement 2017)

Neurosis and anxiety are psychological disturbances that are metaphysically associated with this current phase of Late Capitalism, and further, intersect with the relationship between humans and technology in urban landscapes permeated by the invisible topologies of ubiquitous computing. Such topologies include, on the surface, a swathe of easy entertainment paradigms—Youtube, Snapchat, Facebook, and many others—as well as the ever present but unseen networks of surveillance, and their wider relationship to vectors of algorithmic control. From this milieu, it seems especially appropriate that *Boon* (Fig. 20.7) should emerge, as a burst of translucent light from the belly of one of the world's great mega-cities, New York. In an age where algorithmic control has come to define many of our public spaces in the name of good governance, *Boon* opens up a space of resistance.

20.6 Closing Remarks

Mobile ARt as an experimental cultural practice has emerged as a critical phlanx to block the onslaught of both the banal virtuality advanced by industrial AR, and also of the more timid participatory artwork produced by the fine art world, where ideas are softened as not to offend, curated so heavily as to provoke a loss of political vitality. As a proactive mode of interrogative artmaking for and by a social corpus whose electrate fluency is ever increasing, mobile ARt is of crucial importance. As I have traced its material topology, the concept of the software assemblage offers a strategy for articulating the nuances of ARt, and has the capacity to evoke, in a relational way, a myriad of technical, aesthetic, and affective concerns that relate the body, mobile devices, and software to the vibrant milieu of early twenty-first century urban culture. The software assemblage offers an extension to, yet is contra distinct from, conventional art world terms such as 'site-specific installation', imported from traditional fine art and often blindly applied to ephemeral

Fig. 20.7 *Boon* 3, participant wearing the Boon button is surrounded by an aura. Image courtesy of the artist. New York Moving Image Fair (2017)

technological art. It offers an alternative way of thinking that explicates the special role of software in creating the participatory experiences that cause mobile ARt to flourish, and the special place of assemblages in contemporary life (Wright 2016). In the context of its attraction and attachment to the material flows of all adjacent forces and energies, the assemblage holds a capacity to harness relational movements (be they political, cultural, or otherwise) that disrupt the accepted order. It is this nuance of assemblage that I have picked up on here—the ability to reassemble a material or conceptual flow based on the desire and capacity of the forces involved to engage with one another. In ARt as software assemblage, such forces are algorithmic, machinic, human, environmental, networked, and nascent in all aspects of culture and society at a planetary level.

Acknowledgements The author would like to sincerely thank Tamiko Thiel, Will Pappenheimer and John Craig Freeman for their artistic generosity and assistance with the assembly of this article. She is grateful for the invaluable support of the University of New South Wales, Sydney, as well as the Australian Government Research Training Program (RTP) Scholarship. Lastly, she would like to extend a warm 'thank you' to Vladimir Geroimenko, who has provided a critical platform for this research.

References

Braidotti R. Posthuman humanities. Eur Educ Res J. 2013;12(1):1–19.

Deleuze G and Guattari F. A thousand plateaus: capitalism and Schizophrenia (trans: Brian Massumi). Minnesota: University of Minnesota Press; 1987.

Freeman JC. Imaging place: the choragraphic method. Rhizomes: cultural studies in emerging knowledge, vol. 18, Freeman. JC, Saper C and Garrett-Petts WF (Eds.) 2008.

Freeman JC. Imaging place. Networked art project. http://ImagingPlace.net. Accessed 12 Sept 2017.

Hayles K. How we became posthuman: virtual bodies in cybernetics, literature, and informatics, Ill. Chicago: University of Chicago Press; 1999.

Pappenheimer W. Boon, February 27–March 2; 2017, Moving image art fair—waterfront New York tunnel. http://www.willpap-projects.com. Accessed 12 Sept 2017.

Pappenheimer W, Brady Z. Sky Petition city 2013, Manifest: AR at Corcoran Gallery of Art, Gallery 31, August 14–September 1; 2013. http://www.willpap-projects.com. Accessed 12 Sept 2017.

Thiel T, Pappenheimer W. Assemblage and Décollage in virtual public space. In: Media-N: Journal of the New Media Caucus; 2016.

Thiel T, Pappenheimer W. Biomer skelters, artwork performed as iterations at FACT gallery (liverpool), ISEA2014 (Dubai), Virtuale Festival (Switzerland). 2013—ongoing. http://www.biomerskelters.com. Accessed 12 Sept 2017.

Thiel T. Gardens of the Anthropocene, Seattle Art Museum Olympic Sculpture Park. June 25–October 3, 2016. http://www.seattleartmuseum.org/gardens. Accessed 12 Sept 2017.

Ulmer GL, Freeman JC, Revelle BJ, Tilson W. Miami virtue & the ulmer tapes. In: Kamloops BC. Canada: Small Cities Imprint; 2012, Vol. 3, No. 2.

Ulmer GL. Internet invention: from literacy to electracy. Longman; 2002.

Ulmer GL, Freeman JC. Beyond the virtual public square: ubiquitous computing and the new politics of well-being. In: V. Geroimenko (Ed.), Augmented Reality Art. Springer; 2014, p. 61–79.

Ulmer GL. Electronic monuments. University of Minnesota Press; 2005, Vol. 15.

Wright R. From the bleeding edge of the network: Augmented Reality and the 'software assemblage', In: Post screen: device, medium and concept. CIEBA-FBAUL; 2014.

Wright R. Mobile Augmented Reality Art and the politics of re-assembly. In: Proceedings of the 21st international symposium on electronic art ISEA2015, Vancouver; 2015. http://isea2015.org/publications/proceedings-of-the-21st-international-symposium-on-electronic-art/. Accessed 12 Sept 2017.

Wright R. Augmented Reality as experimental art practice: from information overlay to software assemblage. In: Proceedings of the 22nd international symposium on electronic art ISEA2016. Hong Kong; 2016. https://isea2016.scm.cityu.edu.hk/openconf/modules/. Accessed 12 Sept 2017.

Chapter 21
Really Fake or Faking Reality?
The Riot Grrrls Project

Claudia Hart and Rose Marie May

21.1 Foreword to this Chapter

Research conducted in museums has shown that the average visitor spends only seconds in front of a work of art (Hein 1998). The typical visitor engages in a behavior that has been called "grazing" or meandering slowly through the museum and only spending seconds looking at any particular art work (Worts 2003). These are disheartening statistics for museum staff. We spend years carefully developing exhibition content and selecting artworks, and we have the expectation that visitors will share our passion and enthusiasm and want to spend time in our exhibitions.

My role as an Interpretive Planner might be easily explained as the person tasked with solving this problem. Interpretation is a position that emerged in art museums a little more than a decade ago. Specialists in interpretation are typically museum educators with expertise in free-choice learning, visitor motivation, cultural attitudes, accessibility, and modes of response and participation. They work with the curatorial and design departments to consider how to present exhibitions to ensure the subjects are intellectually rigorous but also compelling and digestible for a general audience. We think about whether the spaces are navigable and encourage exhibitions teams to consider ways to move beyond the passive experience.

When I was approached by Claudia Hart about working with her SAIC class I saw an opportunity to offer visitors a more active experience in the Riot Grrrls

C. Hart (✉)
Department of Film Video, New Media and Animation,
School of the Art Institute of Chicago, Chicago, USA
e-mail: chart2@saic.edu
URL: https://www.claudiahart.com

R. M. May
Museum of Contemporary Art Chicago, Chicago, USA
e-mail: rmay@mcachicago.org
URL: https://mcachicago.org

© Springer International Publishing AG 2018
V. Geroimenko (ed.), *Augmented Reality Art*, Springer Series on Cultural Computing, https://doi.org/10.1007/978-3-319-69932-5_21

exhibition and to get people to look at the works of art for a longer period of time which we believe supports deeper engagement and meaning making. Studies have shown a positive relationship between the amount of time spent in an exhibition and learning (Borun et al. 1998).

Visitor research is integral to interpretation at the MCA and Claudia, and I agreed early in the project that her students would be assigned readings on visitor behavior in museums and that visitor testing would be woven into the development phase of the ARs. At a critical point in their creative process, the students spent an afternoon at the museum demonstrating their interventions to randomly selected visitors. Afterward the participants were interviewed by a trained researcher who asked a series of questions designed to determine if the AR added to their experience. The responses were generally positive. People looked longer at art works than they would have otherwise and saw something new which prompted them to think about the work from a different perspective. We had comments such as: "it made the painting come alive," "it blurs the painting and slows it down," "you are made to look closer at the painting," and "it took something static and animated it." However, the students learned that their AR needed to be easy to navigate, clearly communicate its message, and not last too long.

The Riot Grrrls project was a successful experiment. From the perspective of an interpretation specialist who is always thinking about how to slow visitors down and create active experiences, AR offers a lot of possibilities. However, we all learned during the course of the project that for AR to work in museums, there are a lot of technical challenges that need to be solved ranging from consistently functioning wireless to tablets with the AR app already loaded the AR or a custom museum app that is easier for viewers to download. But, AR does offer opportunities to encourage visitors to linger and engage more deeply.

At the end of the project, Claudia asked me to consider the questions: Is AR the museum of the future or does the mediation block and make more remote the possibility of a more visceral and emotional experience of the art? From my perspective, I think the potential for AR falls somewhere between those two poles. I believe AR offers a vehicle for enhancing and deepening the experience with the art work. We work to offer multiple ways into the work of art that support different learning styles. AR seems to have an appeal for visitors who want to step out of their own environment and into the world of the art work and have a more visual and physical experience.

Rosie May

21.2 Introduction

The Riot Grrrls App is a custom augmented-reality application developed for the Riot Grrrls exhibition organized by Chief Curator Michael Darling at the Museum of Contemporary Art in Chicago. It was a project developed by the media artist Claudia Hart and her 'Virtual Installation' class at the School of the Art Institute of

Chicago in the spring of 2017. Although pedagogical in intent, the layered structure of image-based augmented-reality technology, particularly when produced by young students—some still in their teens—was intended by Hart to result in a poetic piece reflecting the passage of time and the humanistic process of art history. Below, Claudia Hart, an artist who has also built custom augmented apps for her live performances and sculptural installations, expanded in a series of essays for the Chicago MCA on what augmented reality can mean for museums and the process behind developing the app.

21.3 Claudia Hart on Re-Making the Riot Grrrls

I live in an augmented reality where any image can act like a QR code, taking you deeper into meaning and interpretation—if you have the right app. Image-based augmented reality technology, such as Layar, a provider that offers both commercial software and a public app downloadable for free, permits any image to function like a QR code. How it works is simple: when you point your smartphone's camera at an image, the app allows the camera to read it as a graphical code. The app then sends that code up to the Cloud, which beams down a related animation stored there. You can see this layered animation over or resting somewhere near the connected image. Image-based AR relies both on active wireless and plentiful images, making a museum its natural habitat, particularly when it is placed in the hands of a visual artist.

I first explored how these apps could influence interpretation in museums in 2016, when my Virtual Installation class at the School of the Art Institute developed the *Romantic App*[1]. Created in conversation with Gloria Groom, Chair of European Painting and Sculpture at the Art Institute of Chicago (AIC), and her curating staff, the app engaged with the AIC's late nineteenth- and early twentieth-century collection. In developing this app, my students and I took a media-archeological approach to intervene and bring to the fore the effects industrialization and developments in photography had on artists. This was inspired by the current aesthetic paradigm shift, which is on par with the nineteenth century: a move from painting to photography; photography to the internet age. By overlaying and integrating the work of young artists into paintings by artists from another time, I saw the profound way that AR apps can comment on the passage of art historical time.

For the next iteration of my class, I wanted an even more challenging subject. I knew that intervening in a museum with a contemporary position—read intervening in the works of living artists—could be a good challenge for my students. I looked into the MCA and found the perfect exhibition to augment: *Riot Grrrls*[2],

[1] http://romanticapp.tumblr.com/.

[2] https://mcachicago.org/Exhibitions/2016/Riot-Grrrls.

a presentation of abstract paintings from the museum's collection, organized by Chief Curator Michael Darling (Wellen 2017; McKie 2017; MacDonald 2017). *Riot Grrrls* was a feminist and queer punk-rock movement during the 1990s that was known for its powerful zine culture (Darms 2014; Schilt 2004). For me, the connection of contemporary digital media apps to both the marketing and entertainment industries (mail-order catalogs and the wildly successful, albeit short-lived, Pokémon app) and the historical relationship of today's Internet bloggers to nineties zines was inspiring. Our current digital paradigm shift was nascent in the Riot Grrrls movement! This exhibition was ripe for art pedagogy.

I contacted the MCA's Manilow Senior Curator Omar Kholeif, who generously connected me to Rosie May, Associate Director of Education: public programs and interpretive practices. She met with my class, and we immediately proposed a *Riot Grrls App* zine-cum-blog and catalog and a performative demo and tour of the *Riot Grrrls* show using the app. As part of our research, May gave us scholarly papers on museum apps to read and then opened up the entire infrastructure of the museum to us. Amazingly, everyone was open to everything.

In February, Michael Darling spoke with my students, laying out in the open his curatorial process and sharing his analytic decision-making with rigorous criticality. The students were thrilled, and it opened the door for some of them to comment critically on museological processes in their projects. In fact, the first artists to work with augmented reality positioned themselves in relationship to institutional critique movement that included artists like Andrea Fraser, Martha Rosler, and Renée Green. "WeARinMoMA" (2010), organized by Mark Skwarek and Sanders Veenhof, was the first museum intervention by contemporary AR artists. The group producing it evolved into *Manifest AR*, an important new media art collective formed in 2011, which developed critical augmented-reality interventions at museums and geo-political sites in an attempt to question and challenge institutions and world events.

A critical approach is actually embedded in the very structure of augmented reality apps. As a medium, AR lends itself to institutional critique as much as it does to the kind of historiological commentary made by my students in the *Romantic App* and currently being made by many of my students with their works for the *Riot Grrrls App*. Through the layering lens of an augmented app, we can see the process of art history itself, which accounts for a large part of its uncanny delightfulness.

21.4 Forms of Feminism: Responses to Riot Grrrls by the SAIC *Virtual Installation* Students

Some of the initial concept sketches for The Riot Grrrls App and some screenshots of the resulting augments are intermingled below. The concept sketches were conceptualized as "zines" in honor of the 1990s feminist group, the Riot Grrrls

whose punk-rock project was distinguished by its zine culture. The augments evolved differently, through experimentations on site and conversations with exhibition visitors.

21.4.1 Francesca Udeschini on the Augment of Molly Zuckerman-Hartung's 'Hedda Gabler'

The inspiration for my augment stems from Molly Zuckerman-Hartung's unique historical connection to the Riot Grrrls. She is the sole artist in the exhibition who was actually part of their culture!

The grayscale palette of the piece, its graffiti elements, its tin foil and push pins —to me, all of it points toward the assemblage aesthetic of the *Riot Grrrls'* zines. After looking at many examples of these zines and others, I started thinking about DIY methods of distributing printed materials and screen printing and how it relates to band and concert posters. From there, I thought it would be interesting to take the graphic elements of these paper-based, analog methods and combine them with the entirely digital technology of augmented reality.

My augment consists of a digital transformation of the original painting into a black and white bitmap, as though the image were being prepared for screen printing (Fig. 21.1). Using alpha channels, the dots are transformed into transparent sections, so that the original painting can shine through. The movement of the dots creates a rhythmic, almost psychedelic pattern that offers a different kind of abstraction over the original, abstract painting.

The beauty of augmented reality is that, in its overlay of virtual image, something entirely new is created. It is a process that combines continuity and change, thus offering a possibility for transformation.

21.4.2 Jonatan Martinez on the Augment of Tomma Abts's 'Dele'

To create augments means to forge new ground. Augmenting reality allows a viewer to look at art and history layered with the present and in so doing shows us a way to move forward. When we embrace AR and new mediums, we are able to look into the future of our world. It is very important that the MCA is open to new technologies.

At this moment, such actions are transformative for art and art institutions. Art institutions and the art establishment are currently going through a rapid change. Change is not usually facilitated by institutions, who are usually willing to go with the flow of artistic creation and of society at large. I am really grateful that there at least are a few institutions that are willing to shake their own foundations in order to continue to grow.

Fig. 21.1 Riot Grrrls App augment, 2017 by Francesca Udeschini on Molly Zuckerman-Hartung's *Hedda Gabler*, 2011. Collection Museum of Contemporary Art Chicago, Bernice and Kenneth Newberger Fund. Screenshot: Tiffany Holmes

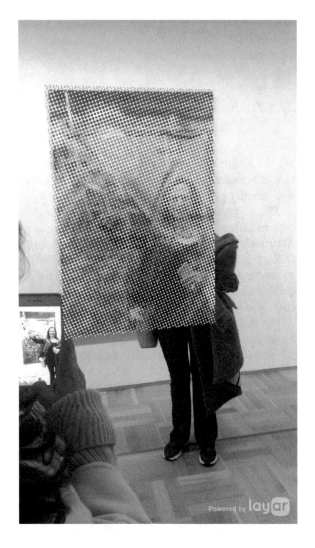

This kind of idealism is related to the ideals that the Riot Grrrls had in mind: to shake the current order to make way for cultural, social, political, and human growth. "Brash, bold, and unafraid to take space," is written in the wall text for the *Riot Grrrls* exhibition we are working with. So, my particular intention for Tomma Abts's work (Figs. 21.2 and 21.3) is to literally take up a lot of space! I explode her painting into space and, in my mind, give new life to the institution. I hope visitors can feel a sense of excitement and inquiry when viewing the augment and spend more time in the exhibition. I want them to be aware of women artists. To see the potential of new media. To look at art through a different lens. And most importantly, to feel their own inner Riot Grrrls!

Fig. 21.2 Jonatan Martinez
concept sketch for augment
for a painting by Tomma
Abts, courtesy of Jonatan
Martinez

21.4.3 Alex Mendoza on the Augment of Judy Ledgerwood's 'Sailors See Green'

For this project, I approached augmented reality as the process of giving a mediated makeover to both an historical object and the context in which that object exists. In my case, that object is the painting *Sailors See Green* (2013) by Judy Ledgerwood, which exists in the context of the white wall of the MCA, feminist history (both art and generally), and the nineties punk collective Riot Grrrls (who do not have a place on the wall of said museum!), among other things. My intention was to identify, break down, and express the many issues and concerns encountered by my *Virtual Installation* class as a whole, and also by me personally—as a male artist— while developing and executing this exhibition app (Fig. 21.4).

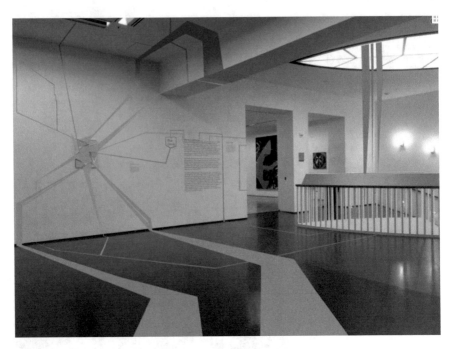

Fig. 21.3 2017 Screenshot of augment by Jonatan Martinez (courtesy of Jonatan Martinez) over Tomma Abts's *Dele*, 2014, acrylic and oil on canvas, 19 3/16 × 15 1/16 in. (48.7 × 38.3 cm). Collection Museum of Contemporary Art Chicago, gift of Marshall Field's by exchange, 2015.3

21.4.4 Christina Chin on 'Love Letter to a Violet' Augment by Ellen Burkenblit

The goal for my AR is to respond to the sexist atmosphere of the art world and also of aspects of this exhibition! My AR uses the context behind Ellen Burkenblit's *Love Letter to a Violet* to reveal a deeper meaning. I am adding to this painting a series of women who are fighting their hardest, yet still are unable to break out of the realm of sexism. The images shown are appropriated from Hollywood films to match the pop art style of the painting and to reference how women are represented in the media. The audio I chose to use in my augment is of women throughout history, including political figures like Hillary Clinton, who have chosen to speak out against sexism in its many forms. These are all layered on top of each other to create a kind of cacophony, which is meant to elicit frustration and be over-whelming to viewers—giving them a small sense of how most women artists feel (Fig. 21.5).

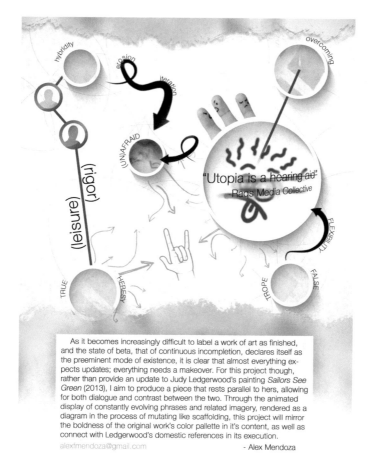

As it becomes increasingly difficult to label a work of art as finished, and the state of beta, that of continuous incompletion, declares itself as the preeminent mode of existence, it is clear that almost everything expects updates; everything needs a makeover. For this project though, rather than provide an update to Judy Ledgerwood's painting *Sailors See Green* (2013), I aim to produce a piece that rests parallel to hers, allowing for both dialogue and contrast between the two. Through the animated display of constantly evolving phrases and related imagery, rendered as a diagram in the process of mutating like scaffolding, this project will mirror the boldness of the original work's color pallette in it's content, as well as connect with Ledgerwood's domestic references in its execution.

alexfmendoza@gmail.com - Alex Mendoza

Fig. 21.4 Alex Mendoza concept sketch (courtesy Alex Mendoza) for an augment of *Sailors See Green* by Judy Ledgerwood, 2013. Oil and metallic oil on canvas; 96 1/8 × 78 1/16 in. (249.2 × 198.3 cm). Collection Museum of Contemporary Art Chicago, gift of Katherine S. Schamberg by exchange 2014.3. © 2013 Judy Ledgerwood Photo: Nathan Keay, © MCA Chicago

21.4.5 Beier Zong on the Mary Heilmann's 'Metropolitan'

The goal for my augmented piece is to expand on the painting by rechanneling it as information, layer upon layer. I wanted to add time elements to static 2D images and give them an organic sense of life. I am attempting to illustrate new ways of defining an exhibition and hopefully even change the viewing behavior of exhibition goers. Mary Heilmann's paintings are conceptually two-dimensional sculpture, confirmed by the objects and installations that she sometimes makes. Extending her method, I created 2D sculptures (2D representations of sculptures) based on a photograph of her painting. I want viewers to see the workings of my

Fig. 21.5 Christina Chine, rendering of the augmentation (courtesy of Christina Chin) for Ellen Berkenblit's *Love Letter to a Violet*, 2015, oil, charcoal, and oil stick on linen, 91 1/2 × 79 7/16 in. (232.4 × 201.8 cm). Collection Museum of Contemporary Art Chicago restricted gift of Sara Albrecht 2015.17. © MCA Chicago

mind, thereby turning her painting into a kind of living creature, growing and expanding and evolving before their eyes (Fig. 21.6).

21.5 Afterword: Reflecting on the Riot Grrrls App

Dear MCA,

When I approached you in the summer of 2016, I had only the vaguest notion of what might become of the project I was proposing: an "augmented" app called *Riot Grrrls*. As it evolved, so did my role in the process. From the usual role of professor at SAIC, I found myself performing something more akin to a conductor or choreographer, coordinating what turned out to be completely unrehearsed moving

Fig. 21.6 2017 Rendering of Mary Heilman augmentation by Beier Zong (courtesy of Beier Zong) over Mary Heilmann's *Metropolitan*, 1999. Oil on canvas; 75 × 60 in. (190.5 × 152.5 cm). Collection Museum of Contemporary Art Chicago, gift of Mary and Earle Ludgin by exchange, 2012.13. © 1999 Mary Heilmann, Photo: Nathan Keay, © MCA Chicago

parts. In this case, the moving parts consisted of your staff in all its variety, from your Chief Curator to your Production Editor, your Director of Digital Media and Chief Content Officer to your Associate Director of Education: Public Programs and Interpretive Practices (jobs I'd never heard of before); the great SAIC students, central to my particular role; and finally, though equally significant, the audience—the actual museum goers themselves!

This extensive list reveals the complexity of your field of study: a concept, also previously, a stranger to me, called museology, or "the science or practice of organizing, arranging, and managing museums." I now think of museology as a collaborative discipline in which museum professionals and artists (my students and

the artists in the exhibition, who I never met but were nonetheless the center of our gravity) perform a kind of pas-de-deux (or three or four). In this dance, augmented reality is like a staccato element within the composition, punctuating each work in the exhibition and bringing a different kind of energy and excitement to the piece.

Within our *pas-de-deux*, our app acts as a conversation starter, a kind of glue that brings visitors together and breaks down boundaries between the viewer and the art. Someone looking at a painting through a phone with rapt attention enacts a very seductive performance. People tend to look over shoulders, to ask one another, "What are you DOING?" This creates dialogue about the exhibition, about its paintings, and about how cool it all is (a favorite word of the app users). I think this happens not just because visitors are looking at the paintings through their very treasured phones, but also because augmented reality is a variety of current high-tech trends that represent the way we live now. When visitors use our app, they are layering related digital animations over more familiar paintings to produce new, unexpected, and very contemporary versions of painting! Together this make for an enthralling experience: the high and the low, the historic and the current moment, the remoteness of high art to the everyday things we do in our normal lives.

So, my dear MCA, the final act of the SAIC "Riot Grrrls App Show" was, to me as conductor and choreographer, an improvisation—both a pleasure and a surprise. I discovered that augmented-reality apps are a kind of museum in a bottle, a device to make curatorial connections, open up different worlds, and create dialogues between the art and the visitor and among museum visitors. I couldn't be more pleased with the result and more grateful for the experience!

xxxxx

Your friend,

Claudia

References

Borun M, et al. Family learning in museums: the PISEC perspective. Philadelphia: PISEC, Franklin Institute; 1998.

Darms L, editor. The Riot Grrrl collection. New York: The Feminist Press at City University of New York; 2014.

Hein G. Learning in the museum. London and New York: Routledge; 1998. p. 102–10.

MacDonald L. Riot Grrrls at the Museum of Contemporary Art Chicago. Provokr. 2017 Feb 28.

McKie K. MCA swings at artistic patriarchy with Riot Grrrls. Third Coast Review. 2017 Jan 5.

Schilt K. The history of Riot Grrrls. The Feminist eZine. 2004.

Wellen B. Riot Grrrls' brings art girls to the front. The Chicago Reader. 2017 Jan 5.

Worts D. On the brink of irrelevance? Art Museums in Contemporary Society. In: Tickle L, Sekules V, Xanthoudaki M, editors. Researching visual arts education in museums and galleries: an international reader. Dordrecht: Kluwer Academic Publishers; 2003. p. 215–31.

Concluding Remarks: Today's Vision of an Art Form of the Future

Vladimir Geroimenko

"The future of Augmented Reality is bright." This would probably be the best sentence to start these concluding thoughts with. The problem is that so many books on so many topics have already used a similar sentence for their final chapters, but no one is now aware or cares about many of those topics any more. So, what about Augmented Reality? Is it going to stay with mankind forever or just for a while? As it was with many other information technologies, only time can provide a correct answer to this question.

What about today? To what extent can we be sure about a promising future for Augmented Reality and also a new form of art, based on this emerging technology? From the birth of mankind until the end of the twentieth century humans have lived in a single world (that we can now call the real reality). The invention of computers and the Internet has added a new realm of reality—a complex, exciting, and useful digital world. Since then, we are living in the two different worlds (physical and digital), but not at the same time—at least, in terms our perception and attention. This is where Augmented Reality comes into play. This unique technology enables the very existence of a new world that is a mixture of the real and the digital. Augmented or Mixed Reality implants digital content into physical world in order to augment and enhance the latter. It makes it possible to experience digital world without leaving the physical one. Augmented Reality is a crucial step from a dualism of physical and digital worlds to their unity, and this makes that technology of paramount value to the future of humankind.

Augmented Reality Art is not only a novel creative medium, but also bound to become an organic part of the emerging hybrid world. It brings a new type of artworks into physical world—works that can be at any place, of any size and of any structural and functional complexity. Any part of physical world can now be used as an artistic canvas, a computer screen, or a gallery. Digital art augments the physical world in a creative way, and we have every reason to predict that this new art form will stay with us forever.

What is next? Next is an exciting creative practice in the new emerging world, and also intensive research into every facet of the newborn form of art. Now in its

© Springer International Publishing AG 2018
V. Geroimenko (ed.), *Augmented Reality Art*, Springer Series on Cultural Computing, https://doi.org/10.1007/978-3-319-69932-5

second edition, this book will continue to inspire new books, new conferences, new exhibitions, and new groundbreaking artworks. This is why this pioneering book has been dedicated to the future generations of Augmented Reality artists.

Printed in the United States
By Bookmasters